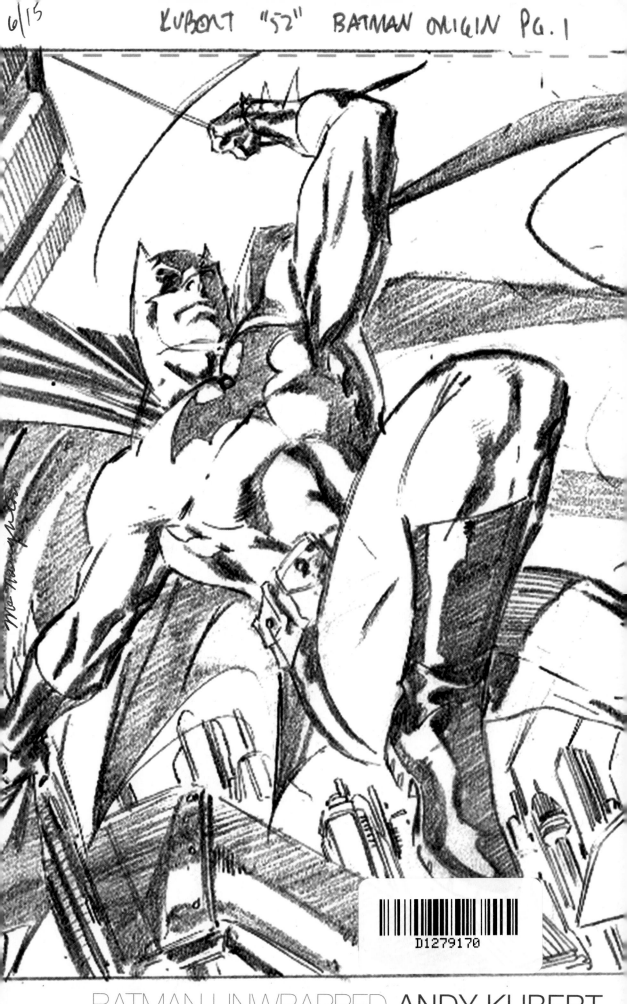

BATMAN UNWRAPPED ANDY KUBERT

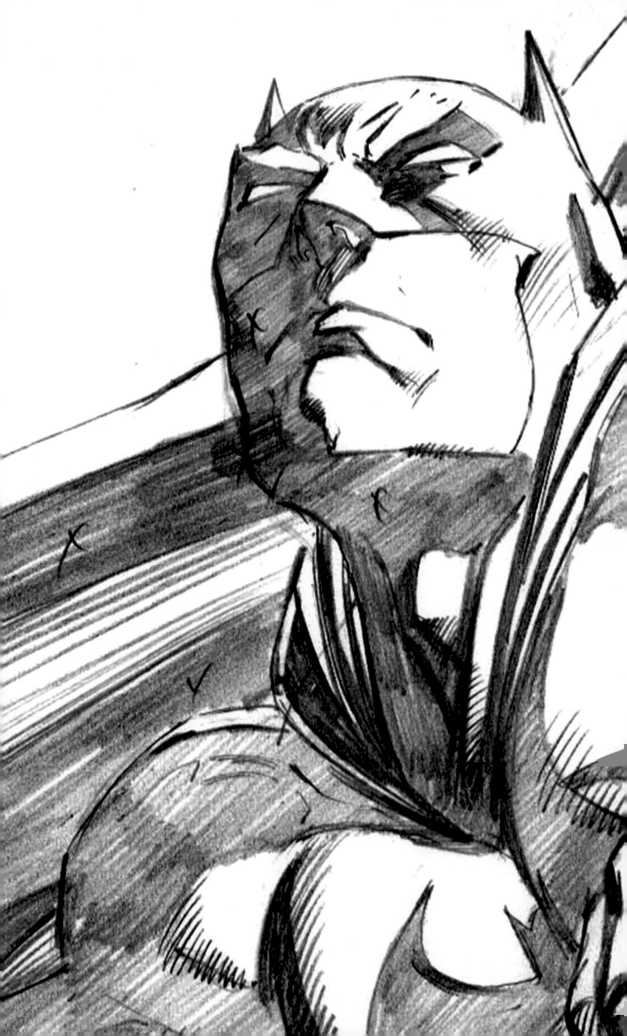

BATMAN UNWRAPPED ANDY KUBERT

ANDY KUBERT ARTIST GRANT MORRISON NEIL GAIMAN SCOTT SNYDER MARK WAID WRITERS

NICK J. NAPOLITANO ROB LEIGH JARED K. FLETCHER PHIL BALSMAN LETTERERS

COVER ART BY ANDY KUBERT BATMAN CREATED BY BOB KANE

Peter Tomasi Mike Marts Michael Siglain Editors – Original Series Jeanine Schaefer Katie Kubert Associate Editors – Original Series Elisabeth V. Gehrlein Janelle Siegel Harvey Richards Assistant Editors – Original Series Peter Hamboussi Editor Robbin Brosterman Design Director – Books Louis Prandi Publication Design

Bob Harras Senior VP – Editor-in-Chief, DC Comics

Diane Nelson President Dan DiDio and Jim Lee Co-Publishers Geoff Johns Chief Creative Officer John Rood Executive VP – Sales, Marketing & Business Development Amy Genkins Senior VP – Business & Legal Affairs Nairi Gardiner Senior VP – Finance Jeff Boison VP – Publishing Planning

Mark Chiarello VP – Art Direction & Design John Cunningham VP – Marketing Terri Cunningham VP – Editorial Administration Alison Gill Senior VP – Manufacturing & Operations Hank Kanalz Senior VP – Vertigo & Integrated Publishing Jay Kogan VP – Business & Legal Affairs, Publishing

Jack Mahan VP – Business Affairs, Talent Nick Napolitano VP – Manufacturing Administration Sue Pohja VP – Book Sales Courtney Simmons Senior VP – Publicity Bob Wayne Senior VP – Sales

BATMAN UNWRAPPED: ANDY KUBERT Published by DC Comics. Copyright © 2014 DC Comics. All Rights Reserved. Originally published in single magazine form in BATMAN 655-658, 664-666, 686, 700; DETEC-

TIVE COMICS 853; COUNTDOWN 52 WEEK 46; BATMAN 18 © 2006, 2007, 2009, 2010, 2013 DC Comics. All Rights Reserved. All characters, their distinctive likenesses and related elements featured in this publication are trademarks of DC Comics. The stories, characters and incidents featured in this publication are entirely fictional. DC Comics does not read or accept unsolicited ideas, stories or artwork. DC Comics, 1700 Broadway, New York, NY 10019. A Warner Bros. Entertainment Company Printed by RR Donnelley, Salem, VA, USA. 1/24/14. First Printing. ISBN 978-1-4012-4242-8

Library of Congress Cataloging-in-Publication Data

Kubert, Andy.
 Batman Unwrapped / by Andy Kubert.
 pages cm
 ISBN 978-1-4012-4242-8
 1. Graphic novels. I. Title.
 PN6728.B36K83 2013
 741.5'973—dc23

2013021255

SUSTAINABLE FORESTRY INITIATIVE

Certified Chain of Custody
At Least 20% Certified Forest Content
www.sfiprogram.org

SFI-01042
APPLIES TO TEXT STOCK ONLY

TABLE OF CONTENTS

5 Introduction

7 BATMAN & SON PART 1:
BUILDING A BETTER BATMOBILE
From BATMAN #655 September 2006
Writer: **Grant Morrison**

35 BATMAN & SON PART 2:
MAN-BATS OF LONDON
From BATMAN #656 October 2006
Writer: **Grant Morrison**

59 BATMAN & SON PART 3:
WONDERBOYS
From BATMAN #657 November 2006
Writer: **Grant Morrison**

82 BATMAN & SON PART 4:
ABSENT FATHERS
From BATMAN #658 December 2006
Writer: **Grant Morrison**

107 THREE GHOSTS OF BATMAN
From BATMAN #664 May 2007
Writer: **Grant Morrison**

131 THE BLACK CASEBOOK
From BATMAN #665 June 2007
Writer: **Grant Morrison**

155 BATMAN IN BETHLEHEM
From BATMAN #666 July 2007
Writer: **Grant Morrison**

179 WHATEVER HAPPENED TO THE CAPED CRUSADER? PART 1:
THE BEGINNING OF THE END
From BATMAN #686 April 2009
Writer: **Neil Gaiman**

213 WHATEVER HAPPENED TO THE CAPED CRUSADER PART 2
From DETECTIVE COMICS #853 April 2009
Writer: **Neil Gaiman**

242 TOMORROW
From BATMAN #700 August 2010
Writer: **Grant Morrison**

252 THE ORIGIN OF THE BATMAN
From COUNTDOWN 52 #46 May 2007
Writer: **Mark Waid**

256 RESOLVE
From BATMAN #18 May 2013
Writer: **Scott Snyder**

276 Cover Gallery

286 Biographies

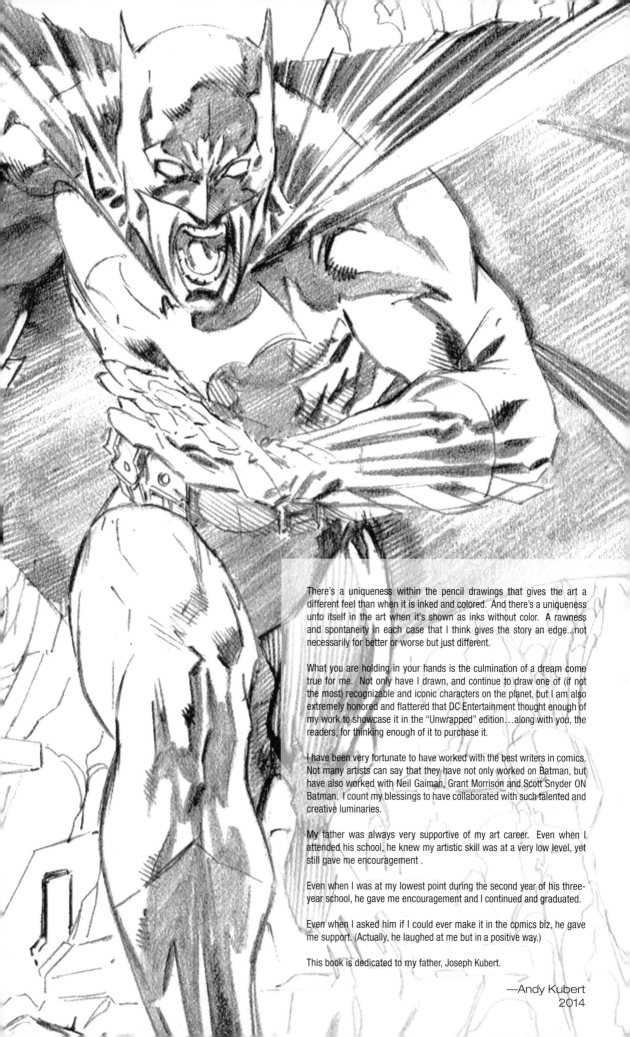

There's a uniqueness within the pencil drawings that gives the art a different feel than when it is inked and colored. And there's a uniqueness unto itself in the art when it's shown as inks without color. A rawness and spontaneity in each case that I think gives the story an edge...not necessarily for better or worse but just different.

What you are holding in your hands is the culmination of a dream come true for me. Not only have I drawn, and continue to draw one of (if not the most) recognizable and iconic characters on the planet, but I am also extremely honored and flattered that DC Entertainment thought enough of my work to showcase it in the "Unwrapped" edition…along with you, the readers, for thinking enough of it to purchase it.

I have been very fortunate to have worked with the best writers in comics. Not many artists can say that they have not only worked on Batman, but have also worked with Neil Gaiman, Grant Morrison and Scott Snyder ON Batman. I count my blessings to have collaborated with such talented and creative luminaries.

My father was always very supportive of my art career. Even when I attended his school, he knew my artistic skill was at a very low level, yet still gave me encouragement .

Even when I was at my lowest point during the second year of his three-year school, he gave me encouragement and I continued and graduated.

Even when I asked him if I could ever make it in the comics biz, he gave me support. (Actually, he laughed at me but in a positive way.)

This book is dedicated to my father, Joseph Kubert.

—Andy Kubert
2014

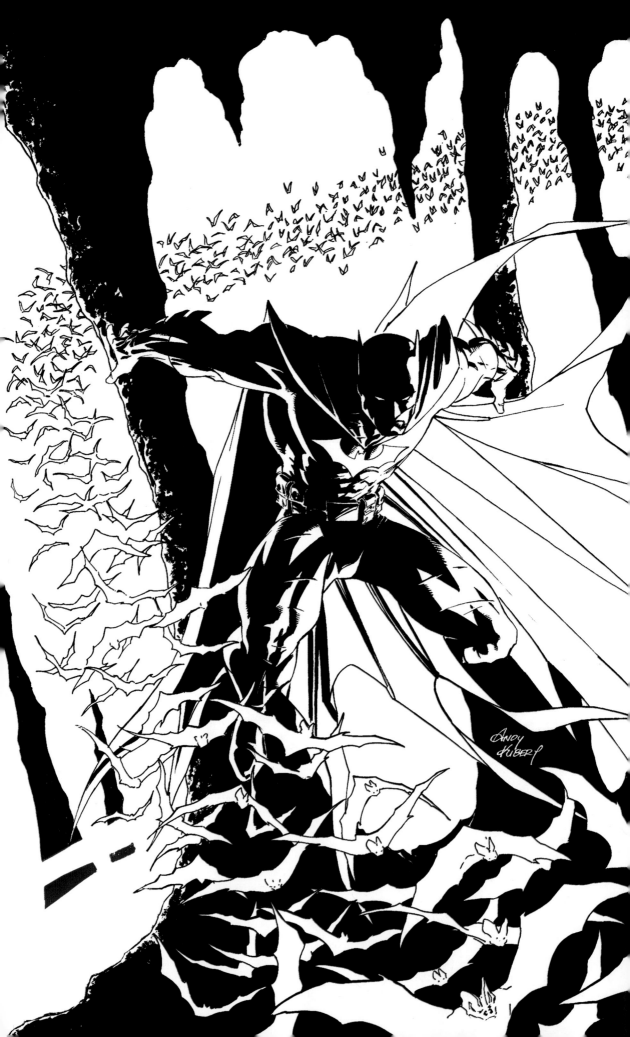

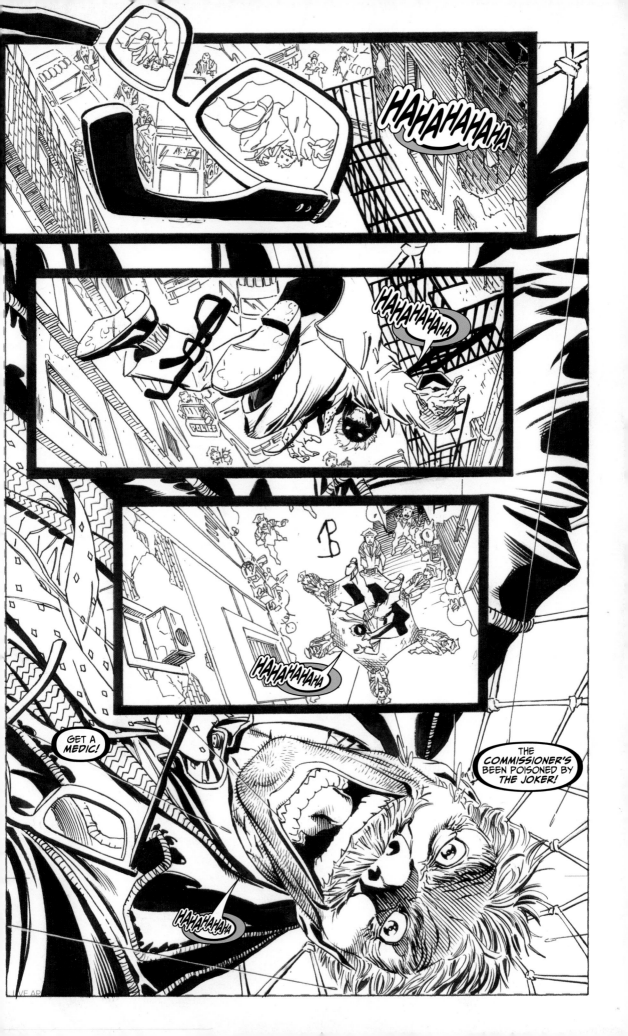

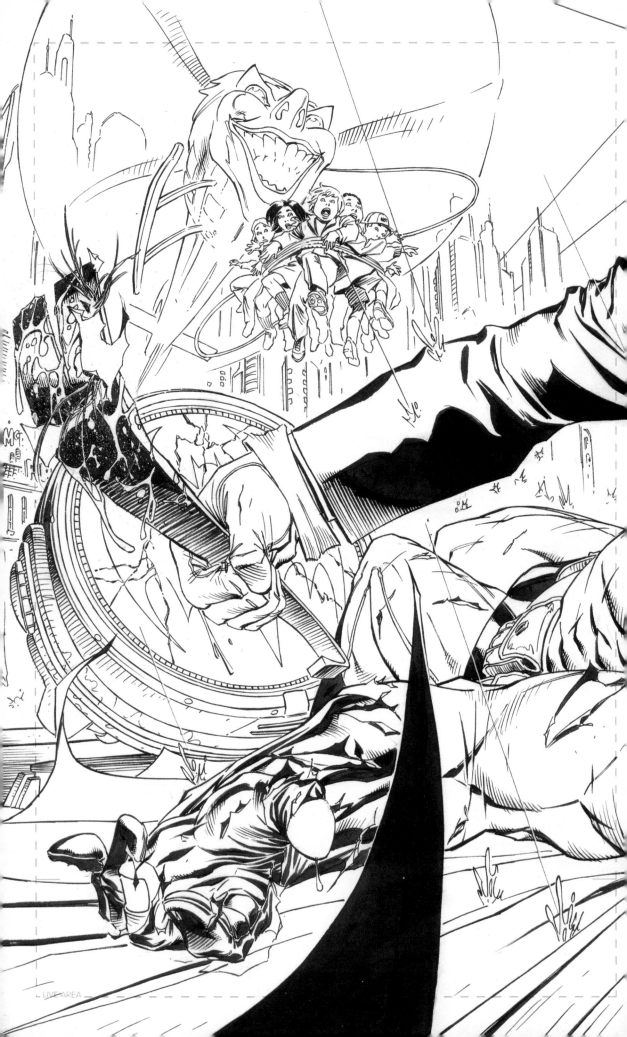

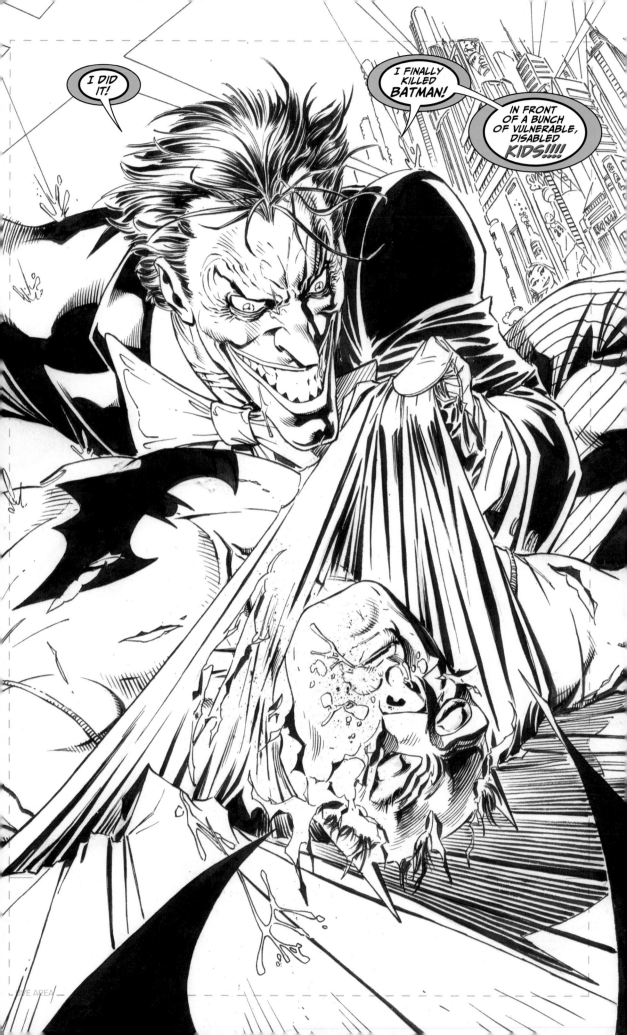

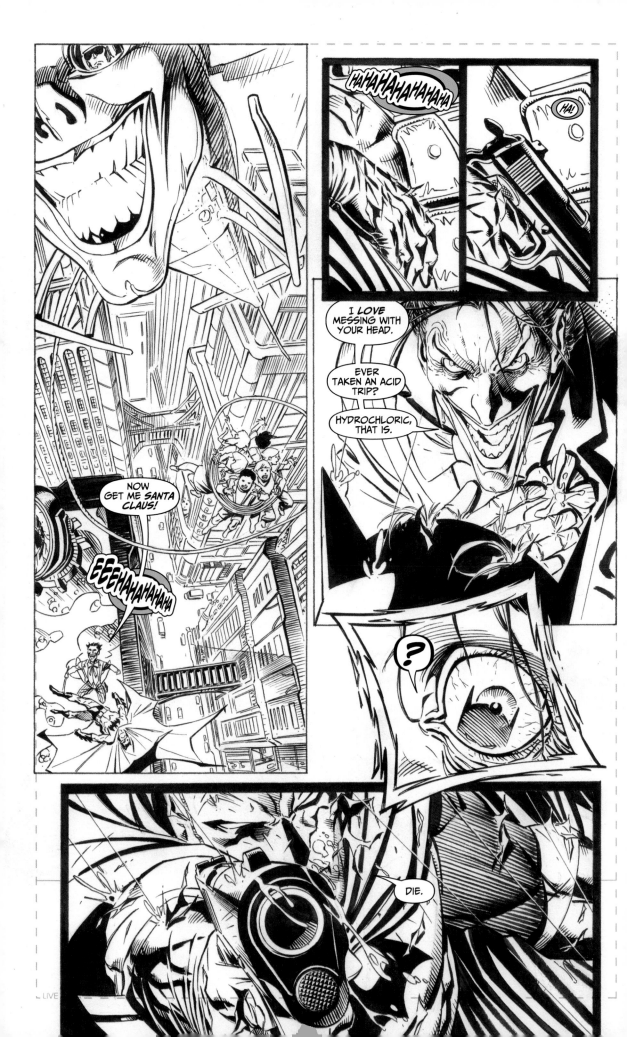

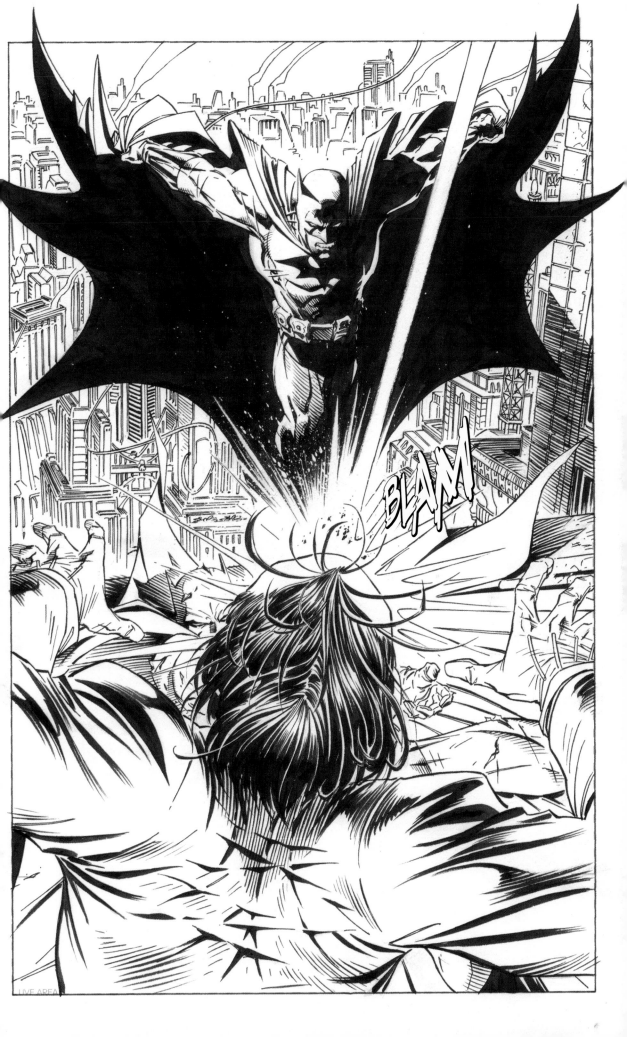

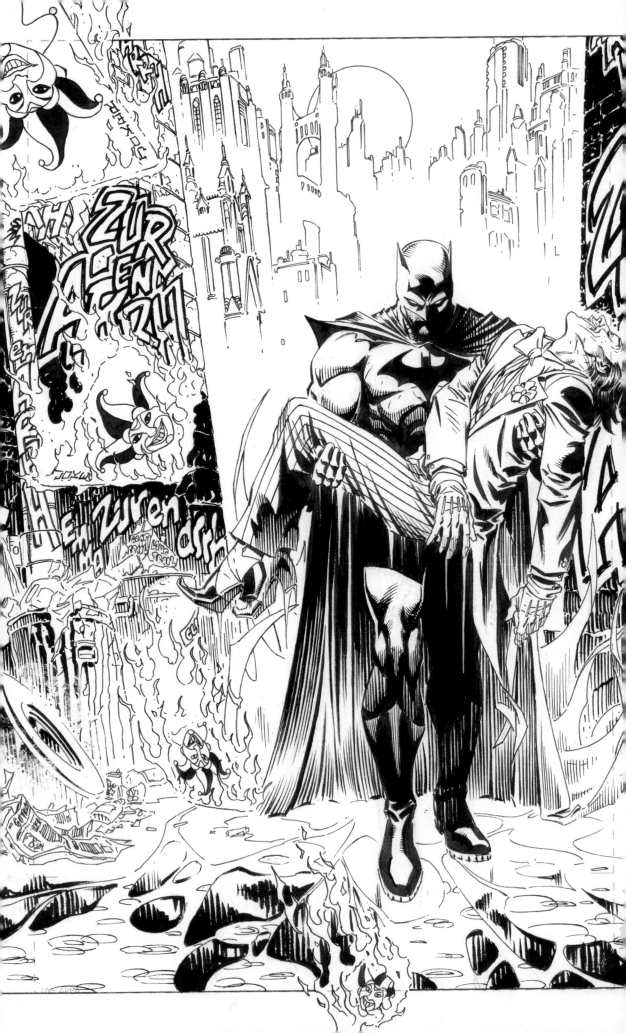

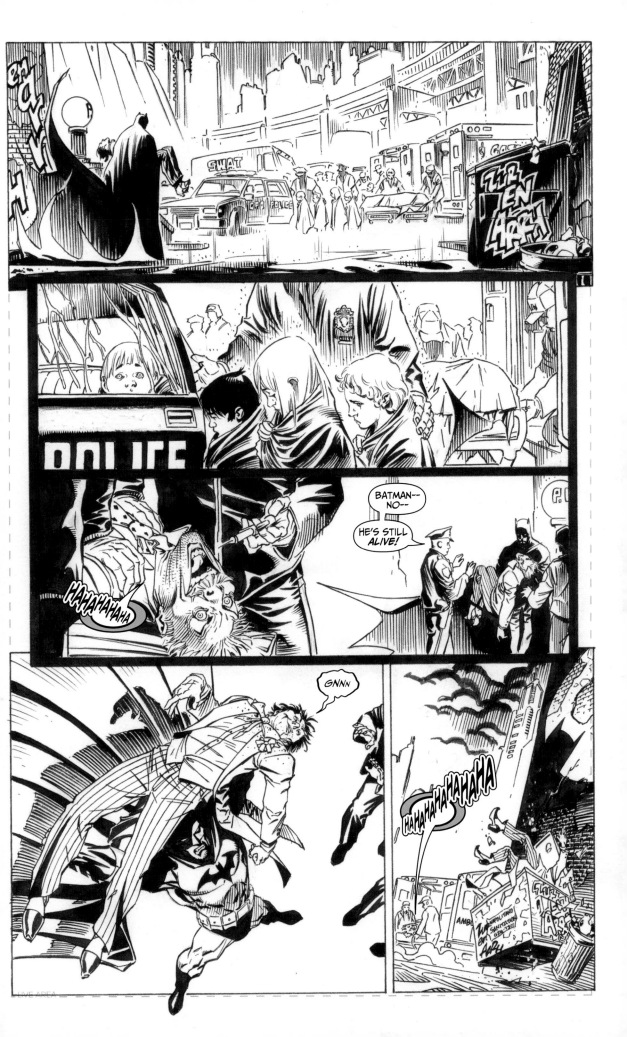

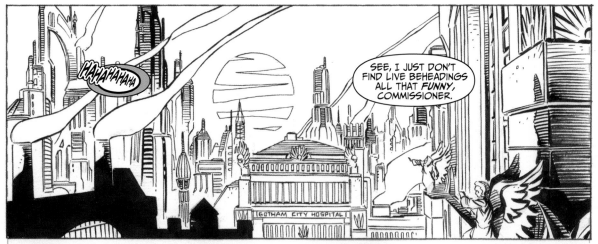

HAHAHAHAHA

SEE, I JUST DON'T FIND LIVE BEHEADINGS ALL THAT *FUNNY*, COMMISSIONER.

GOTHAM CITY HOSPITAL

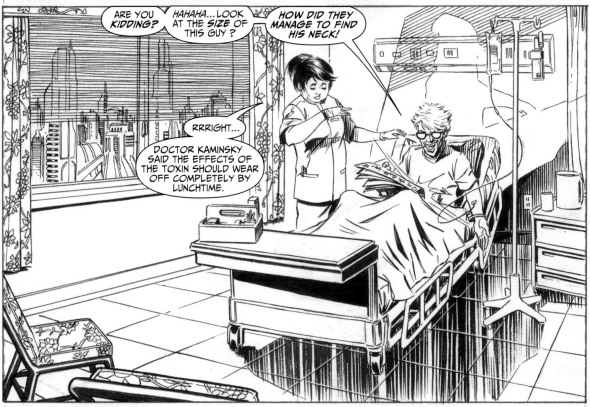

ARE YOU KIDDING?

HAHAHA...LOOK AT THE *SIZE* OF THIS GUY?

HOW DID THEY MANAGE TO FIND HIS NECK!

RRRIGHT...

DOCTOR KAMINSKY SAID THE EFFECTS OF THE TOXIN SHOULD WEAR OFF COMPLETELY BY LUNCHTIME.

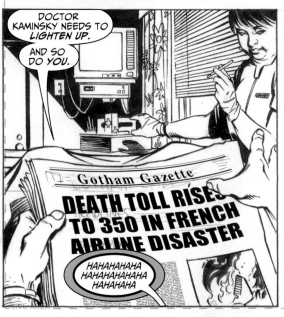

DOCTOR KAMINSKY NEEDS TO *LIGHTEN UP.*

AND SO DO *YOU.*

Gotham Gazette

DEATH TOLL RISES TO 350 IN FRENCH AIRLINE DISASTER

HAHAHAHAHA HAHAHAHAHAHA HAHAHAHA

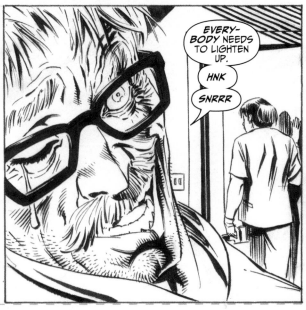

EVERY-BODY NEEDS TO LIGHTEN UP.

HNK

SNRRR

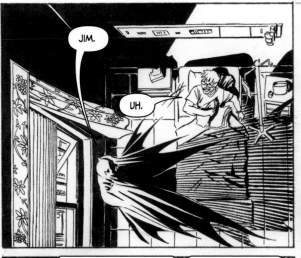

JIM.

UH.

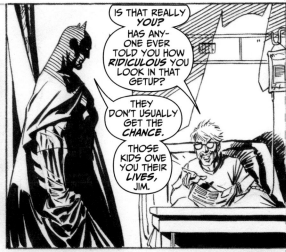

IS THAT REALLY *YOU?* HAS ANY-ONE EVER TOLD YOU HOW *RIDICULOUS* YOU LOOK IN THAT GETUP?

THEY DON'T USUALLY GET THE *CHANCE.*

THOSE KIDS OWE YOU THEIR *LIVES,* JIM.

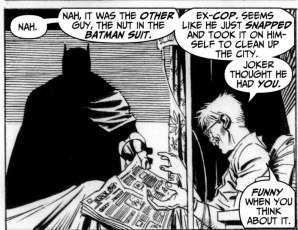

NAH.

NAH, IT WAS THE *OTHER* GUY, THE NUT IN THE *BATMAN SUIT.*

EX-*COP.* SEEMS LIKE HE JUST *SNAPPED* AND TOOK IT ON HIM-SELF TO CLEAN UP THE CITY. *JOKER* THOUGHT HE HAD *YOU.*

FUNNY WHEN YOU THINK ABOUT IT.

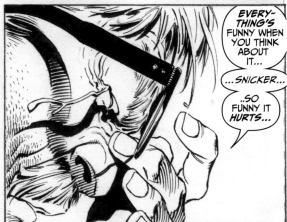

EVERY-THING'S FUNNY WHEN YOU THINK ABOUT IT...

...SNICKER...

..SO FUNNY IT *HURTS...*

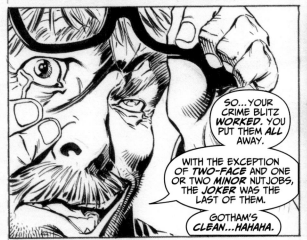

SO...YOUR CRIME BLITZ *WORKED.* YOU PUT THEM *ALL* AWAY.

WITH THE EXCEPTION OF *TWO-FACE* AND ONE OR TWO *MINOR* NUTJOBS, THE *JOKER* WAS THE LAST OF THEM.

GOTHAM'S CLEAN...HAHAHA.

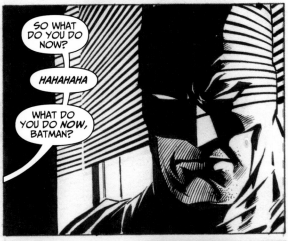

SO WHAT DO YOU DO *NOW?*

HAHAHAHA

WHAT DO YOU DO *NOW,* BATMAN?

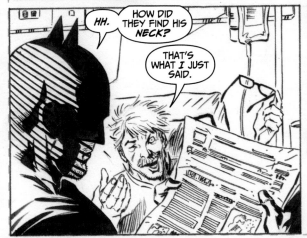

HH.

HOW DID THEY FIND HIS *NECK?*

THAT'S WHAT *I* JUST SAID.

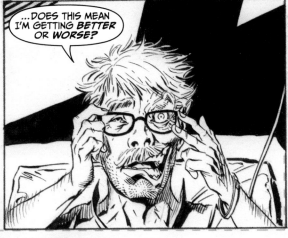

...DOES THIS MEAN I'M GETTING *BETTER* OR *WORSE?*

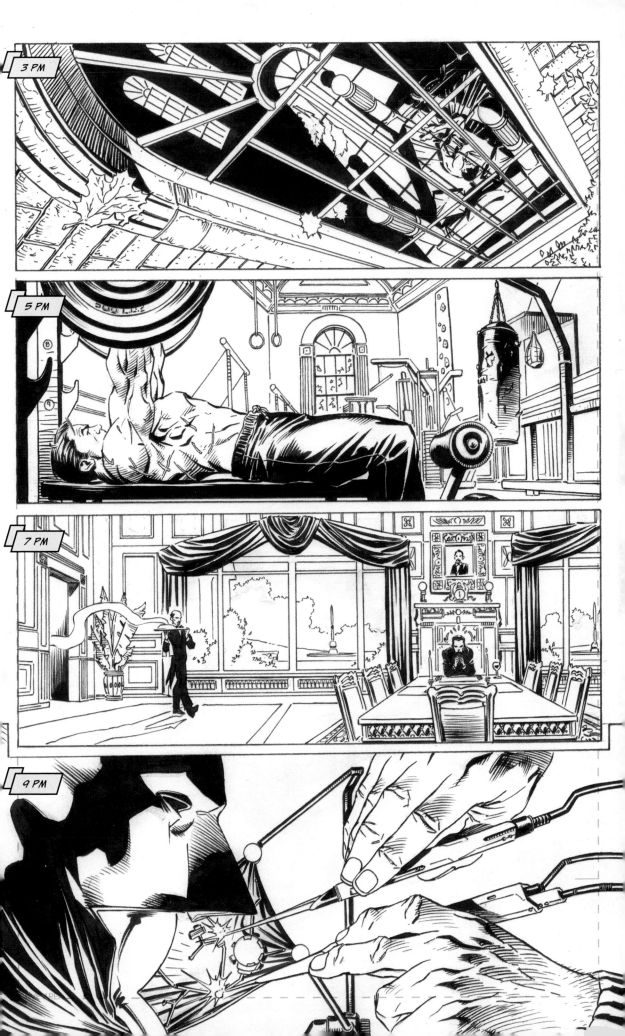

3 PM

5 PM

7 PM

9 PM

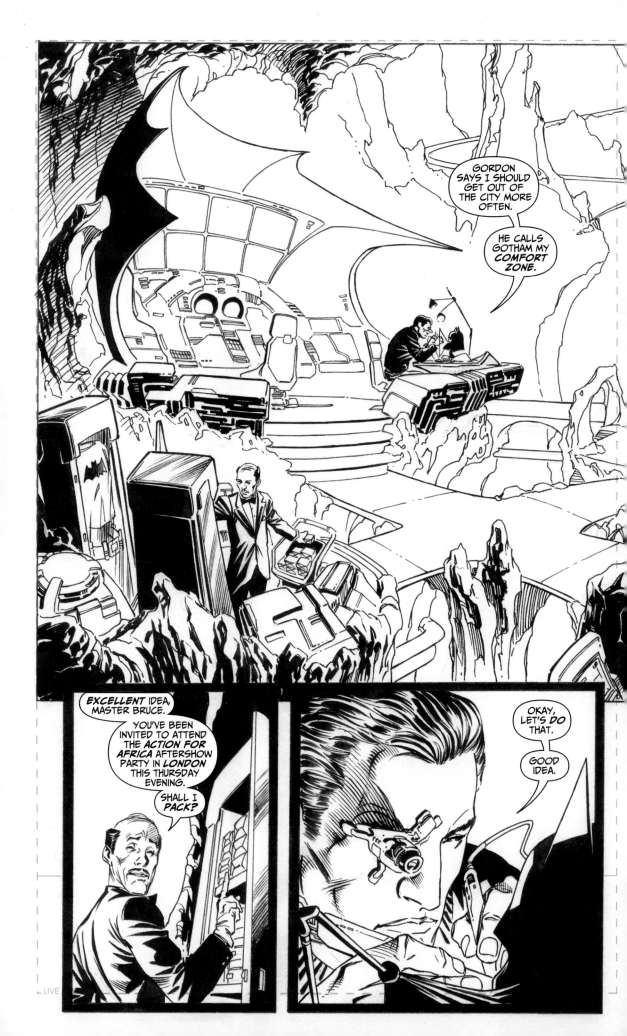

I HOPE YOU DON'T MIND MY SAYING SO, SIR, BUT...

...THAT *GROWL* IN YOUR VOICE-- THE ONE YOU USED TO HAVE TO *PRACTICE* BEFORE YOU WENT OUT AS BATMAN.

MM.

YOU'RE DOING IT *ALL* THE TIME, SIR.

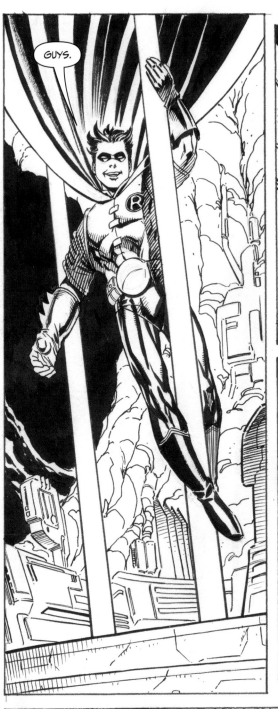

GUYS.

DON'T EVEN ASK.

IT'S *DEAD* OUT THERE.

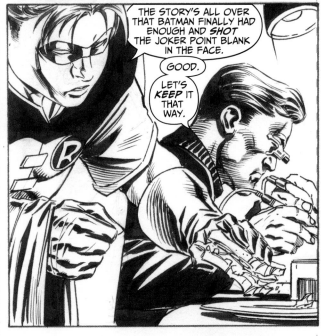

THE STORY'S ALL OVER THAT BATMAN FINALLY HAD ENOUGH AND *SHOT* THE JOKER POINT BLANK IN THE FACE.

GOOD.

LET'S *KEEP* IT THAT WAY.

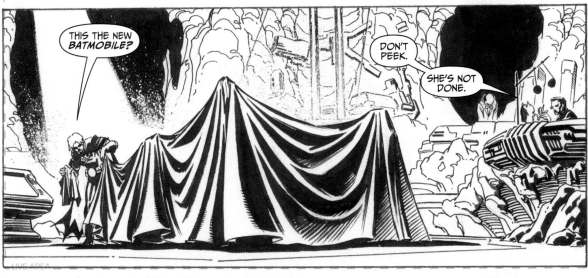

THIS THE NEW *BATMOBILE?*

DON'T PEEK.

SHE'S NOT DONE.

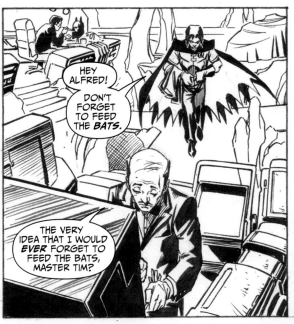

HEY ALFRED!

DON'T FORGET TO FEED THE BATS.

THE VERY IDEA THAT I WOULD EVER FORGET TO FEED THE BATS, MASTER TIM?

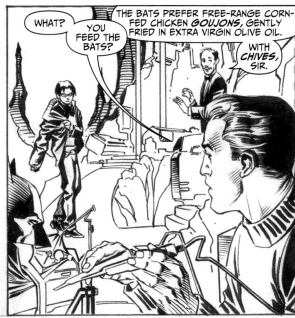

WHAT? YOU FEED THE BATS?

THE BATS PREFER FREE-RANGE CORN-FED CHICKEN GOUJONS, GENTLY FRIED IN EXTRA VIRGIN OLIVE OIL.

WITH CHIVES, SIR.

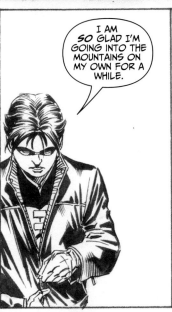

I AM SO GLAD I'M GOING INTO THE MOUNTAINS ON MY OWN FOR A WHILE.

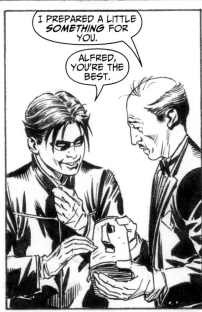

I PREPARED A LITTLE SOMETHING FOR YOU.

ALFRED, YOU'RE THE BEST.

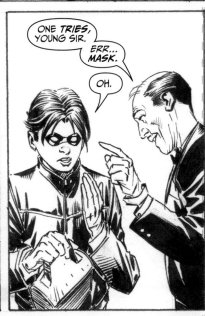

ONE TRIES, YOUNG SIR.

ERR... MASK.

OH.

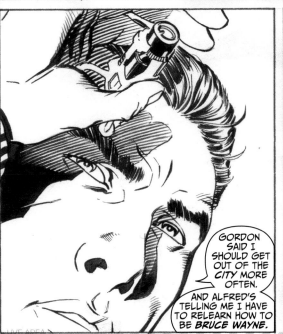

GORDON SAID I SHOULD GET OUT OF THE CITY MORE OFTEN.

AND ALFRED'S TELLING ME I HAVE TO RELEARN HOW TO BE BRUCE WAYNE.

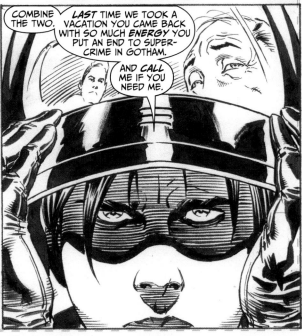

COMBINE THE TWO.

LAST TIME WE TOOK A VACATION YOU CAME BACK WITH SO MUCH ENERGY YOU PUT AN END TO SUPER-CRIME IN GOTHAM.

AND CALL ME IF YOU NEED ME.

HMM.

I THOUGHT I SAW *KILLER CROC*.

IT'S...IT'S JUST A GREEN *RAINCOAT*...

AN EASY MISTAKE TO MAKE.

WHY, JUST THE OTHER DAY I HAD A RATHER FORMIDABLE *NUN* DOWN AS THE *PENGUIN*, SIR.

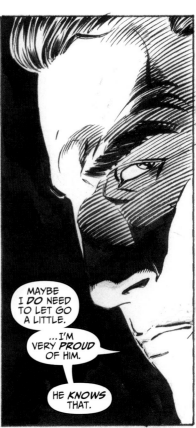

MAYBE I *DO* NEED TO LET GO A LITTLE.

...I'M VERY *PROUD* OF HIM.

HE *KNOWS* THAT.

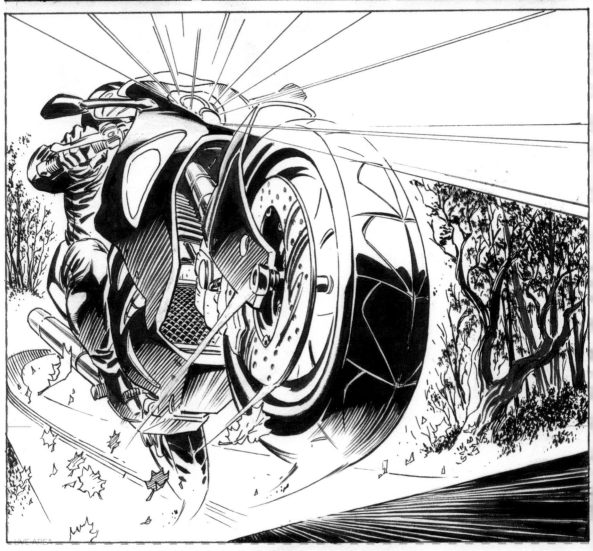

...ARE YOU *LISTENING*, DOCTOR? I KNOW YOU ARE.

I'VE INFECTED SWEET, KIND, BRILLIANT *FRANCINE* WITH A DEGENETRATIVE NEURO-BACILLUS.

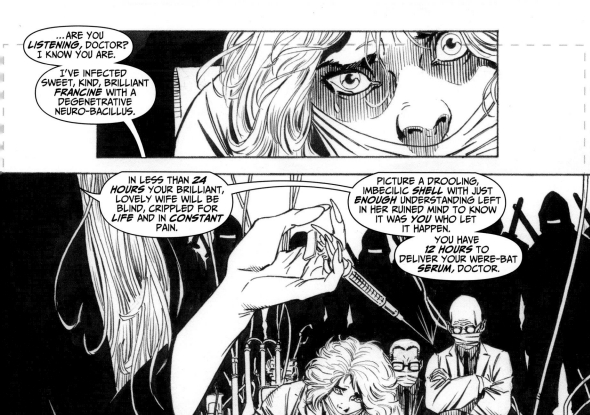

IN LESS THAN *24 HOURS* YOUR BRILLIANT, LOVELY WIFE WILL BE BLIND, CRIPPLED FOR *LIFE* AND IN *CONSTANT* PAIN.

PICTURE A DROOLING, IMBECILIC *SHELL* WITH JUST *ENOUGH* UNDERSTANDING LEFT IN HER RUINED MIND TO KNOW IT WAS *YOU* WHO LET IT HAPPEN.

YOU HAVE *12 HOURS* TO DELIVER YOUR WERE-BAT *SERUM*, DOCTOR.

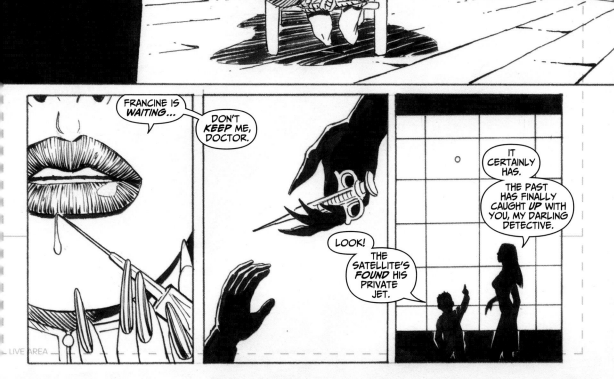

FRANCINE IS *WAITING*... DON'T *KEEP* ME, DOCTOR.

LOOK! THE SATELLITE'S *FOUND* HIS PRIVATE JET.

IT CERTAINLY HAS.

THE PAST HAS FINALLY CAUGHT *UP* WITH YOU, MY DARLING DETECTIVE.

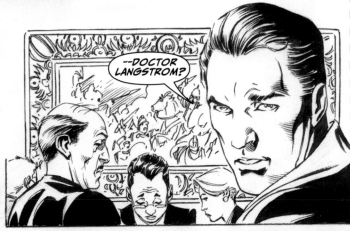

--DOCTOR LANGSTROM?

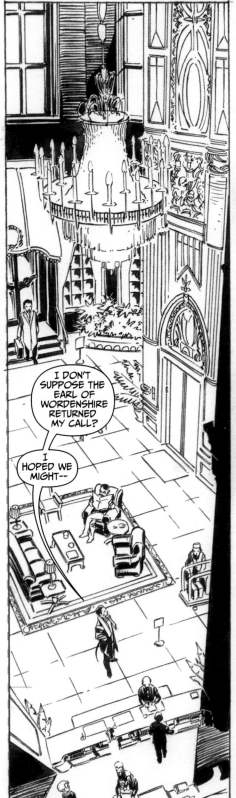

I DON'T SUPPOSE THE EARL OF WORDENSHIRE RETURNED MY CALL?

I HOPED WE MIGHT--

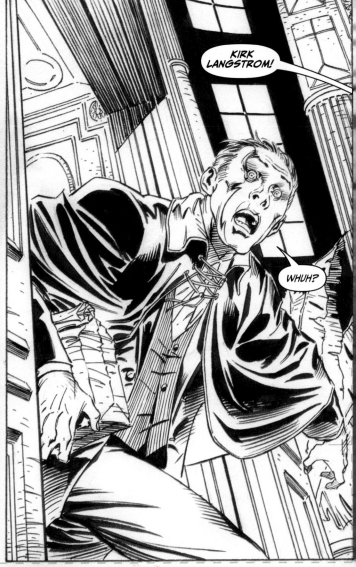

KIRK LANGSTROM!

WHUH?

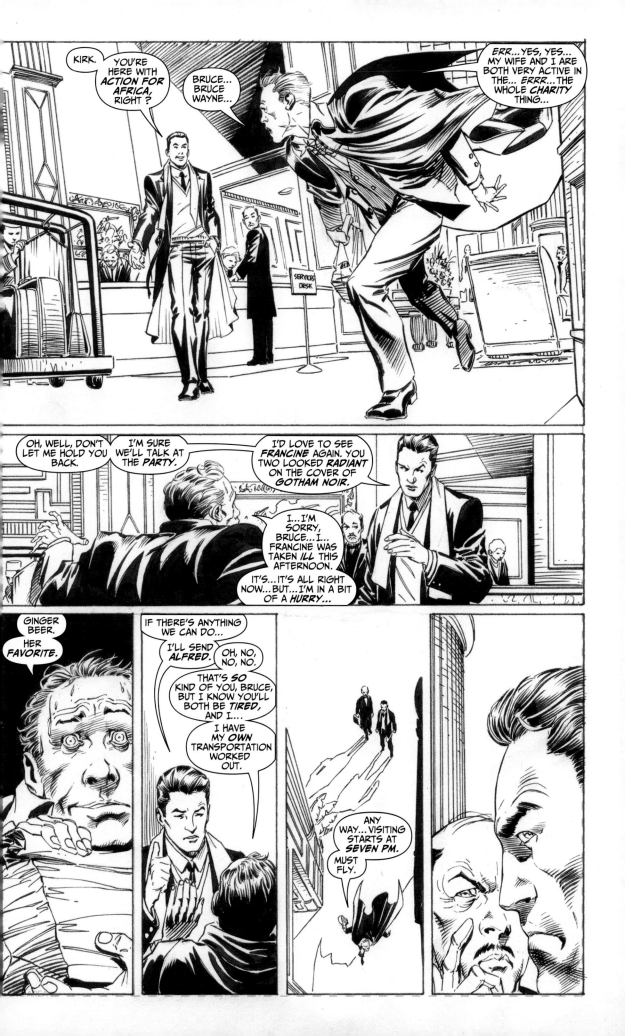

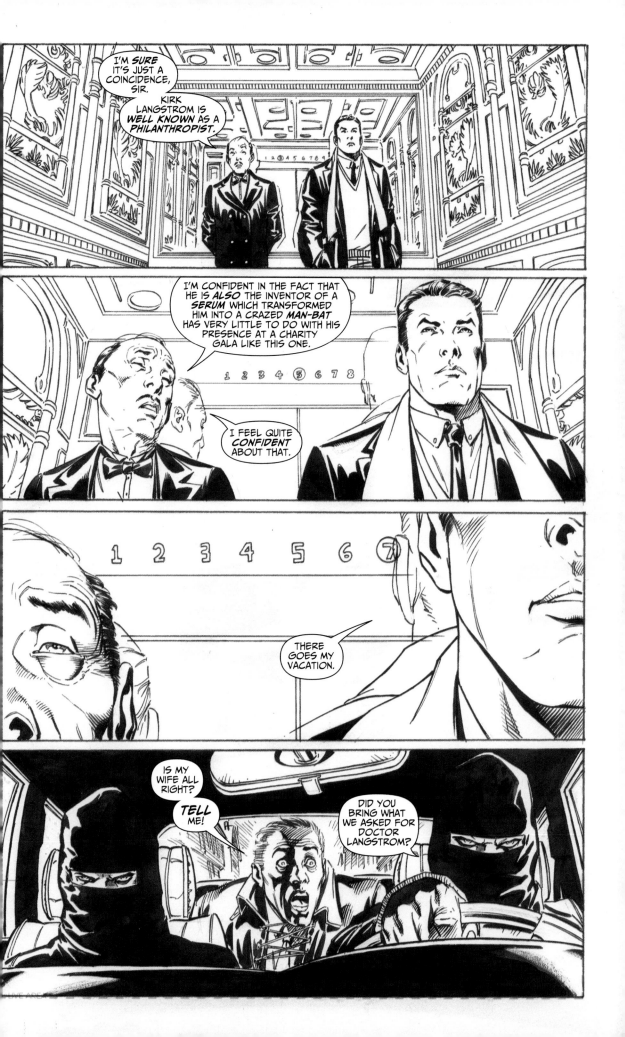

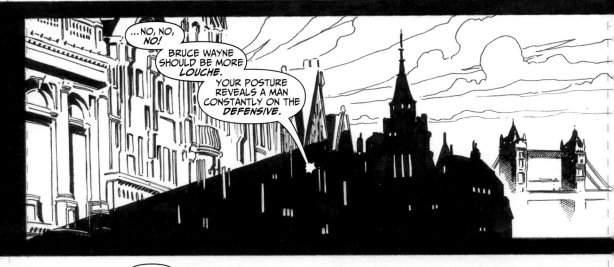

...NO, NO, NO!

BRUCE WAYNE SHOULD BE MORE *LOUCHE*.

YOUR POSTURE REVEALS A MAN CONSTANTLY ON THE *DEFENSIVE*.

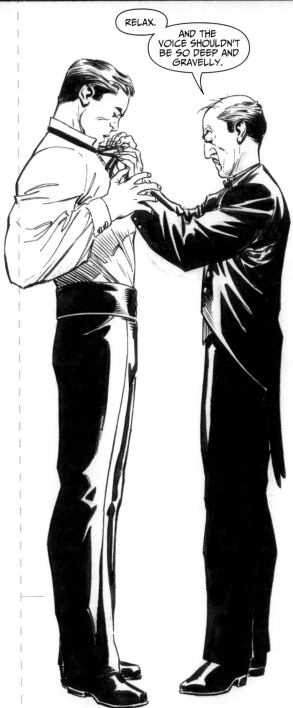

RELAX.

AND THE VOICE SHOULDN'T BE SO DEEP AND GRAVELLY.

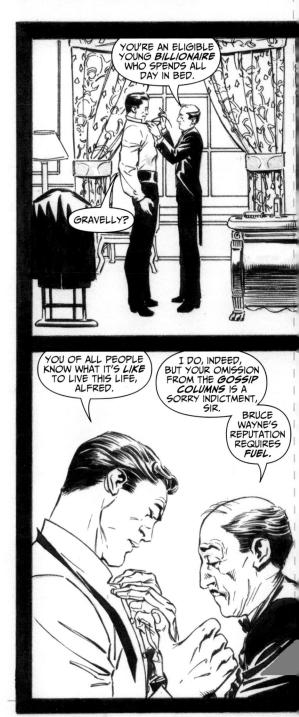

YOU'RE AN ELIGIBLE YOUNG *BILLIONAIRE* WHO SPENDS ALL DAY IN BED.

GRAVELLY?

YOU OF ALL PEOPLE KNOW WHAT IT'S *LIKE* TO LIVE THIS LIFE, ALFRED.

I DO, INDEED, BUT YOUR OMISSION FROM THE *GOSSIP COLUMNS* IS A SORRY INDICTMENT, SIR.

BRUCE WAYNE'S REPUTATION REQUIRES *FUEL*.

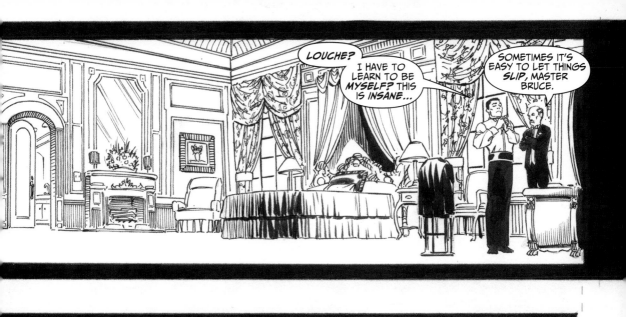

LOUCHE?

I HAVE TO LEARN TO BE *MYSELF?* THIS IS INSANE...

SOMETIMES IT'S EASY TO LET THINGS *SLIP*, MASTER BRUCE.

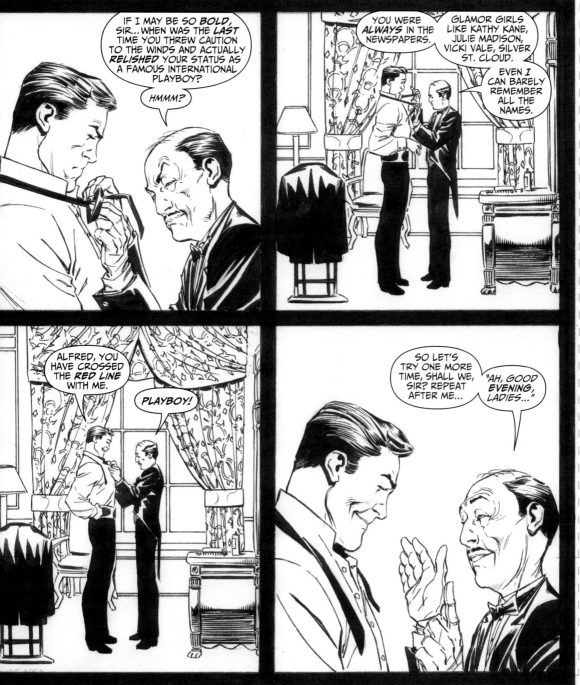

IF I MAY BE SO *BOLD*, SIR... WHEN WAS THE *LAST* TIME YOU THREW CAUTION TO THE WINDS AND ACTUALLY *RELISHED* YOUR STATUS AS A FAMOUS INTERNATIONAL PLAYBOY?

HMMM?

YOU WERE *ALWAYS* IN THE NEWSPAPERS.

GLAMOR GIRLS LIKE KATHY KANE, JULIE MADISON, VICKI VALE, SILVER ST. CLOUD.

EVEN *I* CAN BARELY REMEMBER ALL THE NAMES.

ALFRED, YOU HAVE CROSSED THE *RED LINE* WITH ME.

PLAYBOY!

SO LET'S TRY ONE MORE TIME, SHALL WE, SIR? REPEAT AFTER ME...

"AH, GOOD *EVENING*, LADIES..."

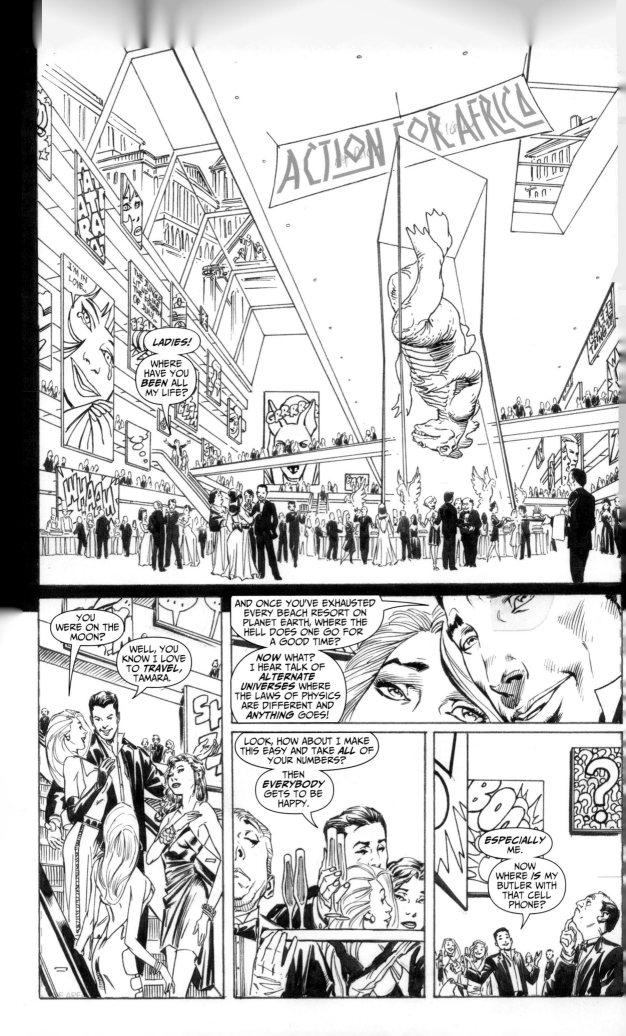

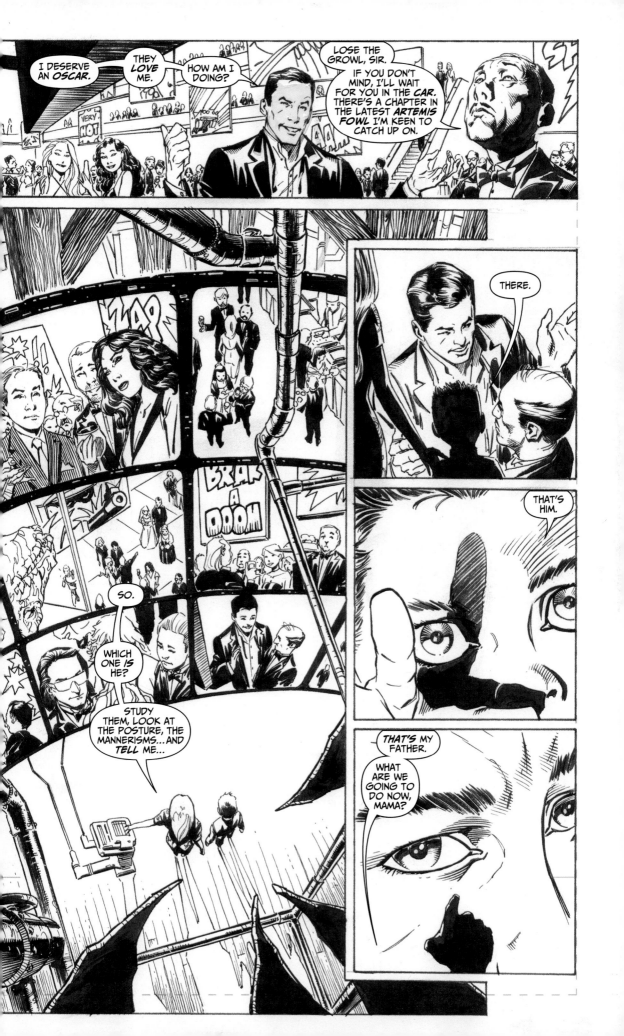

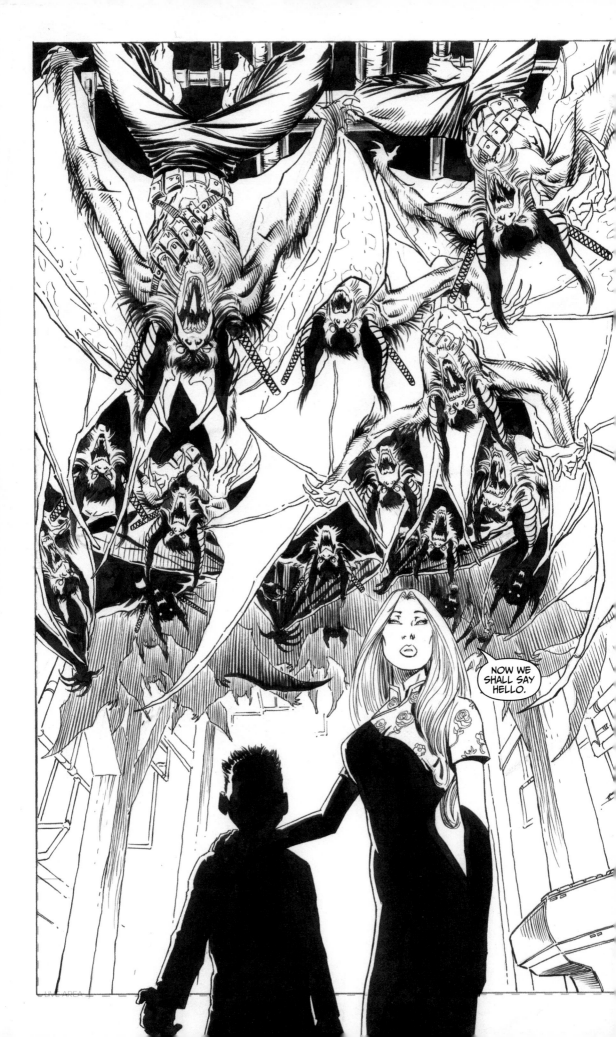

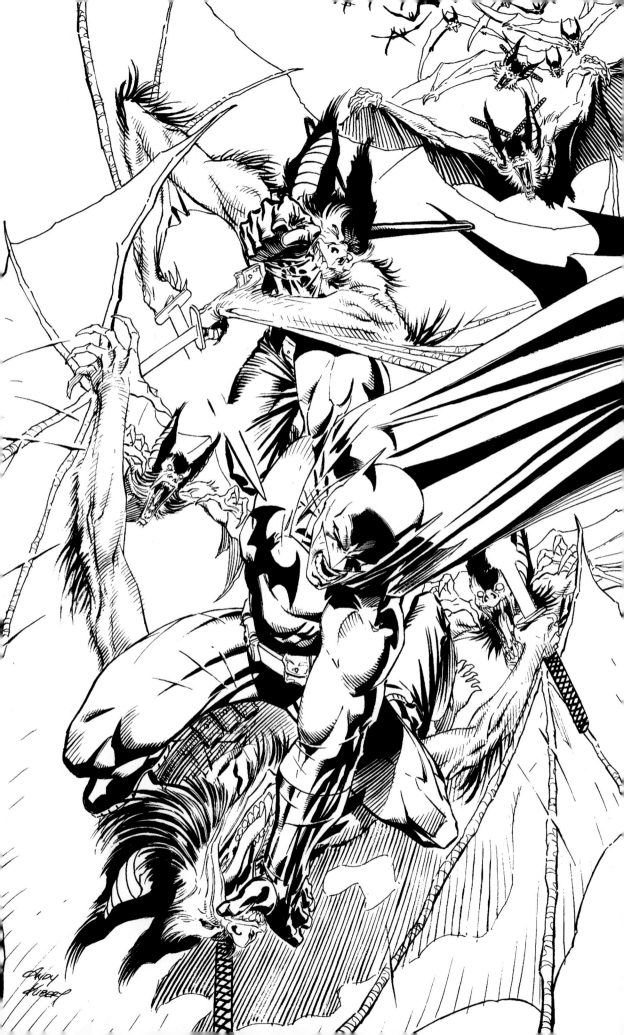

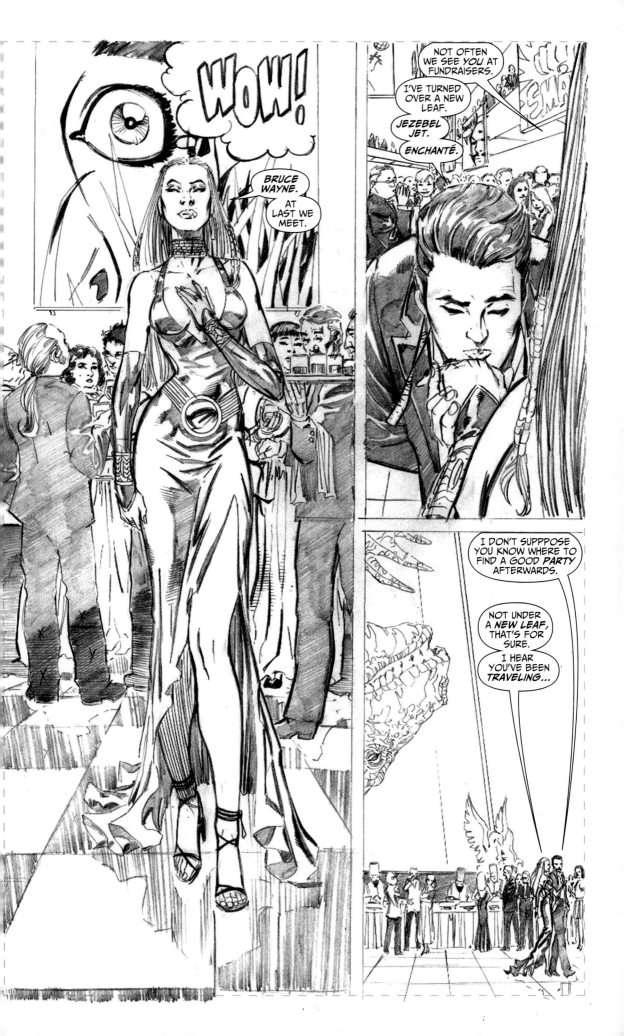

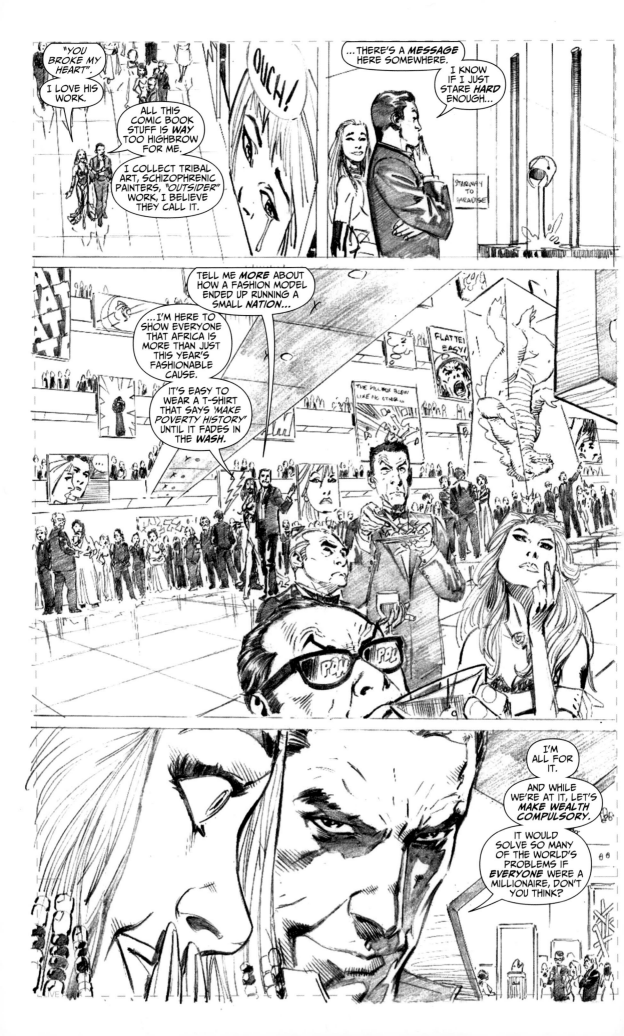

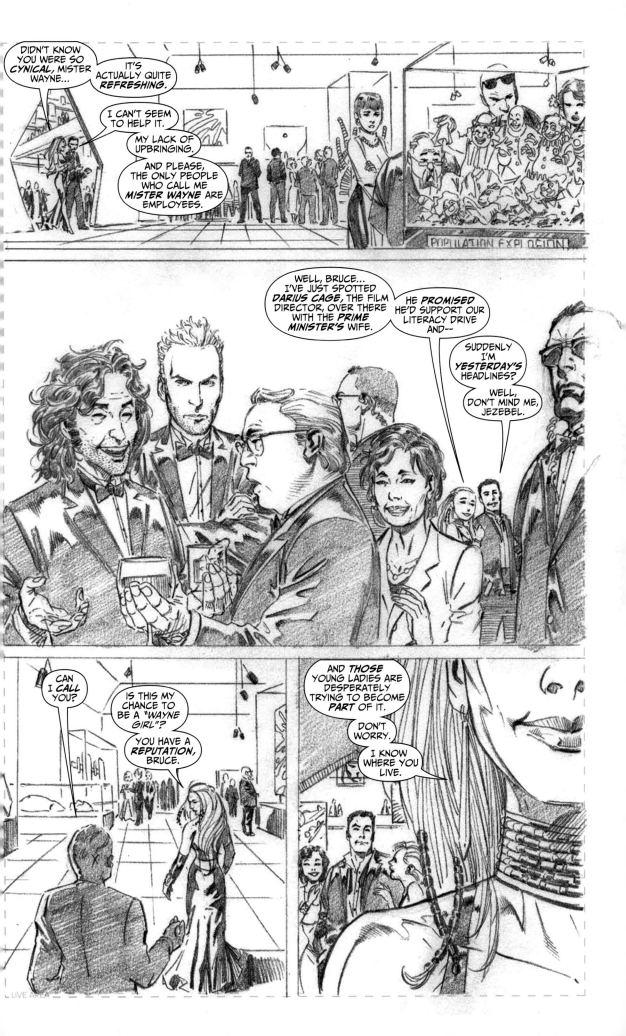

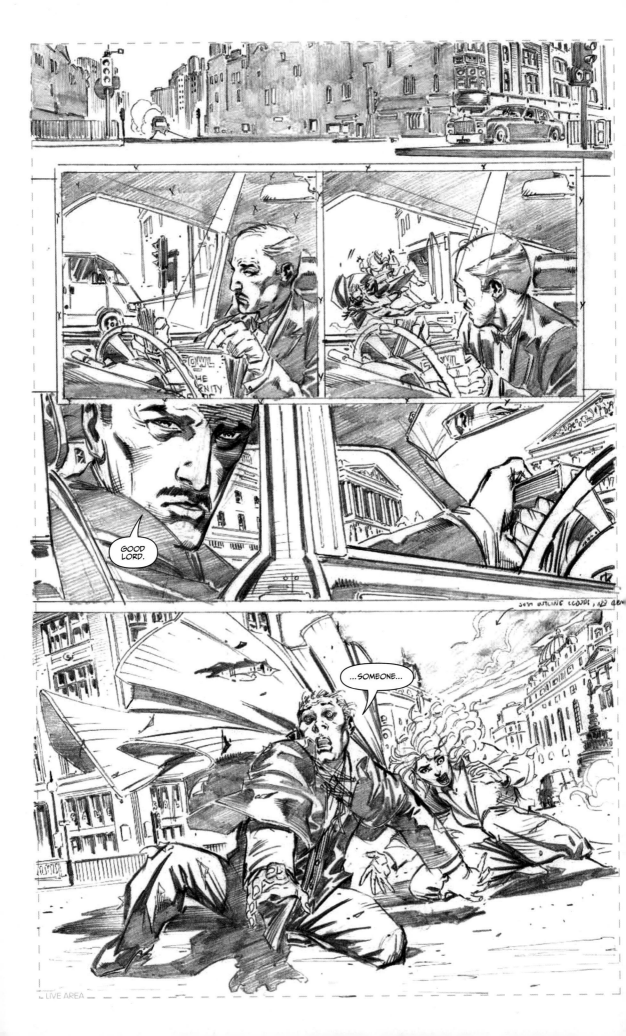

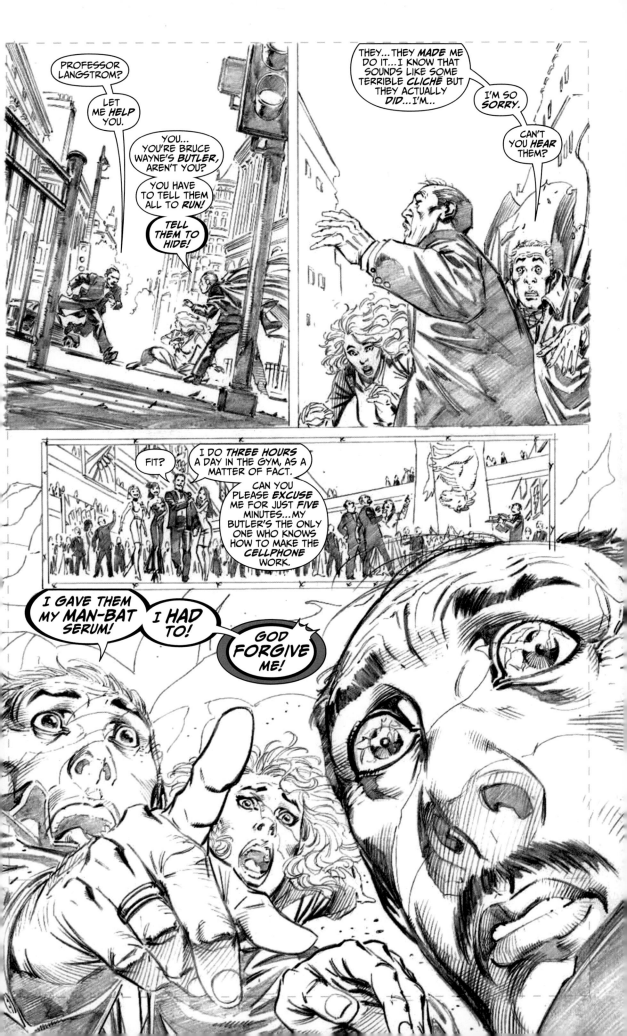

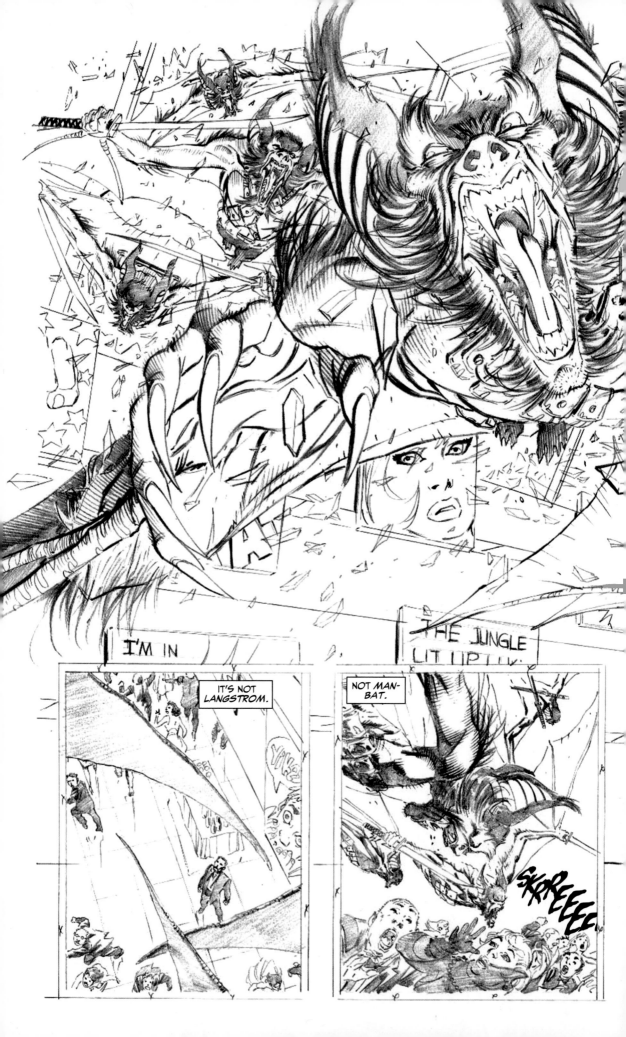

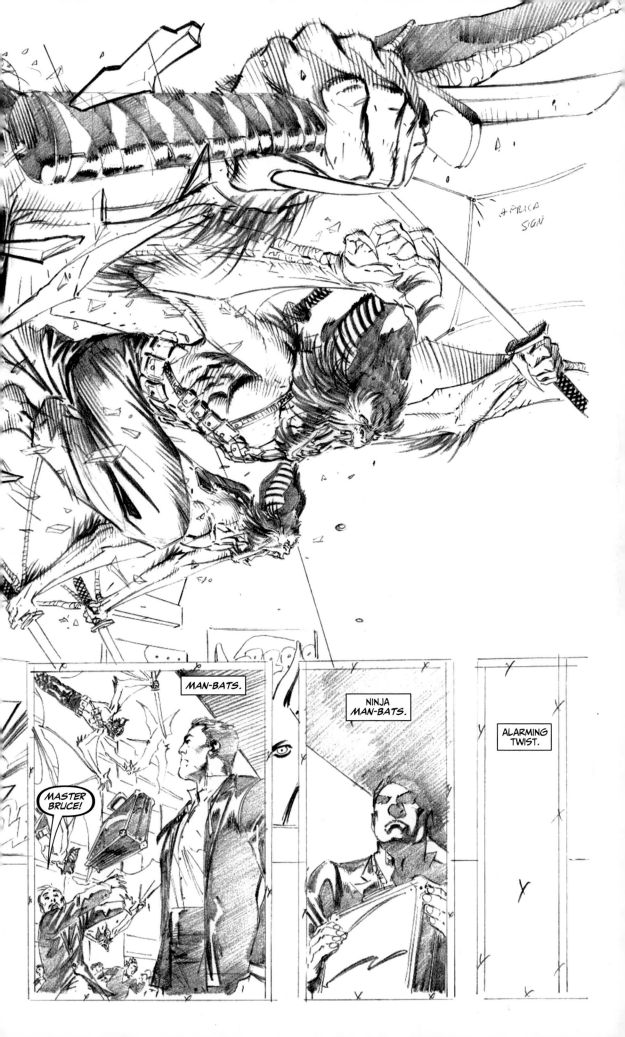

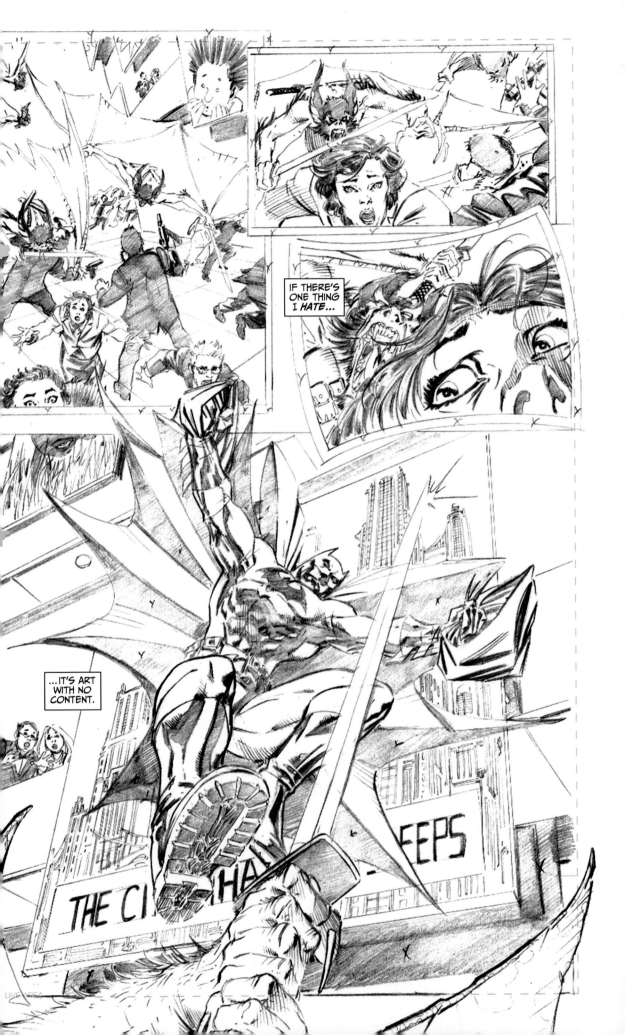

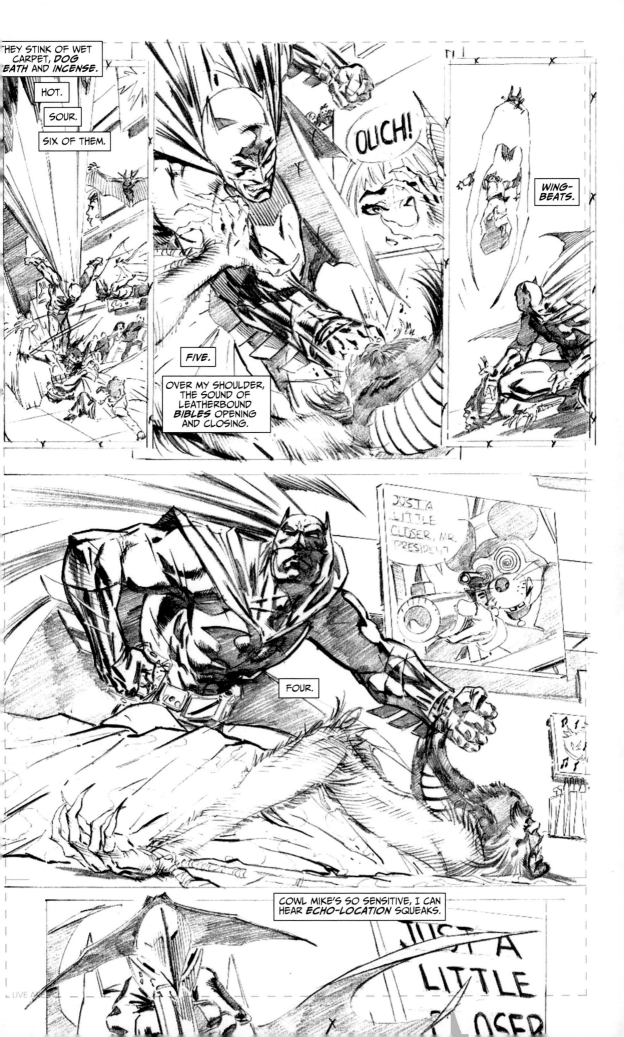

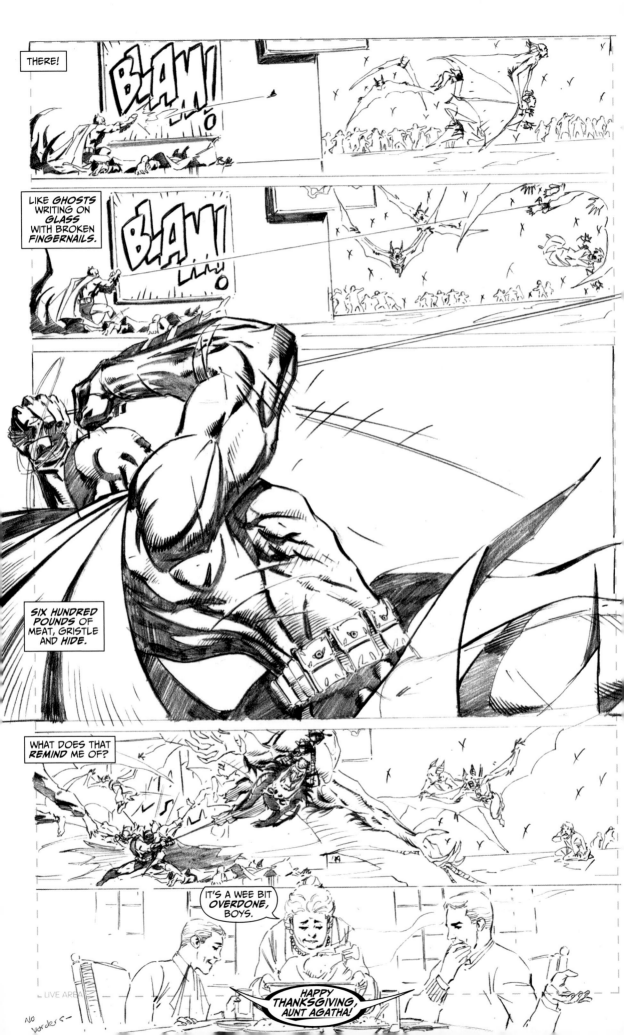

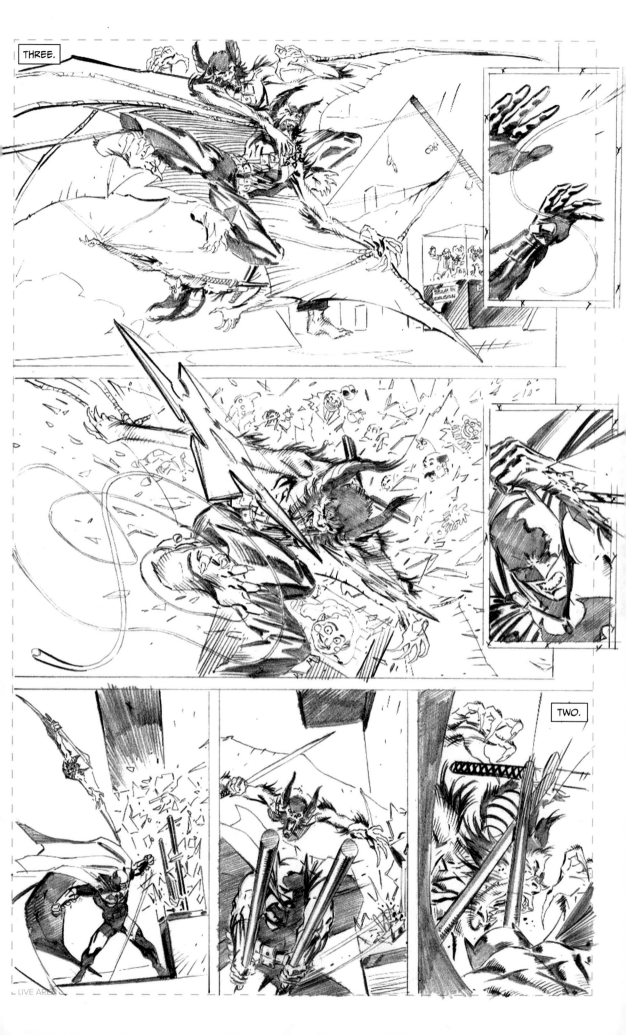

THREE.

TWO.

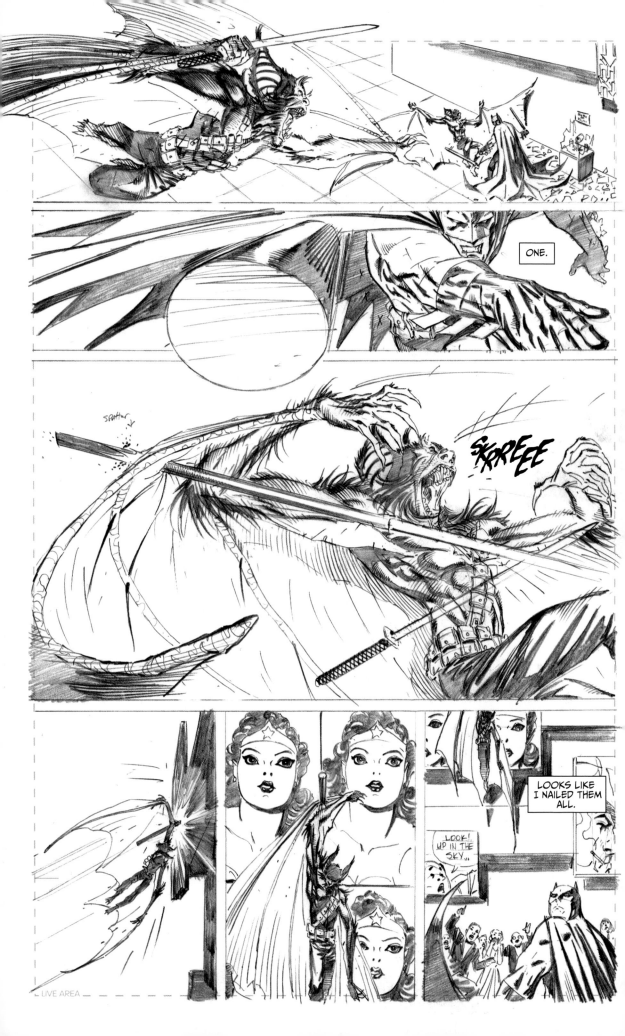

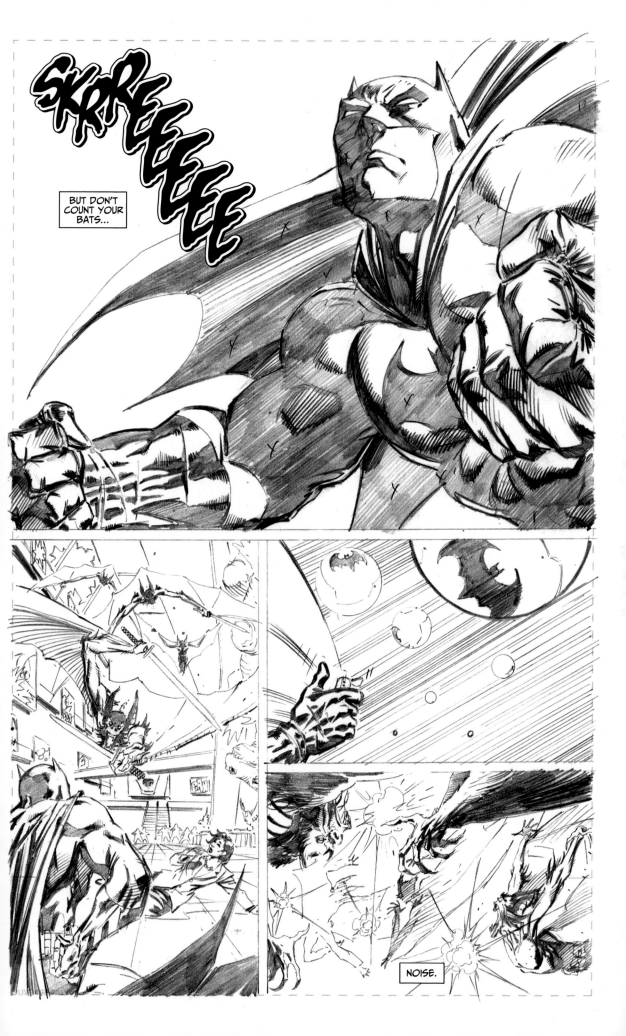

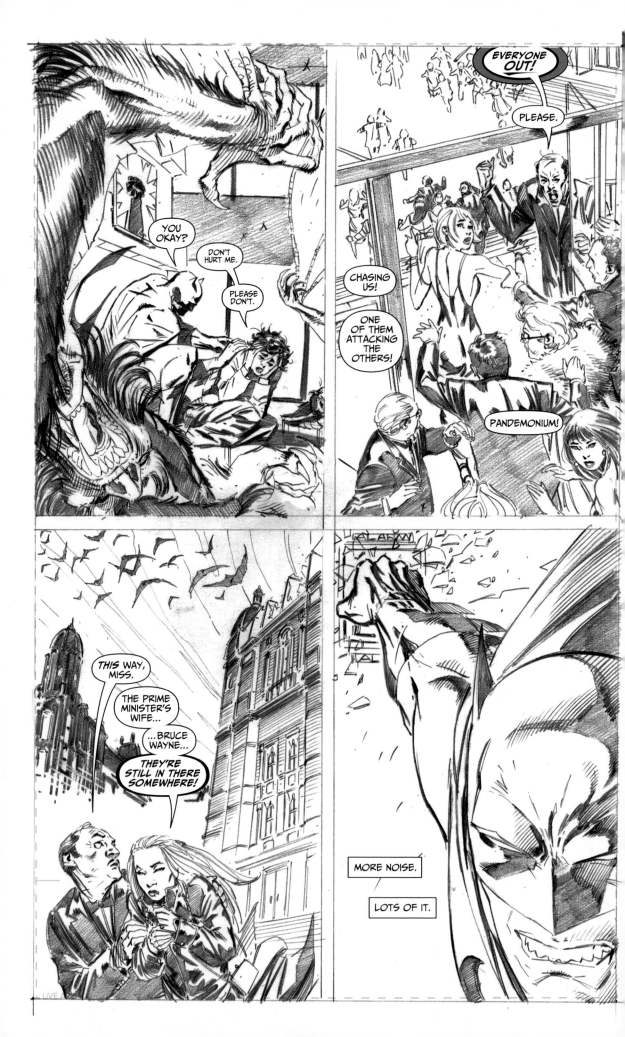

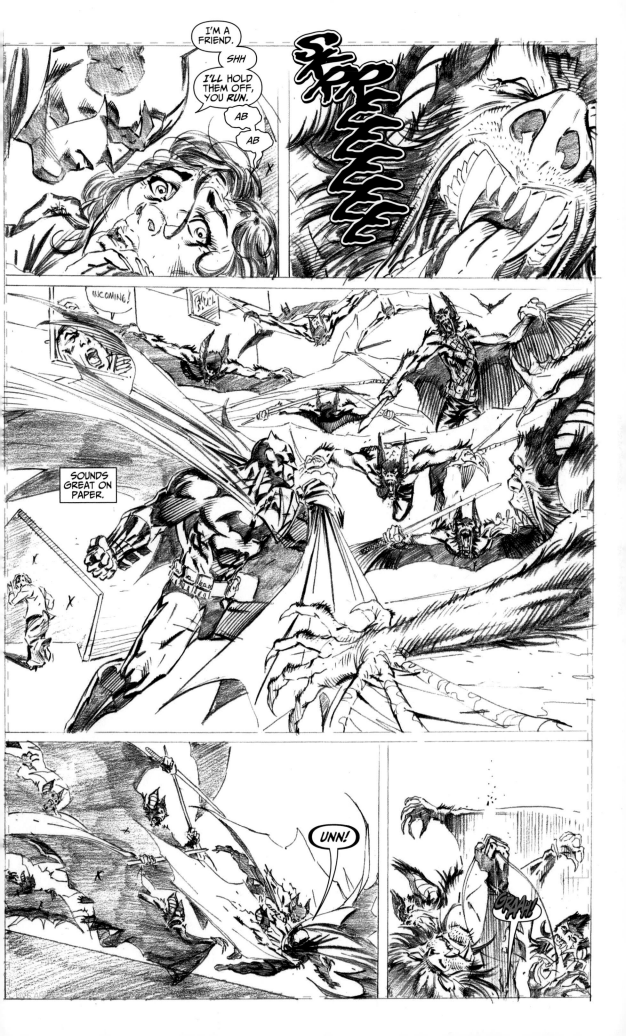

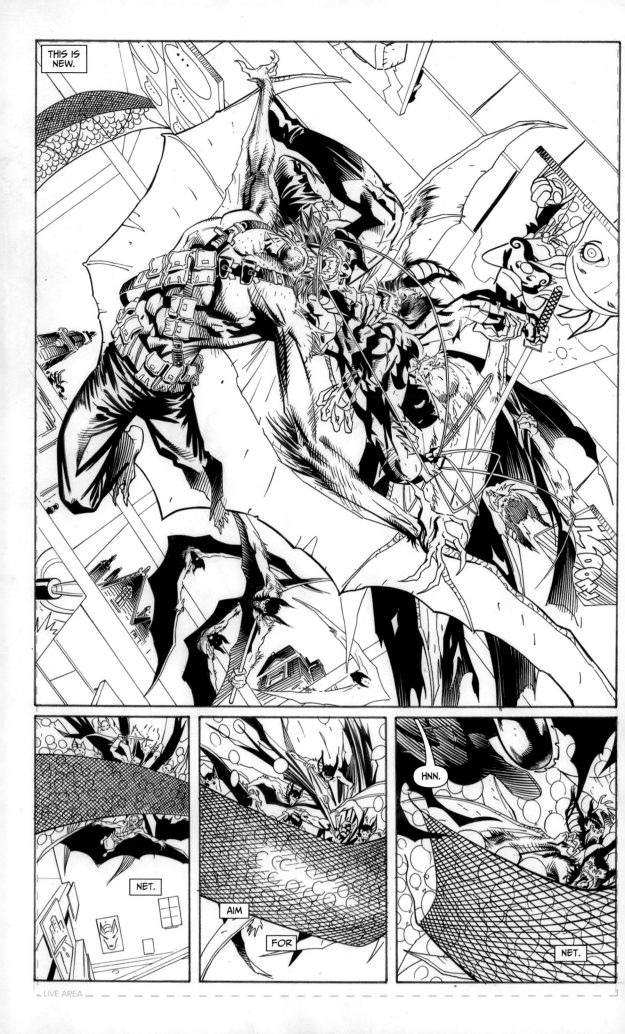

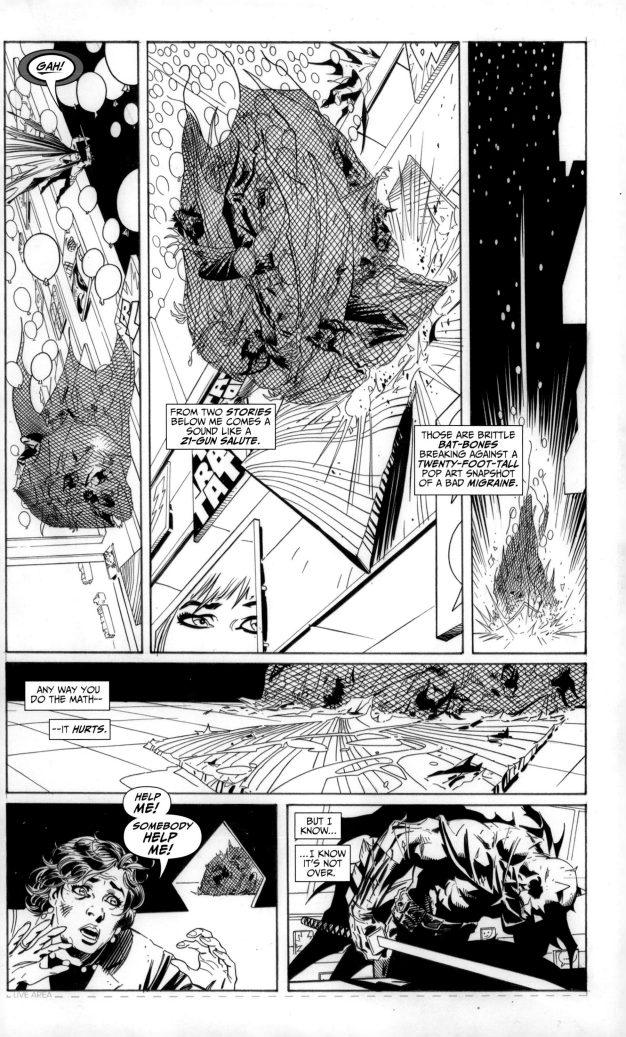

GAH!

FROM TWO STORIES BELOW ME COMES A SOUND LIKE A 21-GUN SALUTE.

THOSE ARE BRITTLE BAT-BONES BREAKING AGAINST A TWENTY-FOOT-TALL POP ART SNAPSHOT OF A BAD MIGRAINE.

ANY WAY YOU DO THE MATH--

--IT HURTS.

HELP ME! SOMEBODY HELP ME!

BUT I KNOW...

...I KNOW IT'S NOT OVER.

LIVE AREA

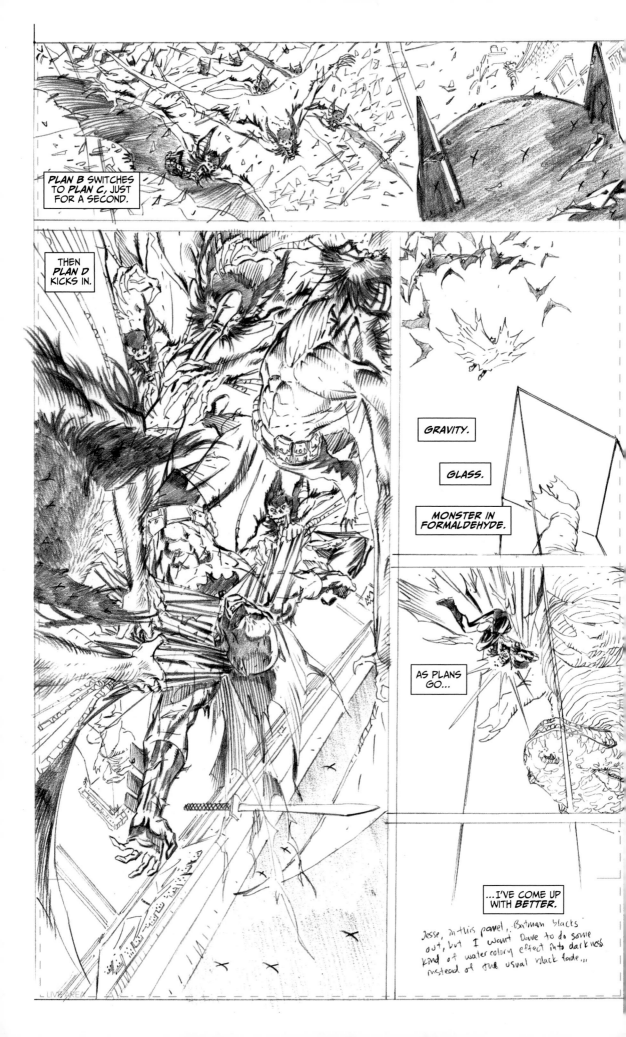

PLAN B SWITCHES TO *PLAN C*, JUST FOR A SECOND.

THEN *PLAN D* KICKS IN.

GRAVITY.

GLASS.

MONSTER IN FORMALDEHYDE.

AS PLANS GO...

...I'VE COME UP WITH *BETTER.*

Jesse, in this panel, Batman blacks out, but I want Dave to do some kind of watercolory effect into darkness instead of the usual black fade...

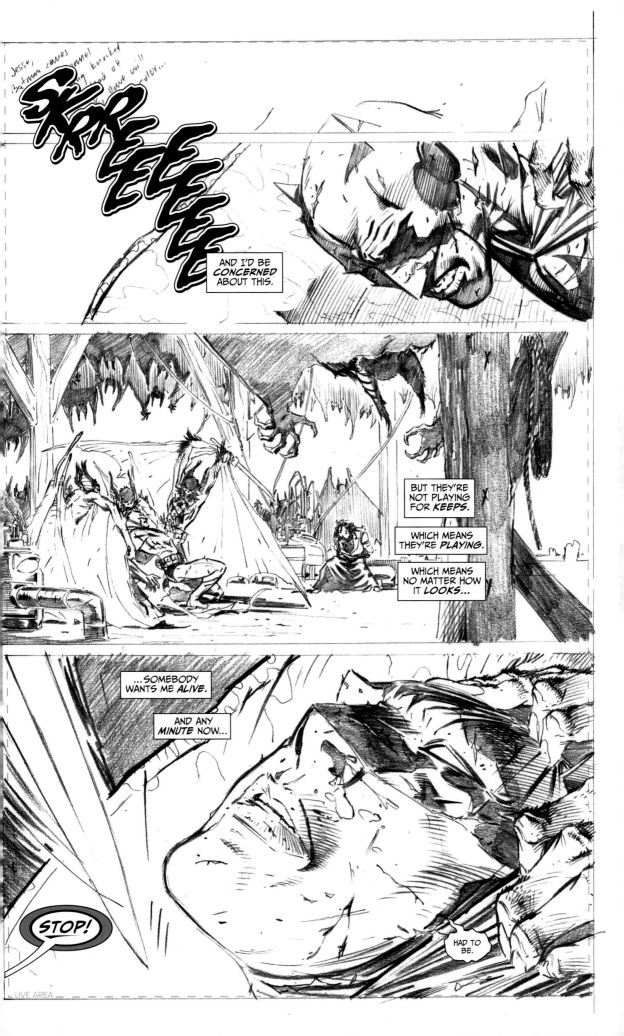

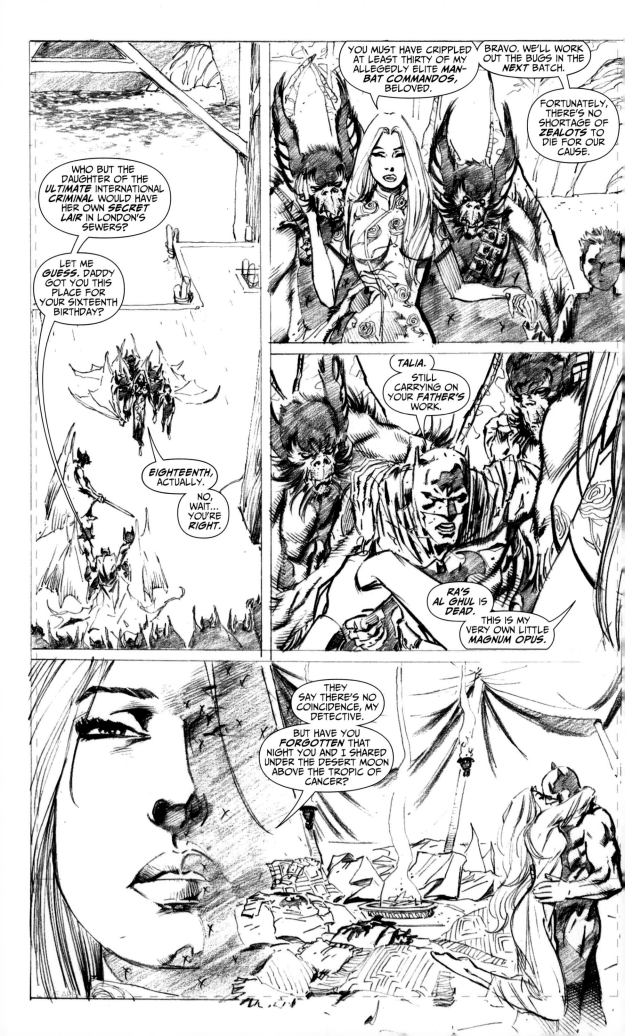

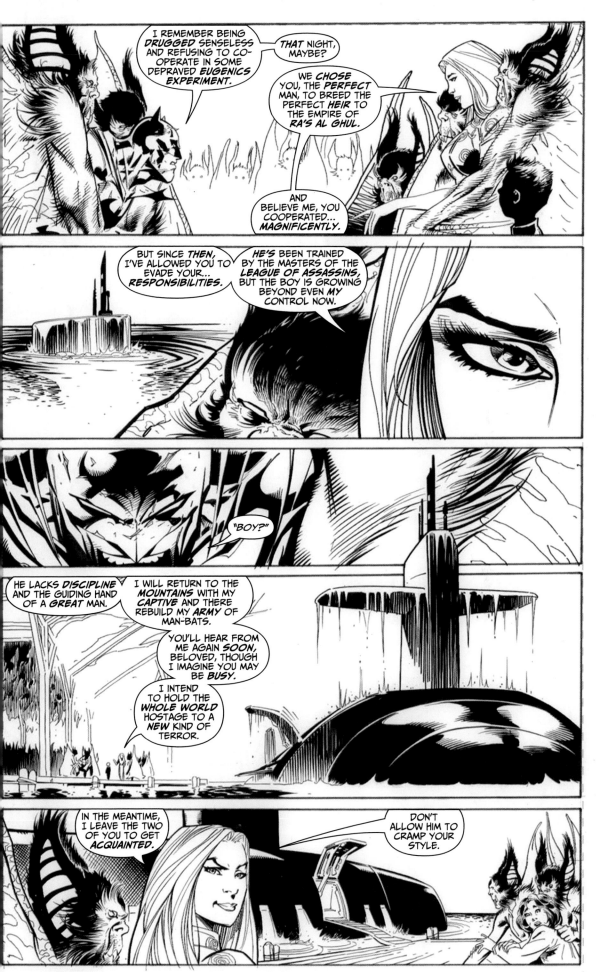

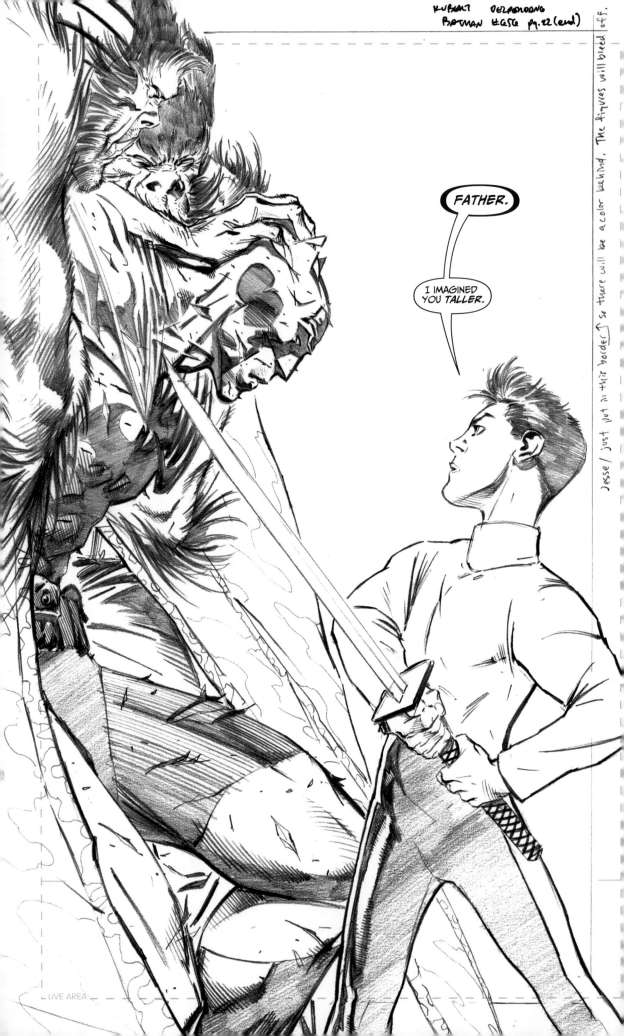

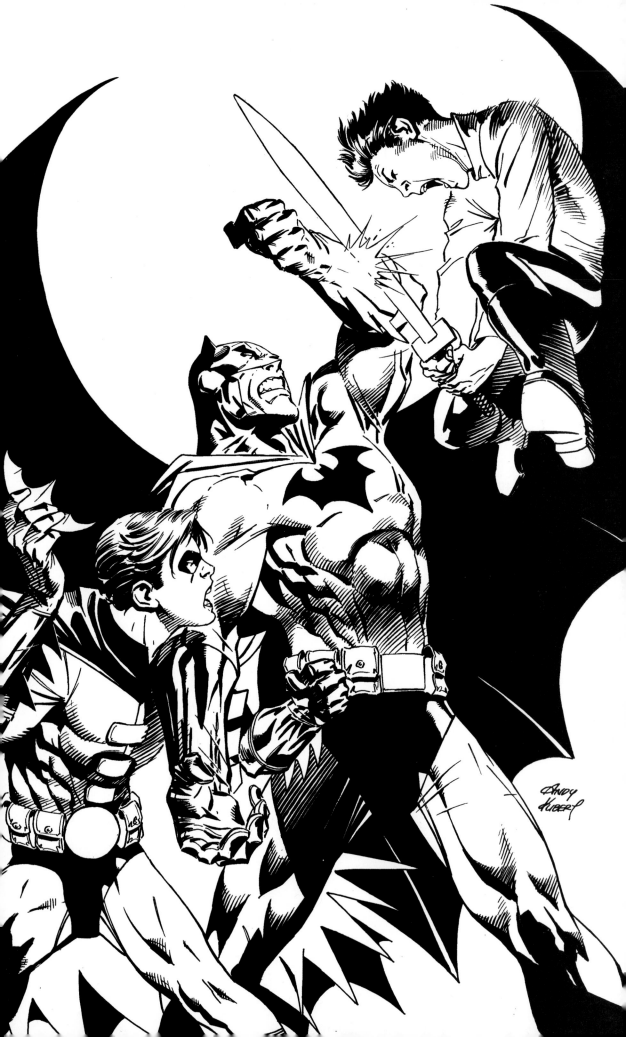

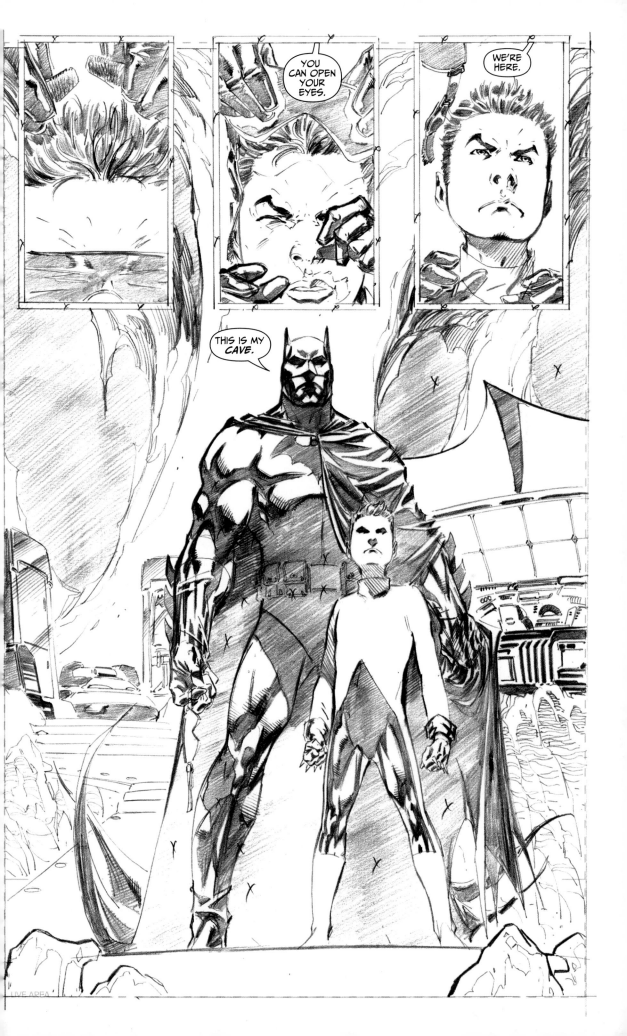

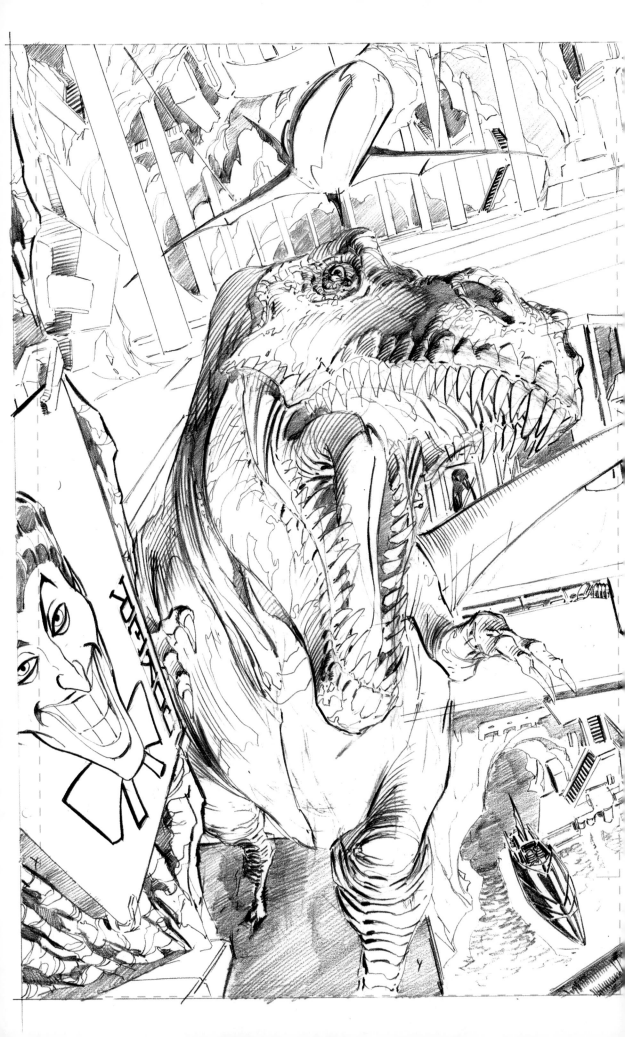

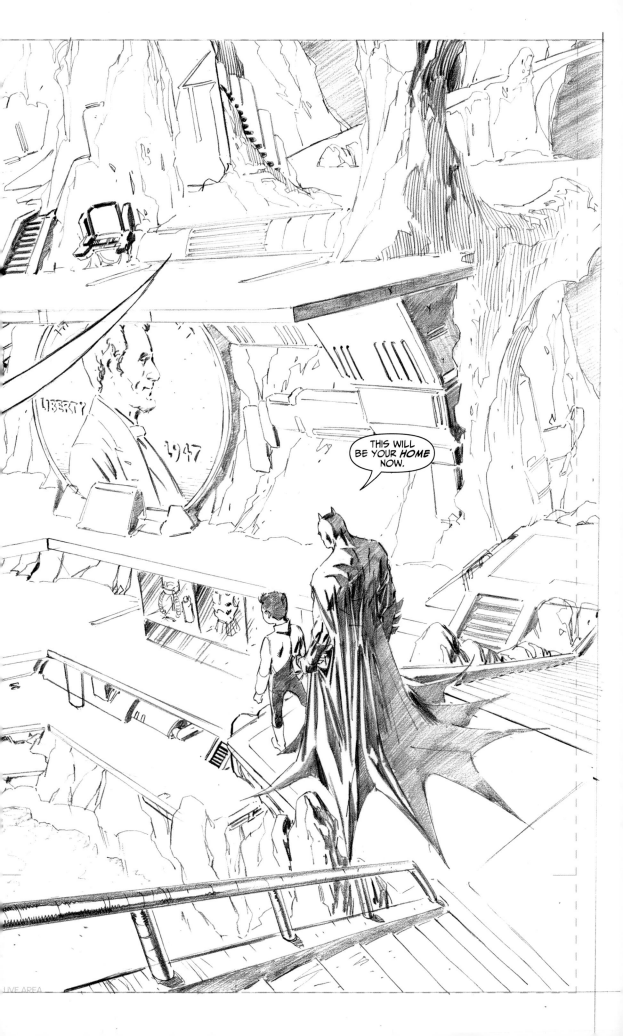

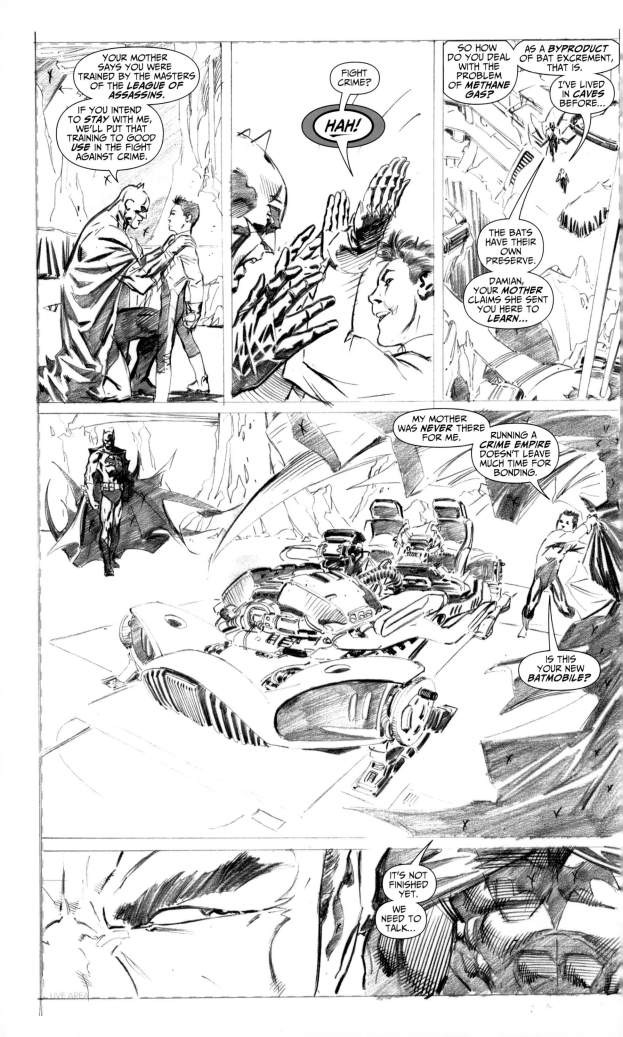

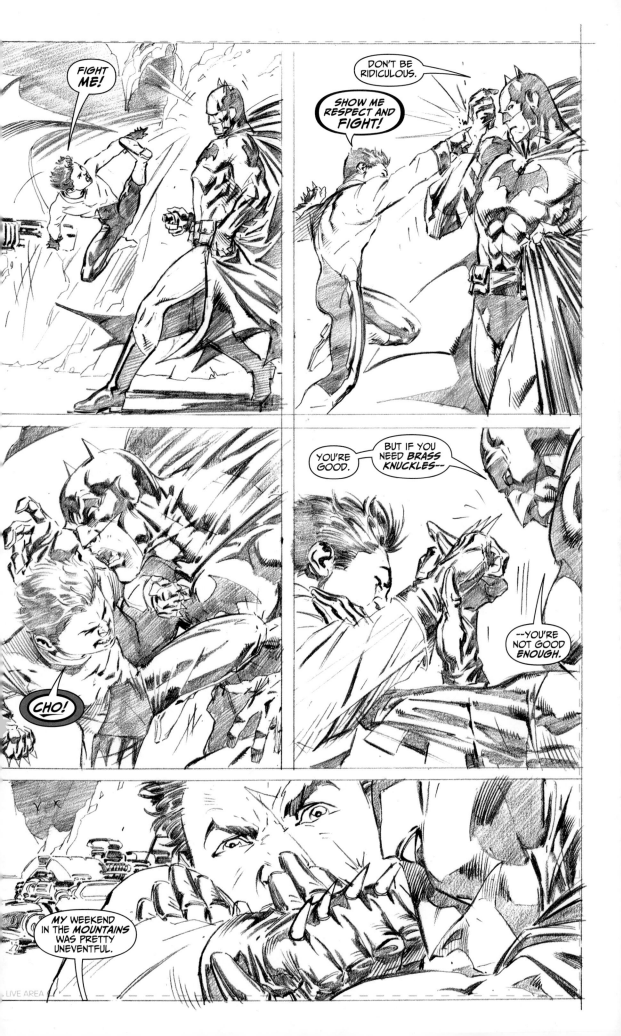

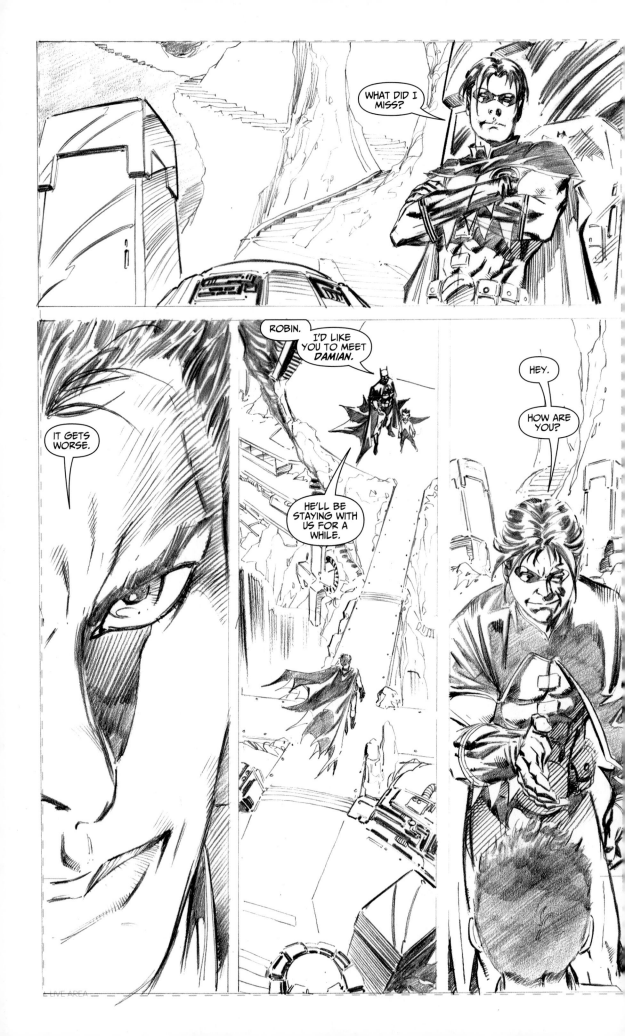

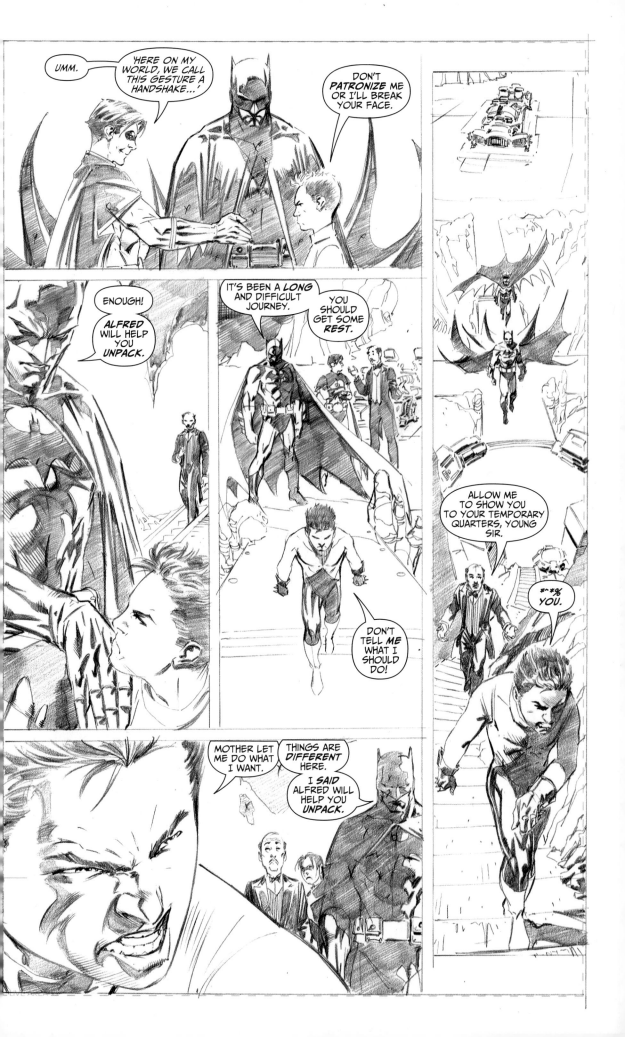

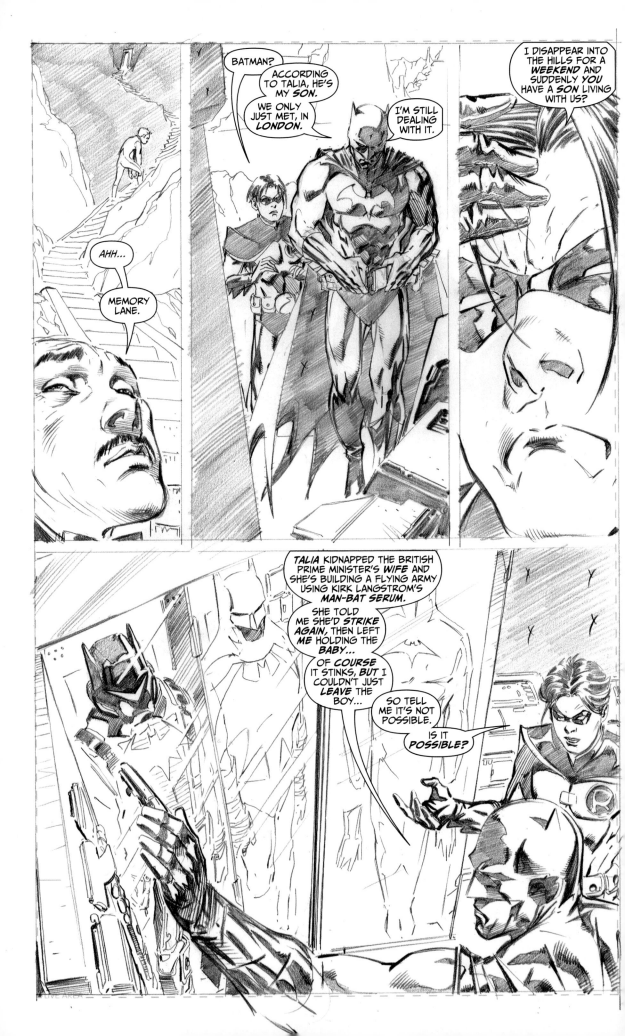

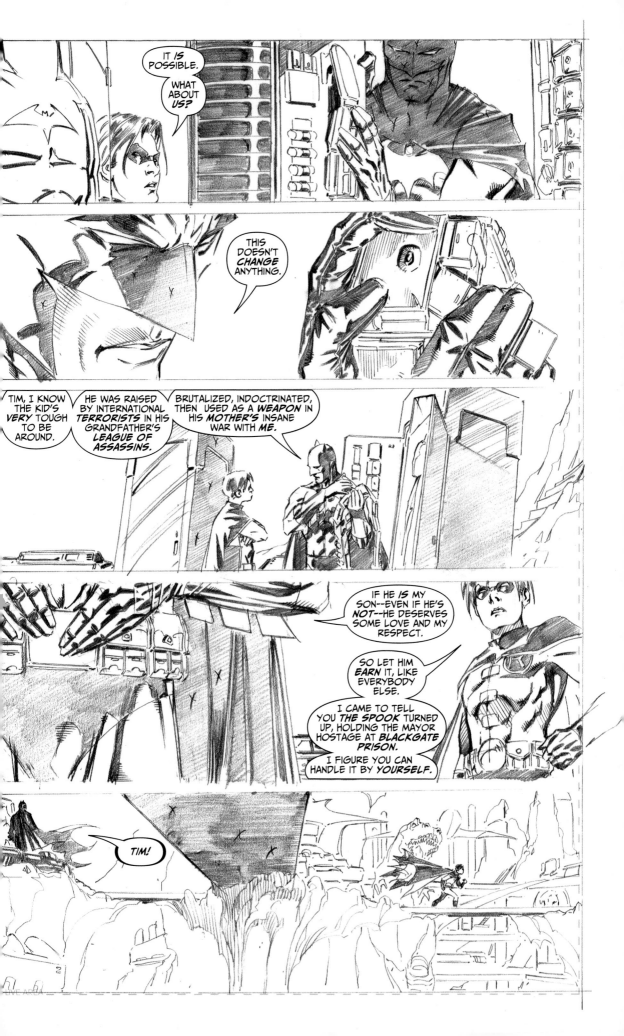

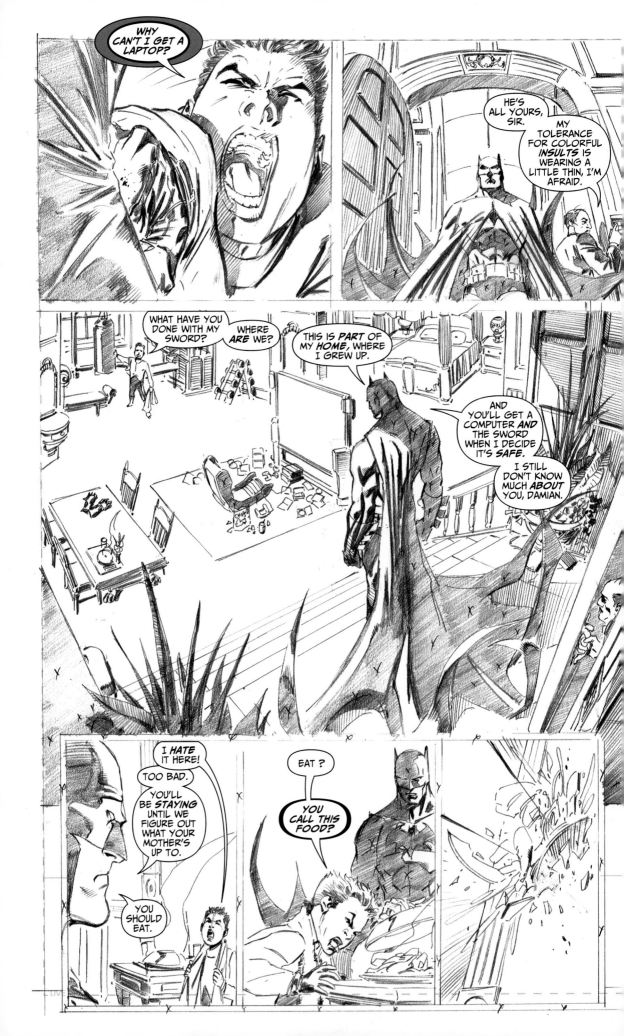

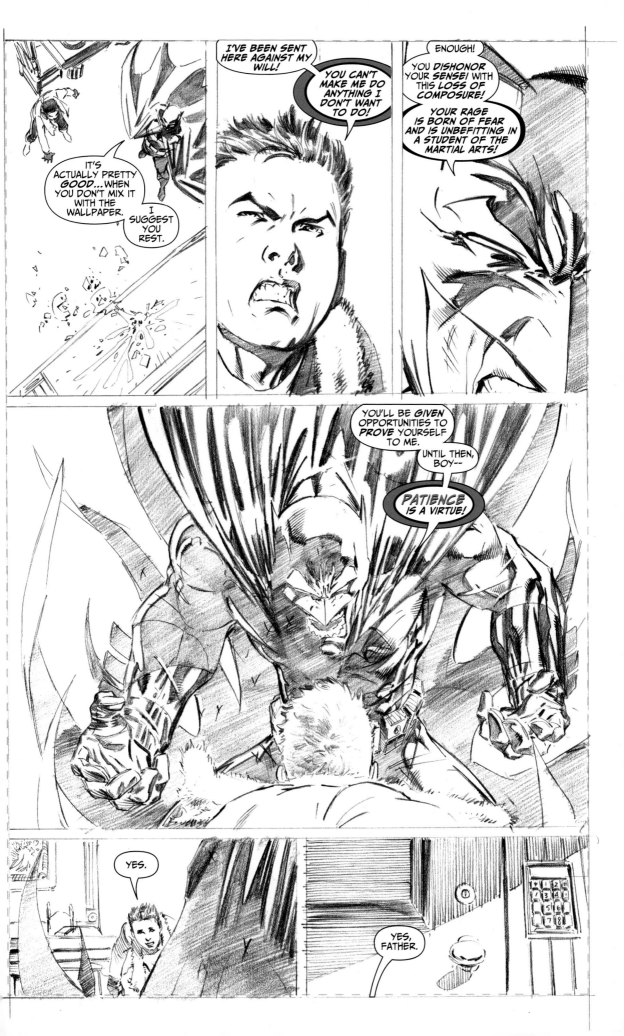

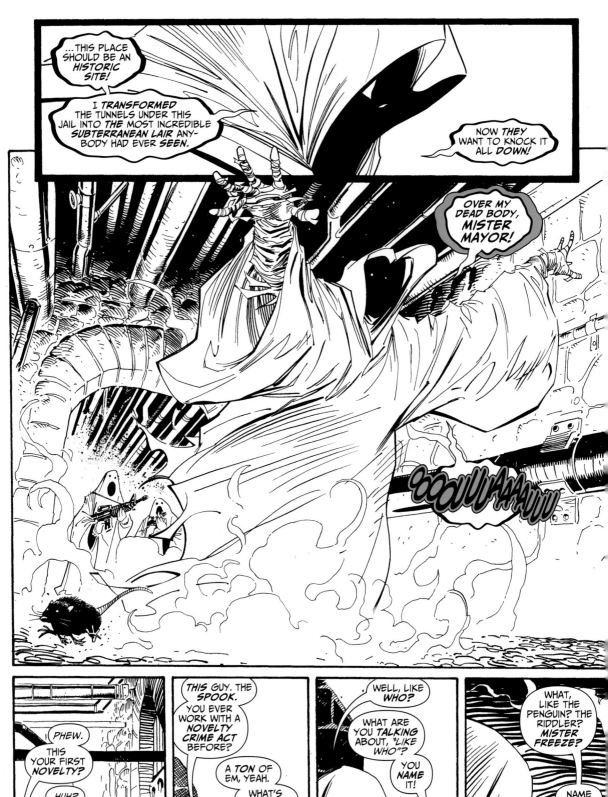

...THIS PLACE SHOULD BE AN *HISTORIC* SITE!

I *TRANSFORMED* THE TUNNELS UNDER THIS JAIL INTO *THE MOST INCREDIBLE SUBTERRANEAN LAIR* ANYBODY HAD EVER *SEEN.*

NOW *THEY* WANT TO KNOCK IT ALL *DOWN!*

OVER MY *DEAD BODY,* MISTER *MAYOR!*

SOOUUUAAUUU

PHEW. THIS YOUR FIRST *NOVELTY?*

HUH?

THIS GUY. THE *SPOOK.* YOU EVER WORK WITH A *NOVELTY CRIME ACT* BEFORE?

A *TON* OF EM, YEAH.

WHAT'S IT TO YOU?

WELL, LIKE *WHO?*

WHAT ARE YOU *TALKING* ABOUT, *"LIKE WHO"?*

YOU *NAME* IT!

WHAT, LIKE THE *PENGUIN?* THE *RIDDLER?* MISTER *FREEZE?*

NAME *ONE.*

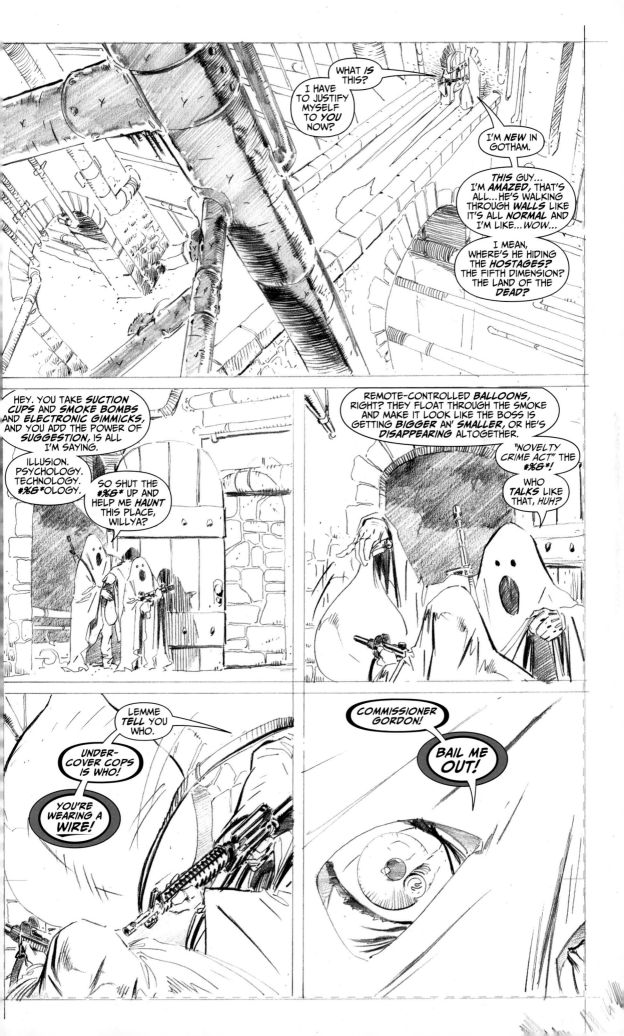

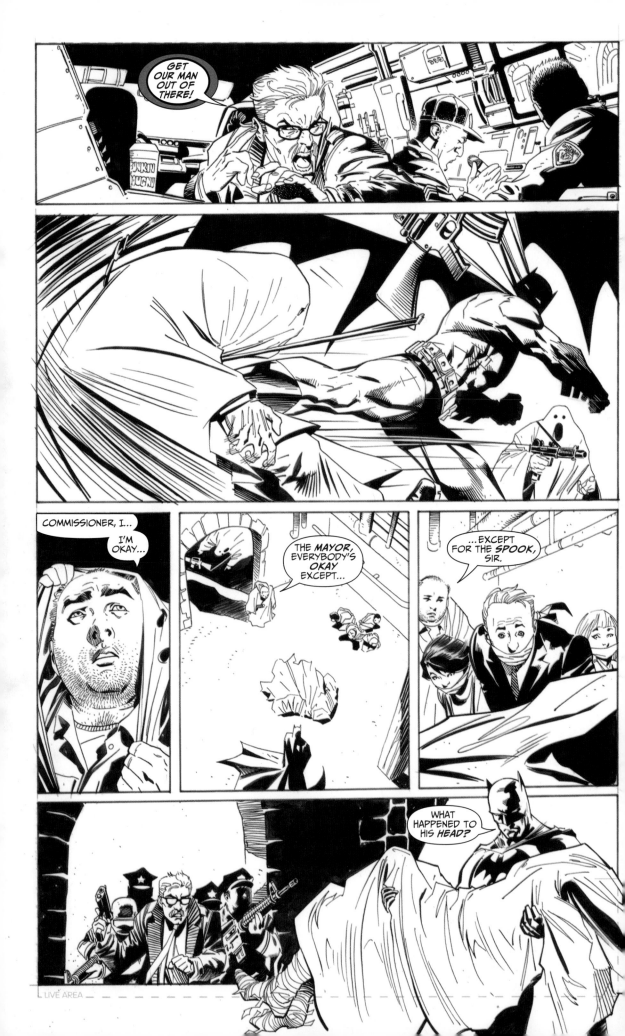

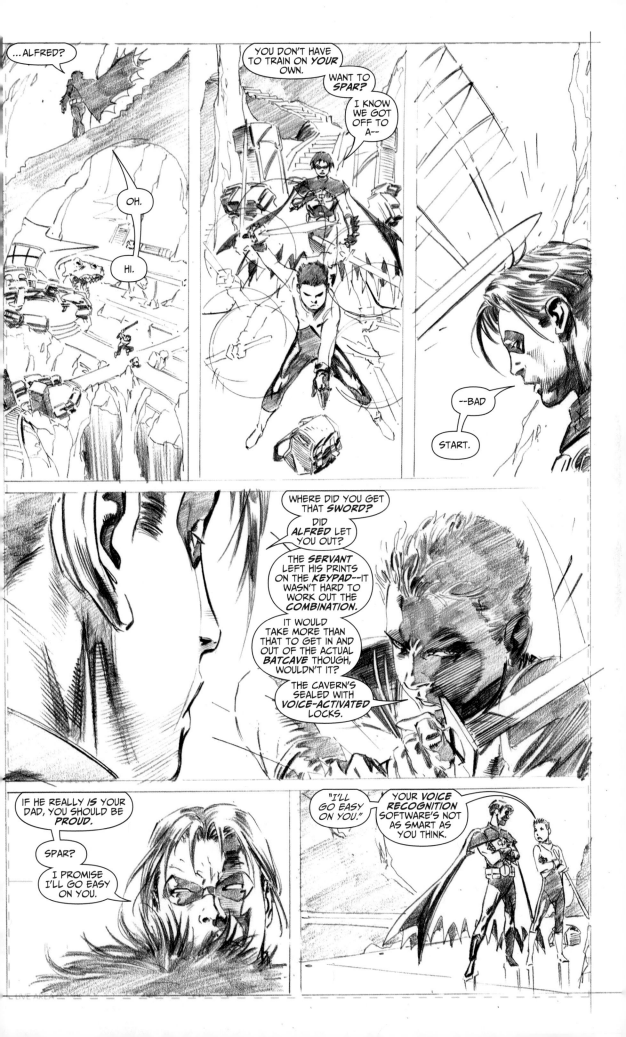

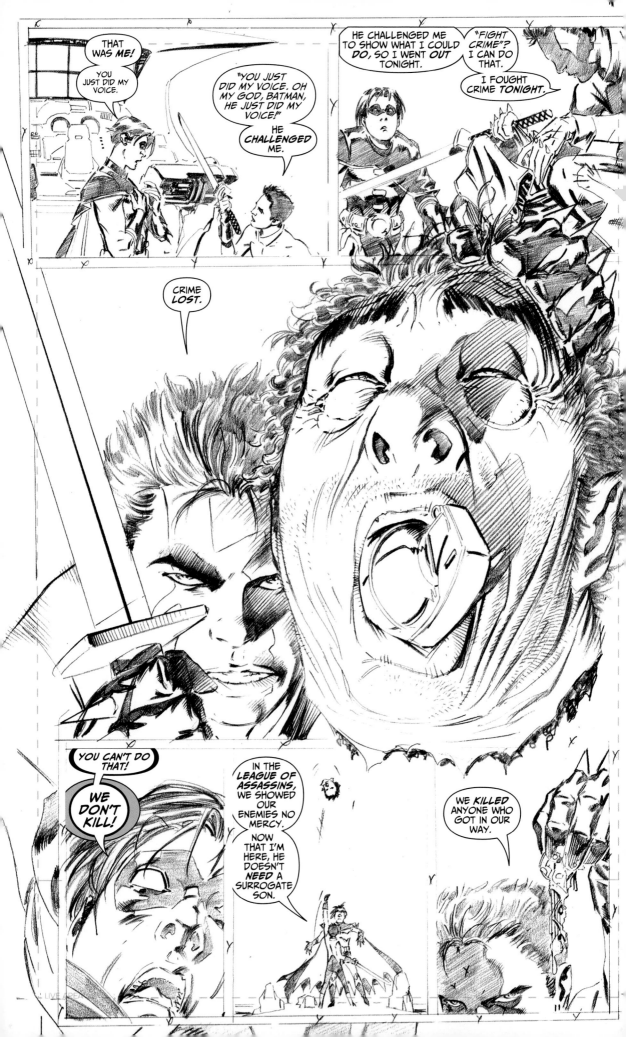

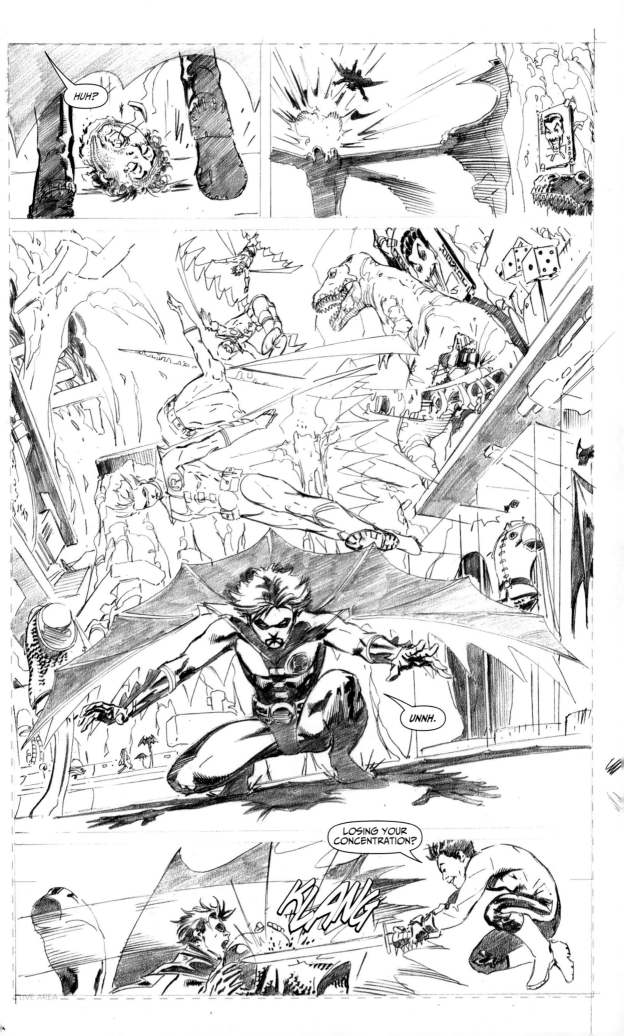

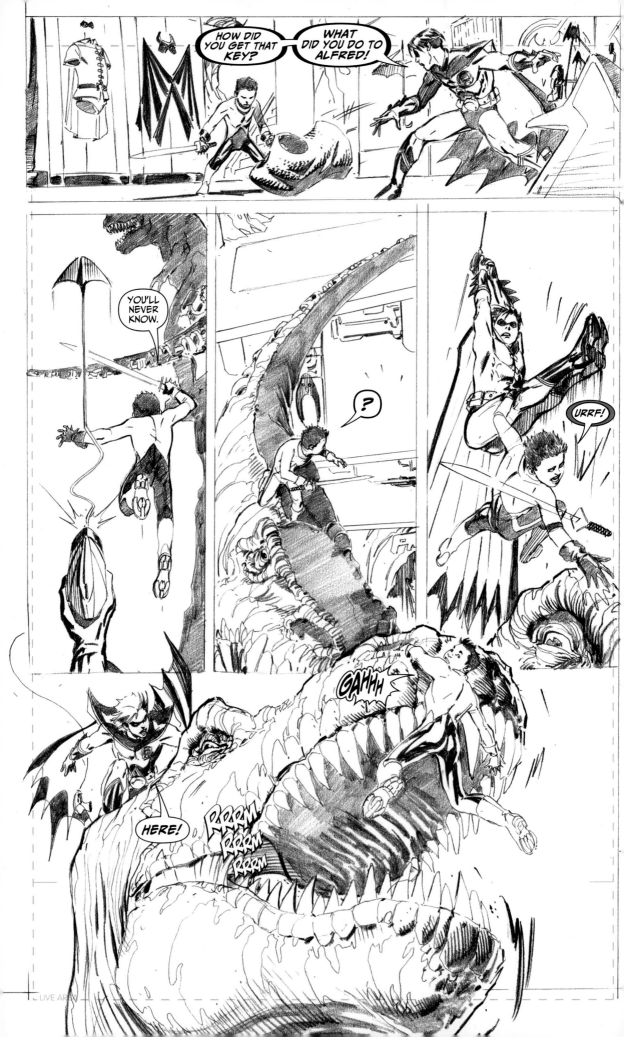

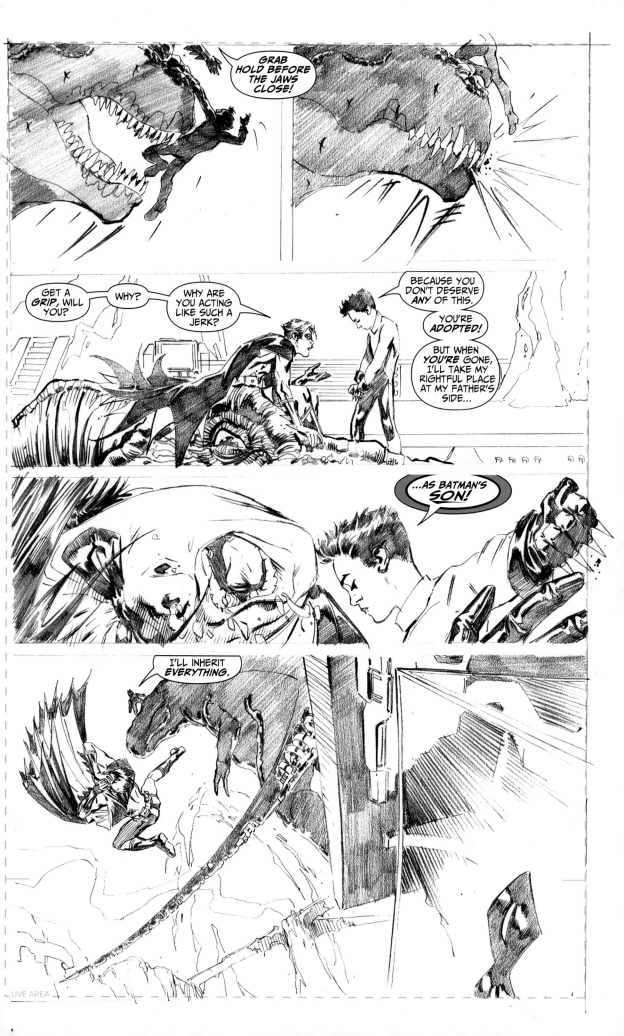

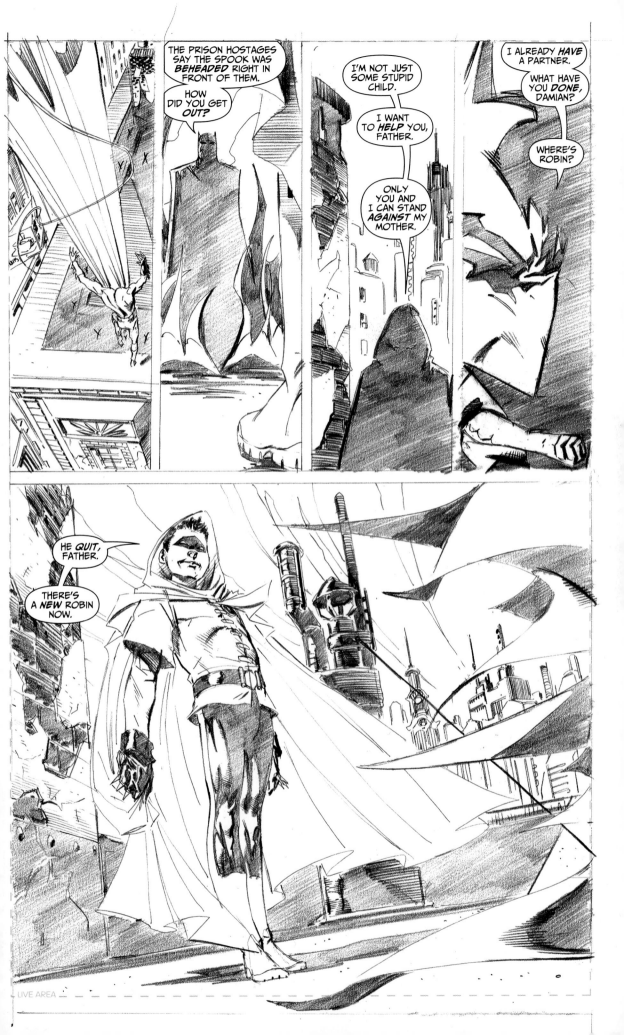

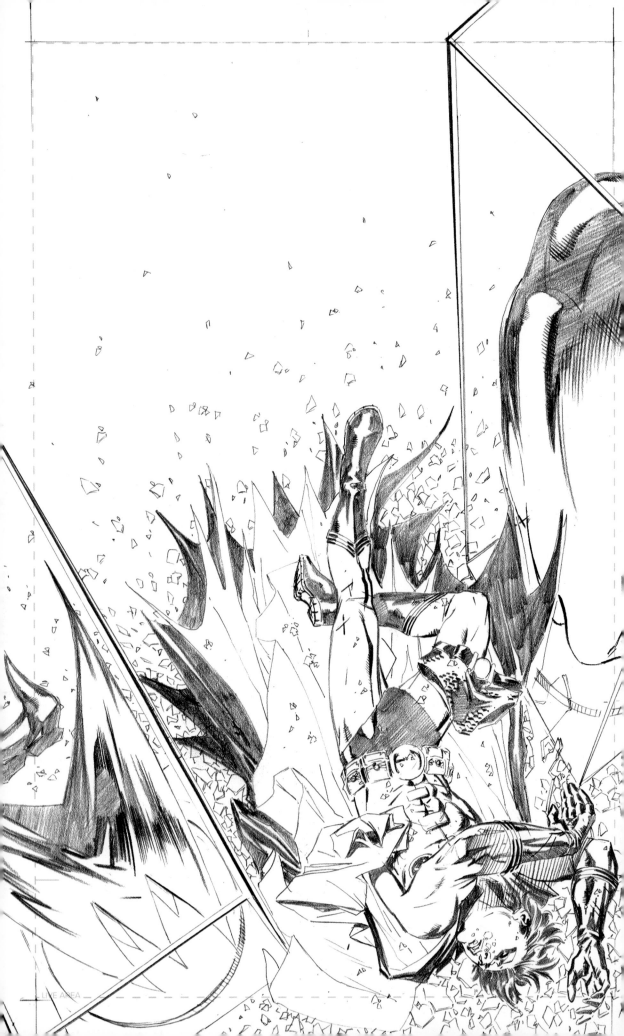

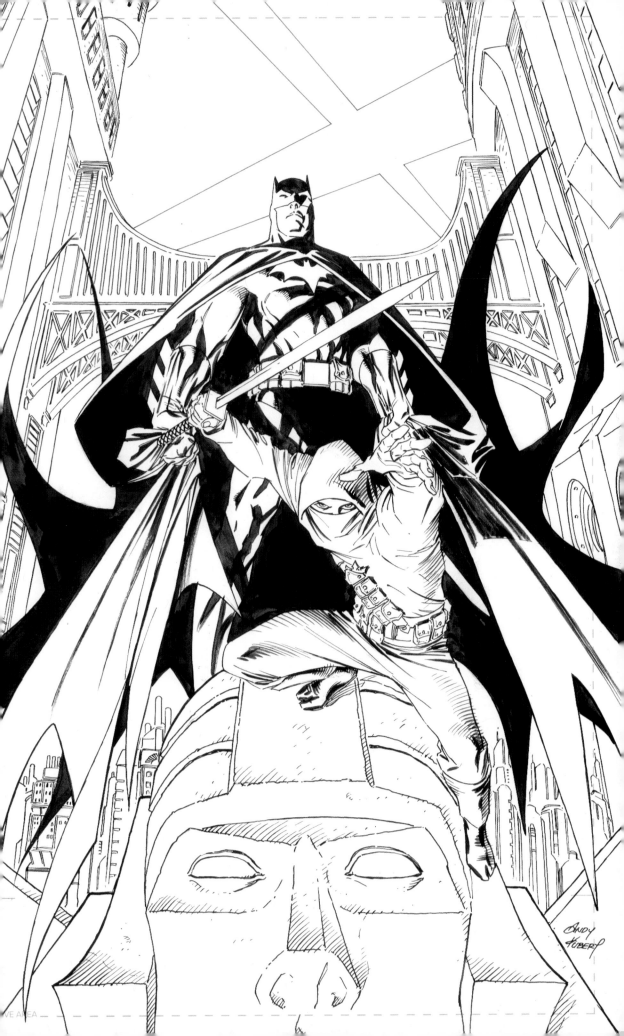

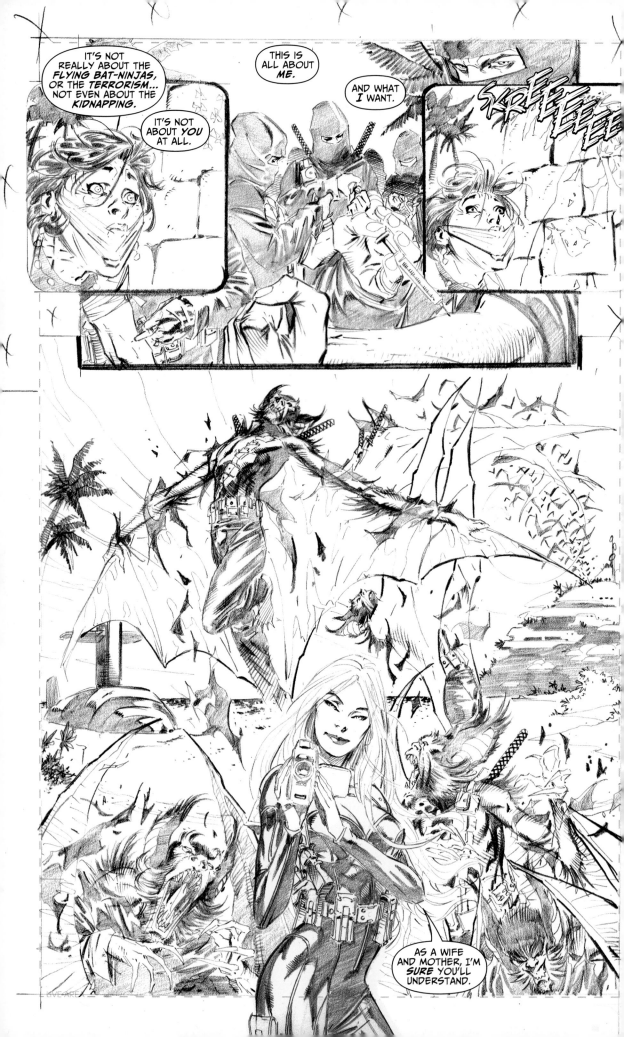

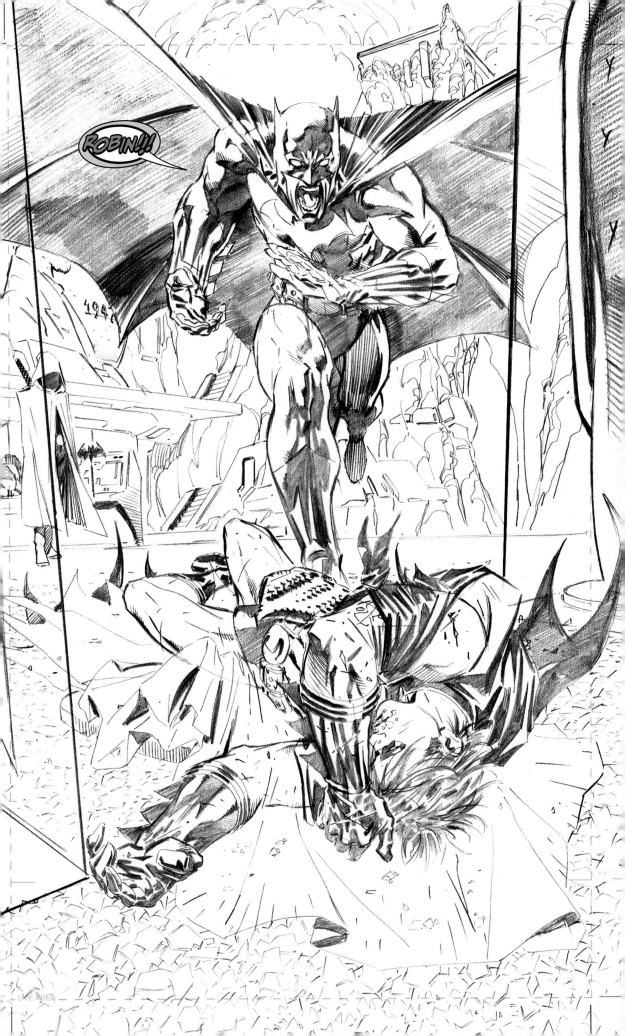

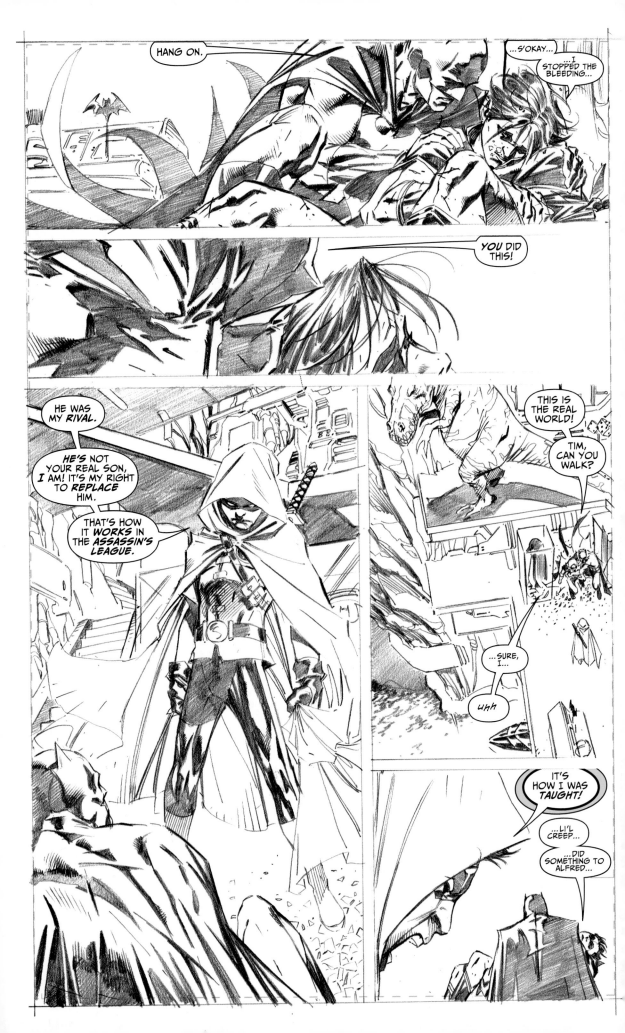

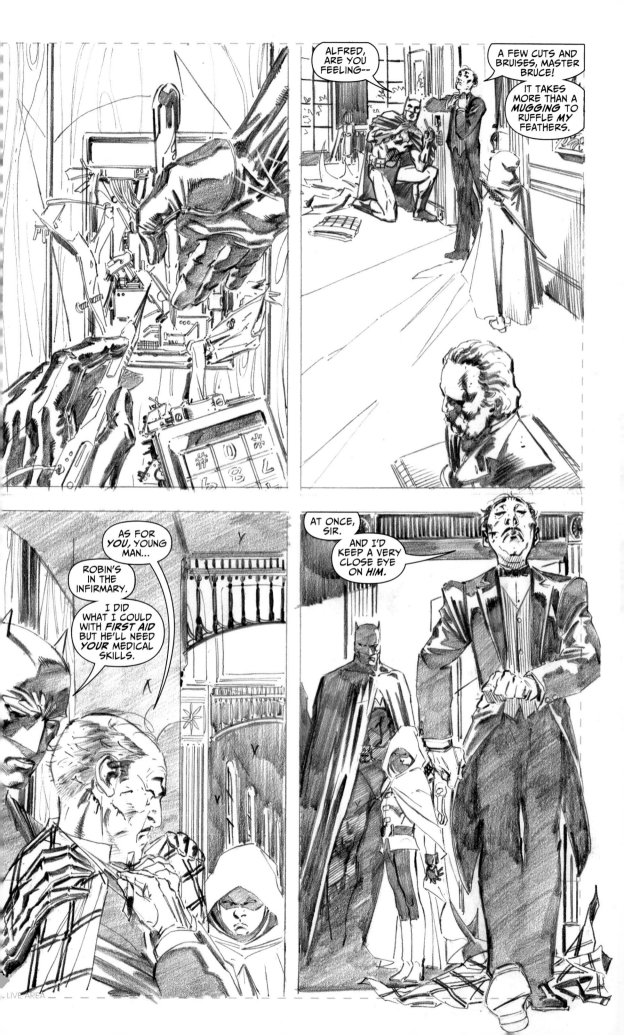

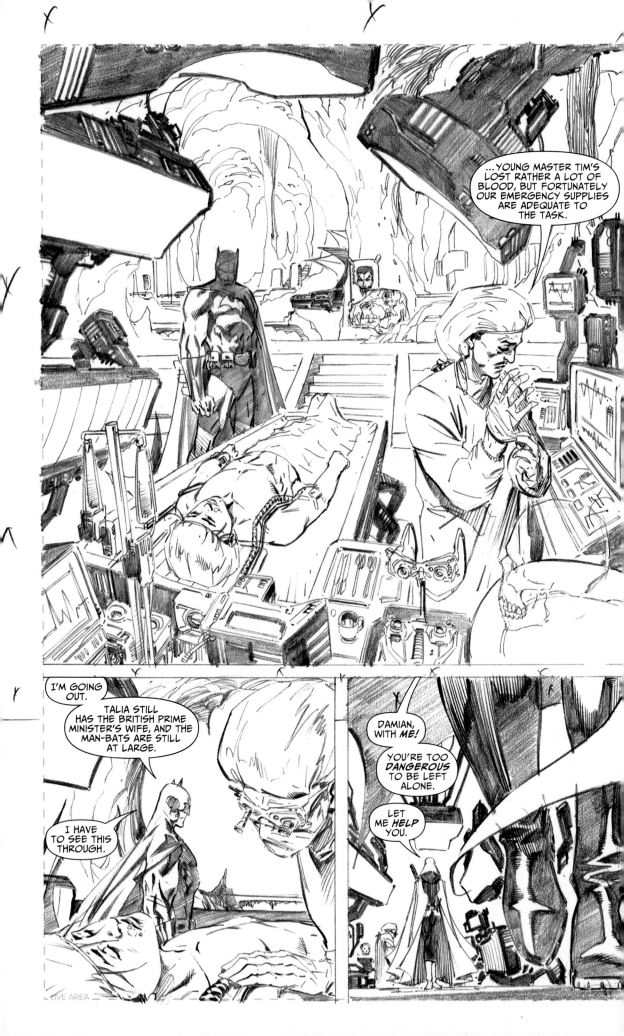

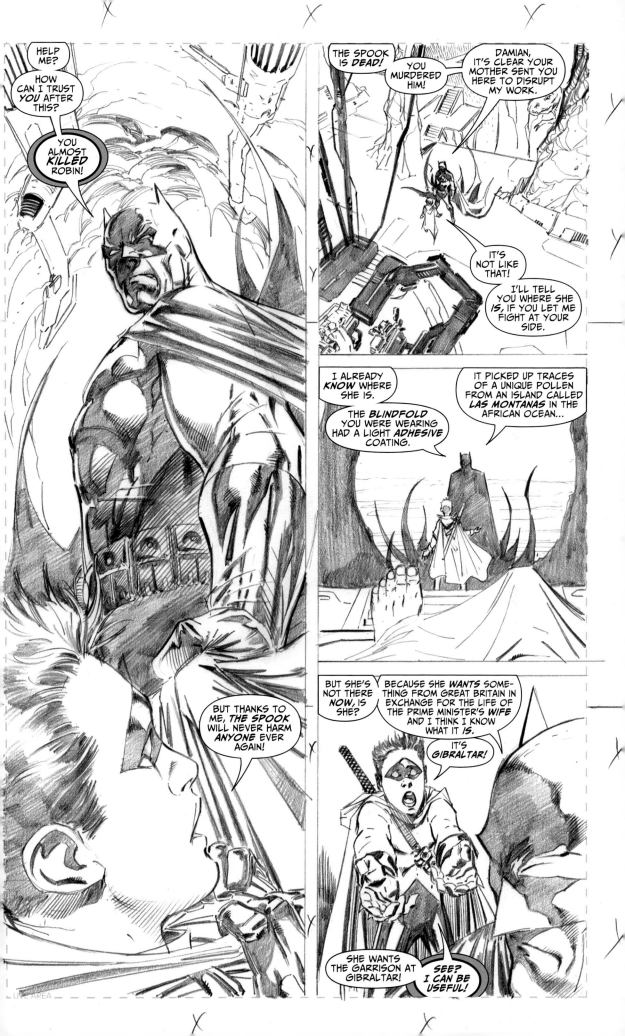

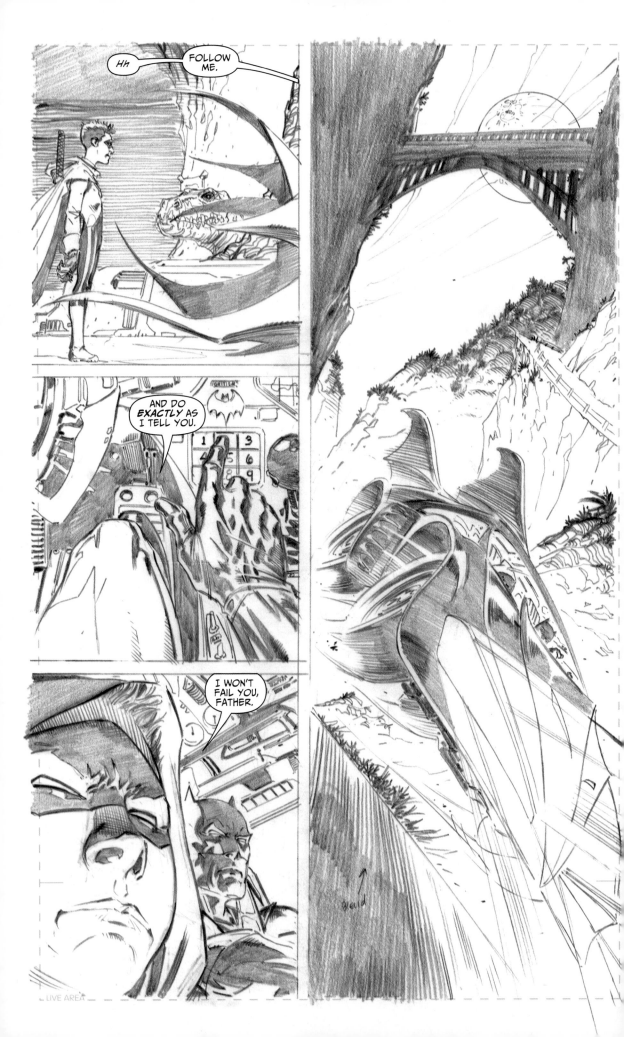

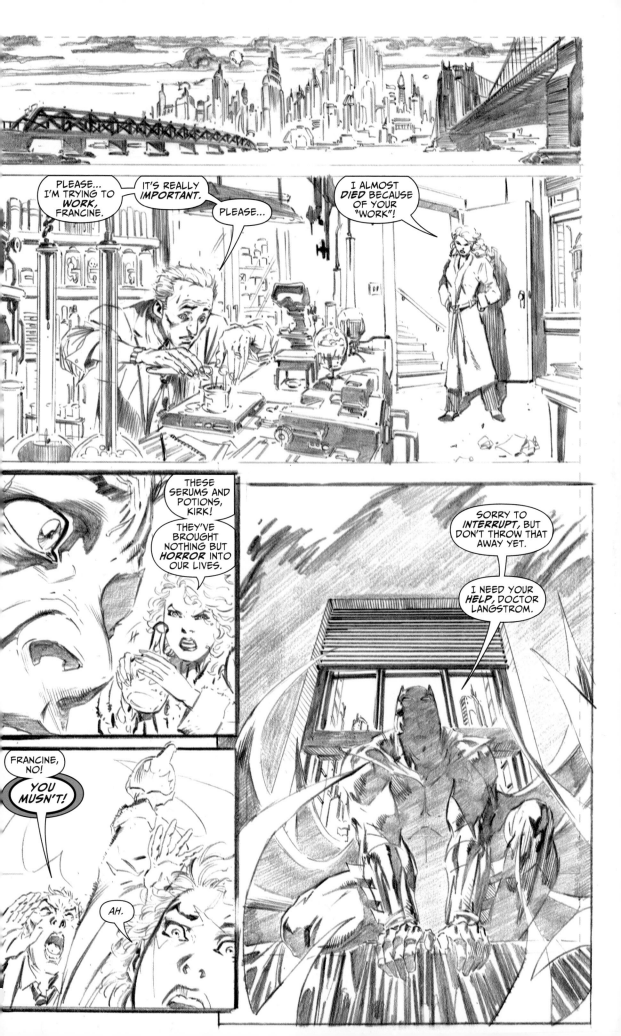

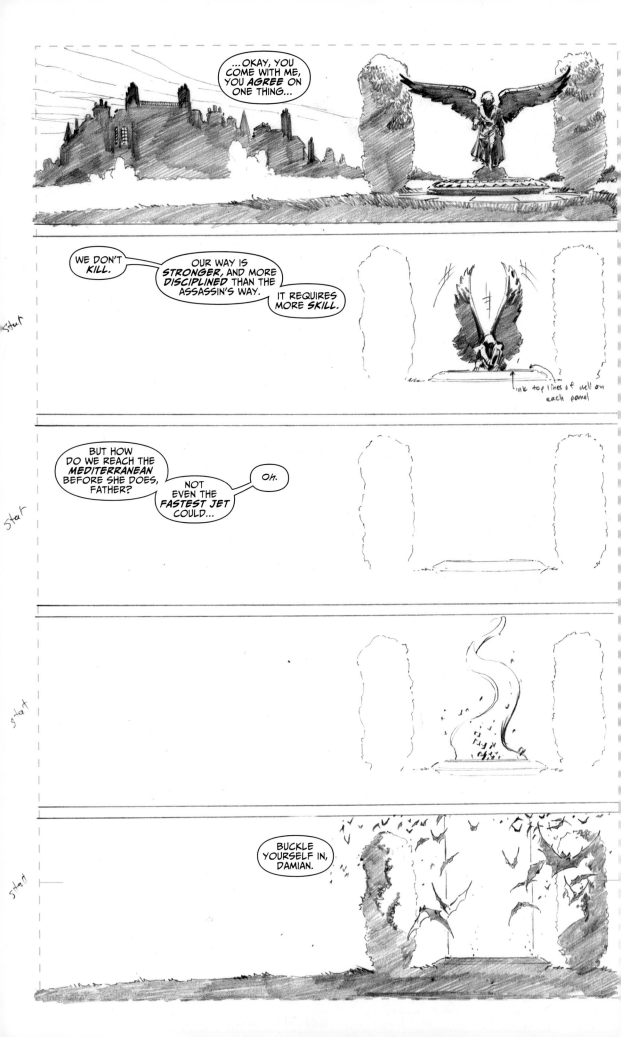

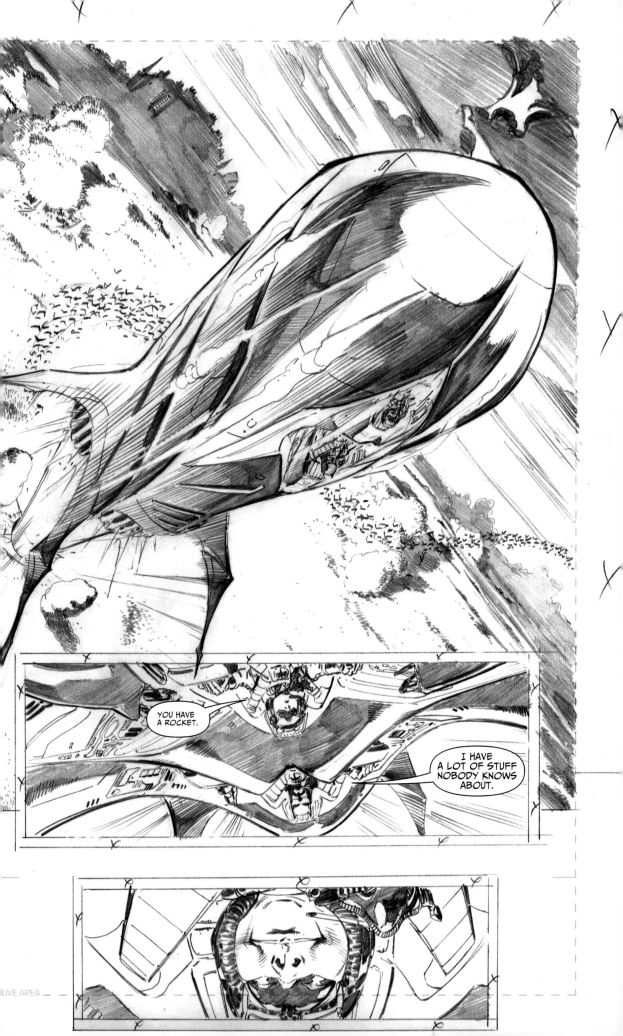

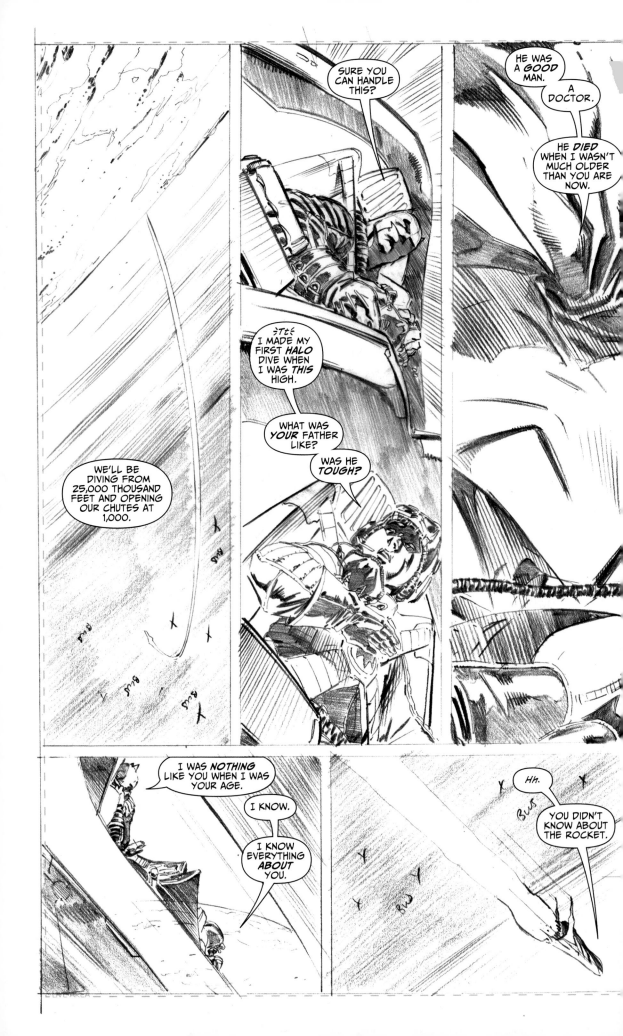

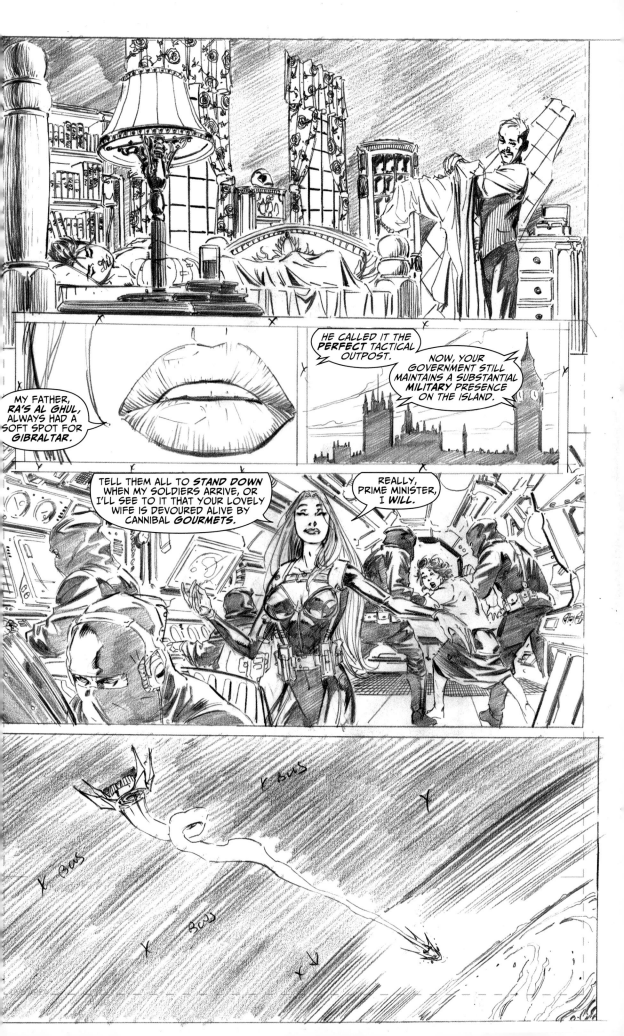

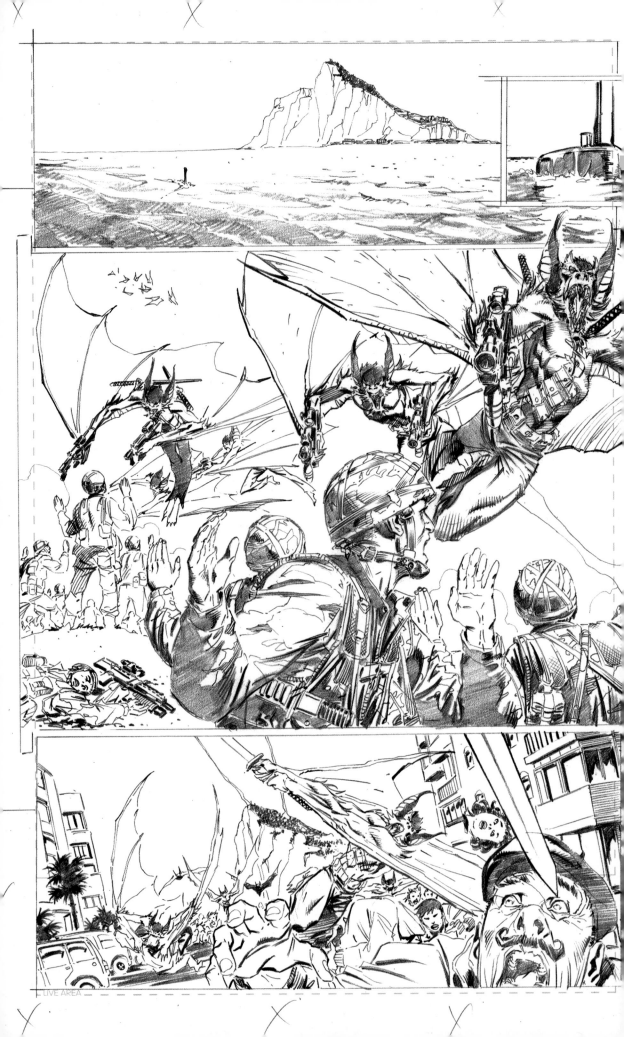

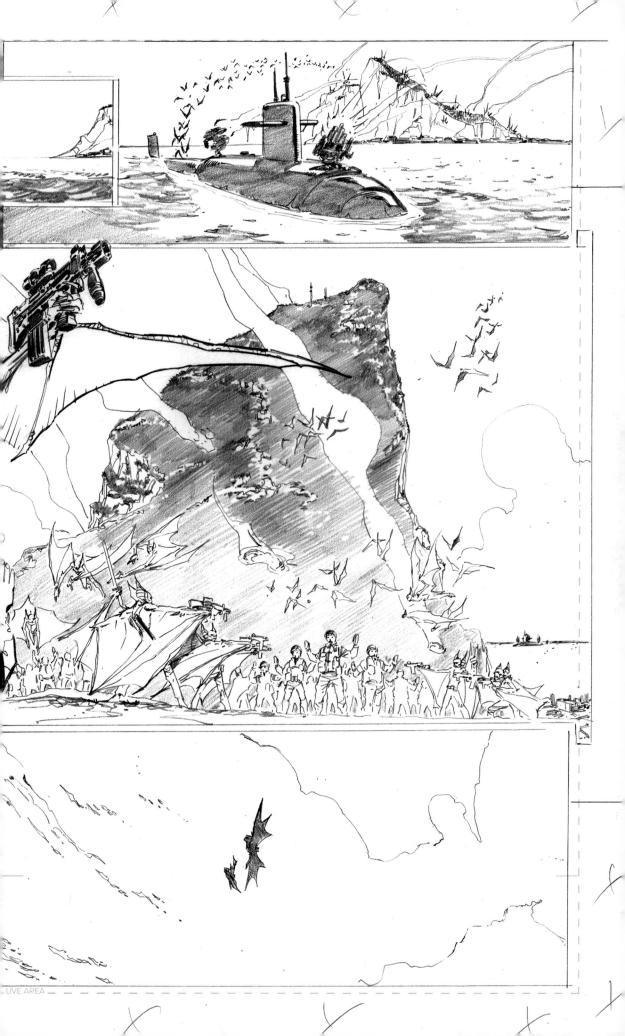

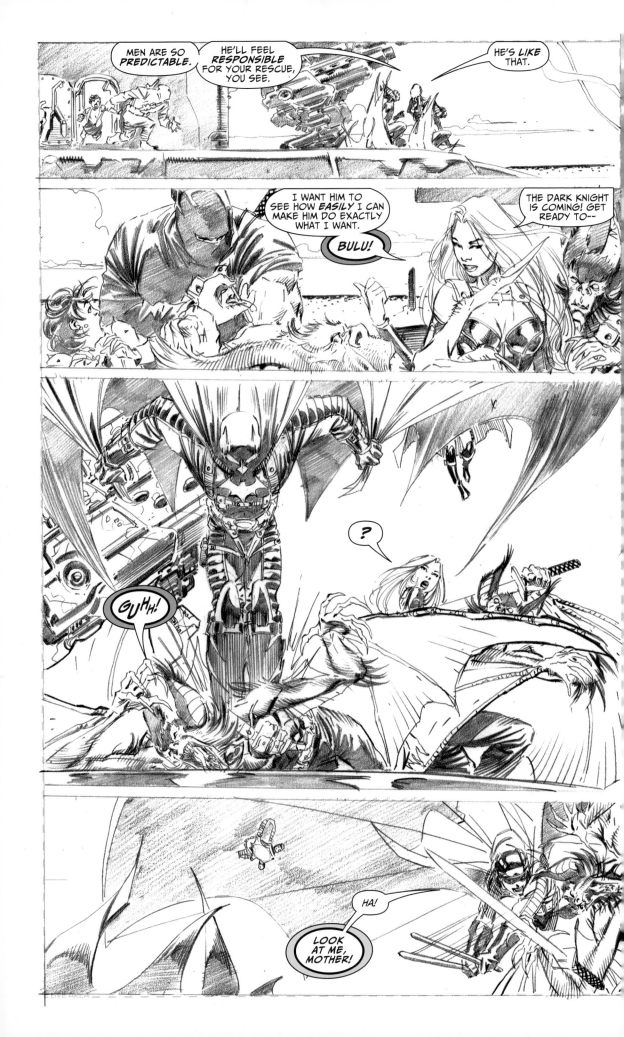

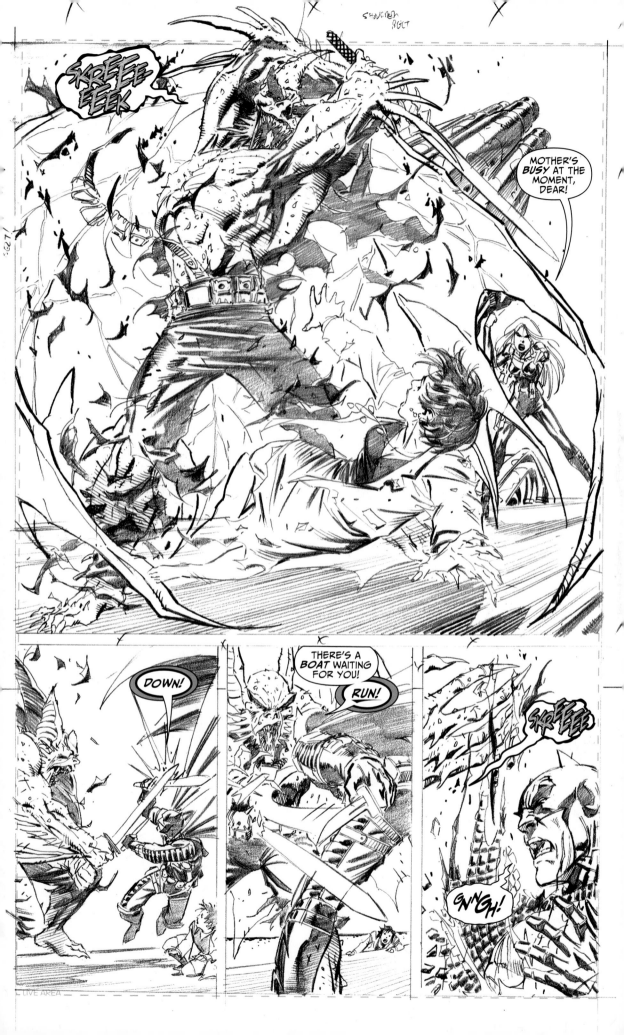

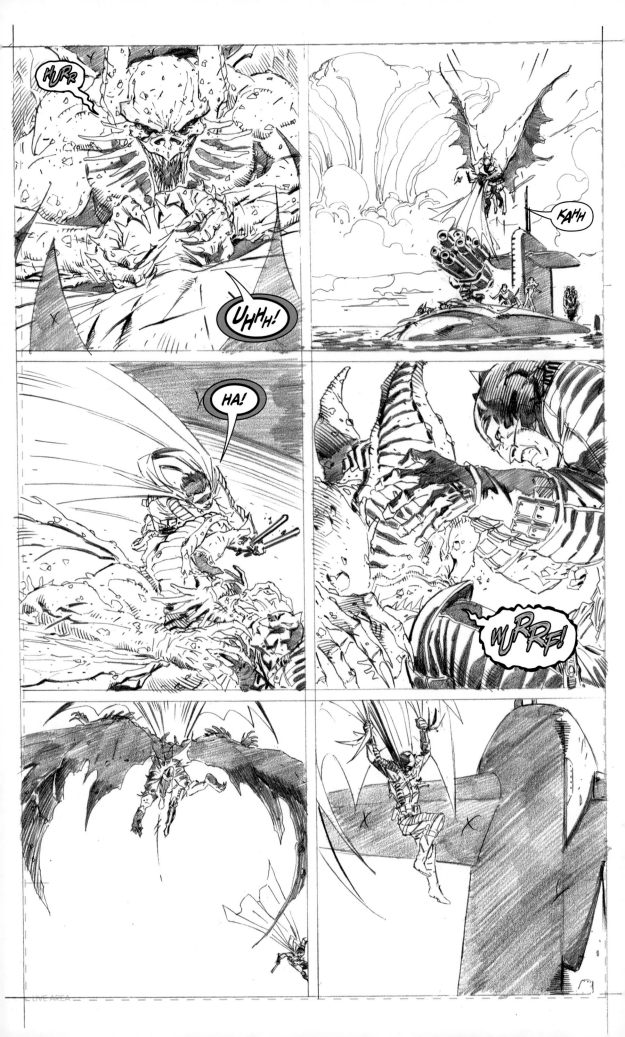

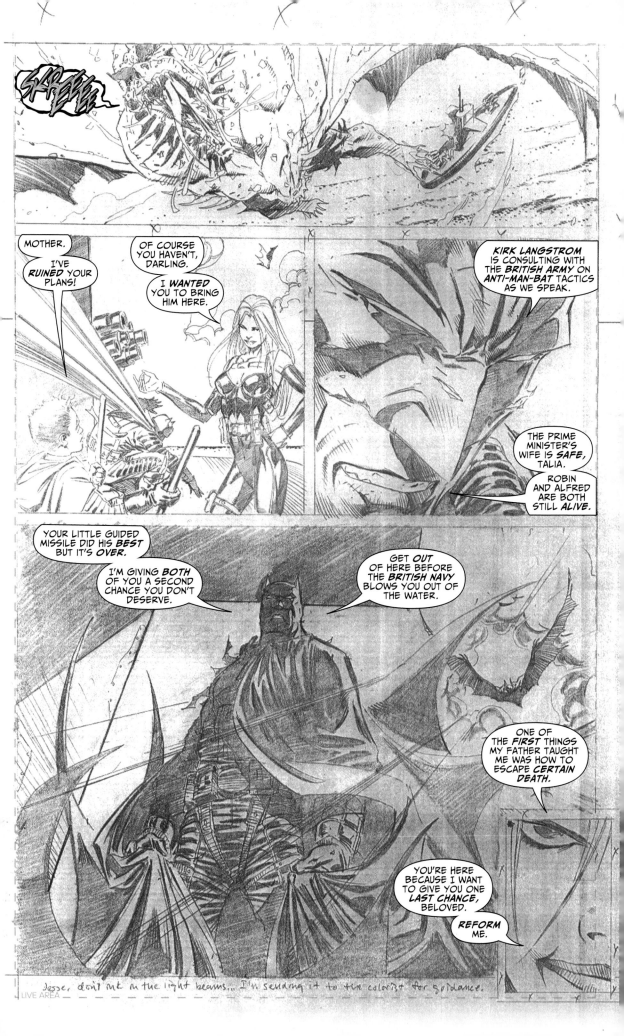

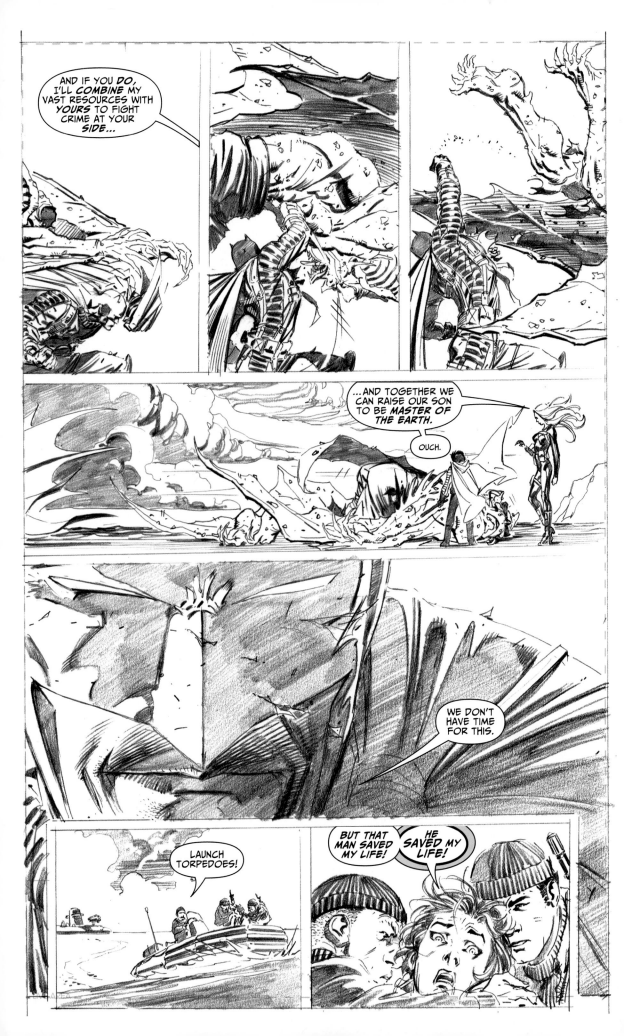

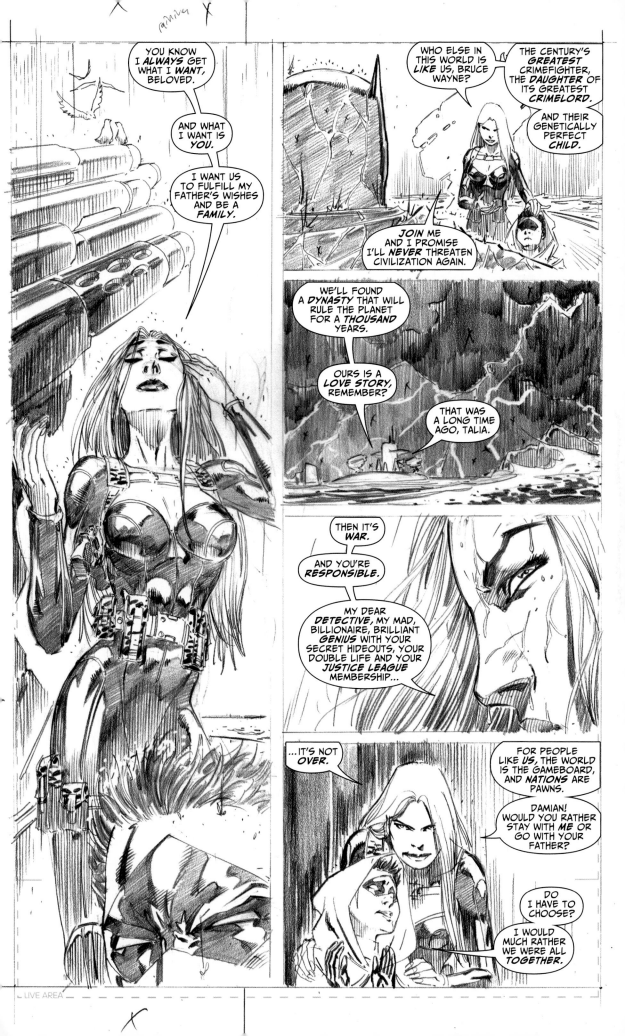

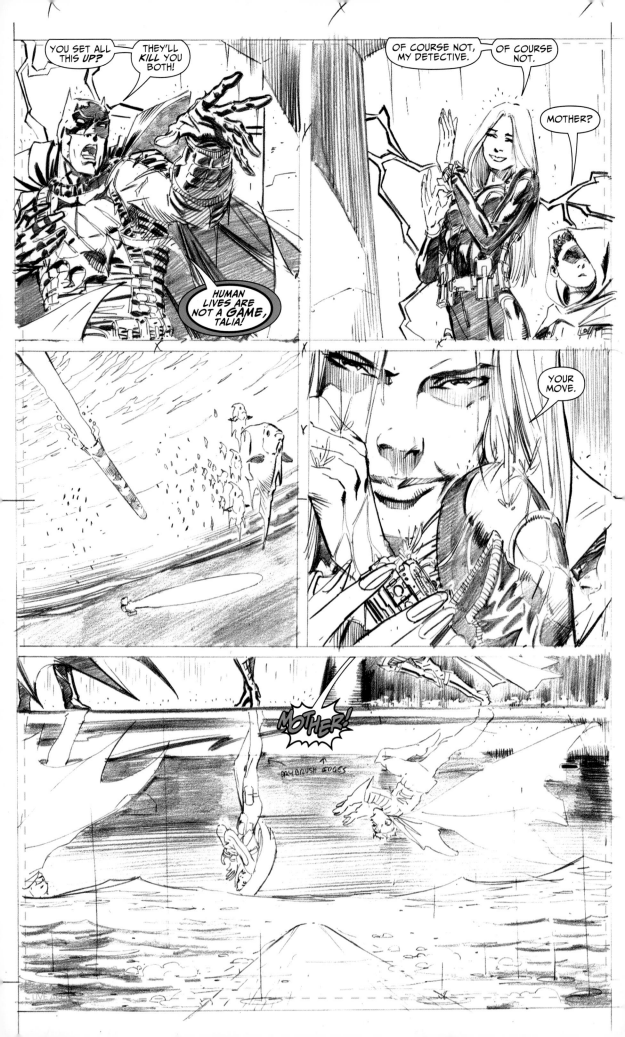

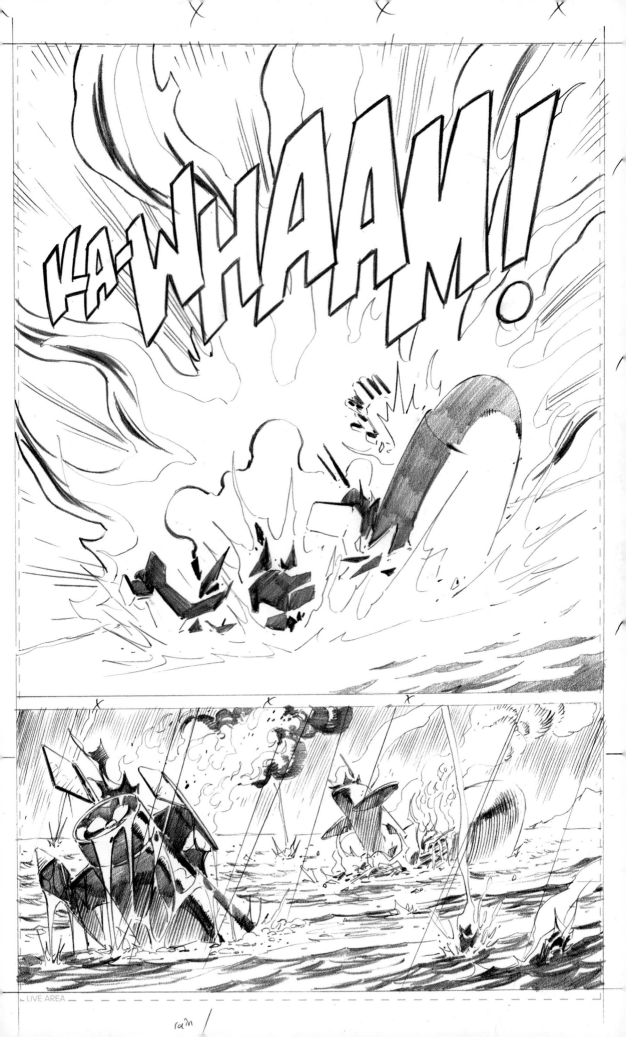

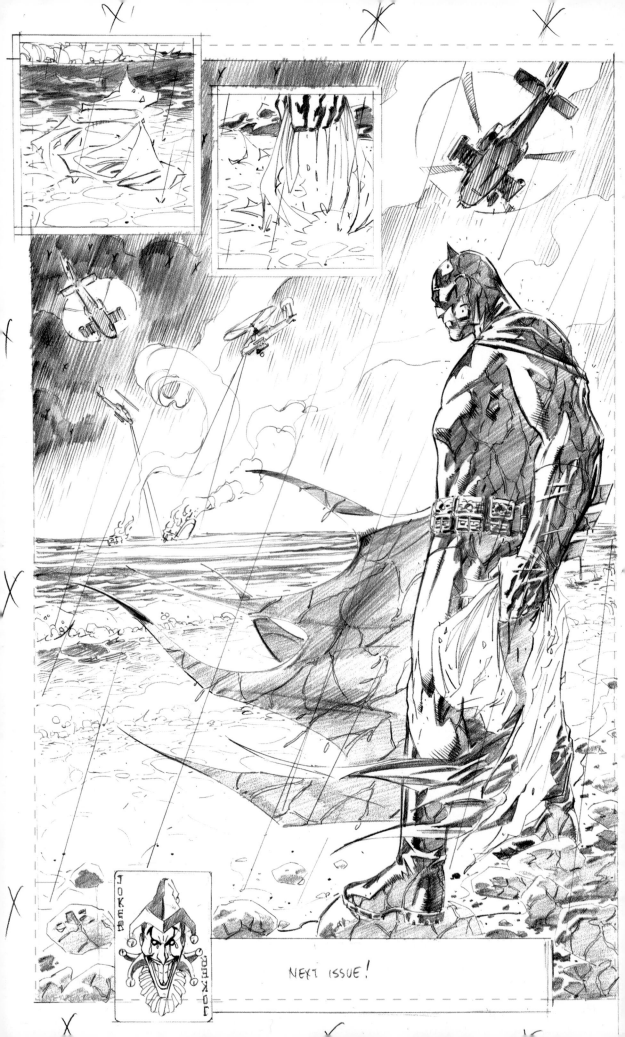

NEXT ISSUE!

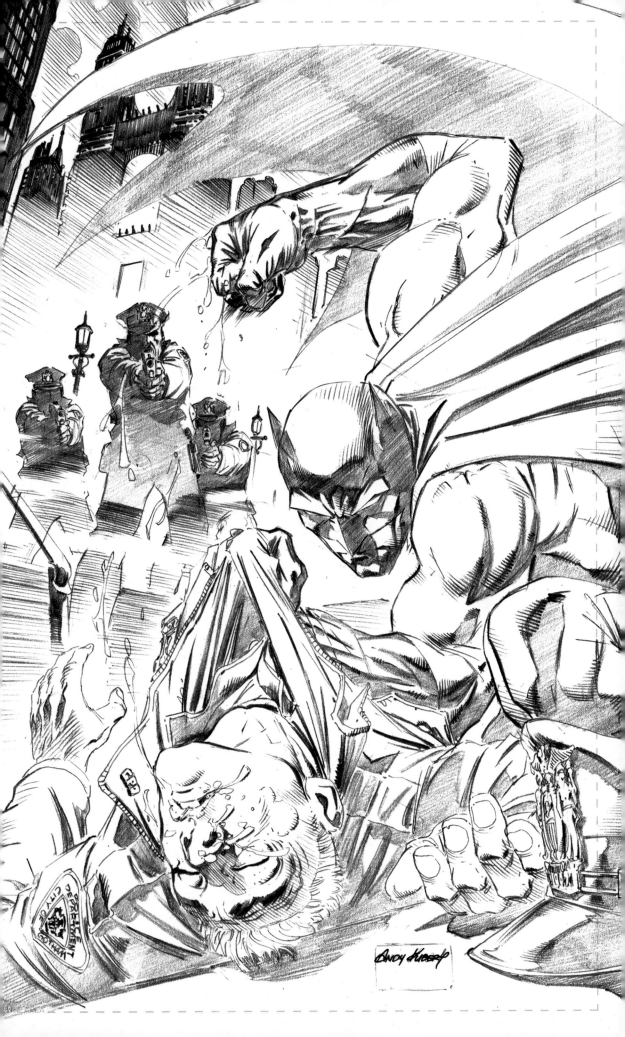

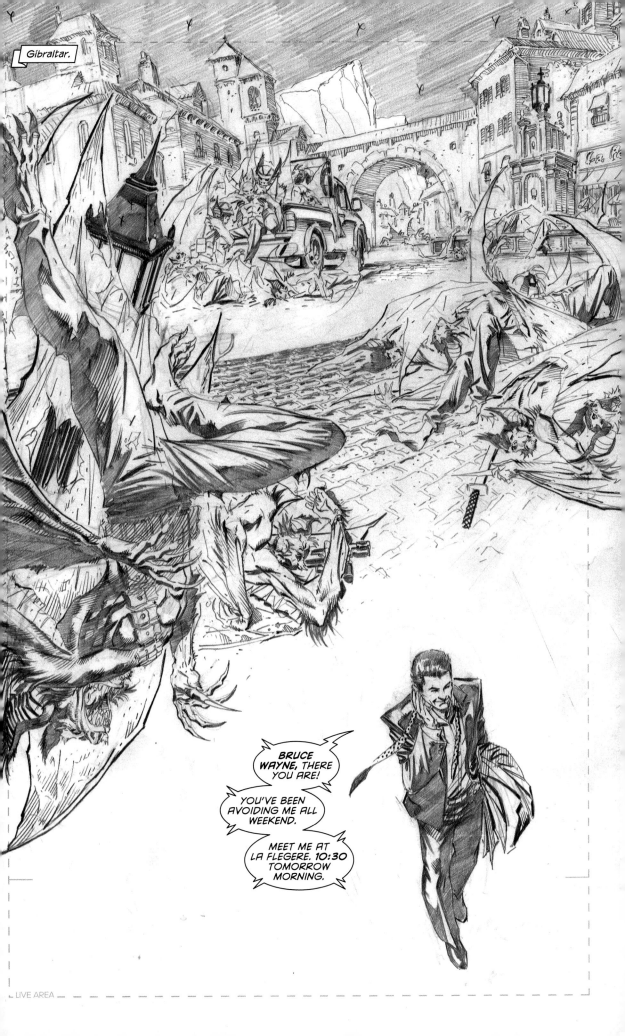

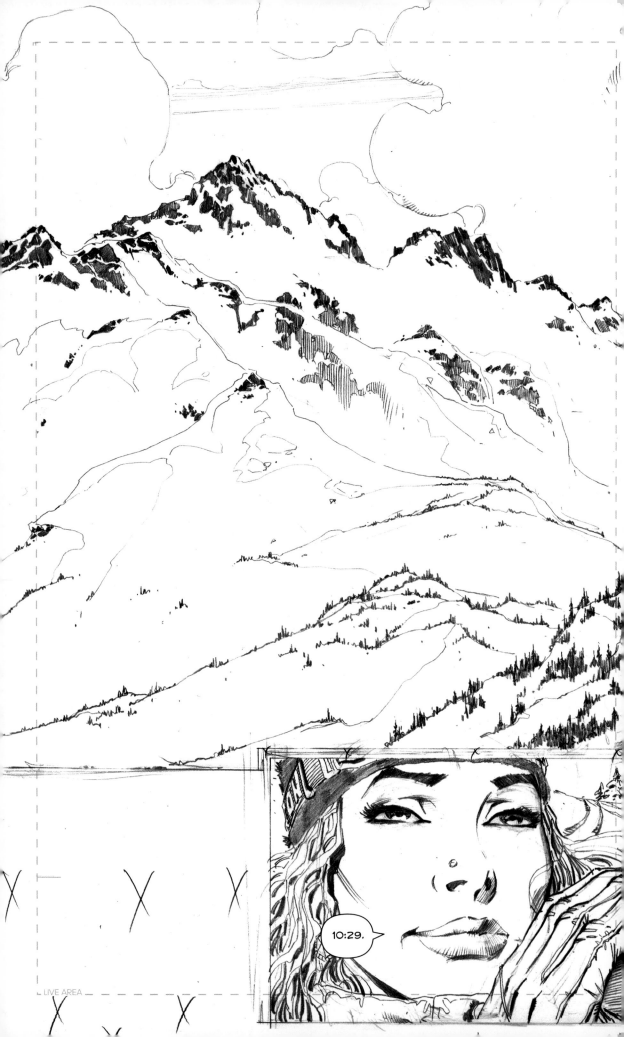

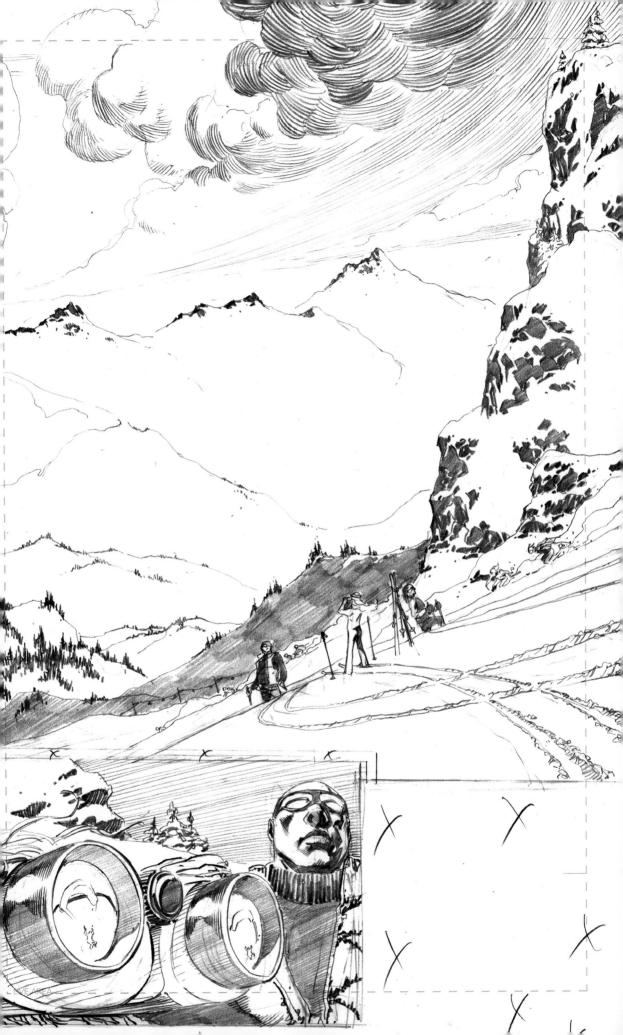

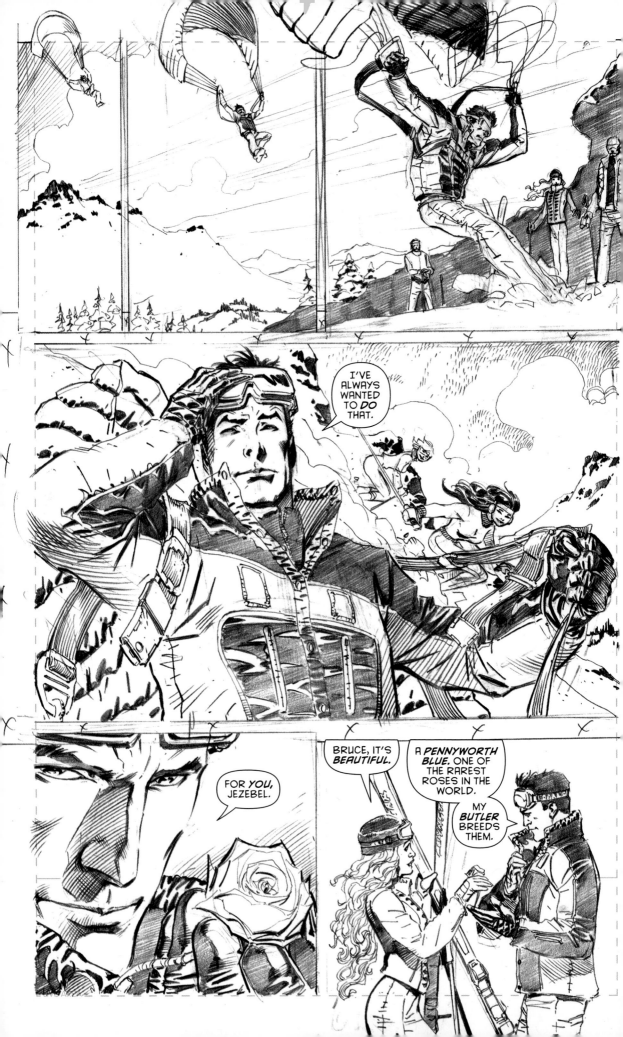

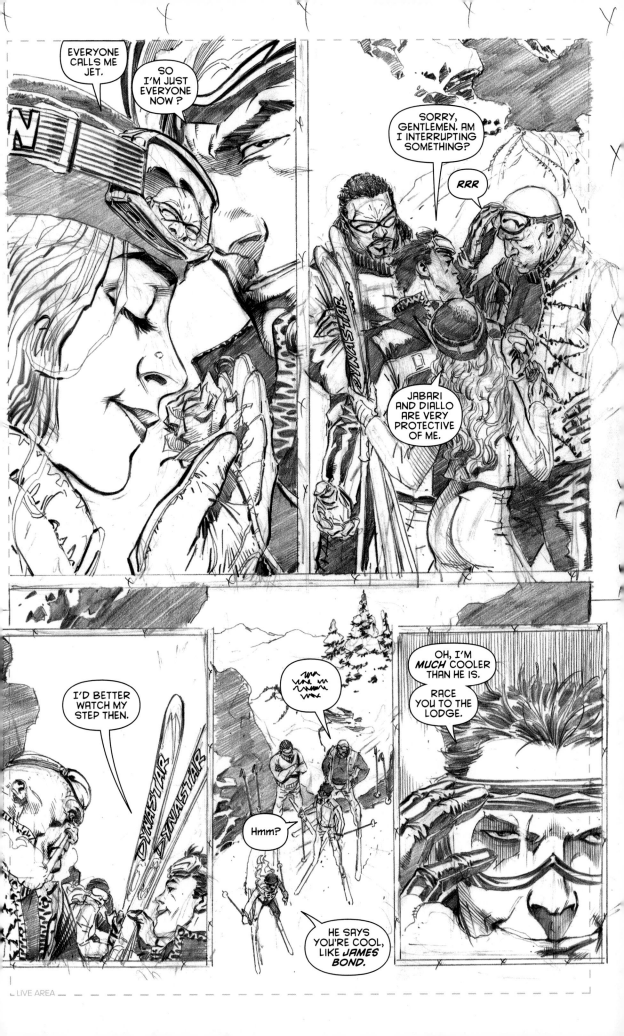

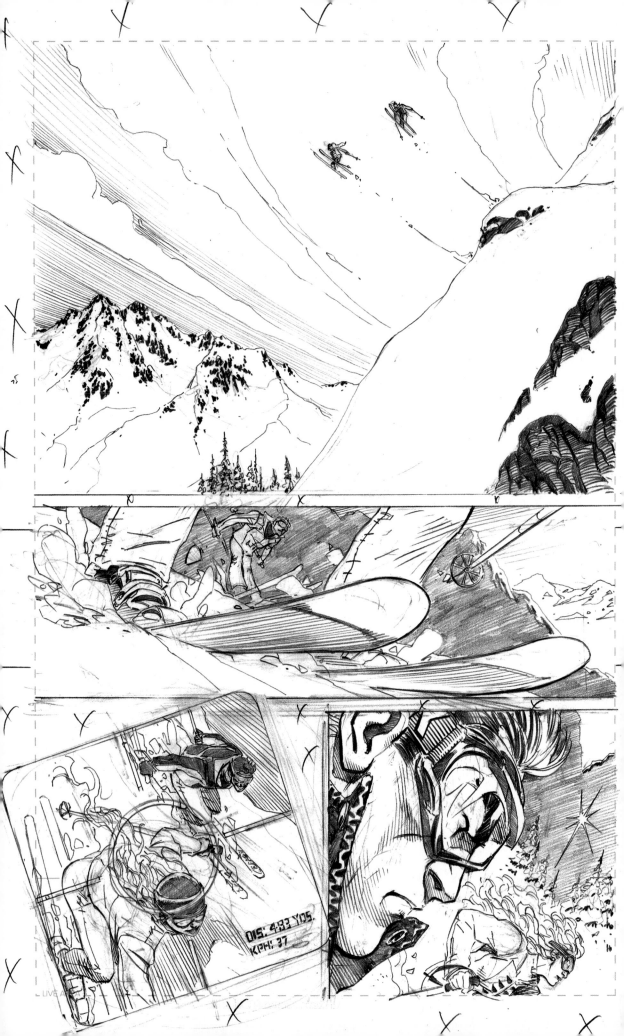

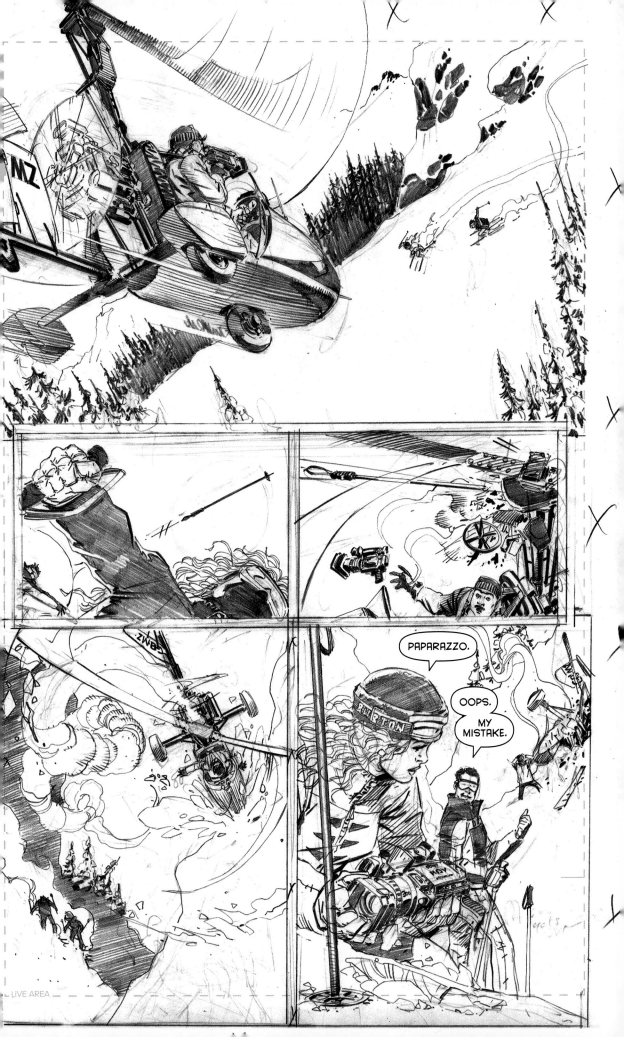

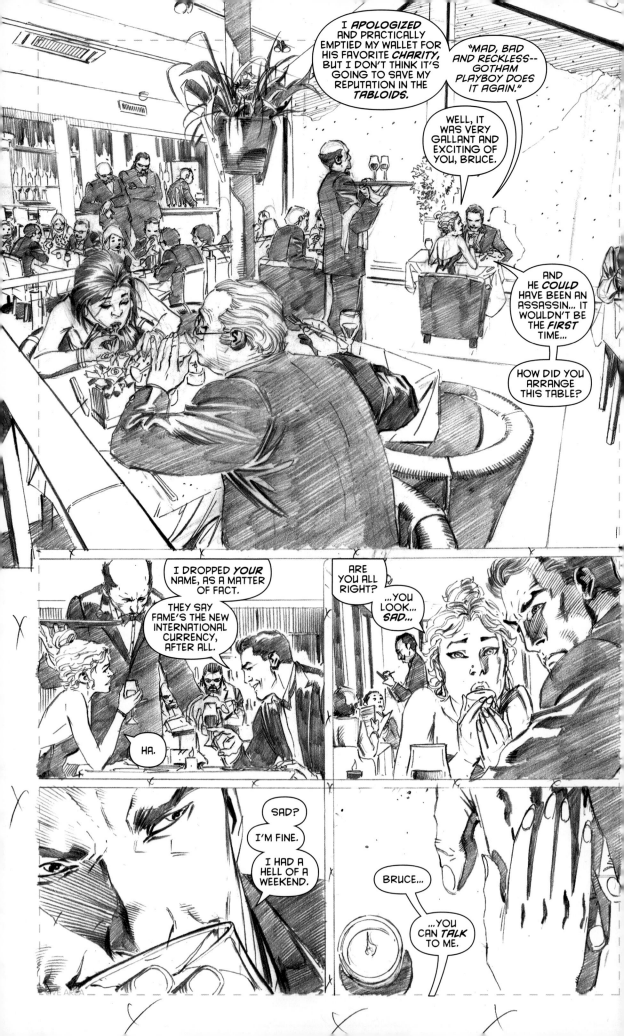

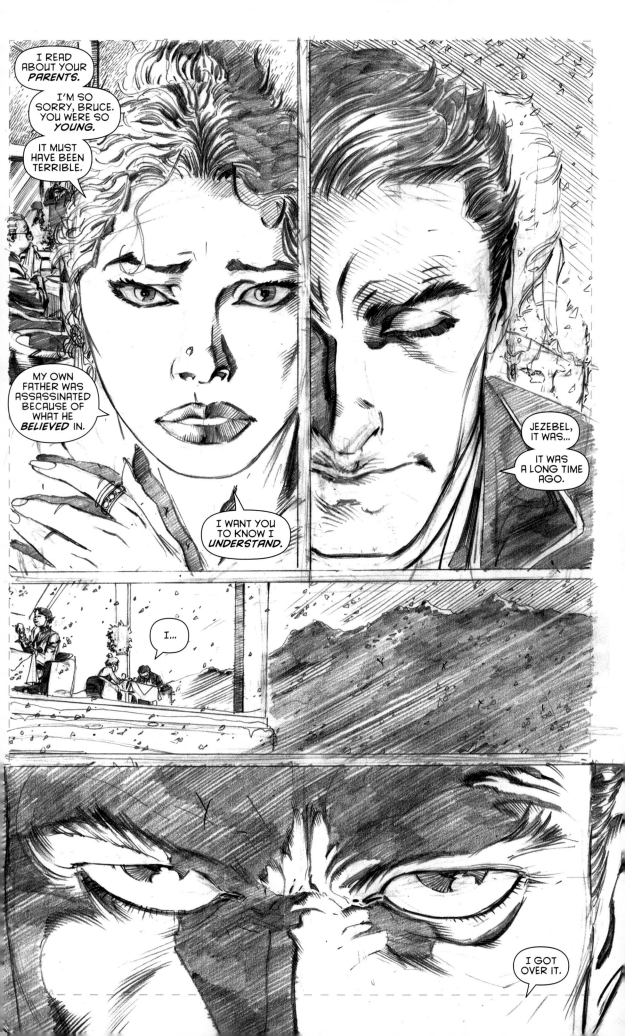

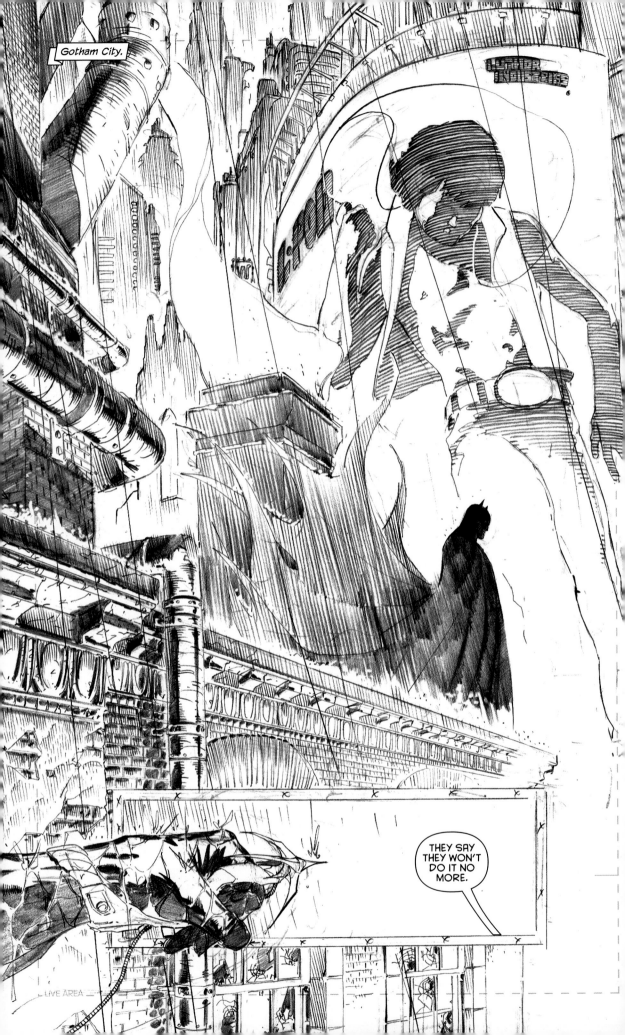

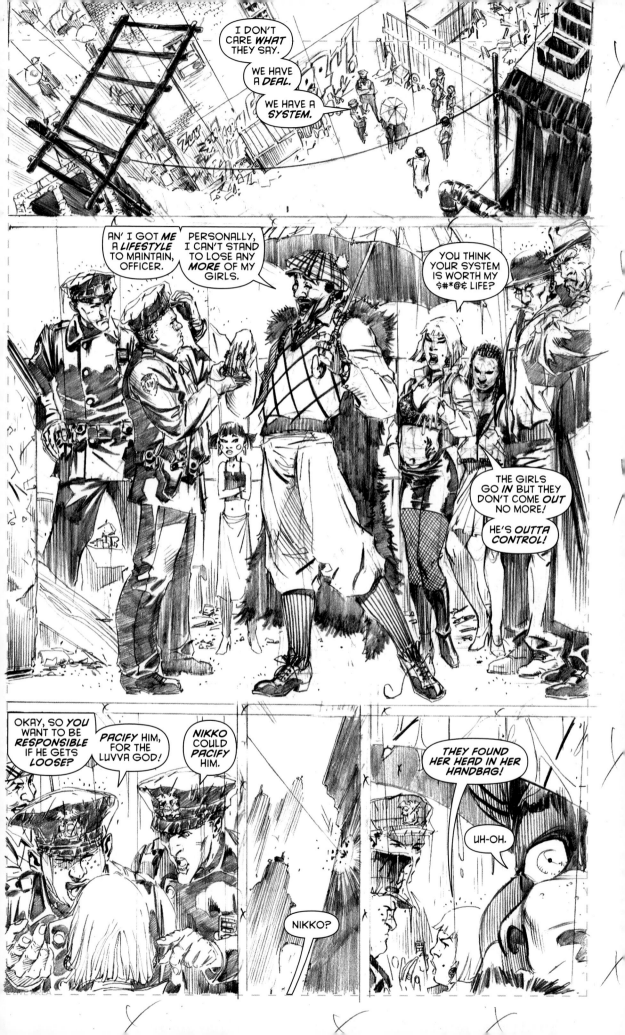

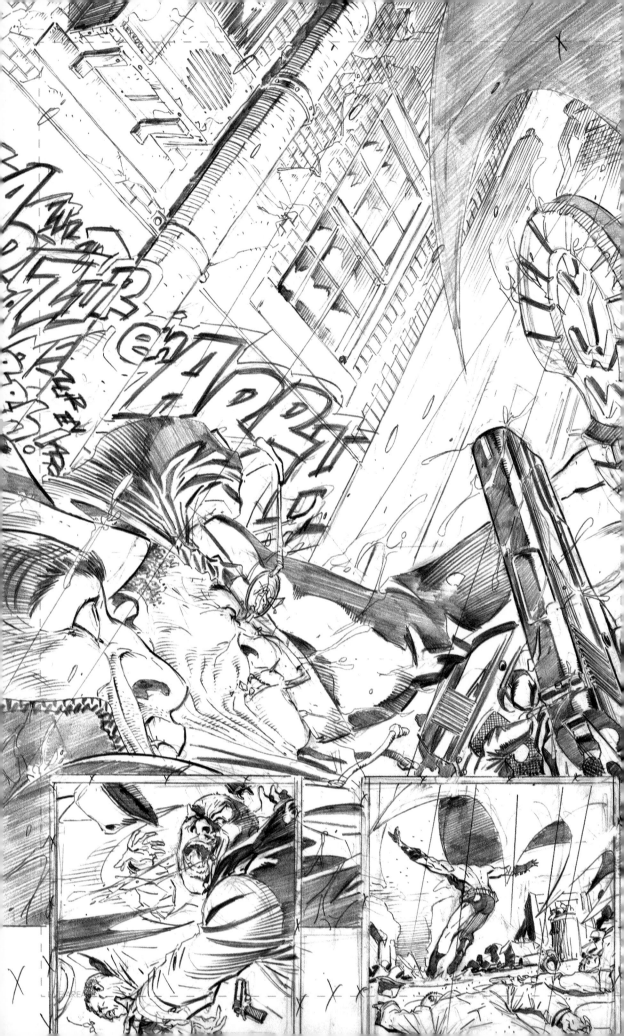

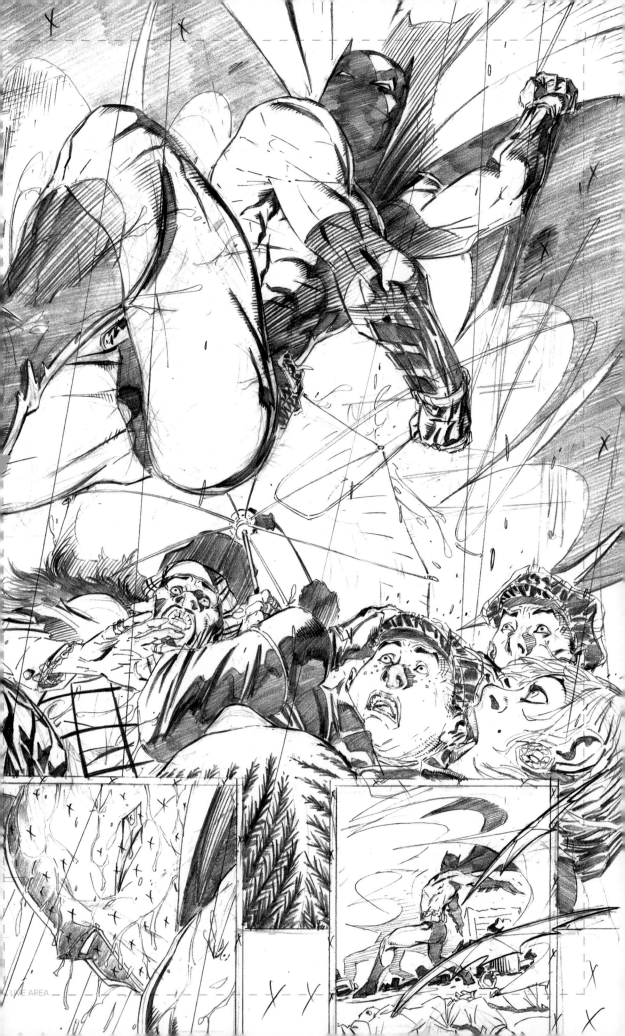

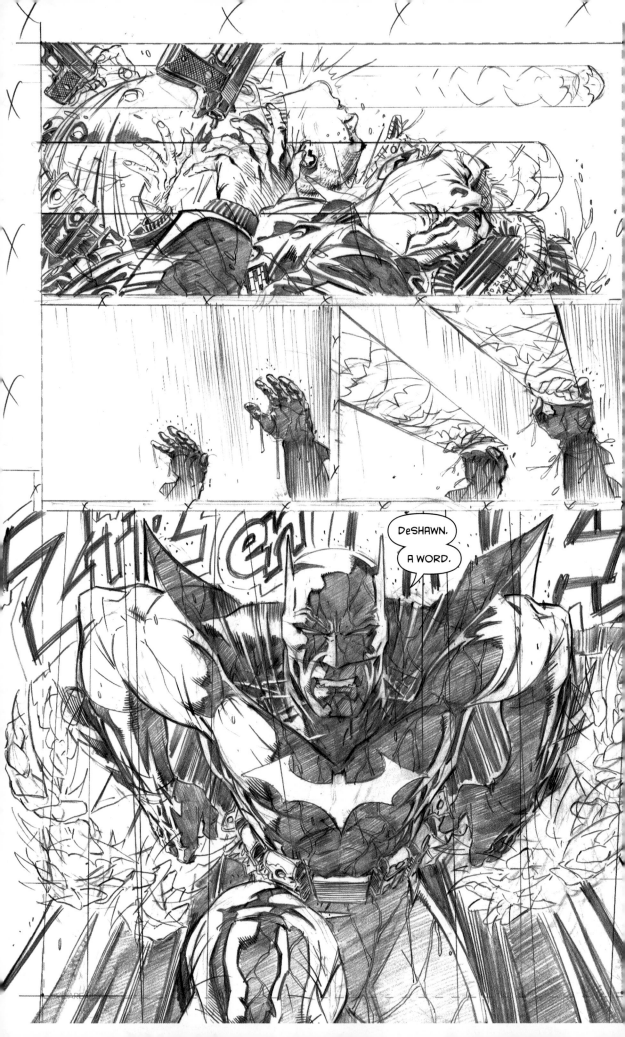

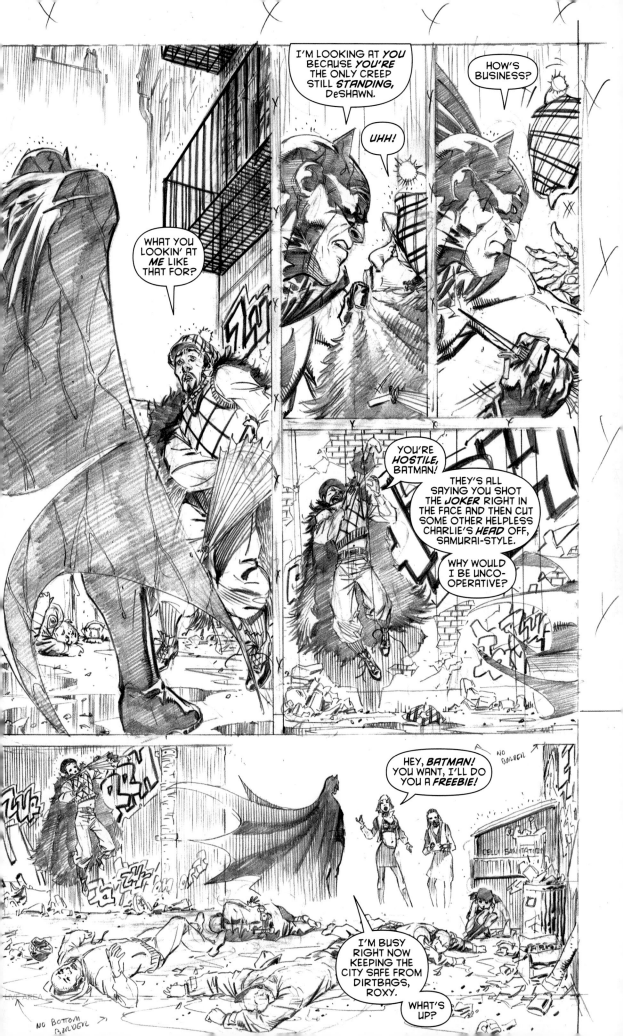

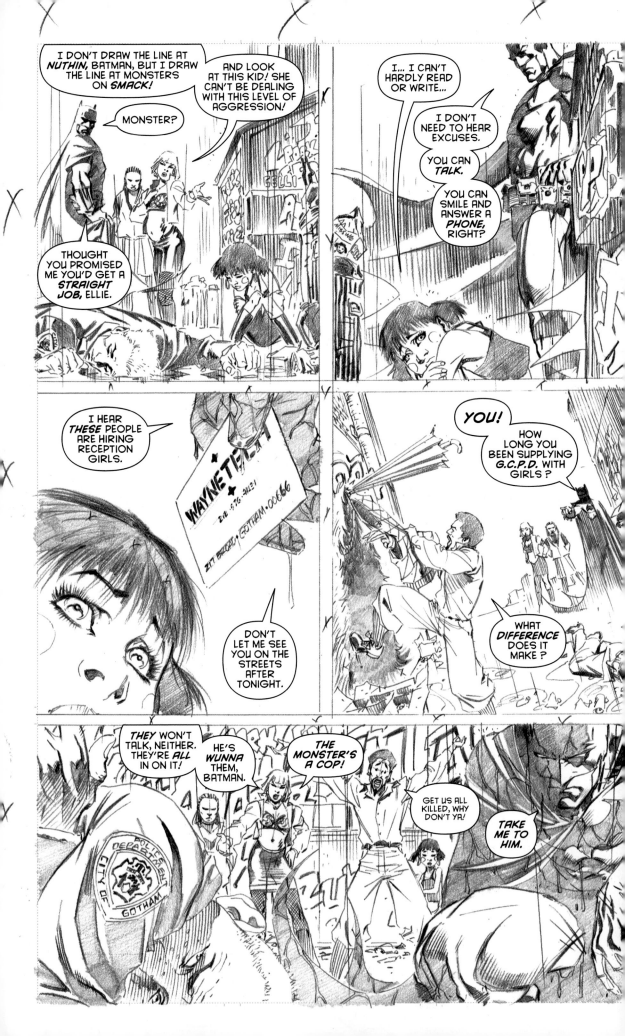

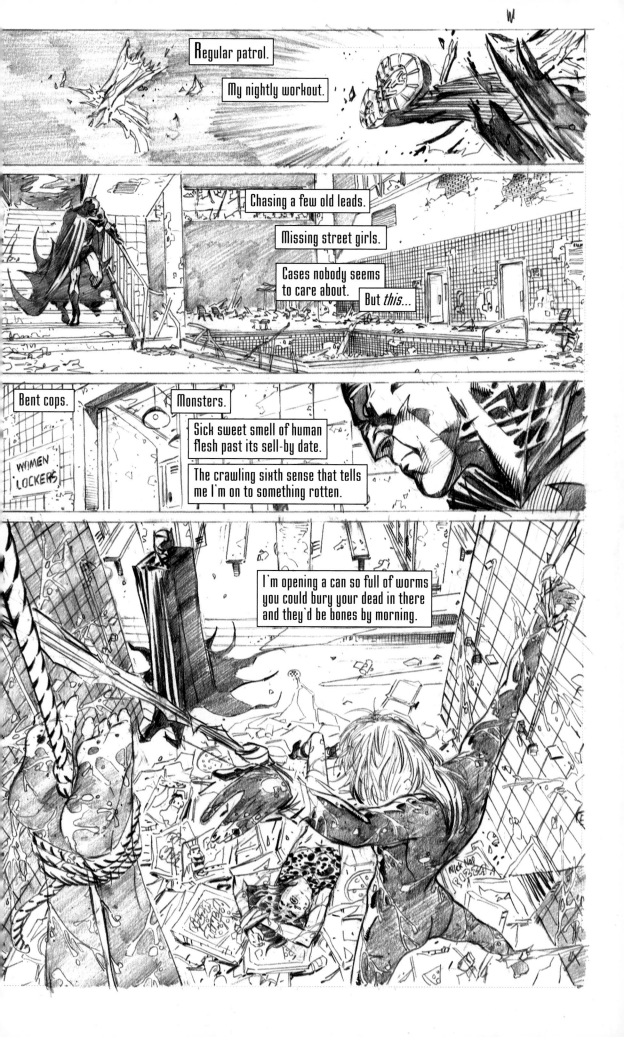

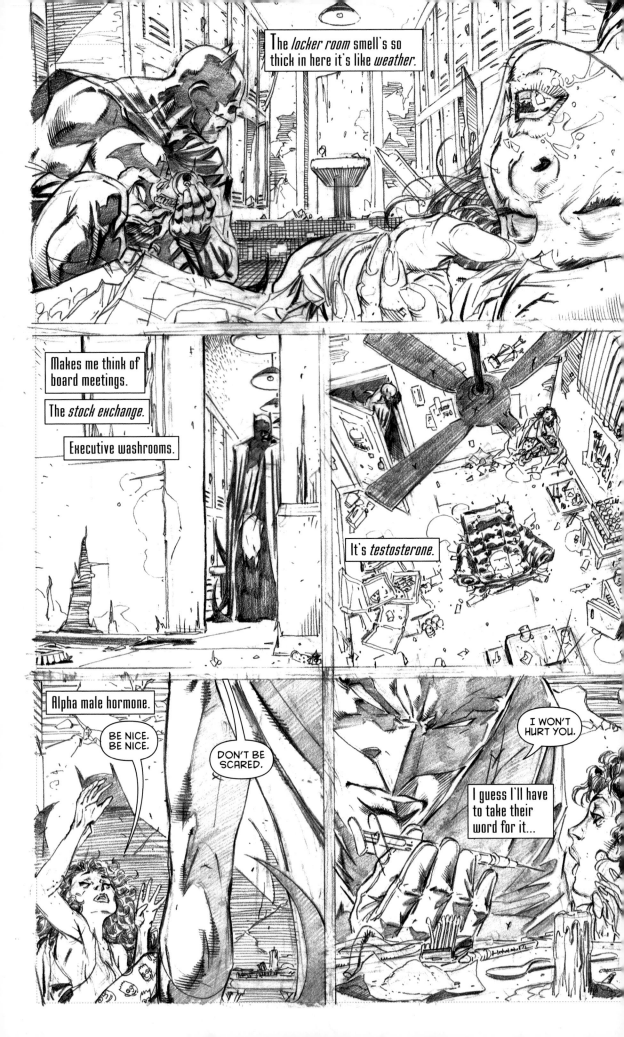

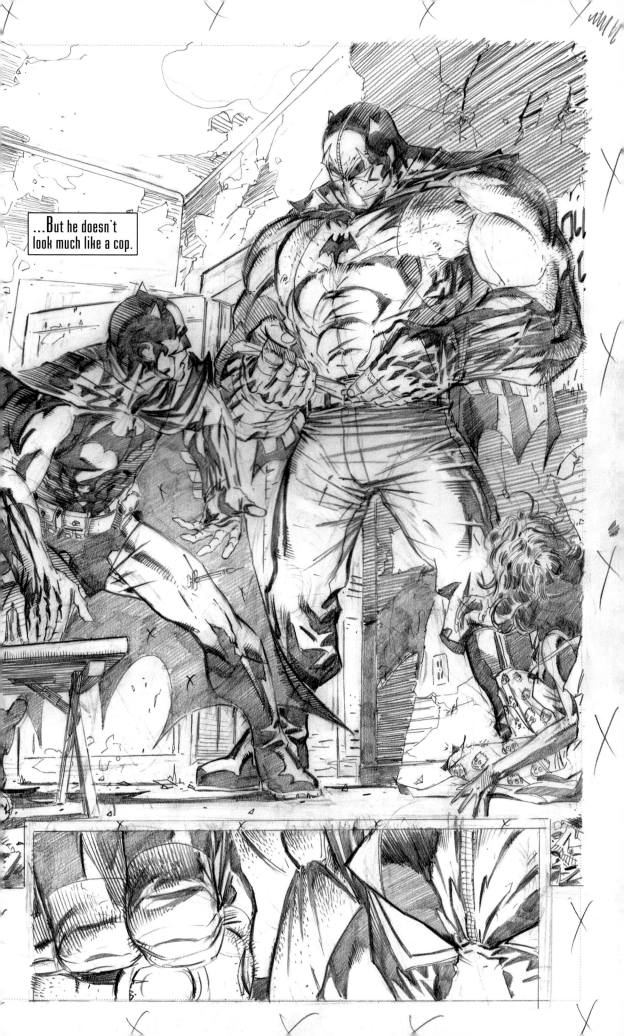

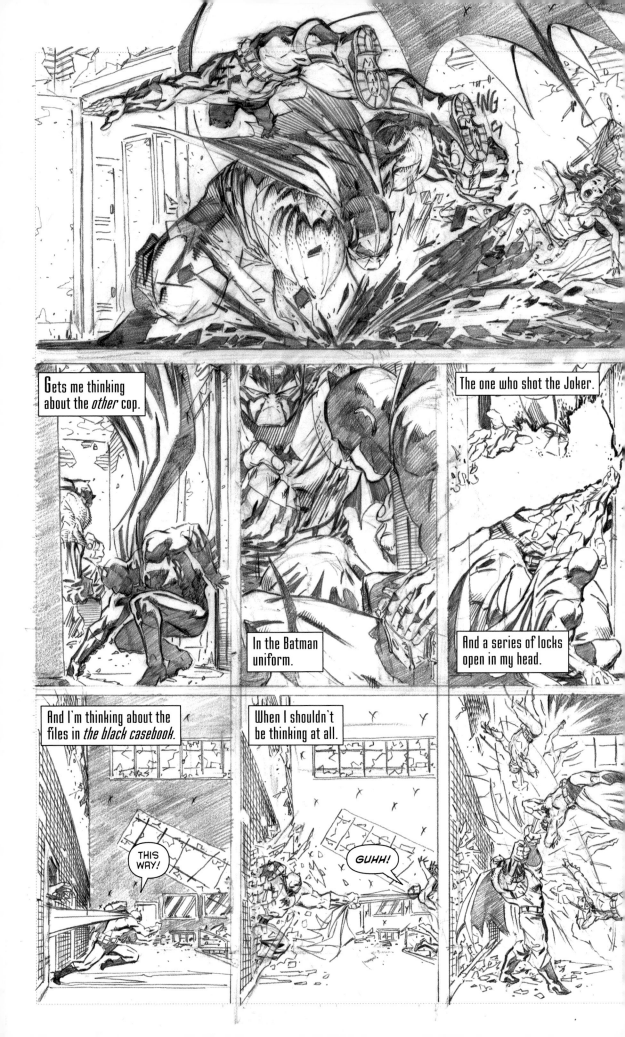

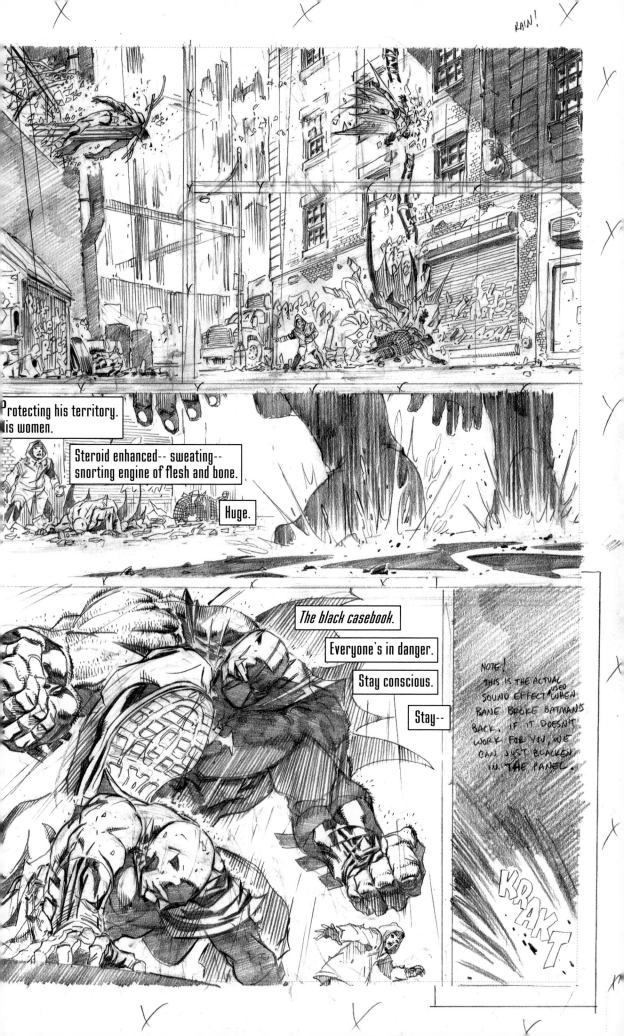

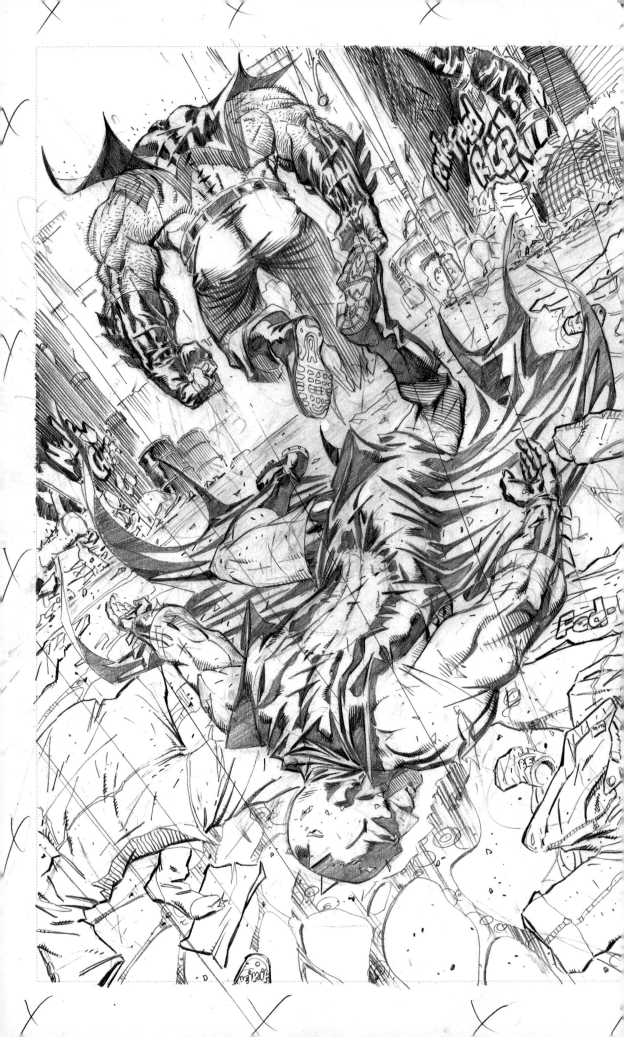

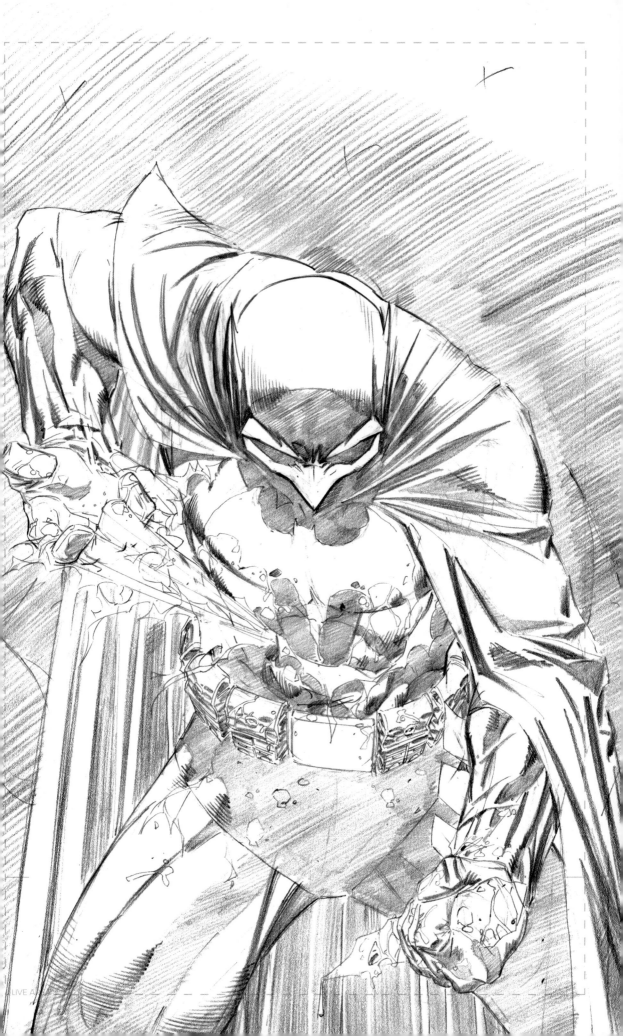

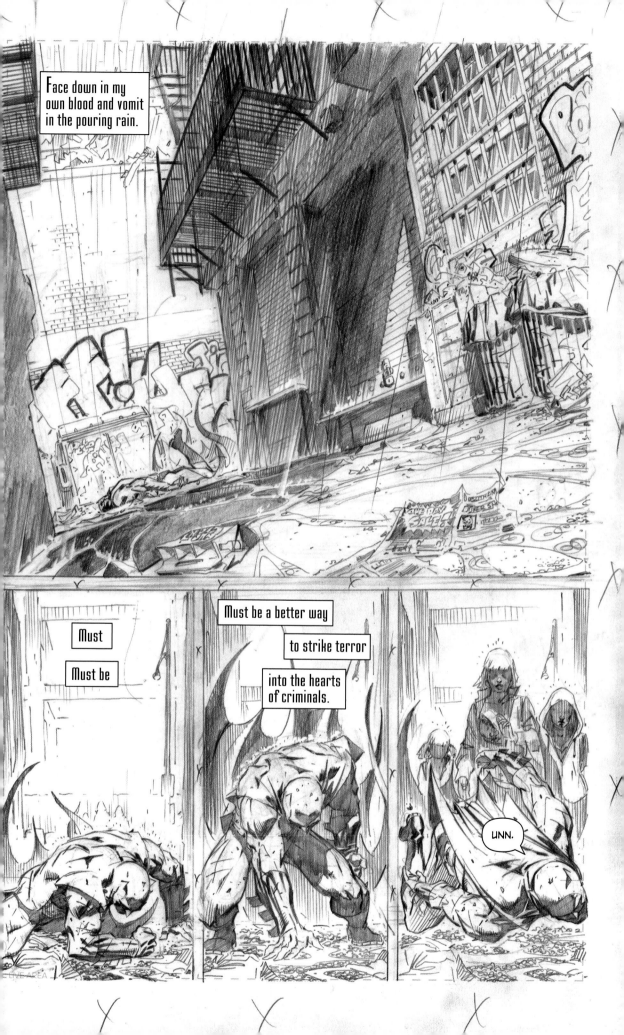

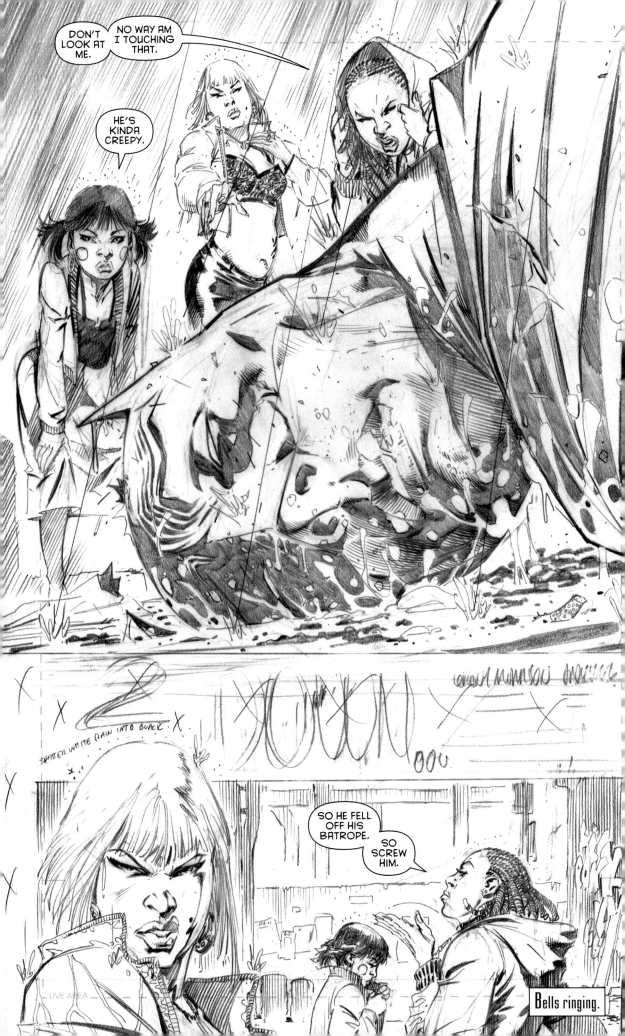

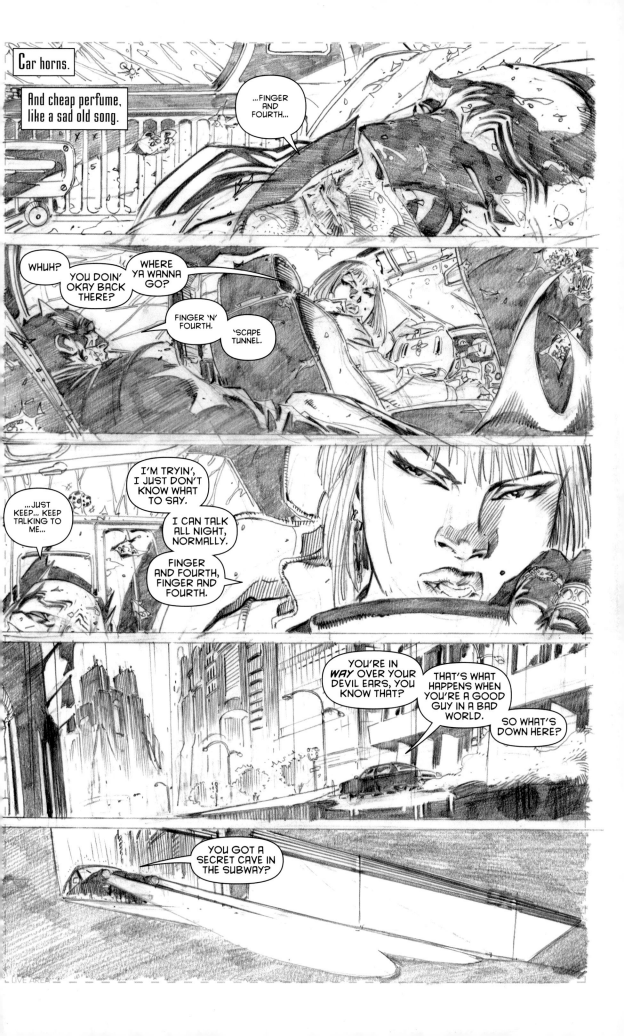

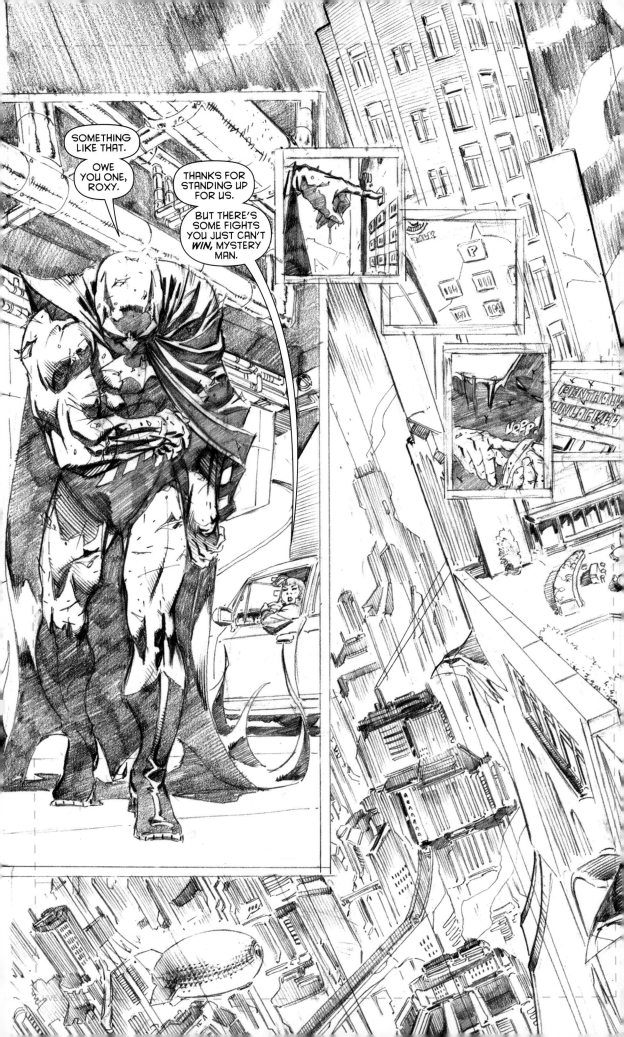

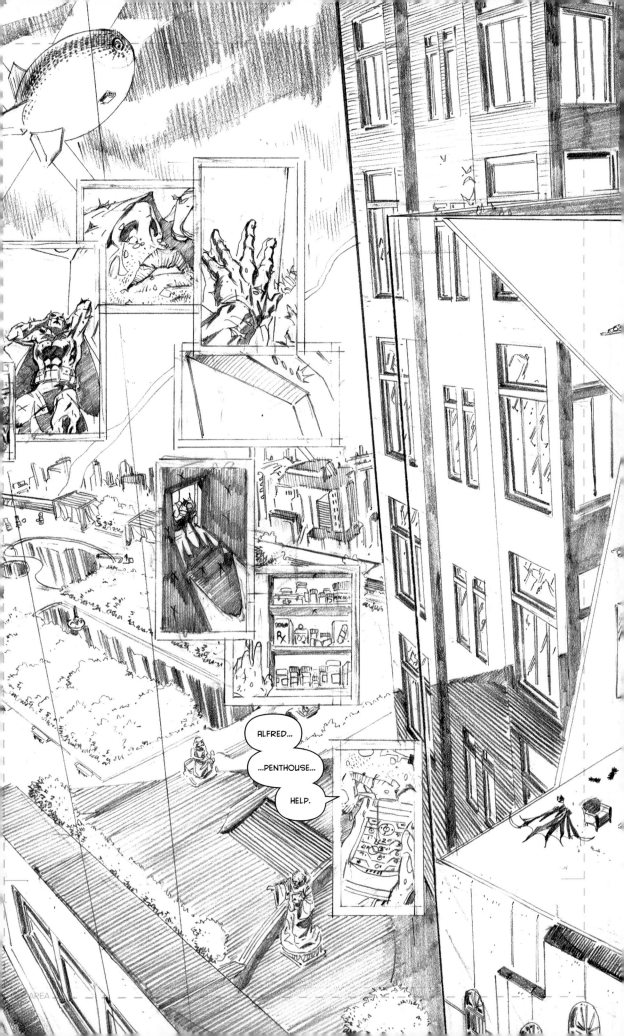

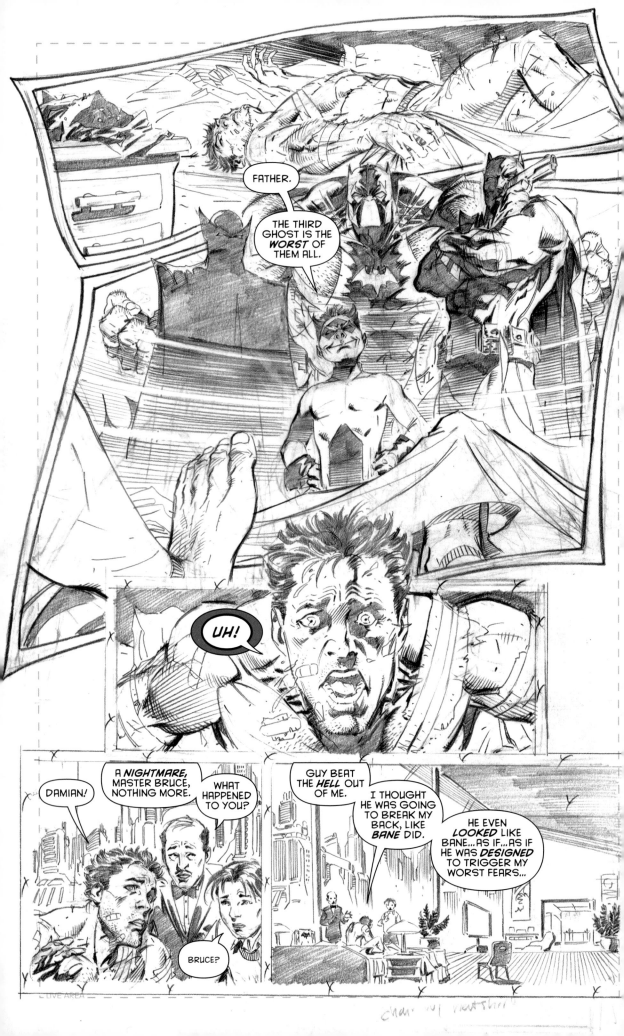

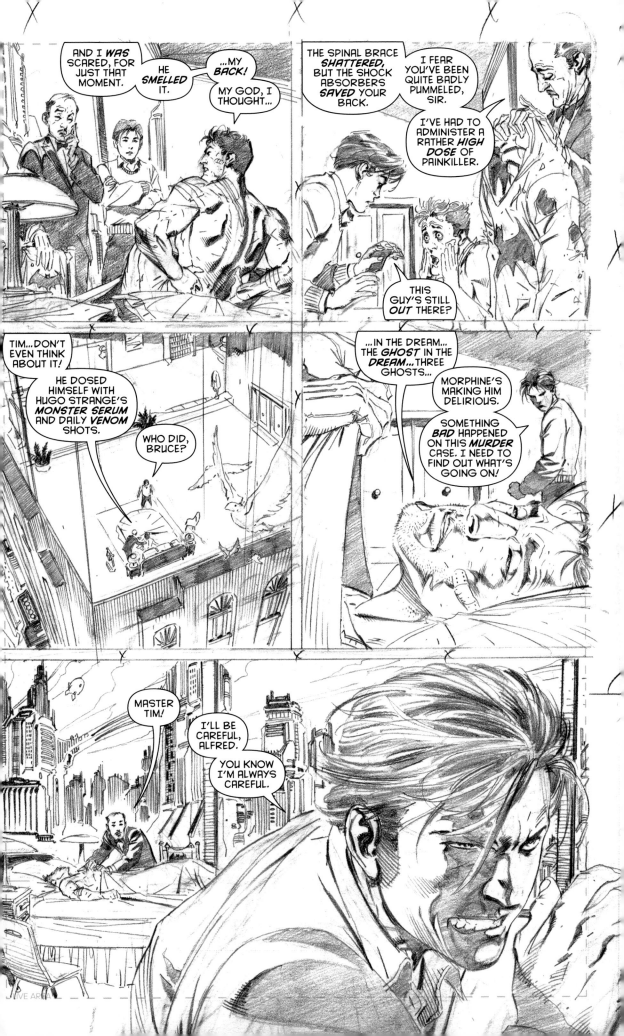

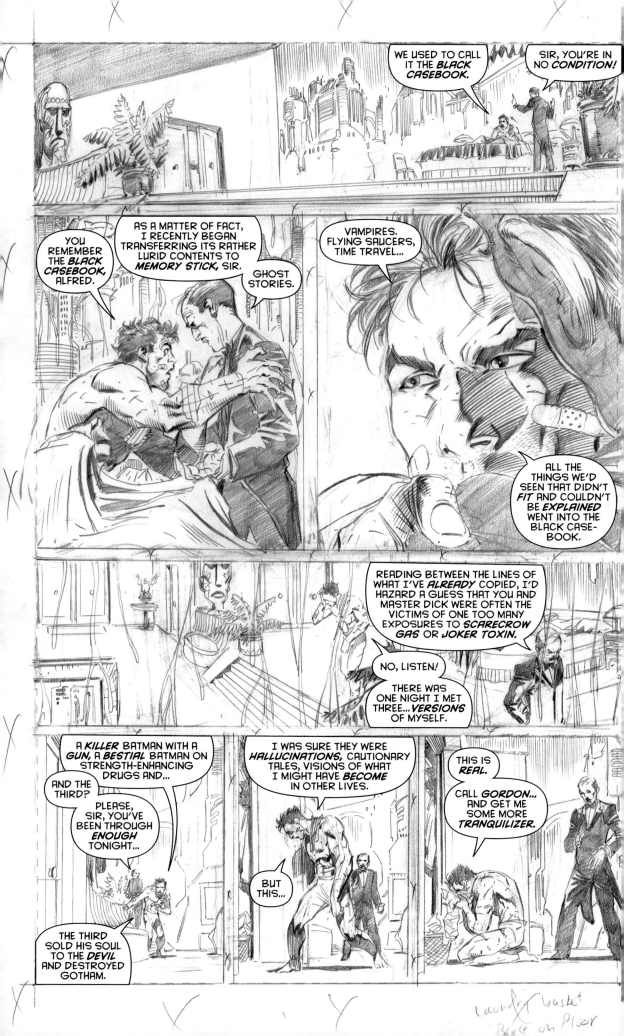

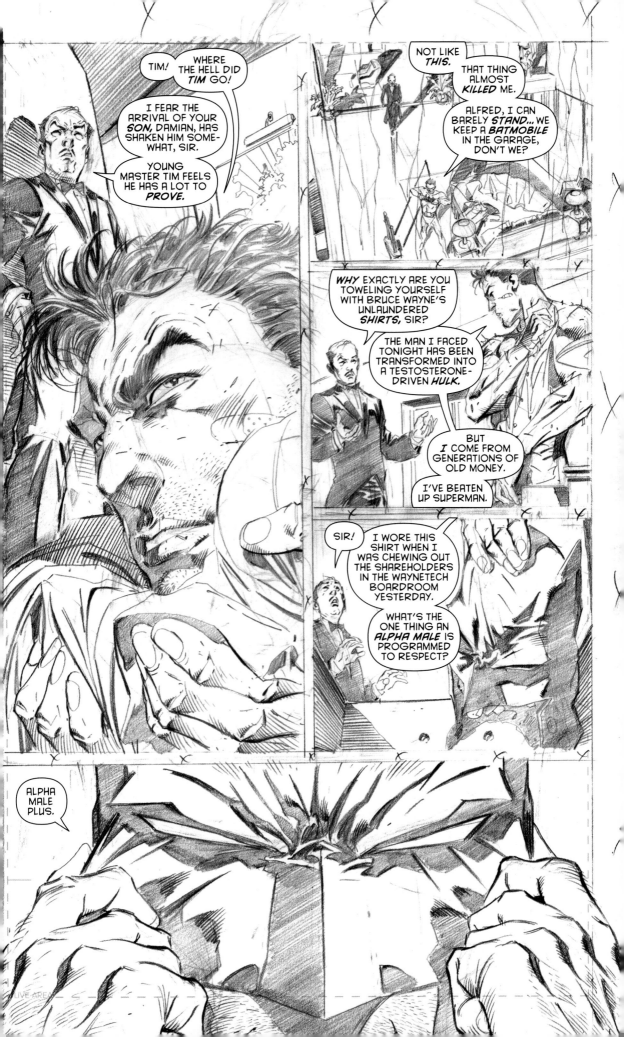

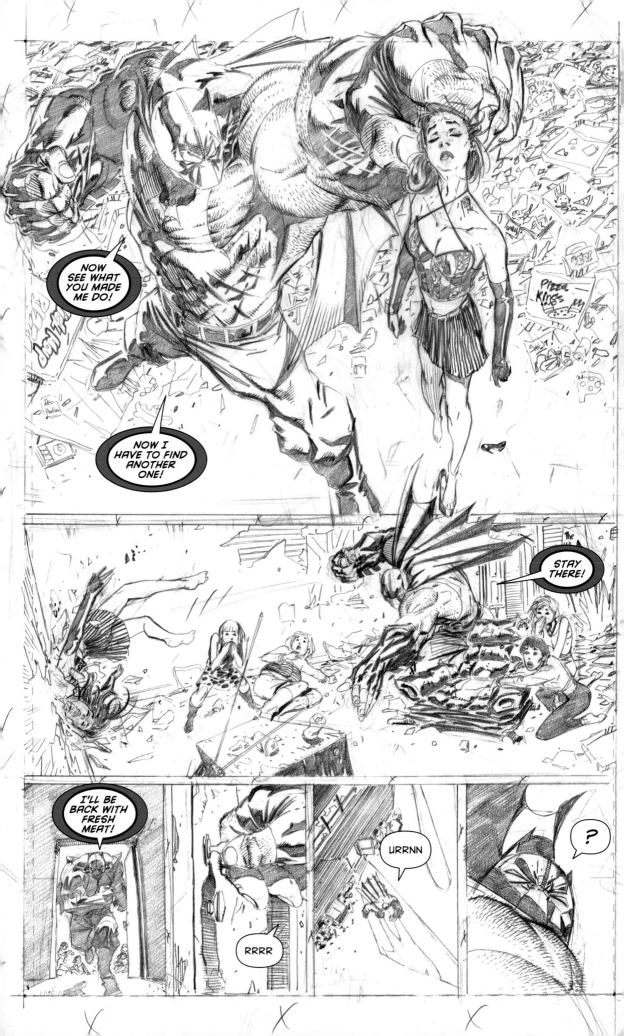

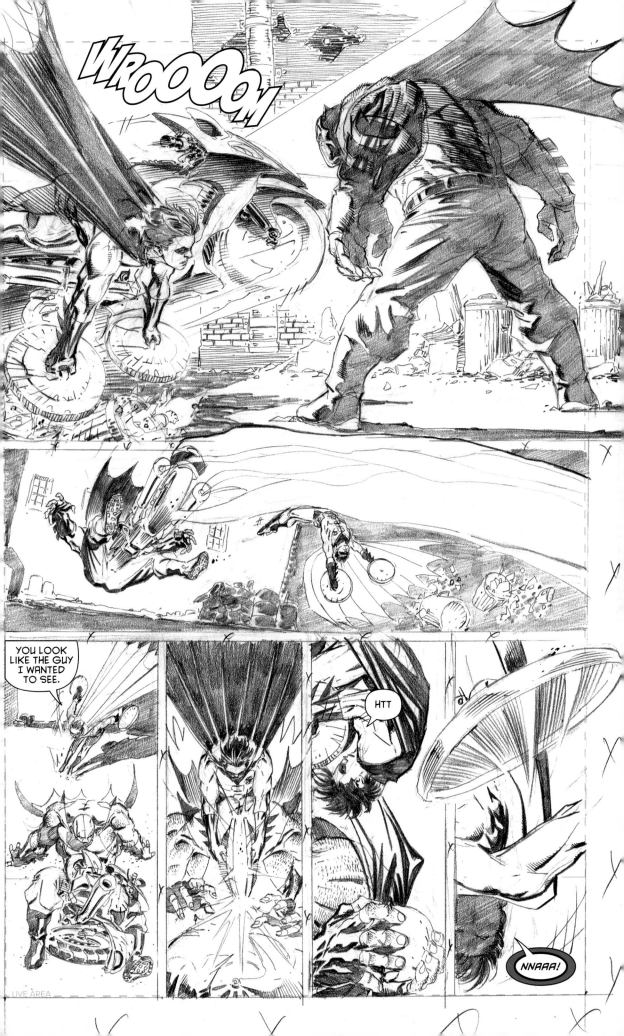

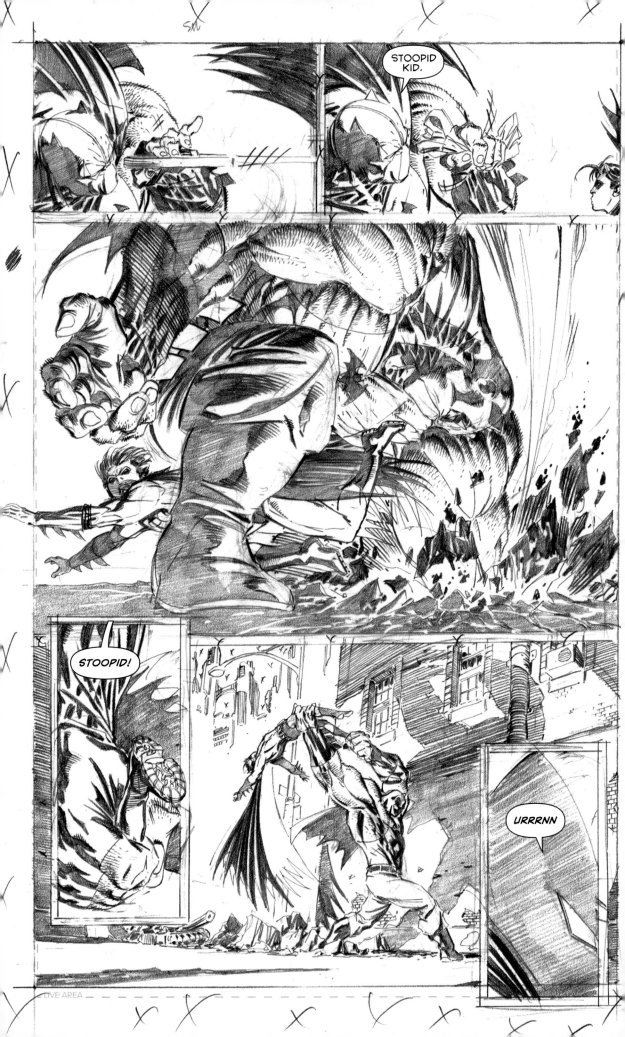

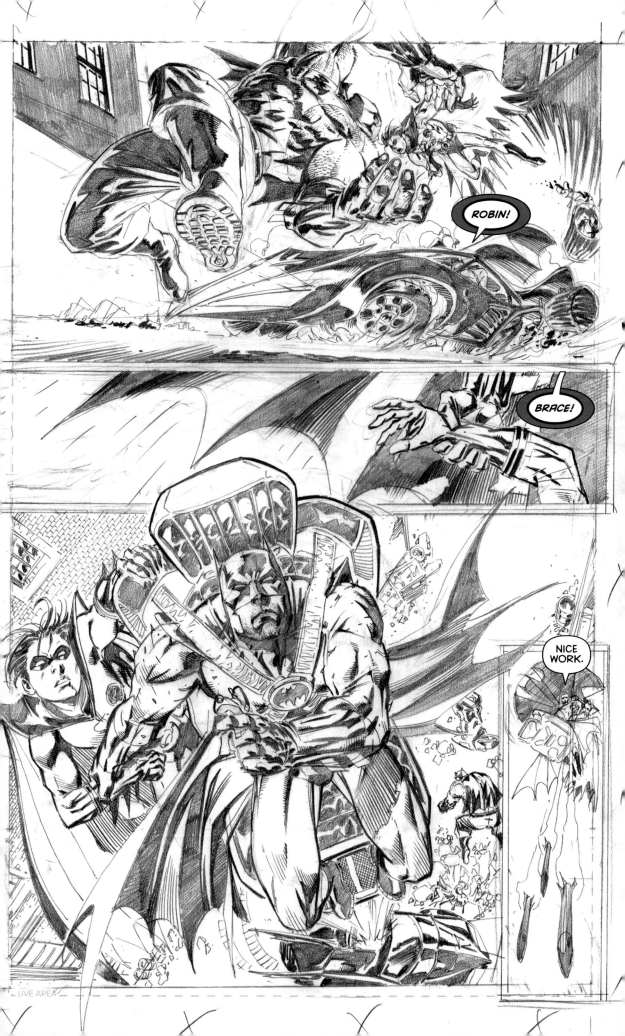

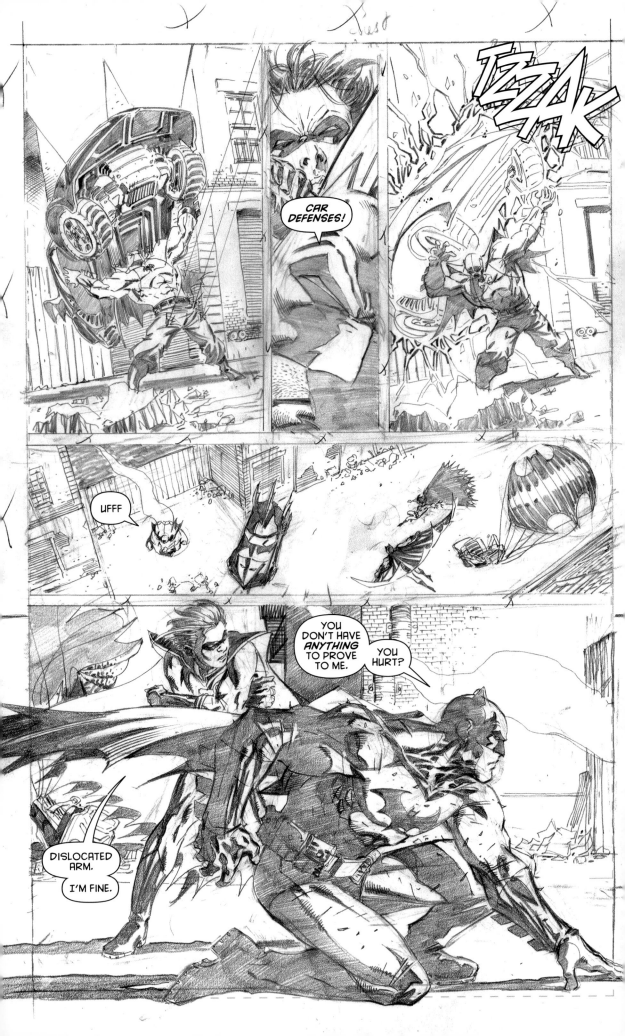

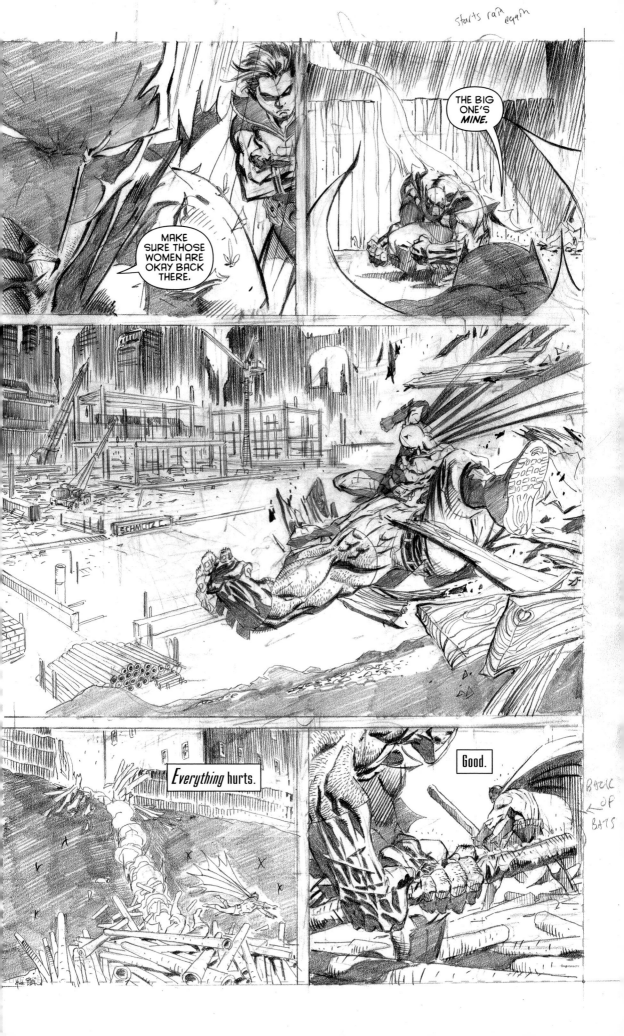

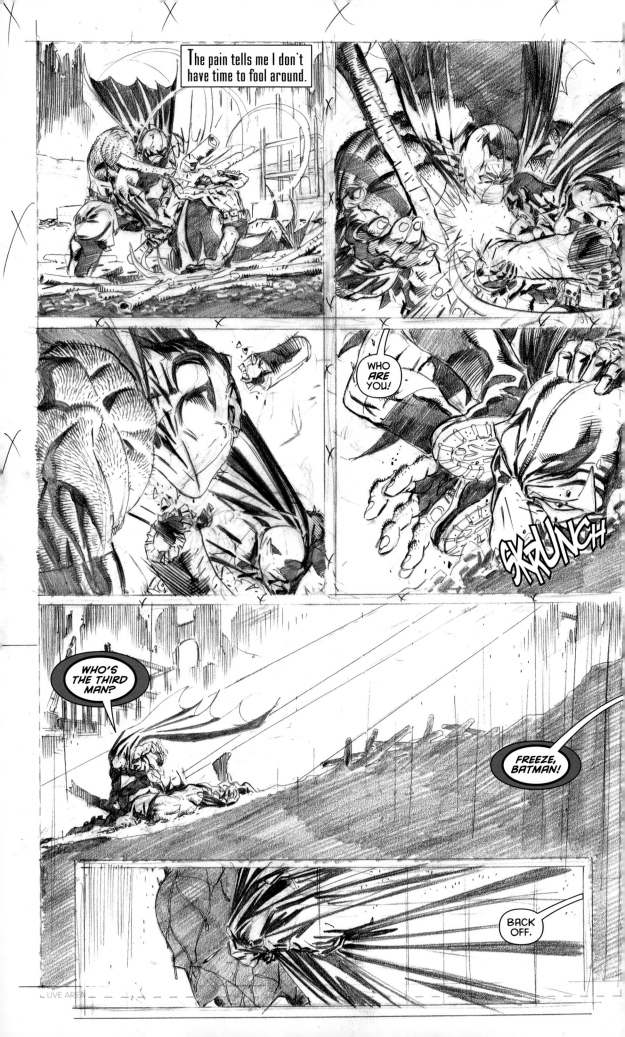

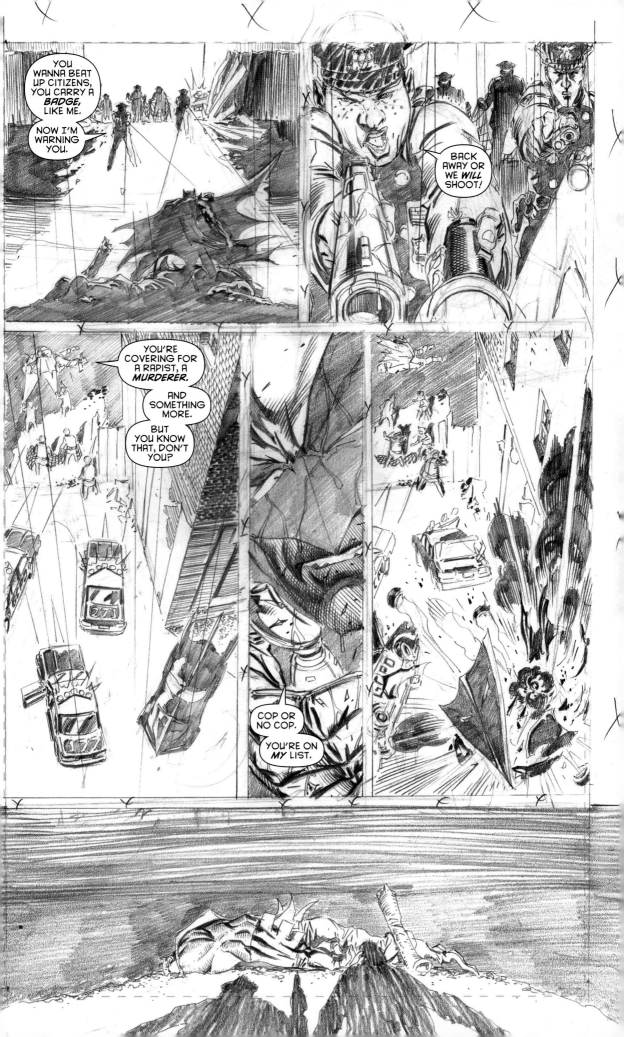

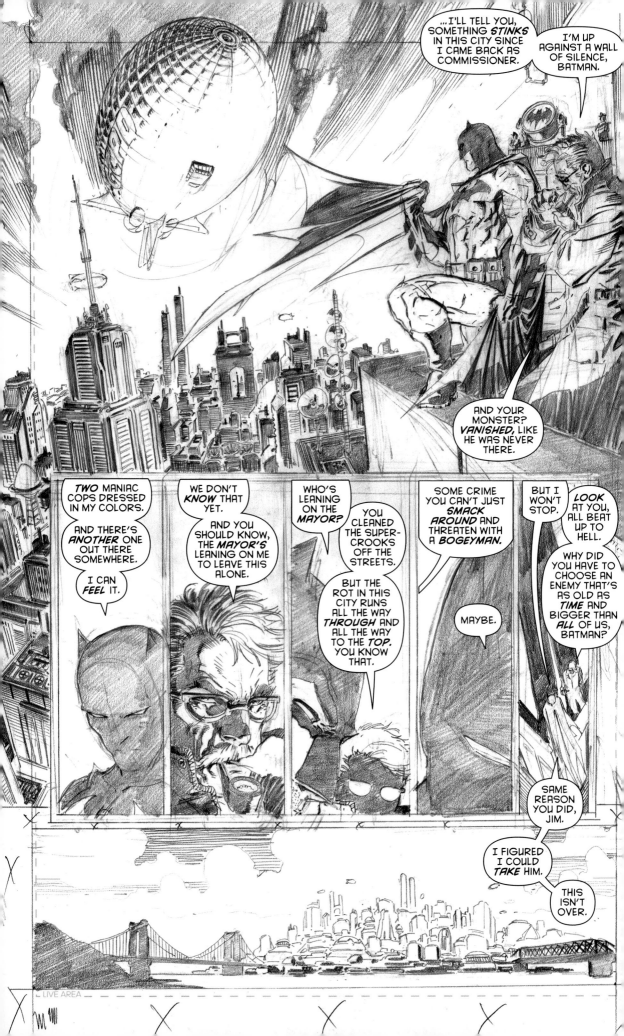

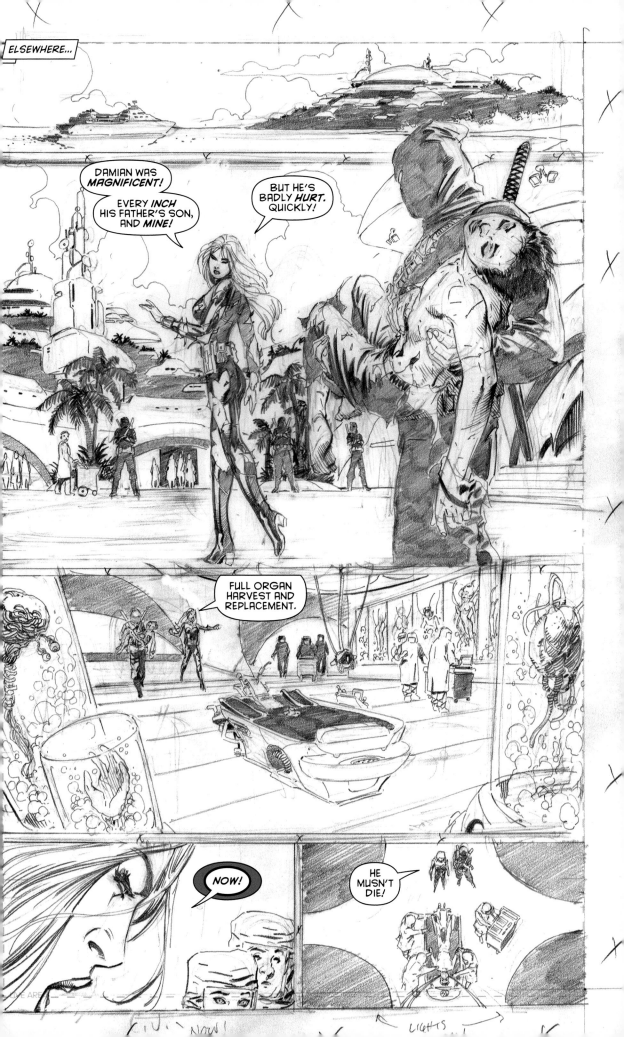

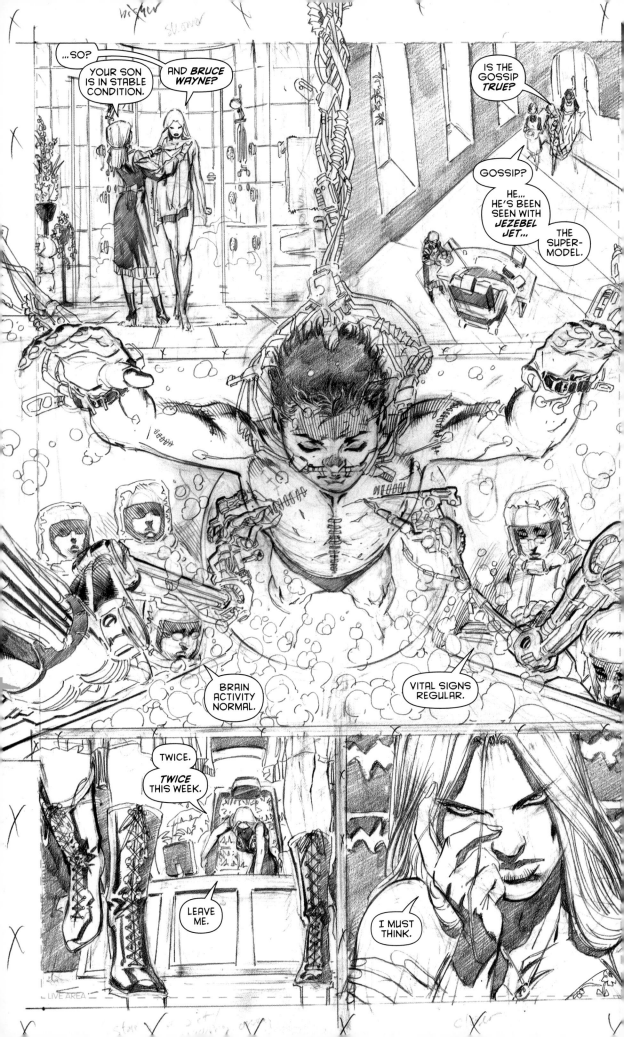

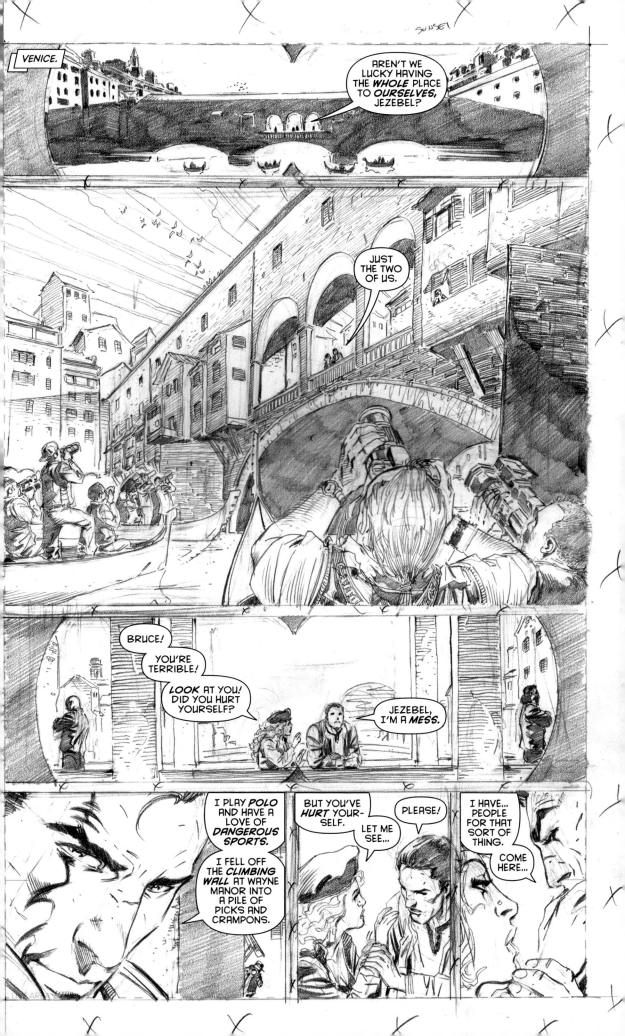

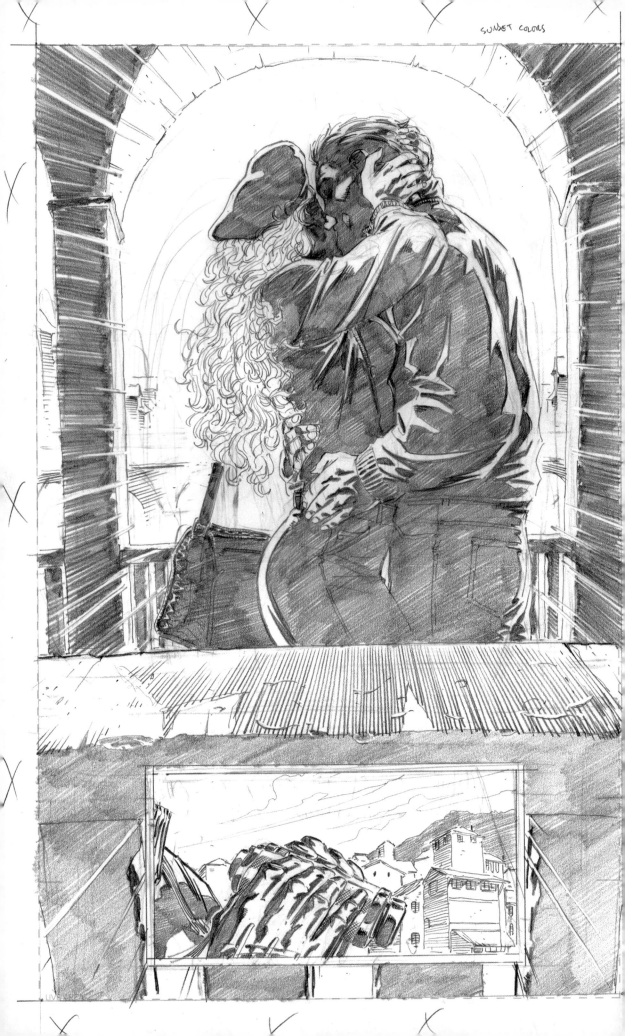

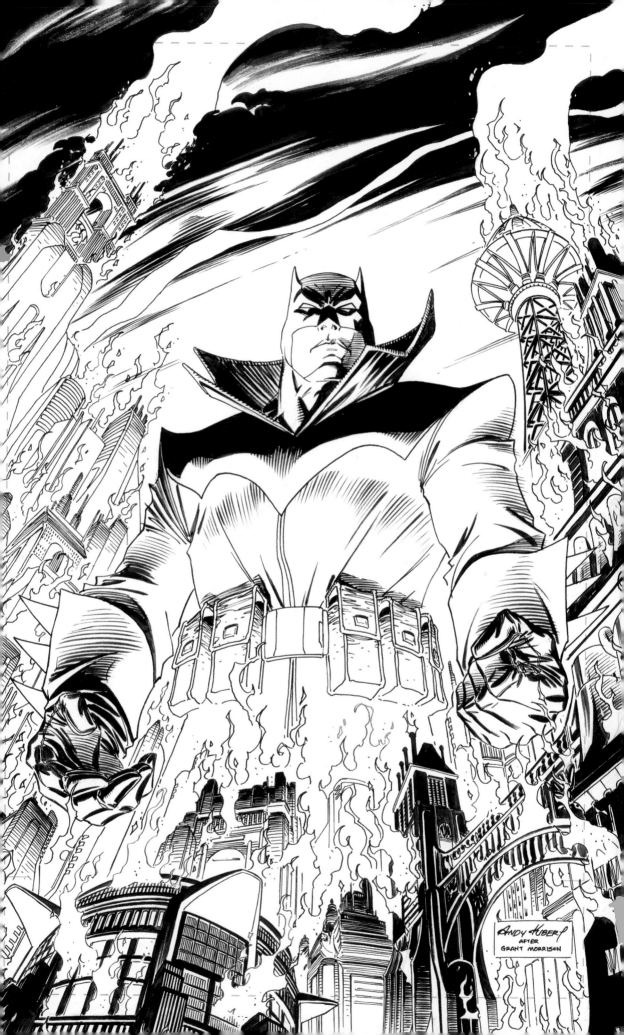

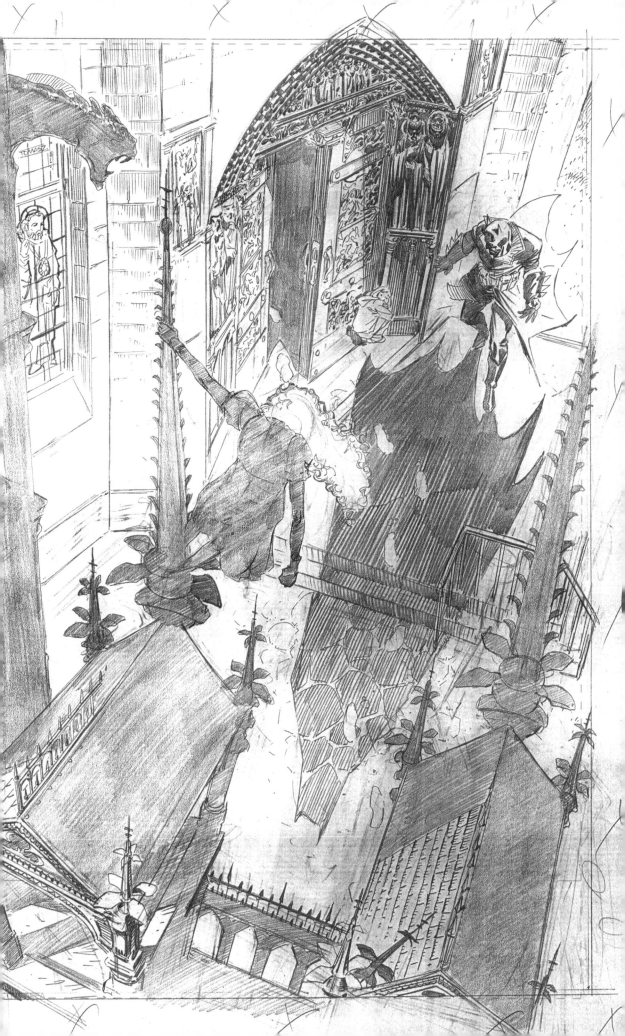

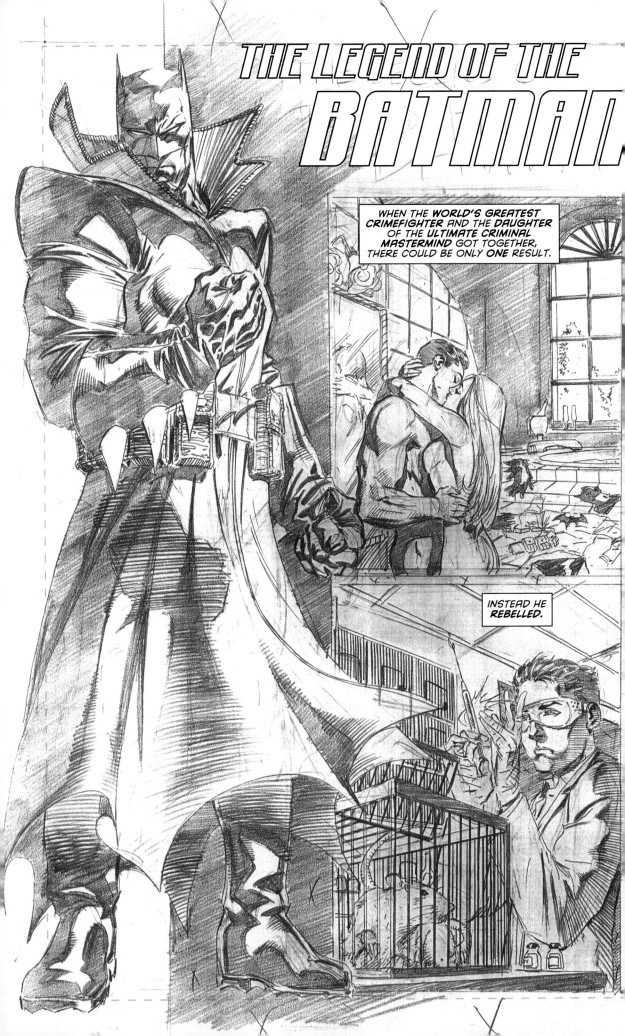

THE LEGEND OF THE BATMAN

WHEN THE *WORLD'S GREATEST CRIMEFIGHTER* AND THE *DAUGHTER OF THE ULTIMATE CRIMINAL MASTERMIND* GOT TOGETHER, THERE COULD BE ONLY *ONE* RESULT.

INSTEAD HE REBELLED.

WHO HE IS AND HOW HE CAME TO BE ...

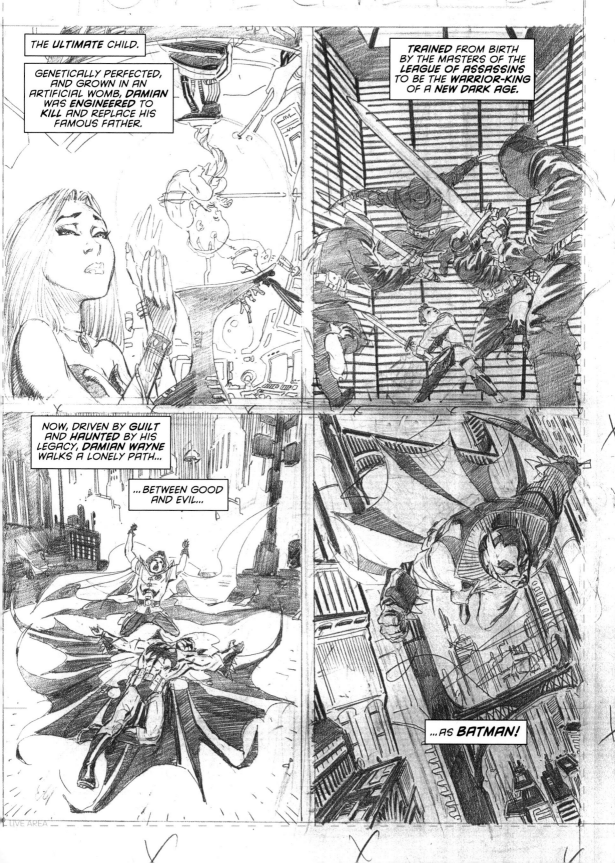

THE *ULTIMATE* CHILD.

GENETICALLY PERFECTED, AND GROWN IN AN ARTIFICIAL WOMB, *DAMIAN* WAS *ENGINEERED* TO *KILL* AND REPLACE HIS FAMOUS FATHER.

TRAINED FROM BIRTH BY THE MASTERS OF THE *LEAGUE OF ASSASSINS* TO BE THE *WARRIOR-KING* OF A *NEW DARK AGE*.

NOW, DRIVEN BY *GUILT* AND *HAUNTED* BY HIS LEGACY, *DAMIAN WAYNE* WALKS A LONELY PATH...

...BETWEEN GOOD AND EVIL...

...AS *BATMAN!*

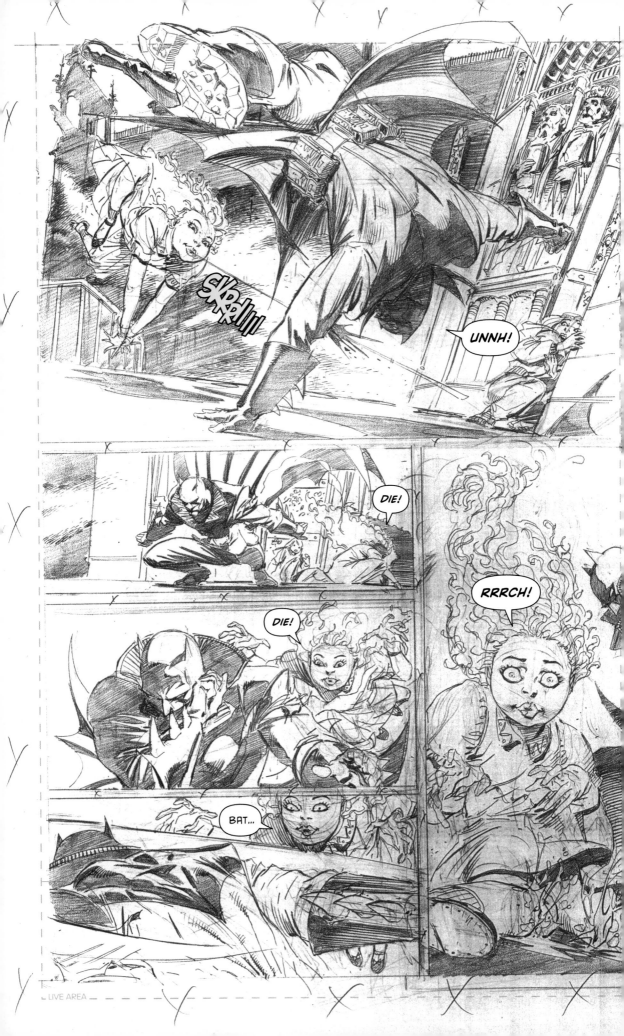

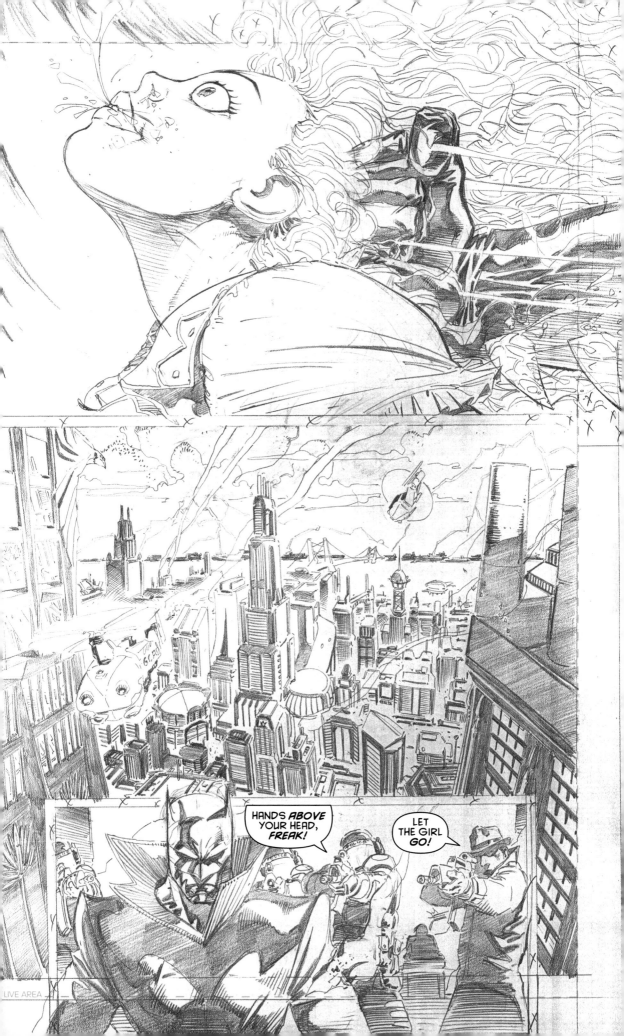

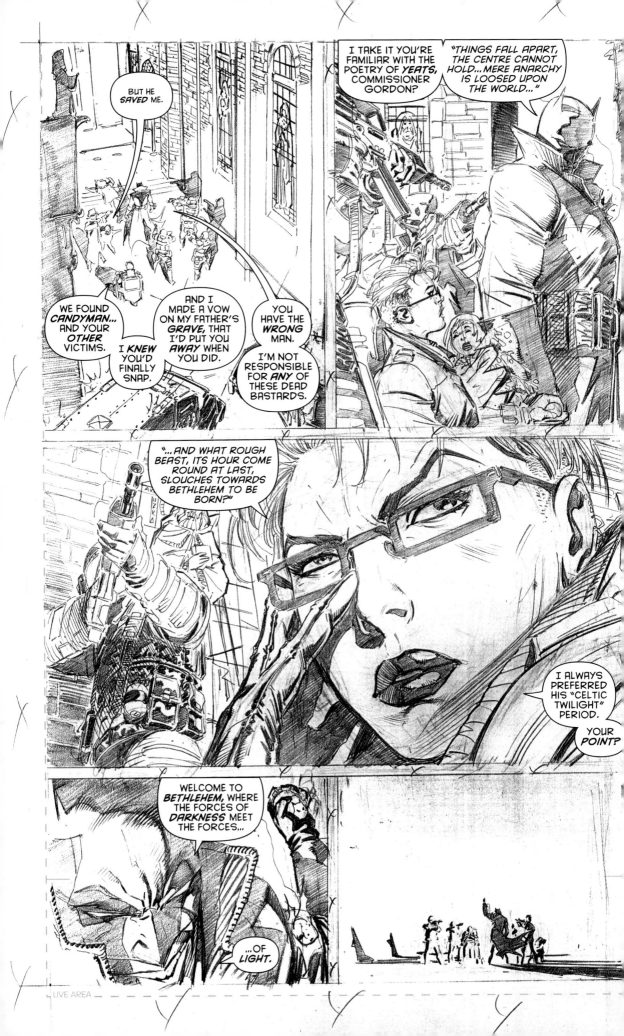

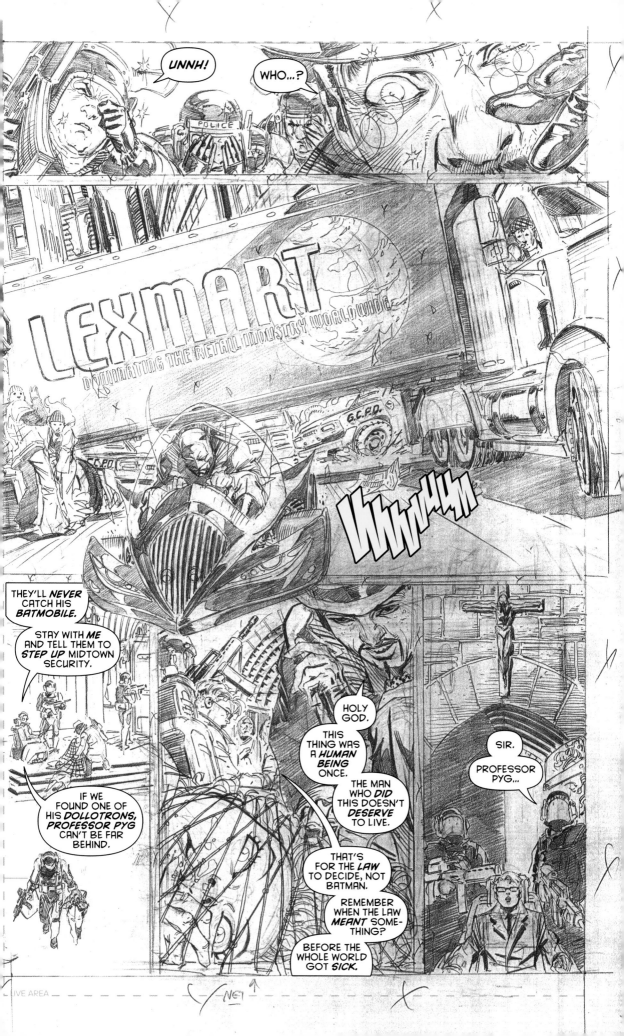

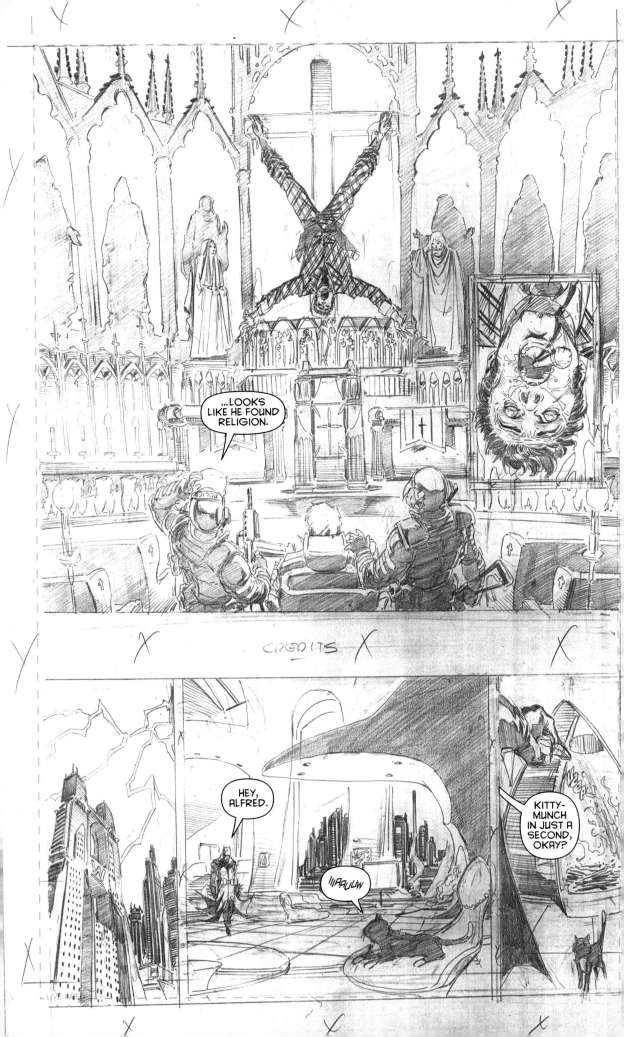

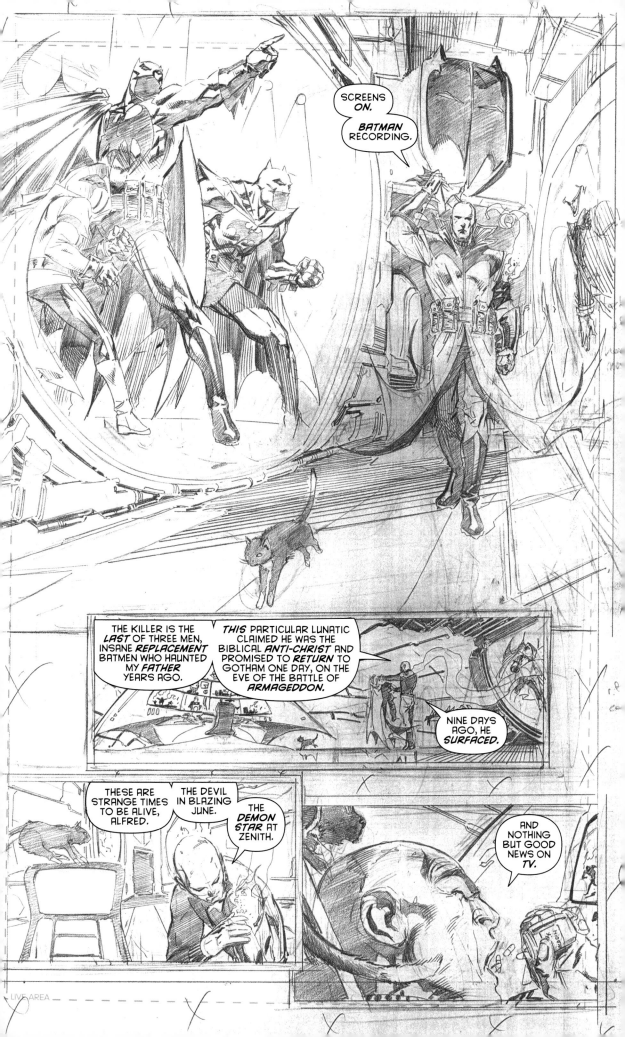

SCREENS *ON*.

BATMAN RECORDING.

THE KILLER IS THE *LAST* OF THREE MEN, INSANE *REPLACEMENT* BATMEN WHO HAUNTED MY *FATHER* YEARS AGO.

THIS PARTICULAR LUNATIC CLAIMED HE WAS THE BIBLICAL *ANTI-CHRIST* AND PROMISED TO *RETURN* TO GOTHAM ONE DAY, ON THE EVE OF THE BATTLE OF *ARMAGEDDON*.

NINE DAYS AGO, HE *SURFACED*.

THESE ARE STRANGE TIMES TO BE ALIVE, ALFRED.

THE DEVIL IN BLAZING JUNE.

THE *DEMON STAR* AT ZENITH.

AND NOTHING BUT GOOD NEWS ON *TV*.

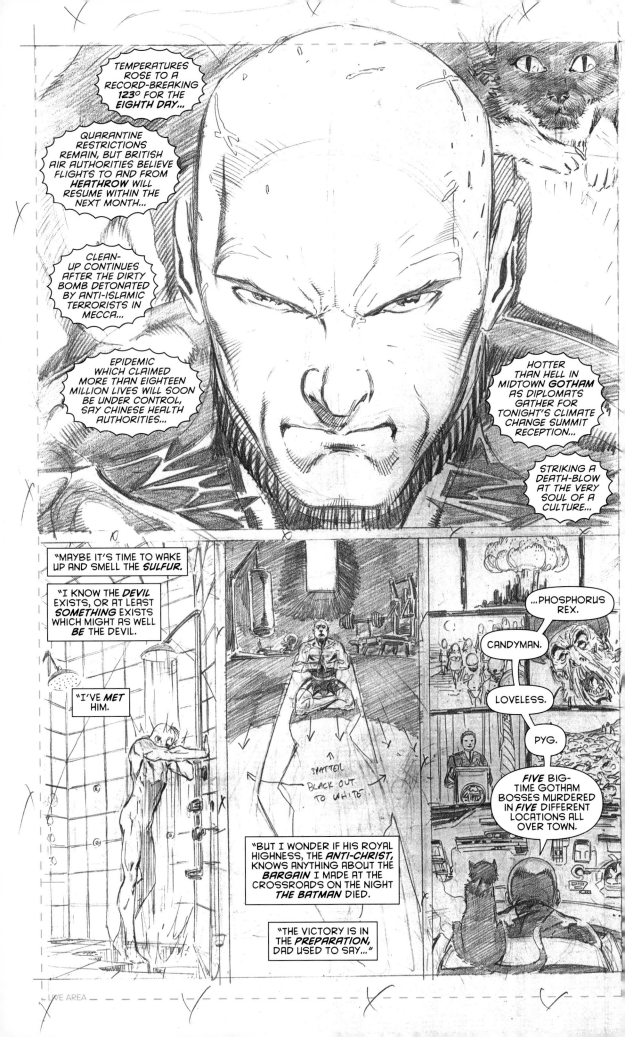

TEMPERATURES ROSE TO A RECORD-BREAKING *123°* FOR THE *EIGHTH DAY*...

QUARANTINE RESTRICTIONS REMAIN, BUT BRITISH AIR AUTHORITIES BELIEVE FLIGHTS TO AND FROM *HEATHROW* WILL RESUME WITHIN THE NEXT MONTH...

CLEAN-UP CONTINUES AFTER THE DIRTY BOMB DETONATED BY ANTI-ISLAMIC TERRORISTS IN *MECCA*...

EPIDEMIC WHICH CLAIMED MORE THAN EIGHTEEN MILLION LIVES WILL SOON BE UNDER CONTROL, SAY CHINESE HEALTH AUTHORITIES...

HOTTER THAN HELL IN MIDTOWN *GOTHAM* AS DIPLOMATS GATHER FOR TONIGHT'S CLIMATE CHANGE SUMMIT RECEPTION...

STRIKING A *DEATH-BLOW* AT THE VERY SOUL OF A CULTURE...

"MAYBE IT'S TIME TO WAKE UP AND SMELL THE *SULFUR.*

"I KNOW THE *DEVIL* EXISTS, OR AT LEAST *SOMETHING* EXISTS WHICH MIGHT AS WELL *BE* THE DEVIL.

"I'VE *MET* HIM.

SPATTER BLACK OUT TO WHITE

"BUT I WONDER IF HIS ROYAL HIGHNESS, THE *ANTI-CHRIST,* KNOWS ANYTHING ABOUT THE *BARGAIN* I MADE AT THE CROSSROADS ON THE NIGHT *THE BATMAN* DIED.

"THE VICTORY IS IN THE *PREPARATION,* DAD USED TO SAY..."

...PHOSPHORUS REX.

CANDYMAN.

LOVELESS.

PYG.

FIVE BIG-TIME GOTHAM BOSSES MURDERED IN *FIVE* DIFFERENT LOCATIONS ALL OVER TOWN.

LIVE AREA

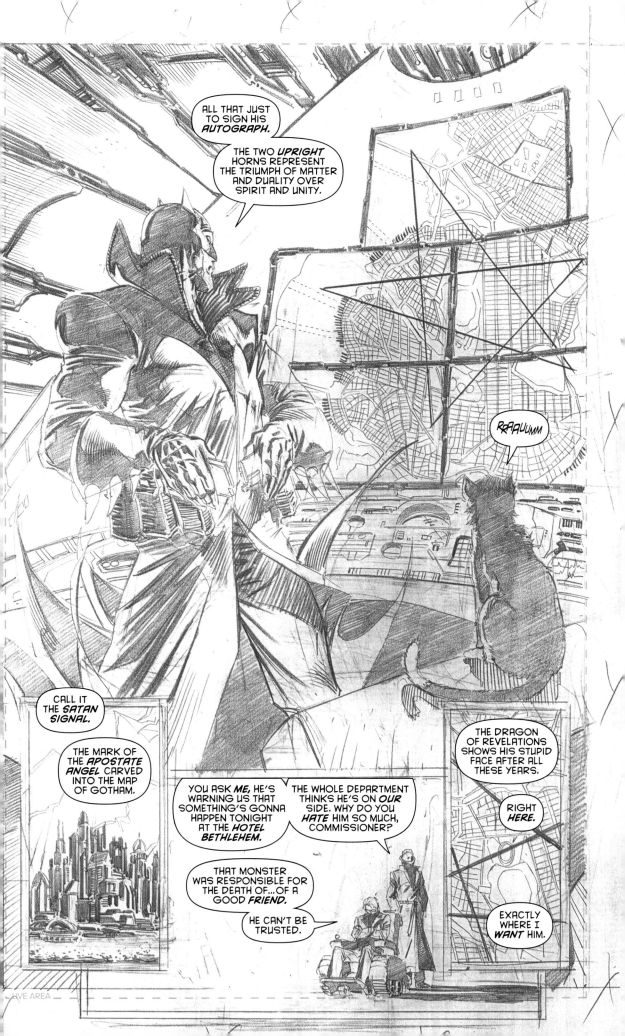

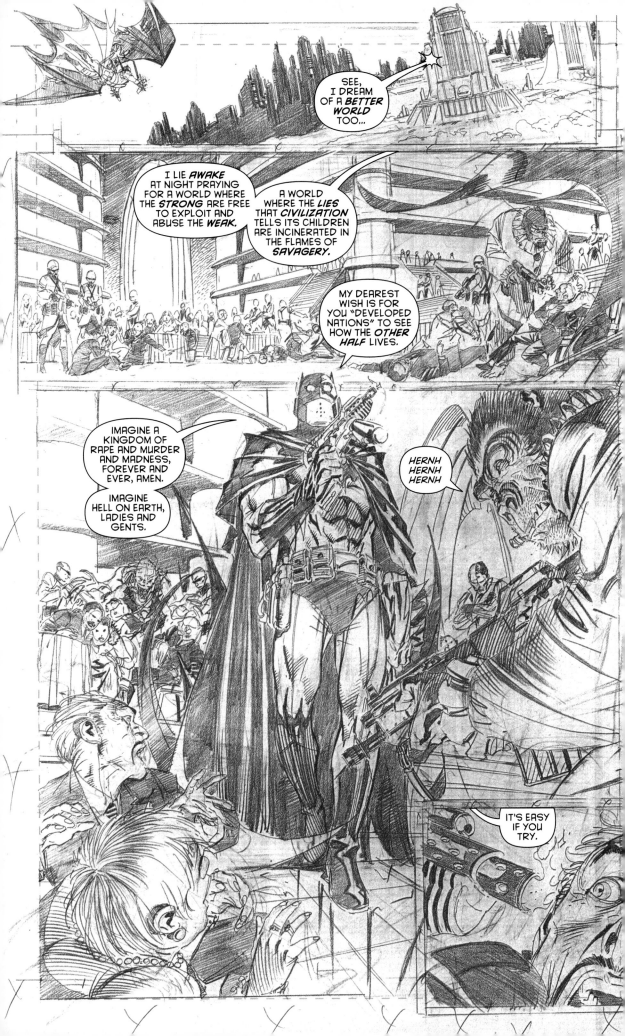

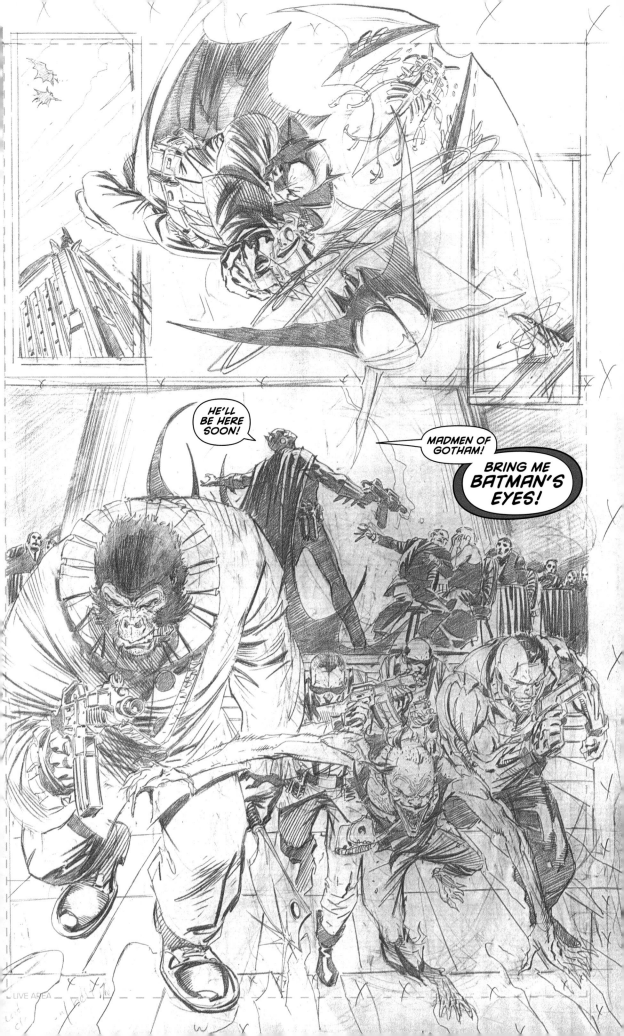

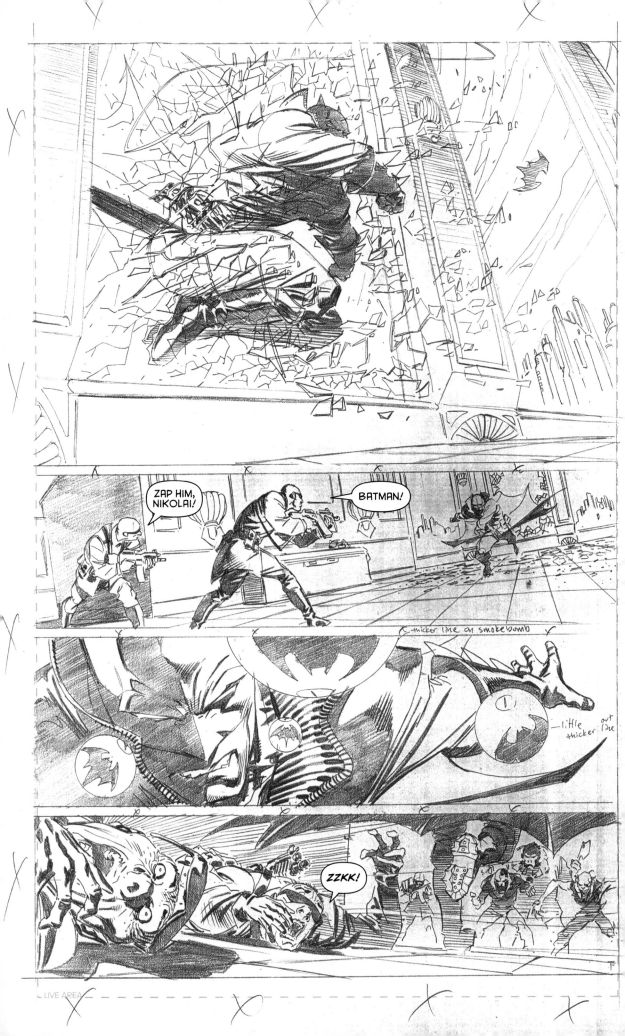

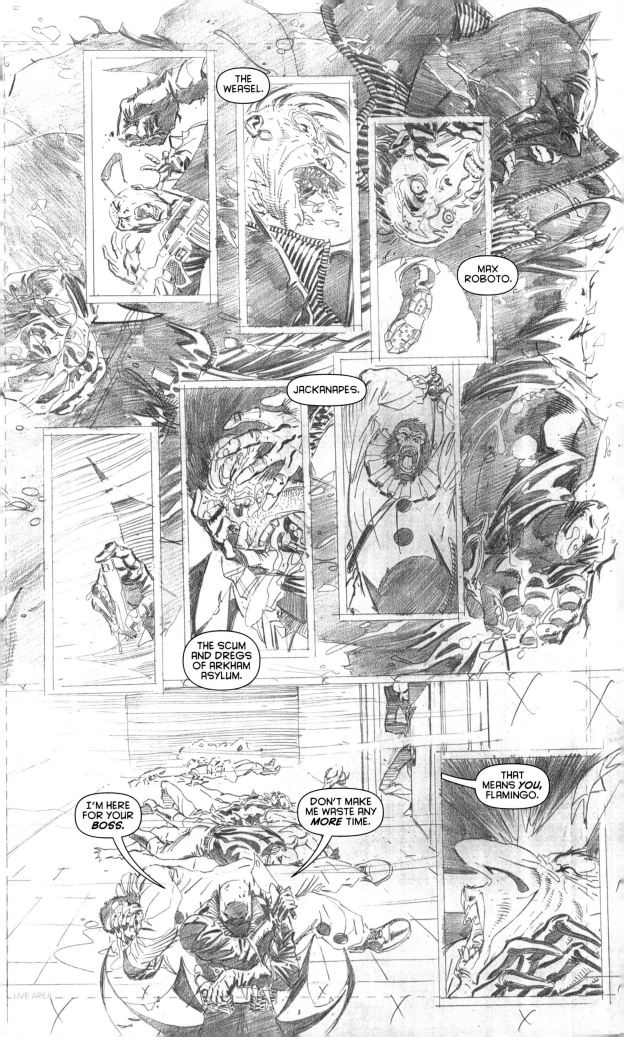

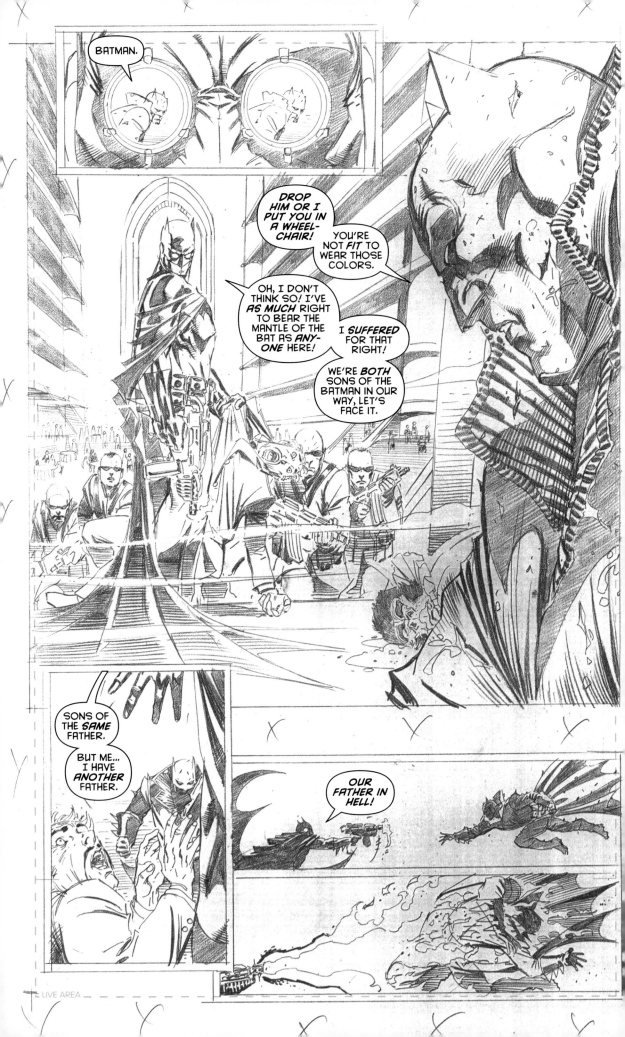

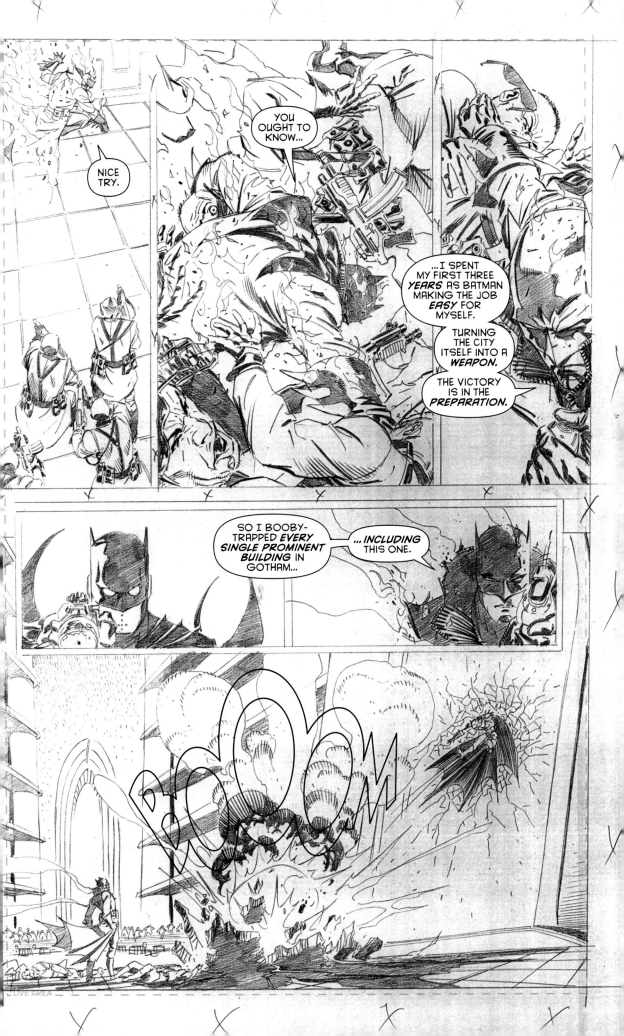

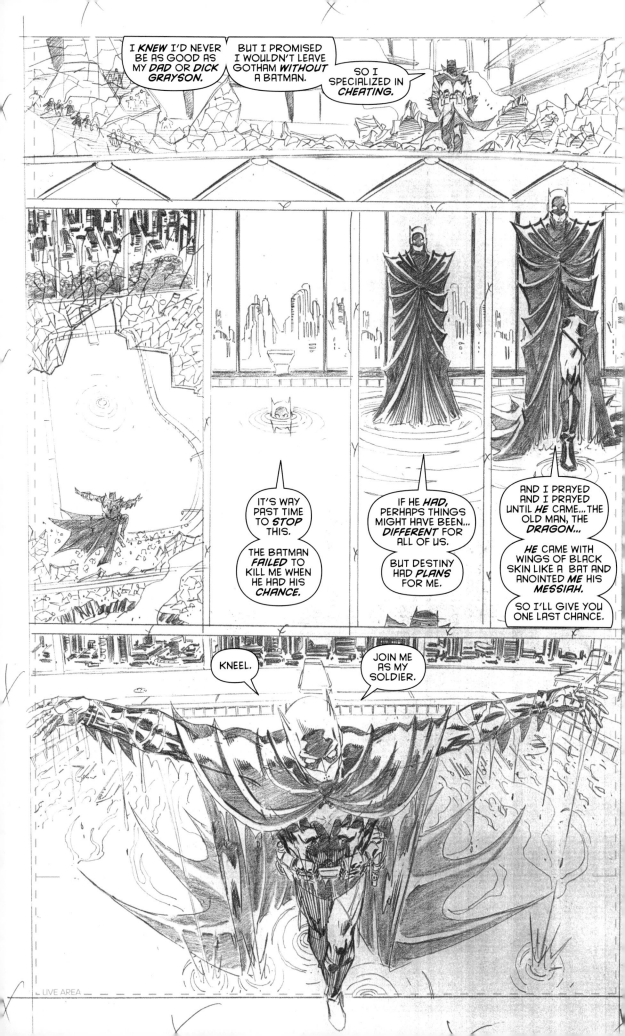

I *KNEW* I'D NEVER BE AS GOOD AS MY *DAD* OR *DICK GRAYSON*.

BUT I PROMISED I WOULDN'T LEAVE GOTHAM *WITHOUT* A BATMAN.

SO I SPECIALIZED IN *CHEATING*.

IT'S WAY PAST TIME TO *STOP* THIS.

THE BATMAN *FAILED* TO KILL ME WHEN HE HAD HIS *CHANCE*.

IF HE *HAD*, PERHAPS THINGS MIGHT HAVE BEEN... *DIFFERENT* FOR ALL OF US.

BUT DESTINY HAD *PLANS* FOR ME.

AND I PRAYED AND I PRAYED UNTIL *HE* CAME...THE OLD MAN, THE *DRAGON*...

HE CAME WITH WINGS OF BLACK SKIN LIKE A BAT AND ANOINTED *ME* HIS *MESSIAH*.

SO I'LL GIVE YOU ONE LAST CHANCE.

KNEEL.

JOIN ME AS MY SOLDIER.

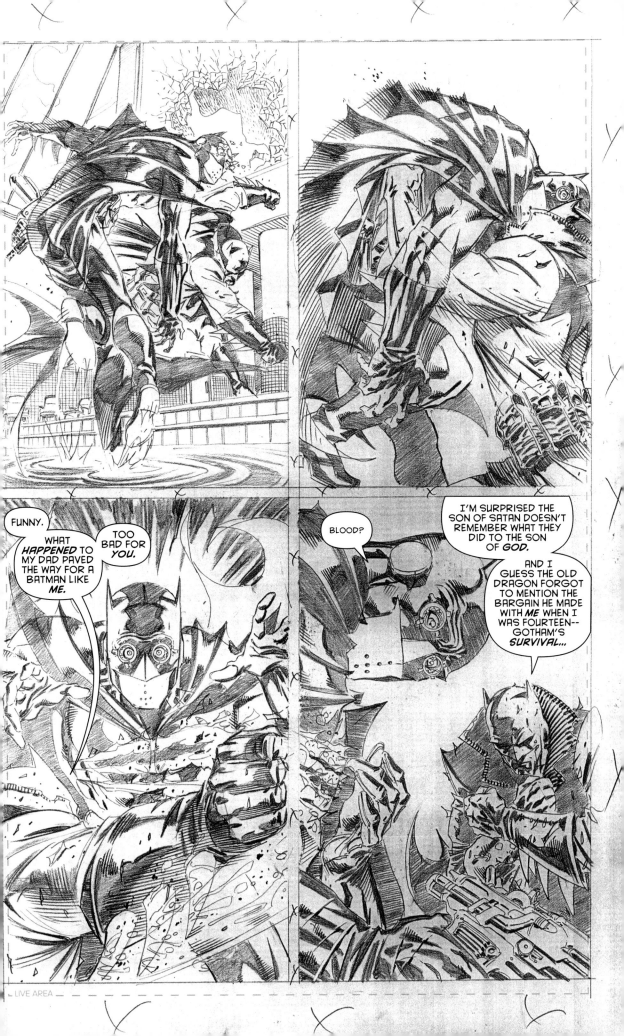

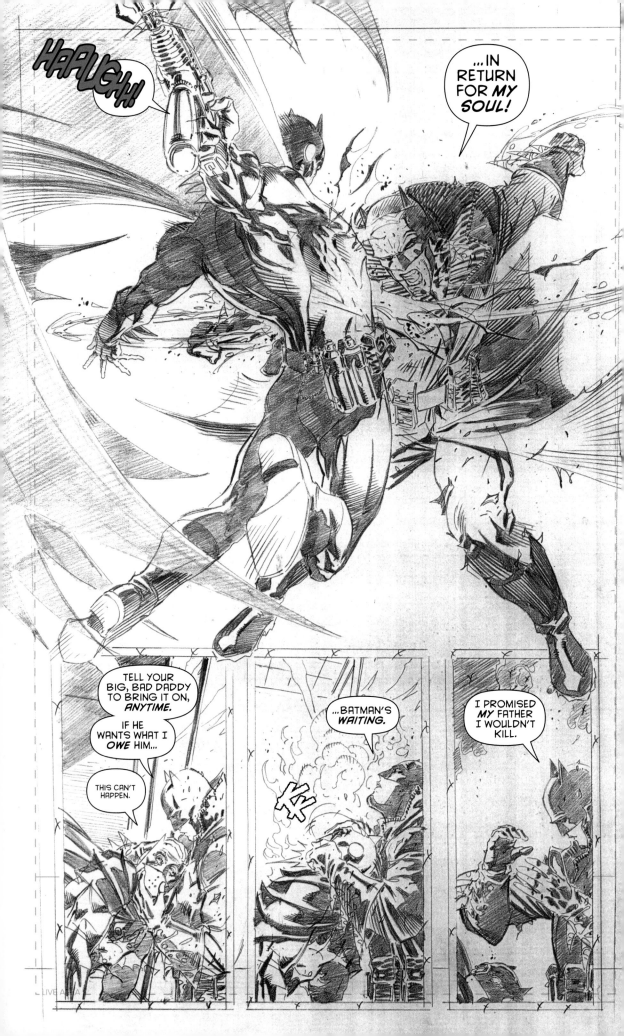

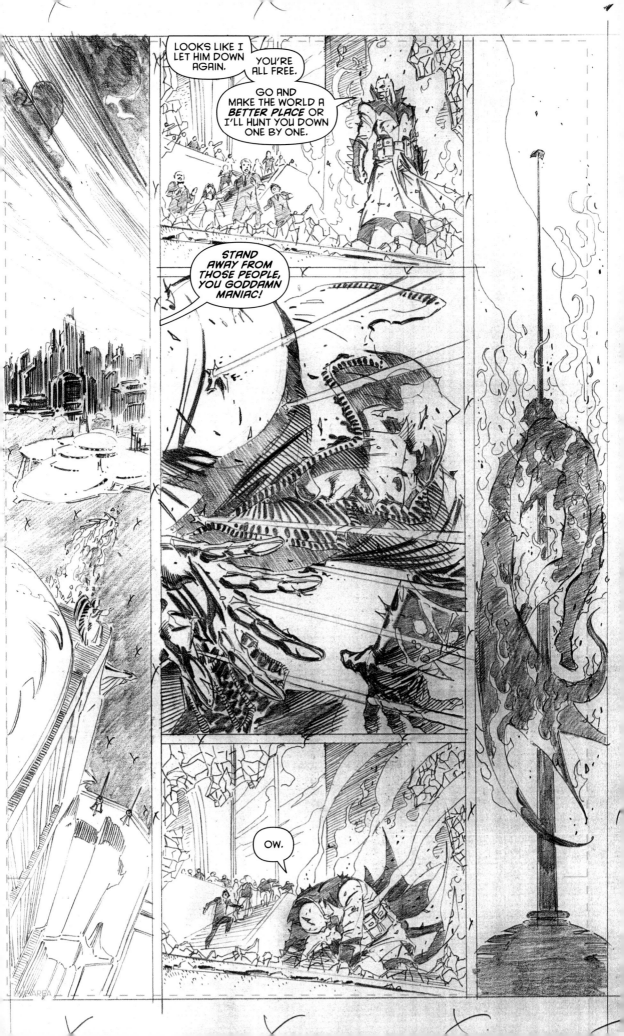

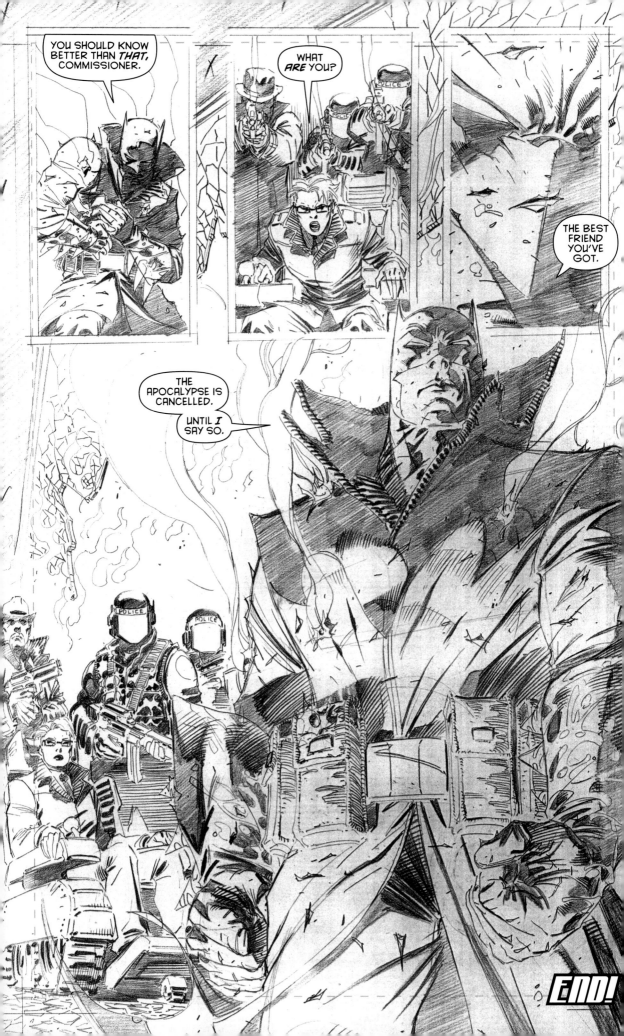

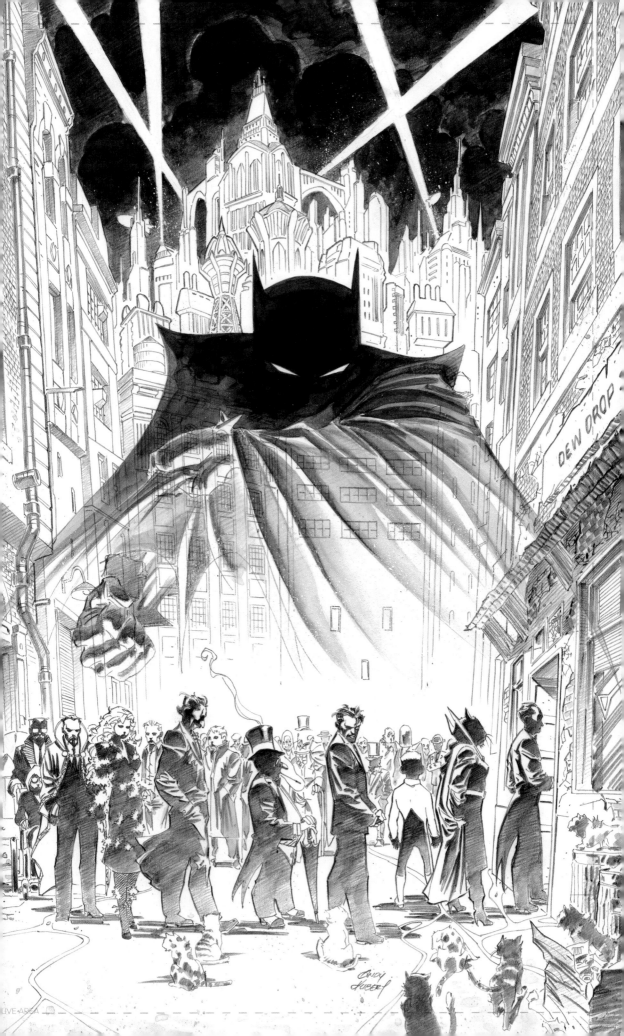

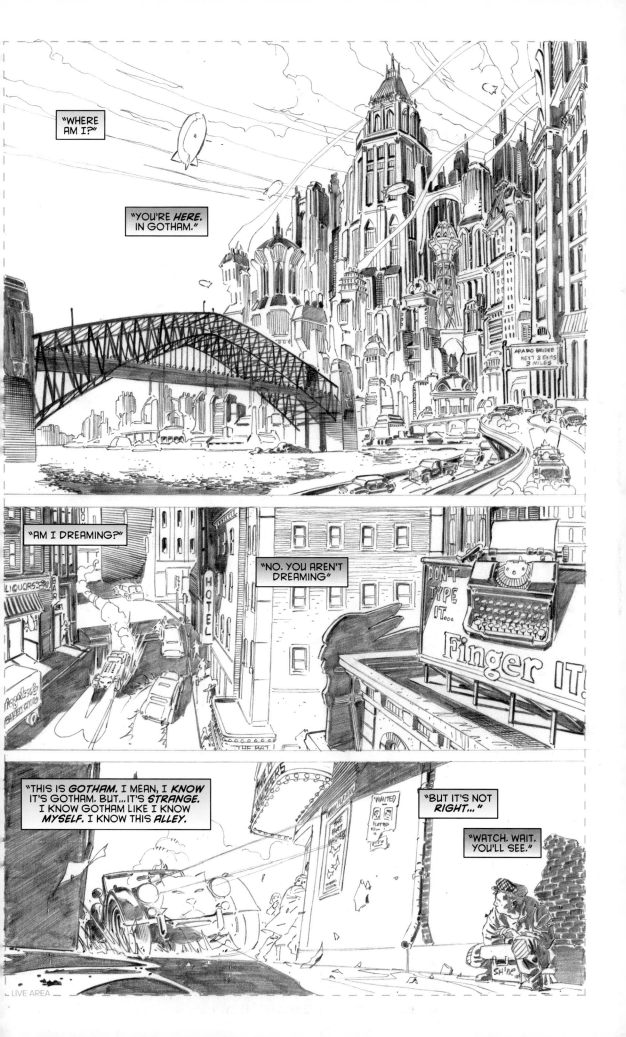

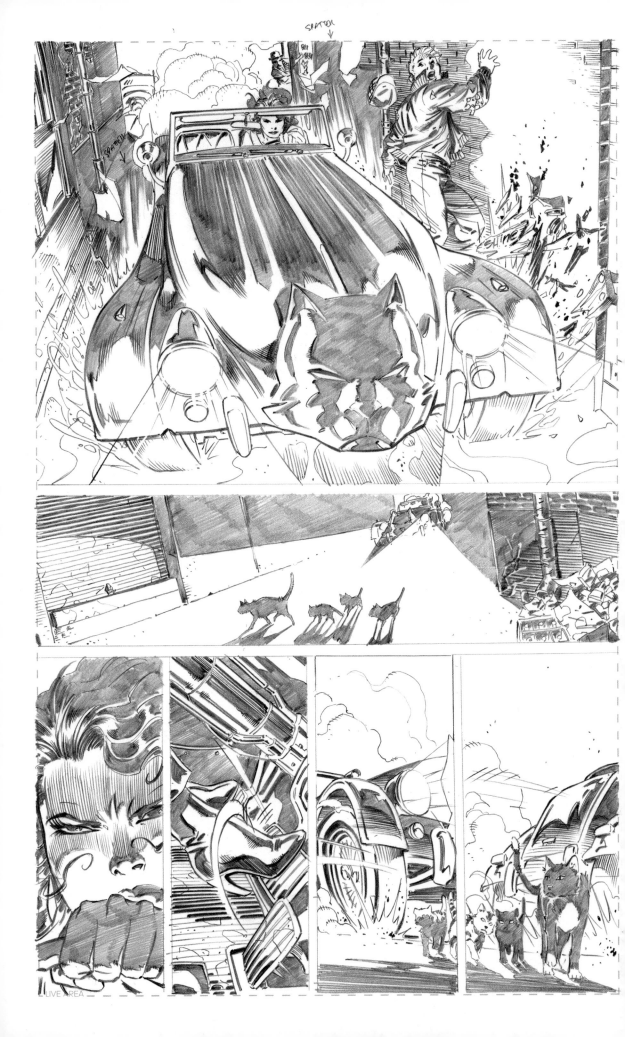

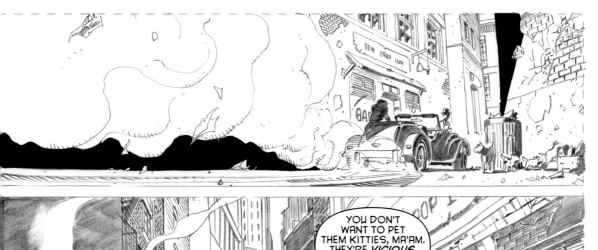

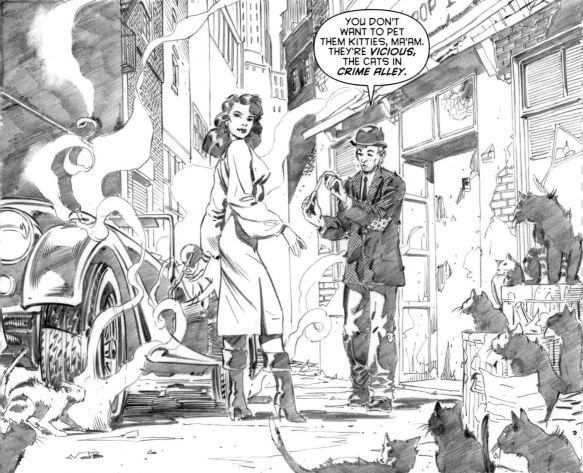

"BOB KANE" SELINA KYLE.

YOU DON'T WANT TO PET THEM KITTIES, MA'AM. THEY'RE *VICIOUS,* THE CATS IN *CRIME ALLEY.*

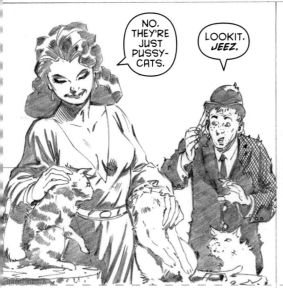

NO. THEY'RE JUST PUSSY-CATS.

LOOKIT. *JEEZ.*

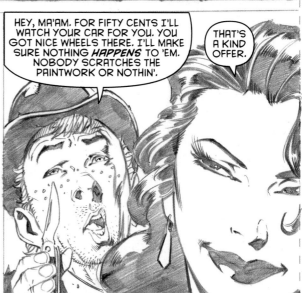

HEY, MA'AM. FOR FIFTY CENTS I'LL WATCH YOUR CAR FOR YOU. YOU GOT NICE WHEELS THERE. I'LL MAKE SURE NOTHING *HAPPENS* TO 'EM. NOBODY SCRATCHES THE PAINTWORK OR NOTHIN'.

THAT'S A KIND OFFER.

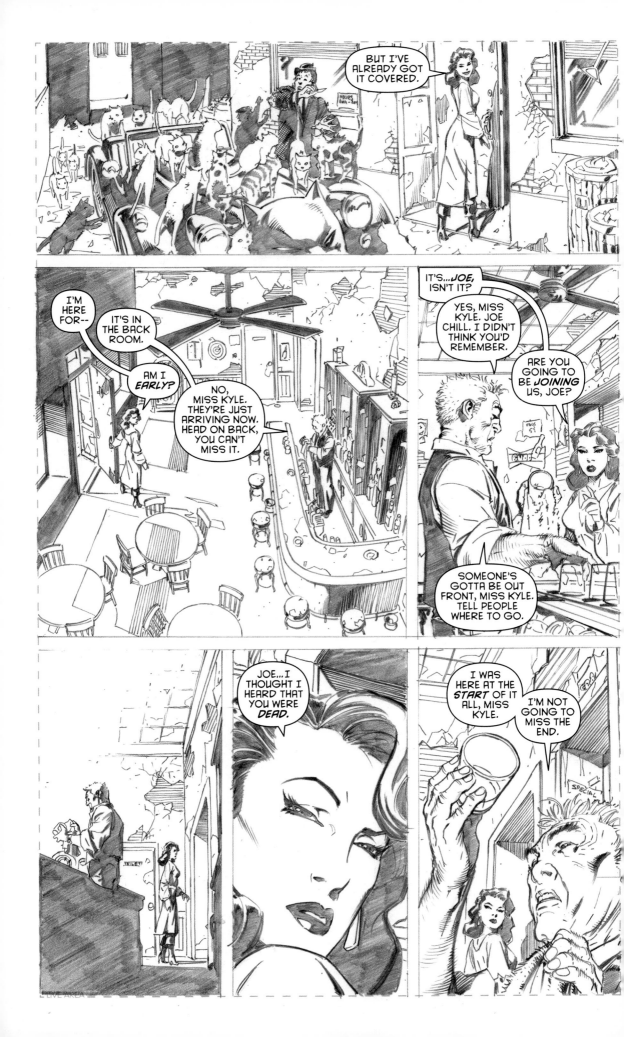

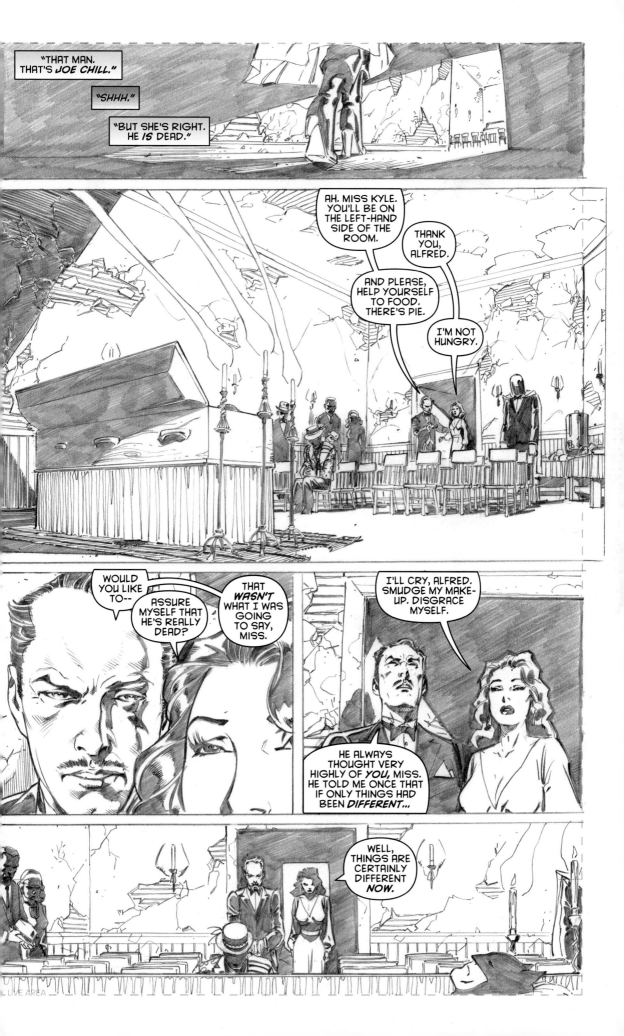

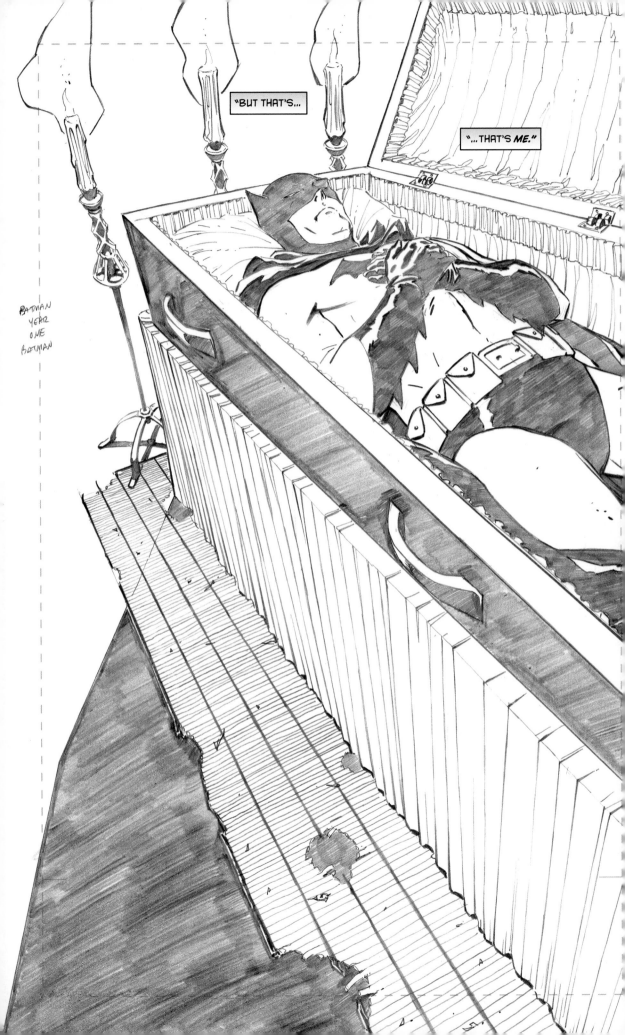

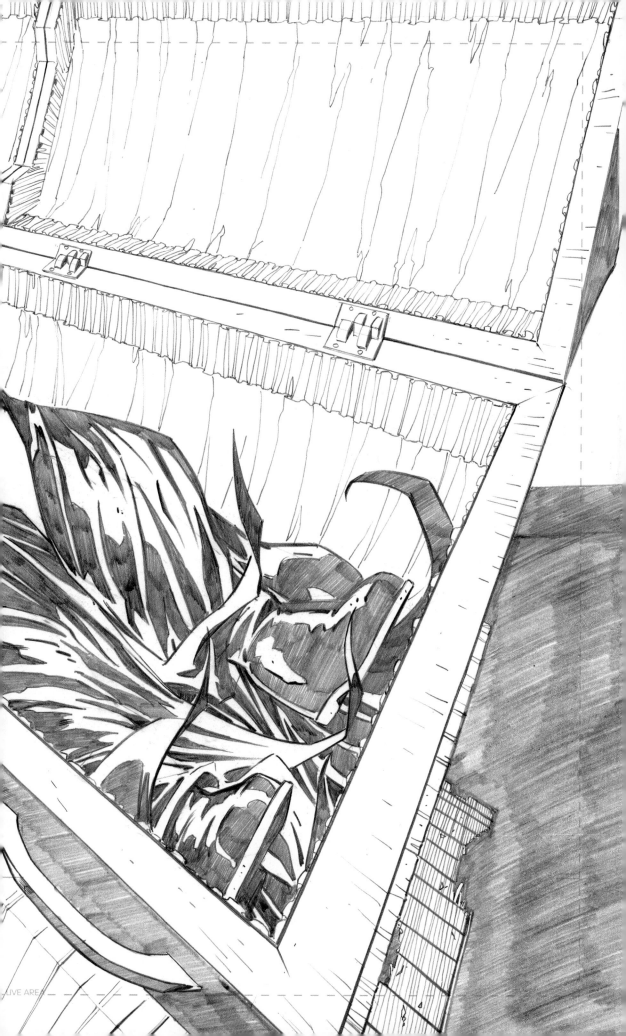

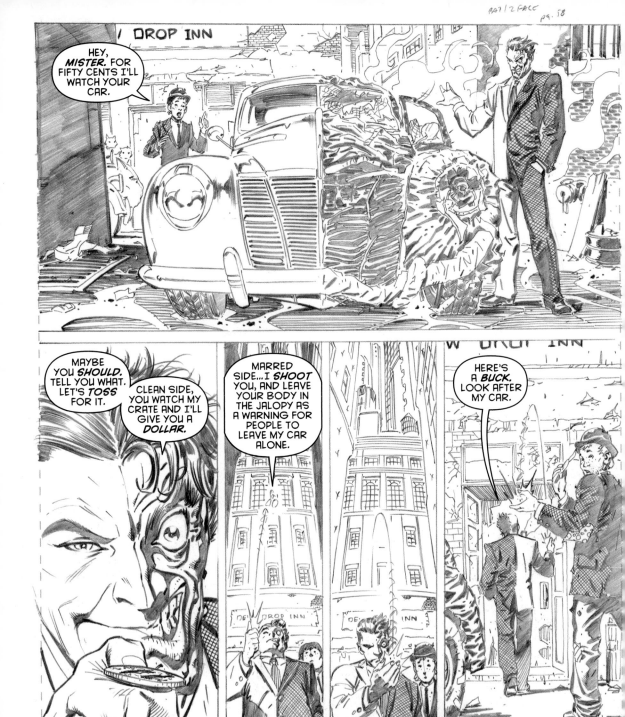
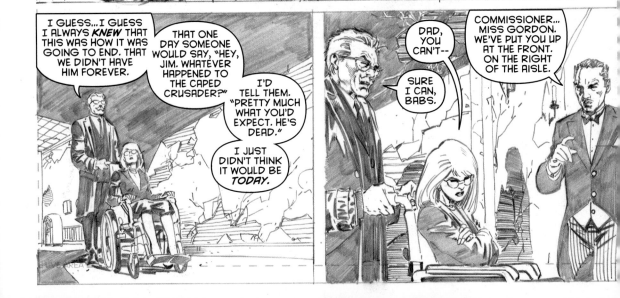

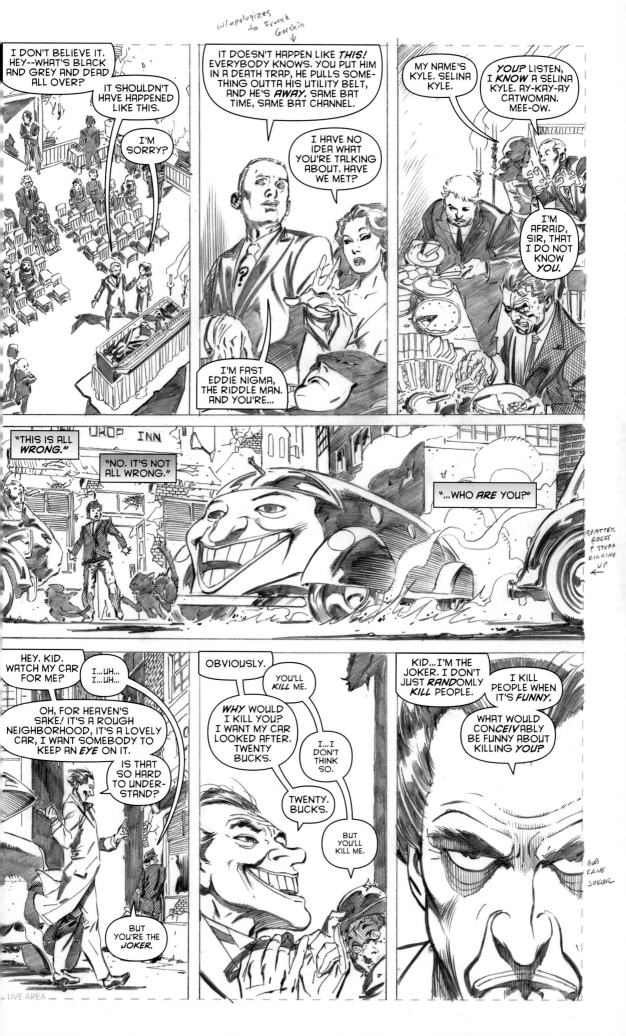

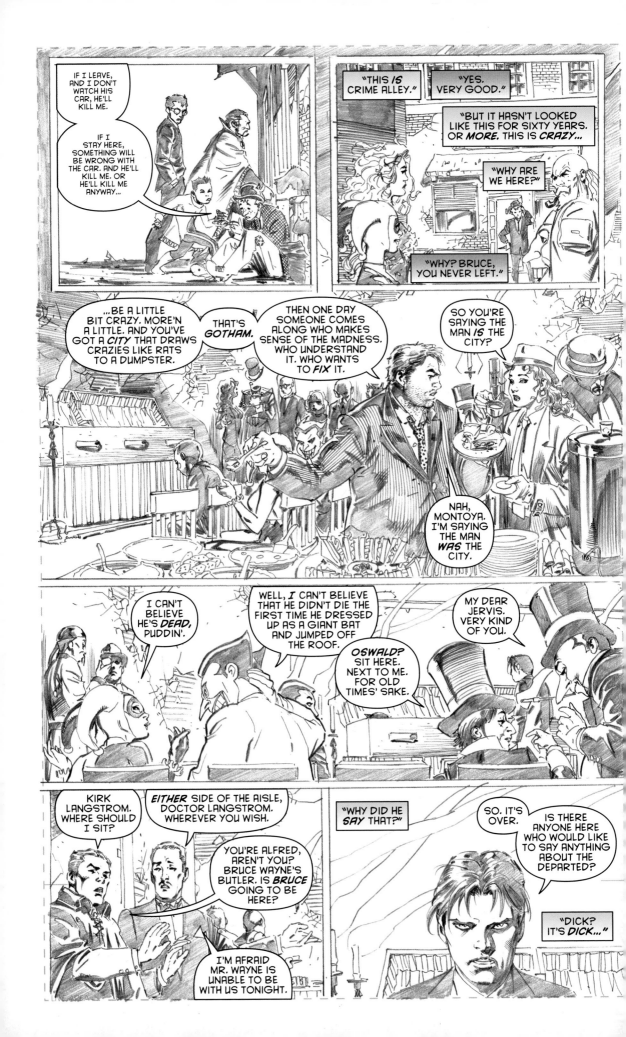

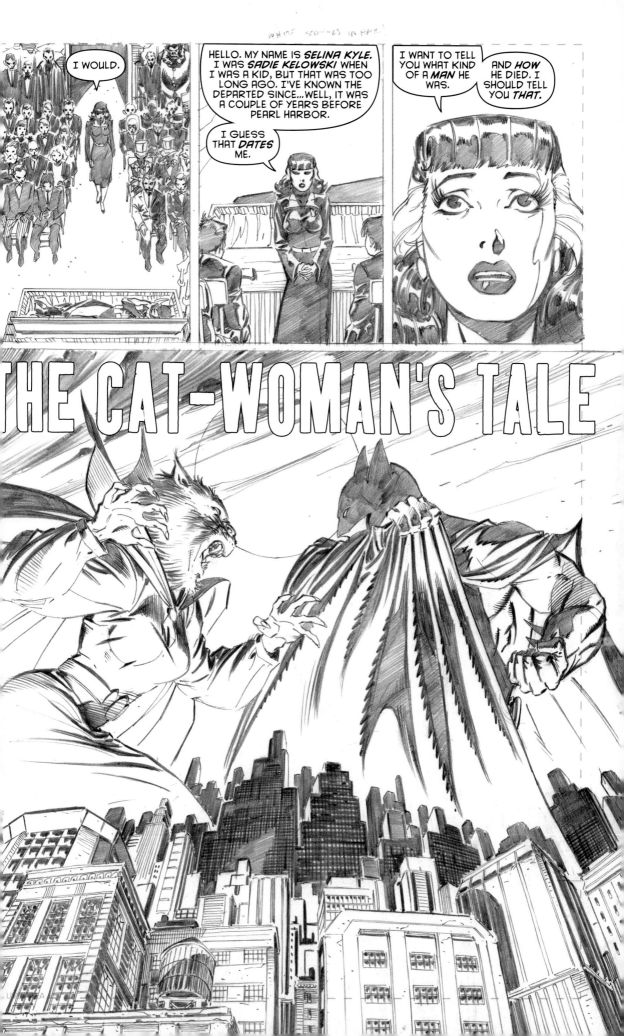

"WE MET SHORTLY AFTER I FIRST BEGAN TO PURSUE THE... THE *CAREER* I HAD EMBARKED UPON.

"A YOUNG LADY WITH NO FAMILY AND NO PROSPECTS MUST MAKE THE BEST OF WHAT SHE HAS, SO TO SPEAK, AND MUST CREATE HER *OWN* OPPORTUNITIES."

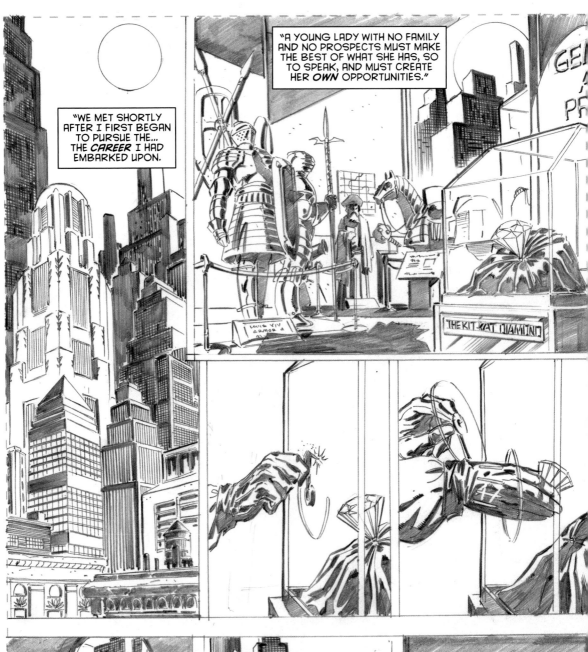

THE KIT-KAT DIAMOND

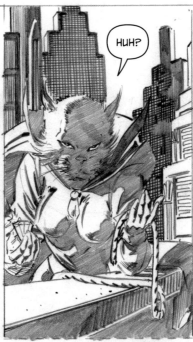

HUH?

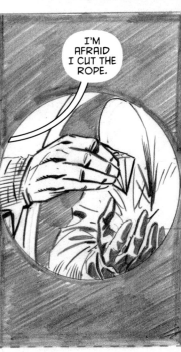

I'M AFRAID I CUT THE ROPE.

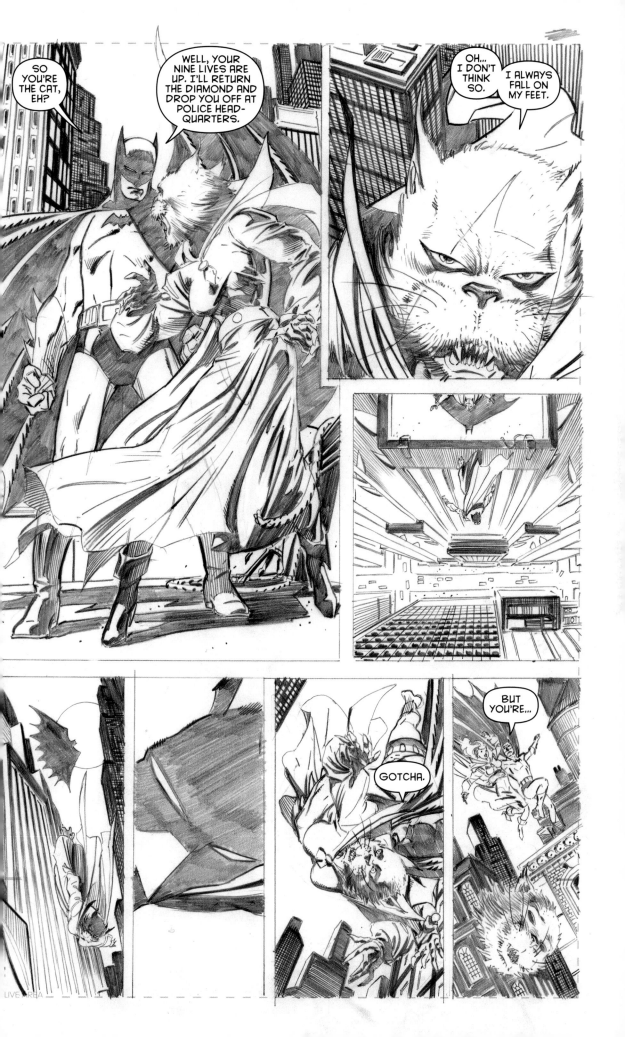

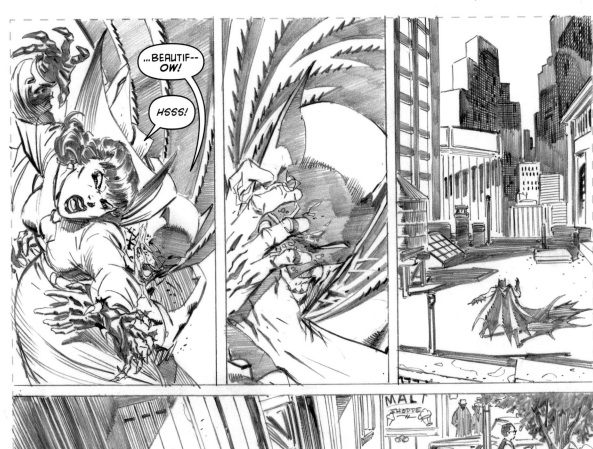

...BEAUTIF--
OW!

HSSS!

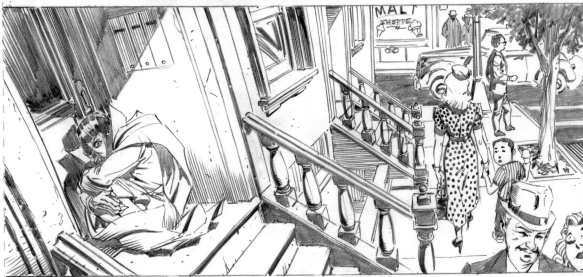

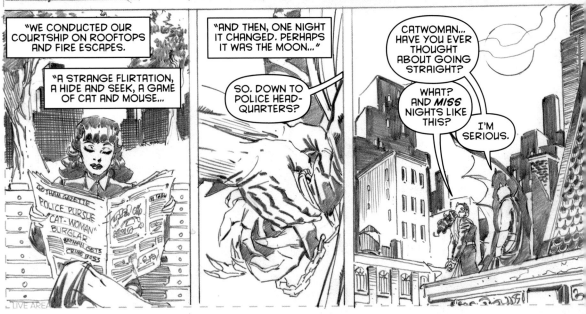

"WE CONDUCTED OUR COURTSHIP ON ROOFTOPS AND FIRE ESCAPES.

"A STRANGE FLIRTATION, A HIDE AND SEEK, A GAME OF CAT AND MOUSE...

"AND THEN, ONE NIGHT IT CHANGED. PERHAPS IT WAS THE MOON..."

SO. DOWN TO POLICE HEAD-QUARTERS?

CATWOMAN... HAVE YOU EVER THOUGHT ABOUT GOING STRAIGHT?

WHAT? AND MISS NIGHTS LIKE THIS?

I'M SERIOUS.

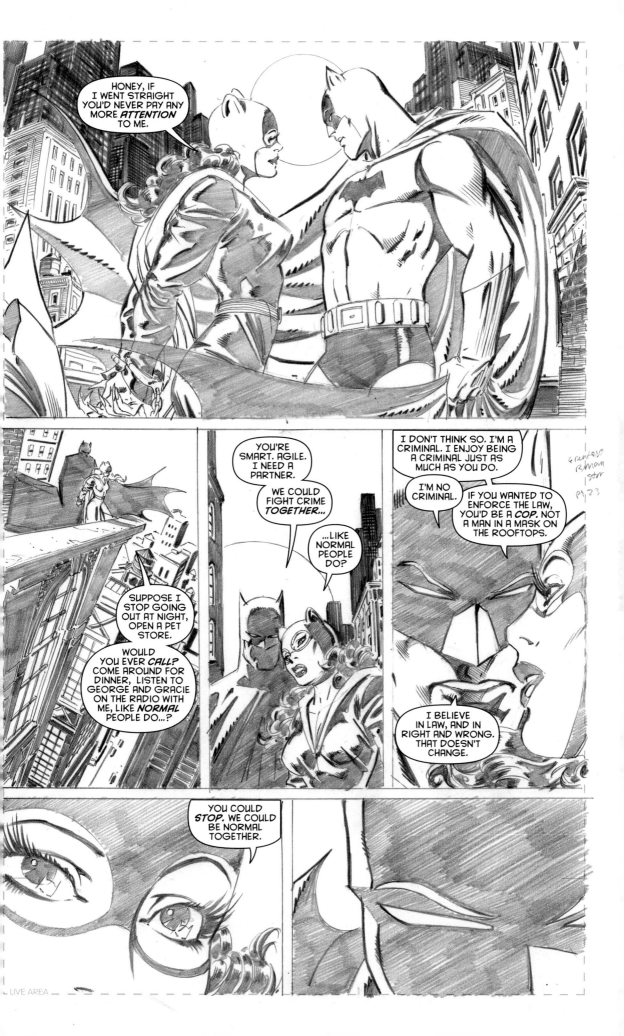

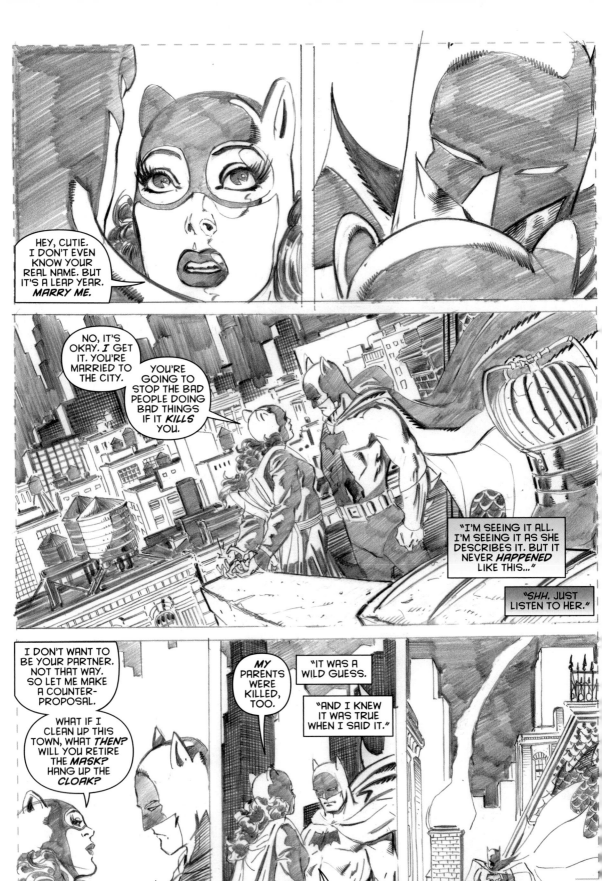

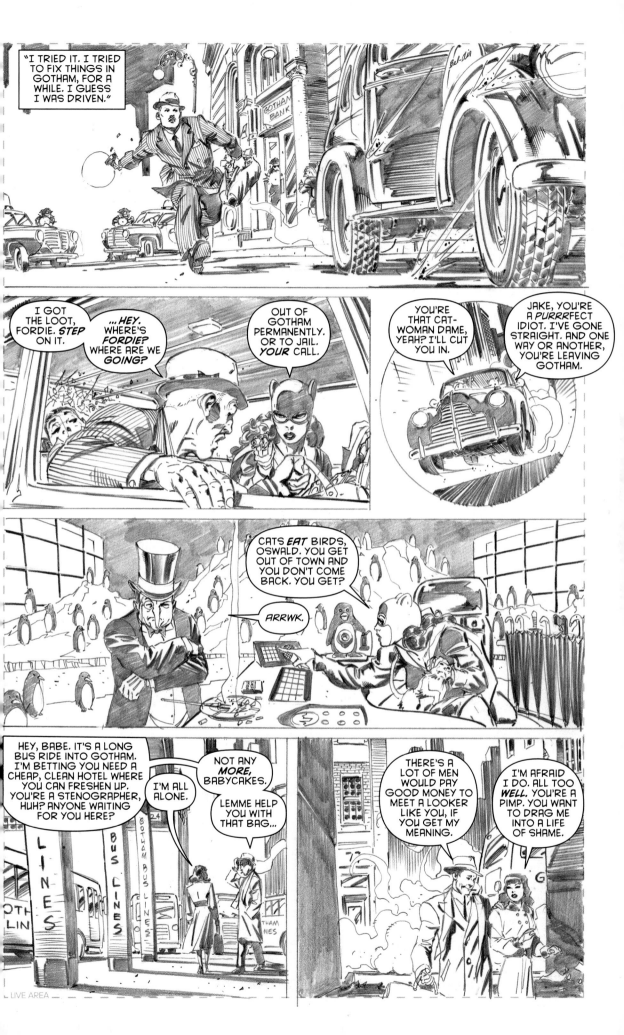

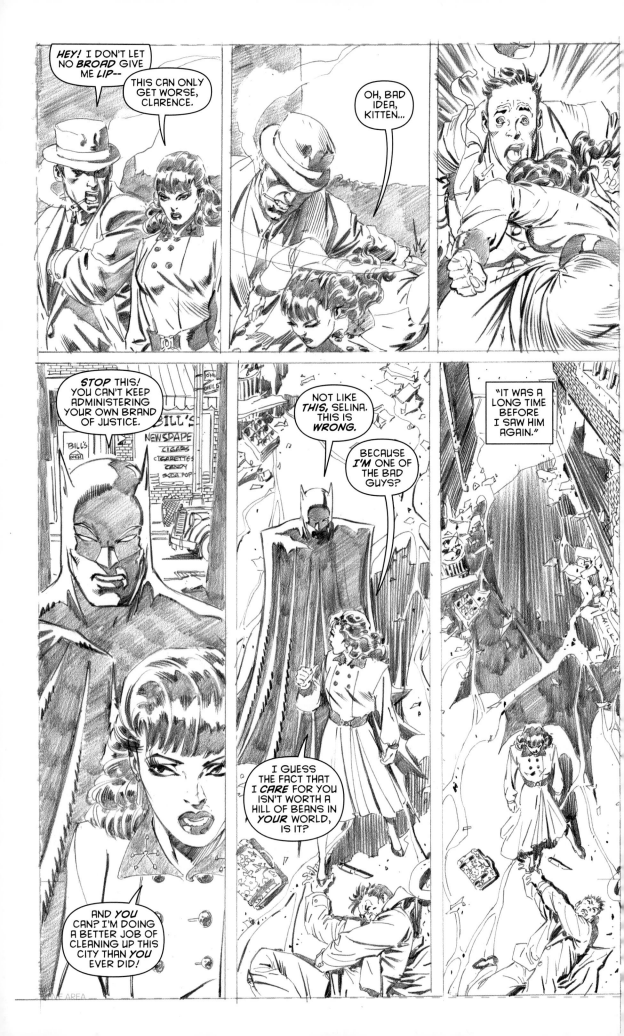

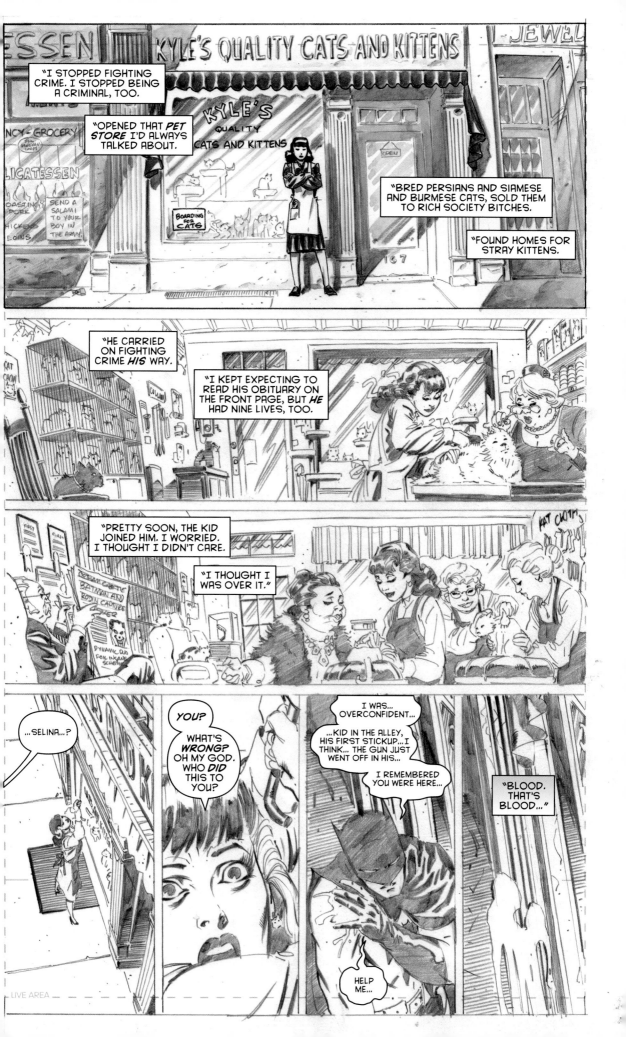

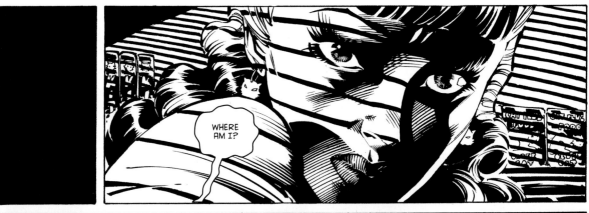

WHERE AM I?

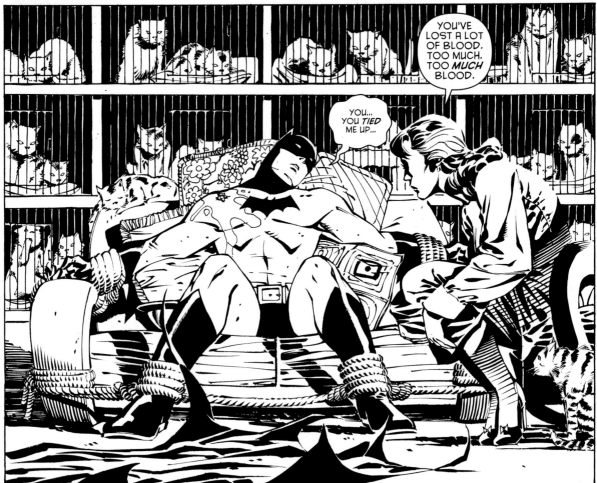

YOU'VE LOST A LOT OF BLOOD. TOO MUCH. TOO *MUCH* BLOOD.

YOU... YOU *TIED* ME UP...

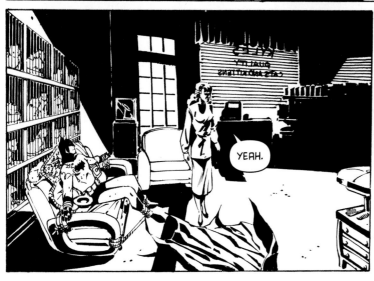

YEAH.

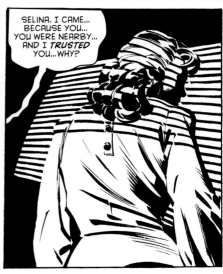

SELINA. I CAME... BECAUSE YOU... YOU WERE NEARBY... AND I *TRUSTED* YOU...WHY?

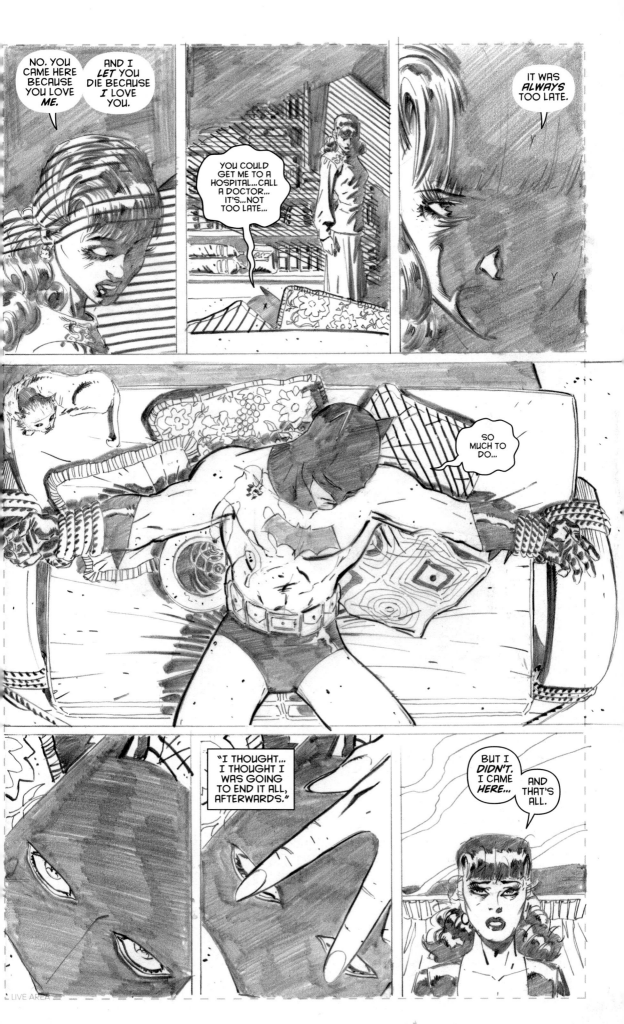

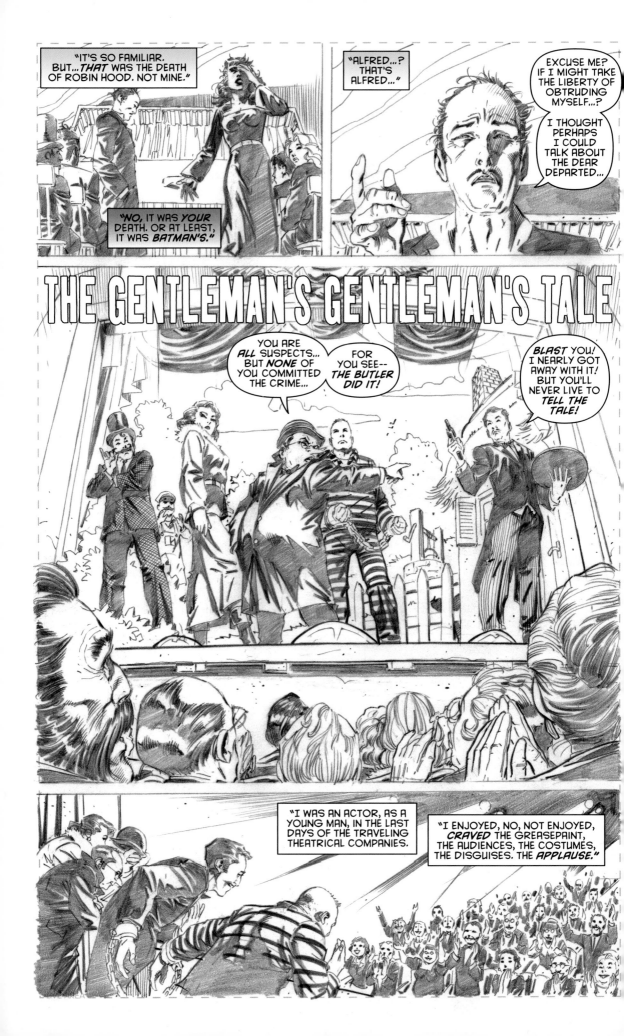

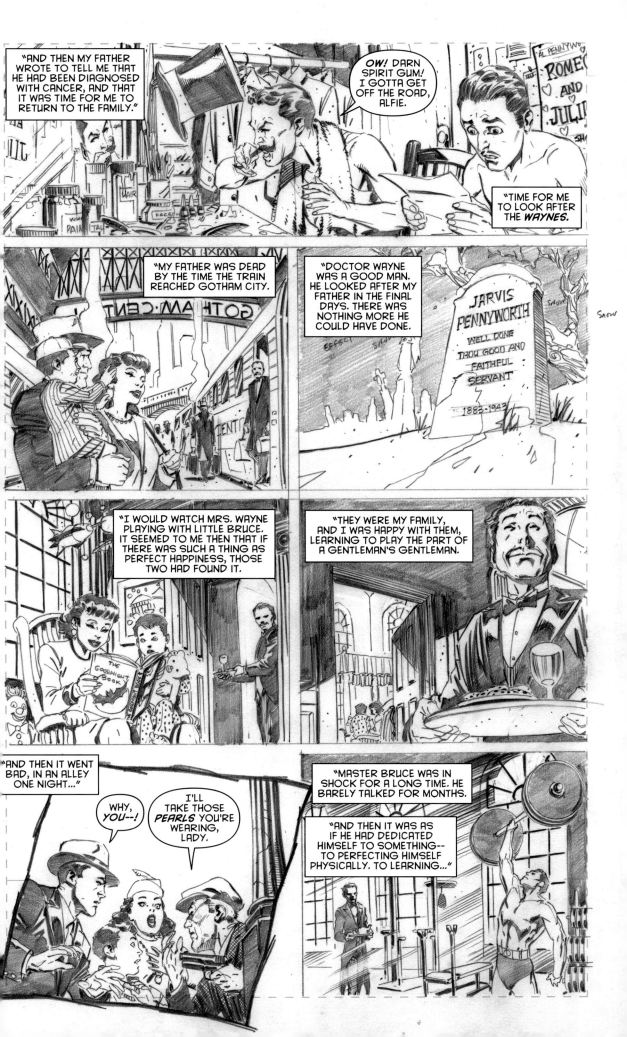

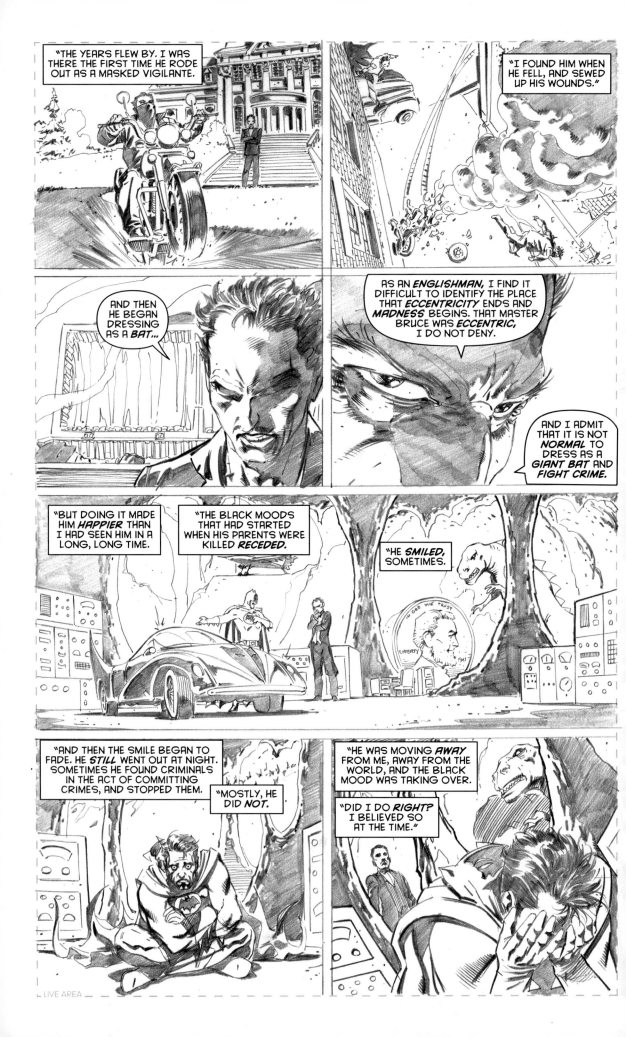

"THE YEARS FLEW BY. I WAS THERE THE FIRST TIME HE RODE OUT AS A MASKED VIGILANTE."

"I FOUND HIM WHEN HE FELL, AND SEWED UP HIS WOUNDS."

AND THEN HE BEGAN DRESSING AS A *BAT...*

AS AN *ENGLISHMAN*, I FIND IT DIFFICULT TO IDENTIFY THE PLACE THAT *ECCENTRICITY* ENDS AND *MADNESS* BEGINS. THAT MASTER BRUCE WAS *ECCENTRIC*, I DO NOT DENY.

AND I ADMIT THAT IT IS NOT *NORMAL* TO DRESS AS A *GIANT BAT* AND FIGHT *CRIME.*

"BUT DOING IT MADE HIM *HAPPIER* THAN I HAD SEEN HIM IN A LONG, LONG TIME.

"THE BLACK MOODS THAT HAD STARTED WHEN HIS PARENTS WERE KILLED *RECEDED.*

"HE *SMILED,* SOMETIMES.

"AND THEN THE SMILE BEGAN TO FADE. HE *STILL* WENT OUT AT NIGHT. SOMETIMES HE FOUND CRIMINALS IN THE ACT OF COMMITTING CRIMES, AND STOPPED THEM.

"MOSTLY, HE DID *NOT.*

"HE WAS MOVING *AWAY* FROM ME, AWAY FROM THE WORLD, AND THE BLACK MOOD WAS TAKING OVER.

"DID I DO *RIGHT?* I BELIEVED SO AT THE TIME."

LIVE AREA

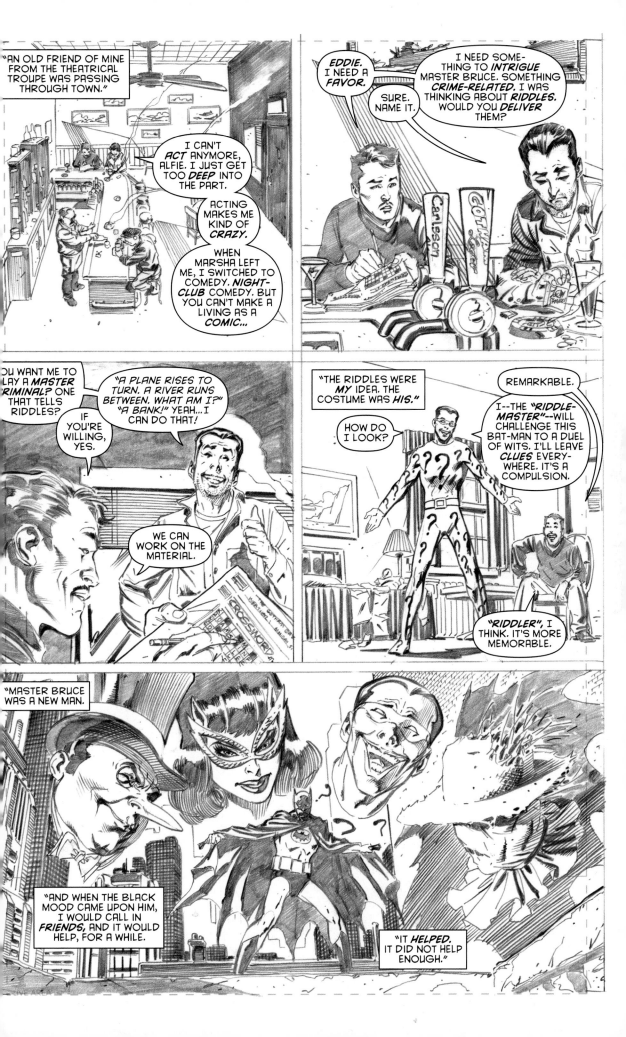

"AN OLD FRIEND OF MINE FROM THE THEATRICAL TROUPE WAS PASSING THROUGH TOWN."

I CAN'T *ACT* ANYMORE, ALFIE. I JUST GET TOO *DEEP* INTO THE PART.

ACTING MAKES ME KIND OF *CRAZY.*

WHEN MARSHA LEFT ME, I SWITCHED TO COMEDY. *NIGHT-CLUB* COMEDY. BUT YOU CAN'T MAKE A LIVING AS A *COMIC...*

EDDIE. I NEED A *FAVOR.*

SURE. NAME IT.

I NEED SOME-THING TO *INTRIGUE* MASTER BRUCE. SOMETHING *CRIME-RELATED.* I WAS THINKING ABOUT *RIDDLES.* WOULD YOU *DELIVER* THEM?

OU WANT ME TO LAY A *MASTER RIMINAL?* ONE THAT TELLS RIDDLES?

IF YOU'RE WILLING, YES.

"A PLANE RISES TO TURN. A RIVER RUNS BETWEEN. WHAT AM I?" "A BANK!" YEAH... I CAN DO THAT!

WE CAN WORK ON THE MATERIAL.

"THE RIDDLES WERE *MY* IDEA. THE COSTUME WAS *HIS.*"

HOW DO I LOOK?

REMARKABLE.

I--THE *"RIDDLE-MASTER"*--WILL CHALLENGE THIS BAT-MAN TO A DUEL OF WITS. I'LL LEAVE *CLUES* EVERY-WHERE. IT'S A COMPULSION.

"RIDDLER", I THINK. IT'S MORE MEMORABLE.

"MASTER BRUCE WAS A NEW MAN.

"AND WHEN THE BLACK MOOD CAME UPON HIM, I WOULD CALL IN *FRIENDS,* AND IT WOULD HELP, FOR A WHILE.

"IT *HELPED.* IT DID NOT HELP ENOUGH."

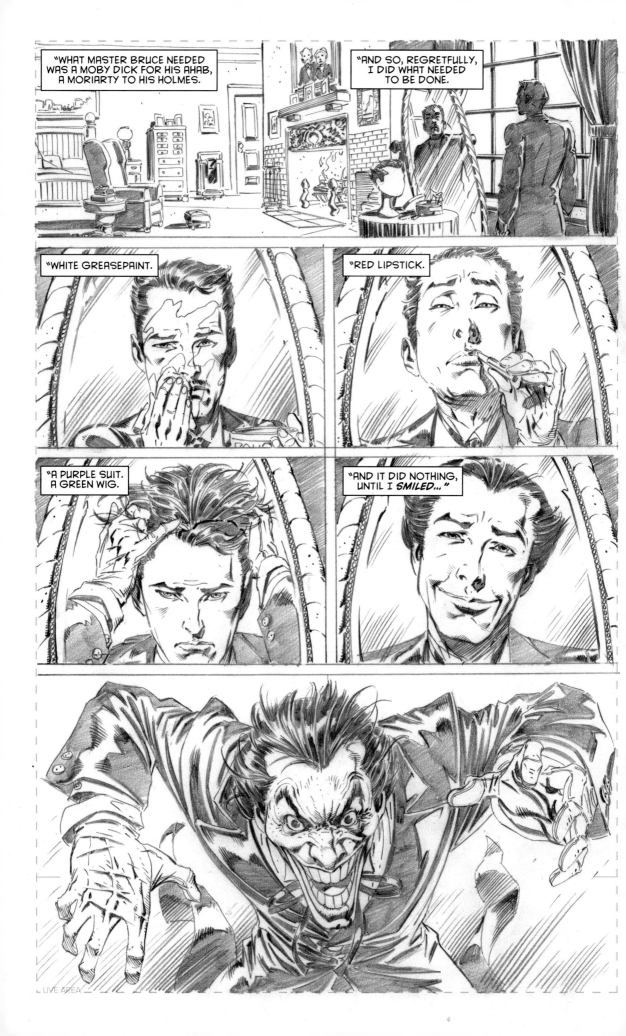

"WHAT MASTER BRUCE NEEDED WAS A MOBY DICK FOR HIS AHAB, A MORIARTY TO HIS HOLMES.

"AND SO, REGRETFULLY, I DID WHAT NEEDED TO BE DONE.

"WHITE GREASEPAINT.

"RED LIPSTICK.

"A PURPLE SUIT. A GREEN WIG.

"AND IT DID NOTHING, UNTIL I *SMILED...*"

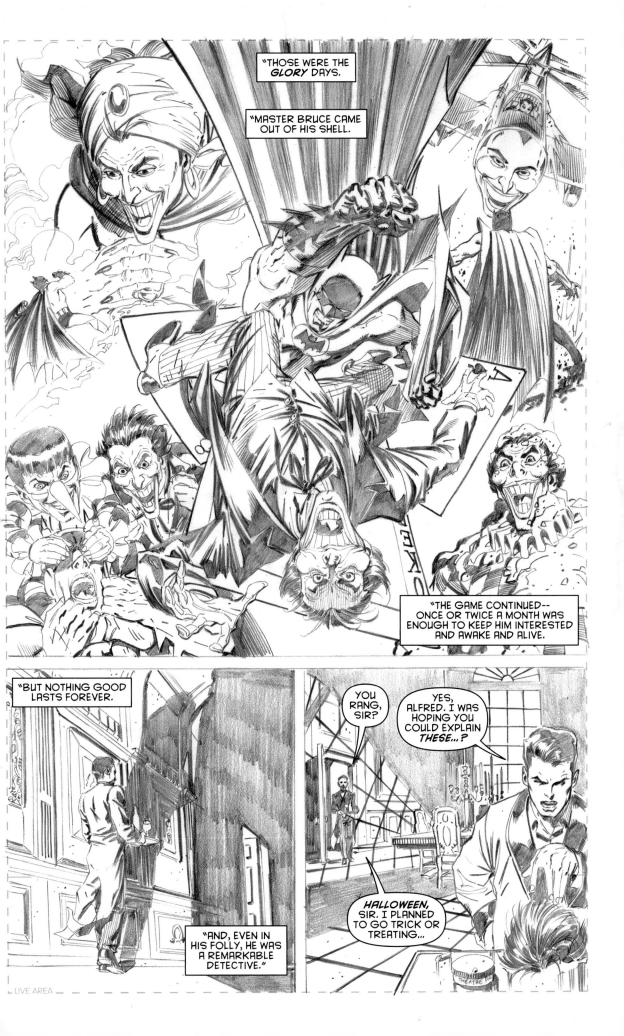

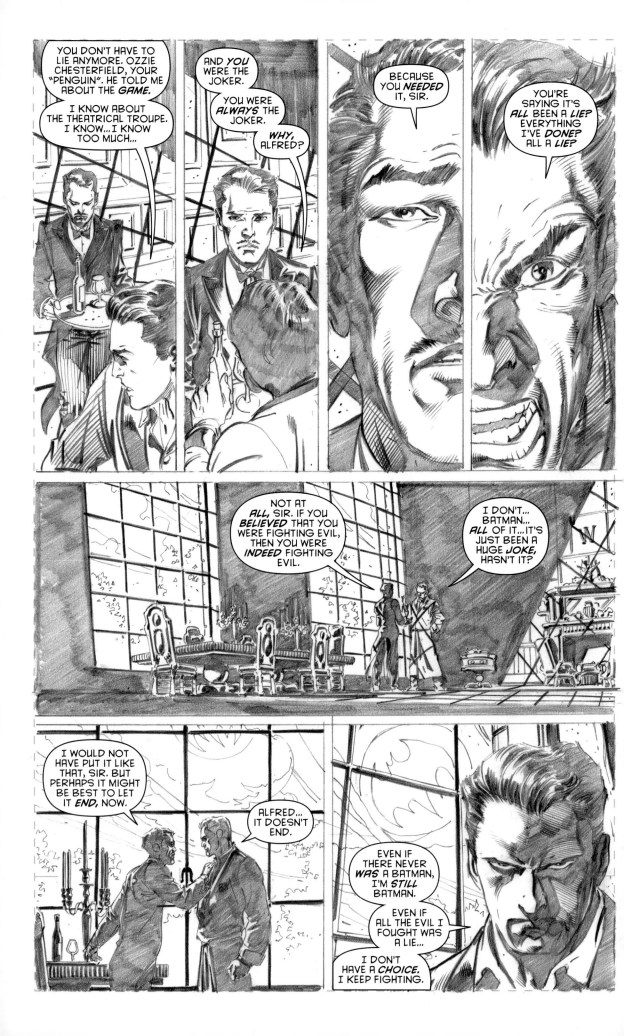

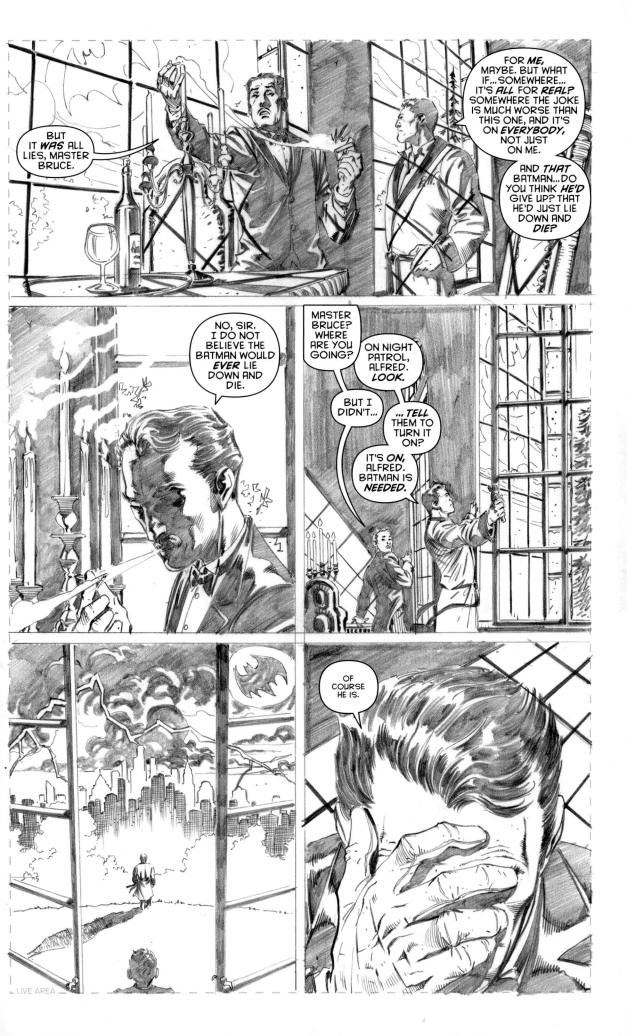

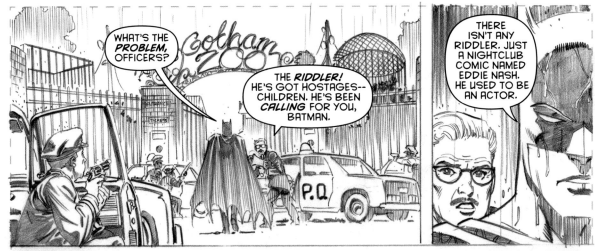

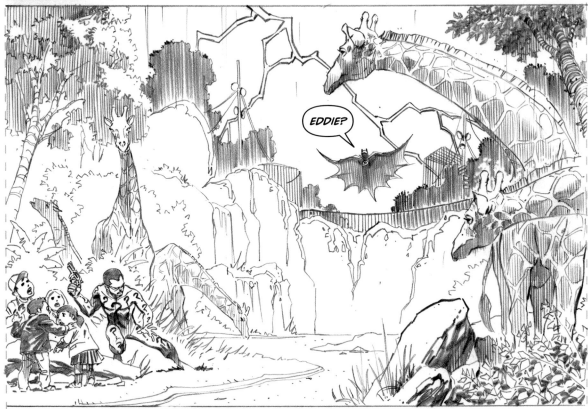

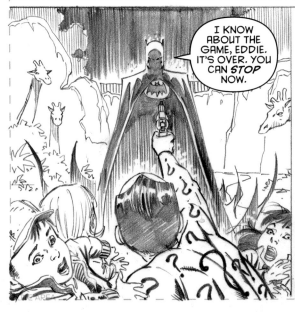

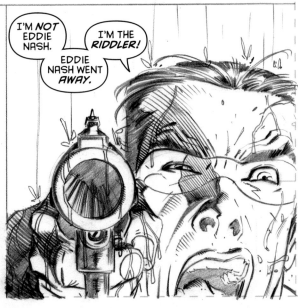

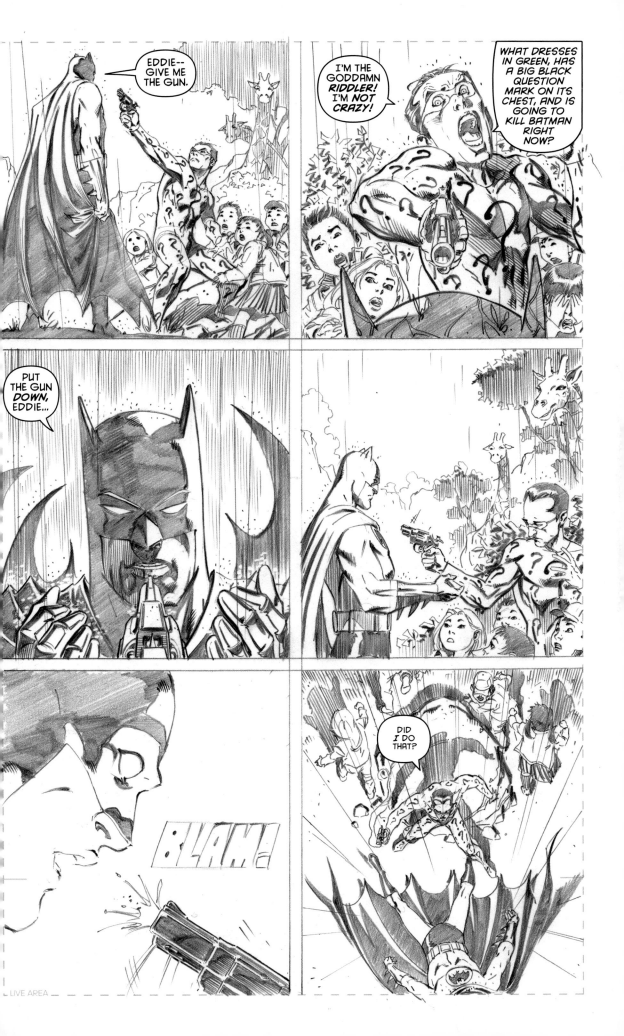

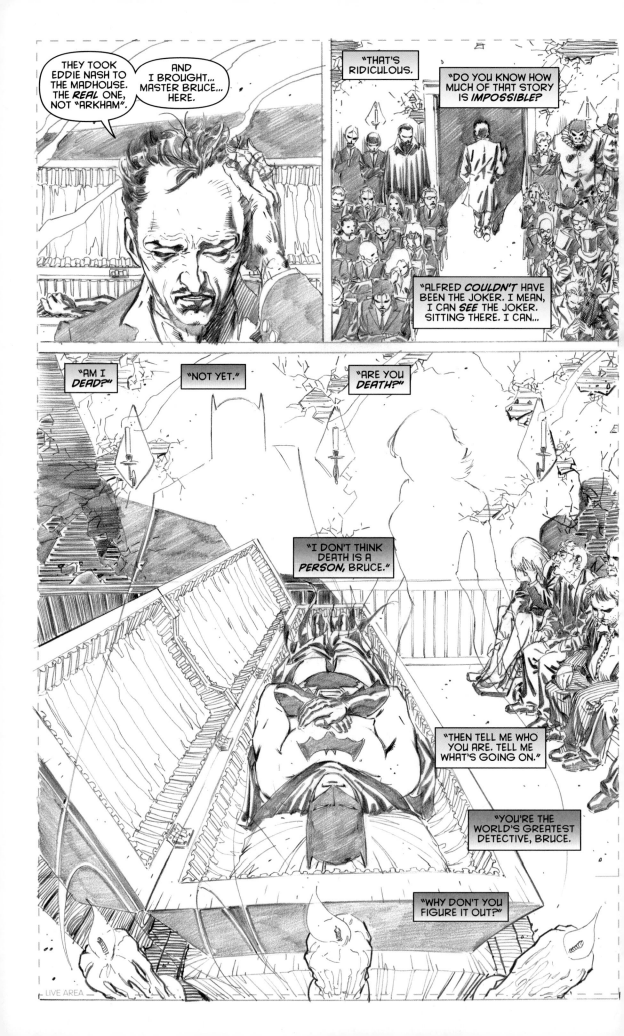

DEAD BATMAN LAYING OVER GOTHAM CITY

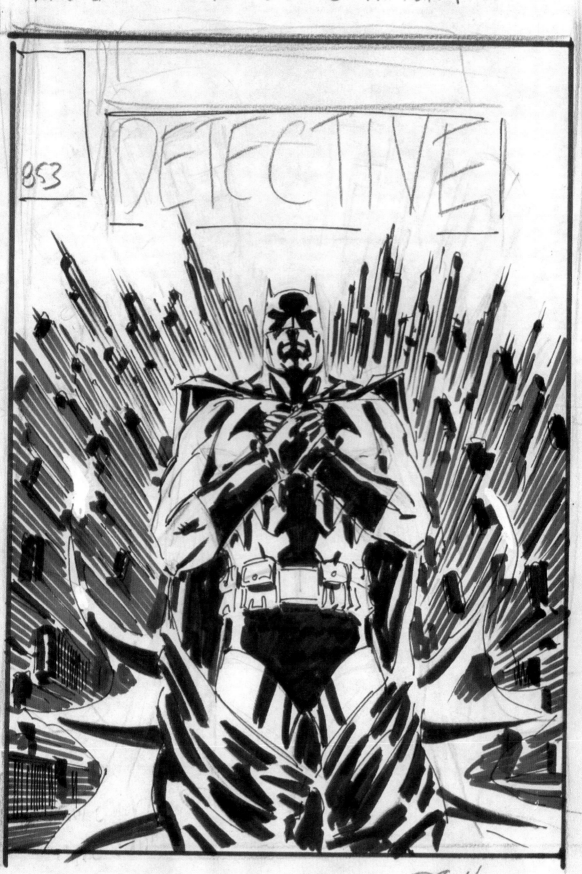

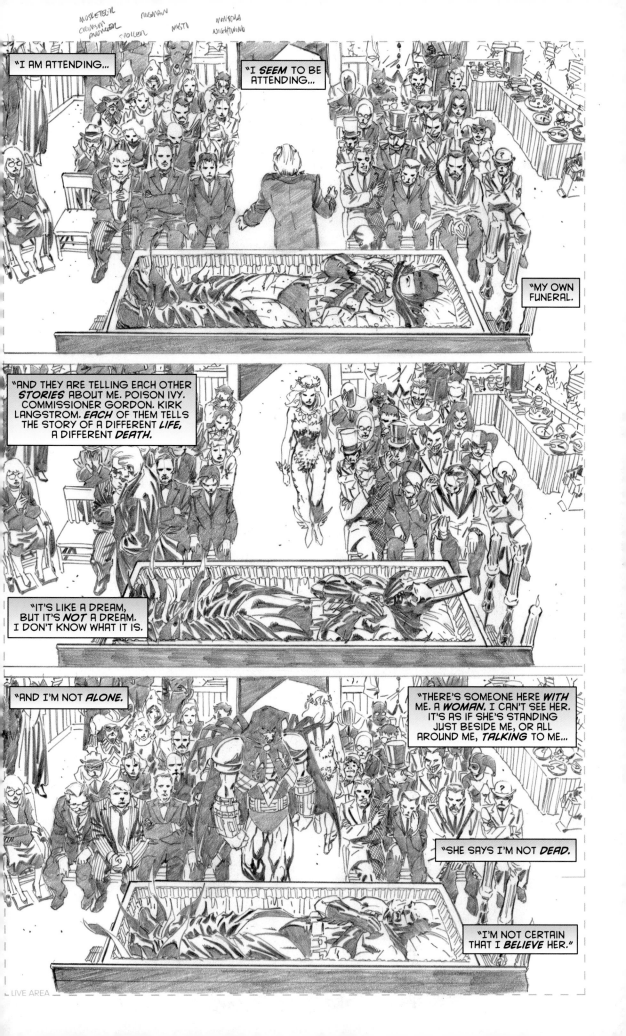

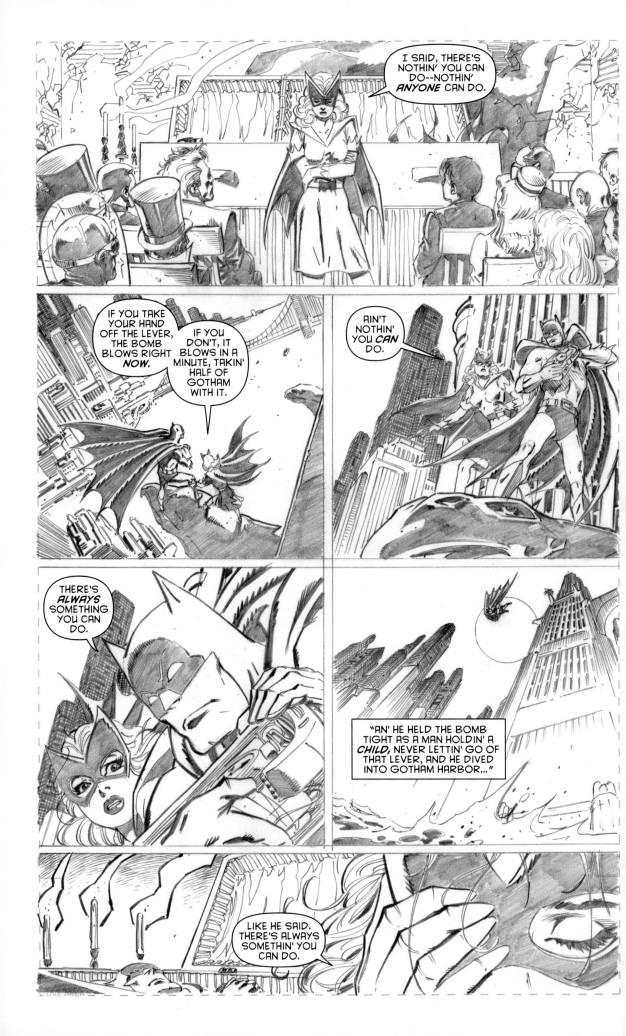

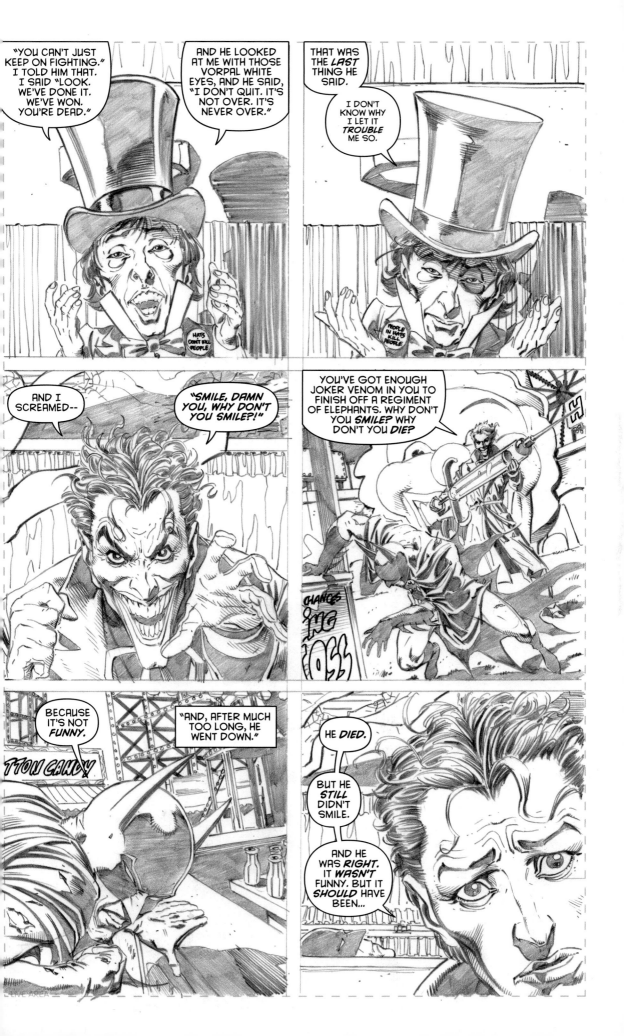

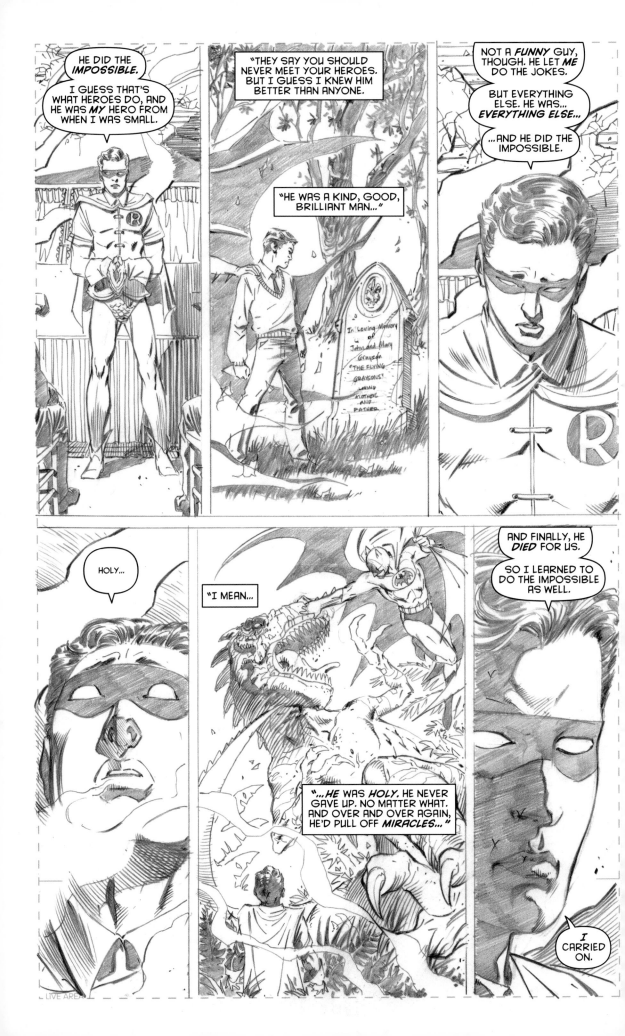

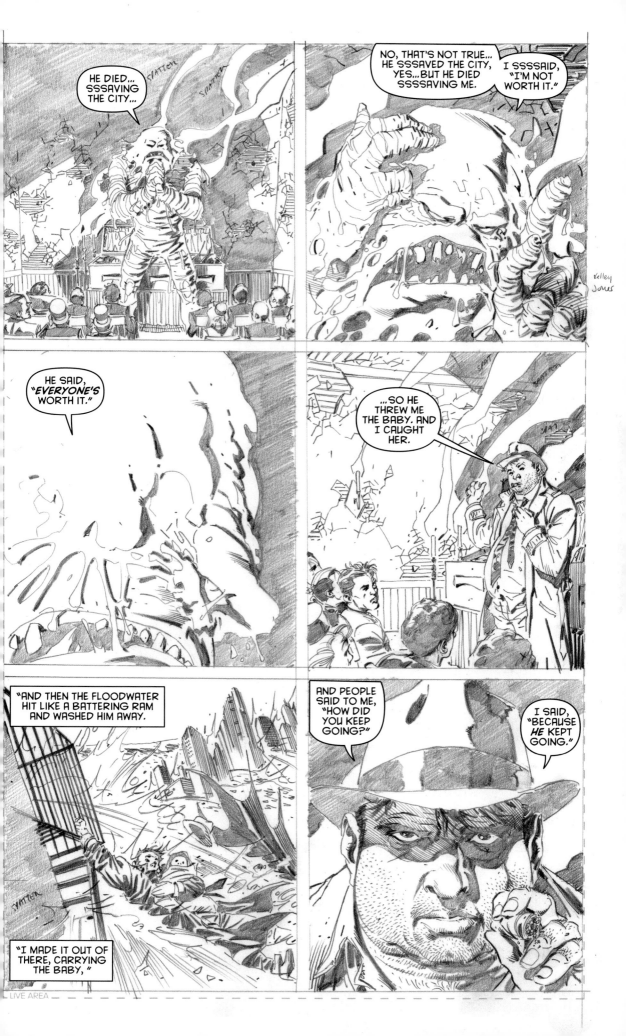

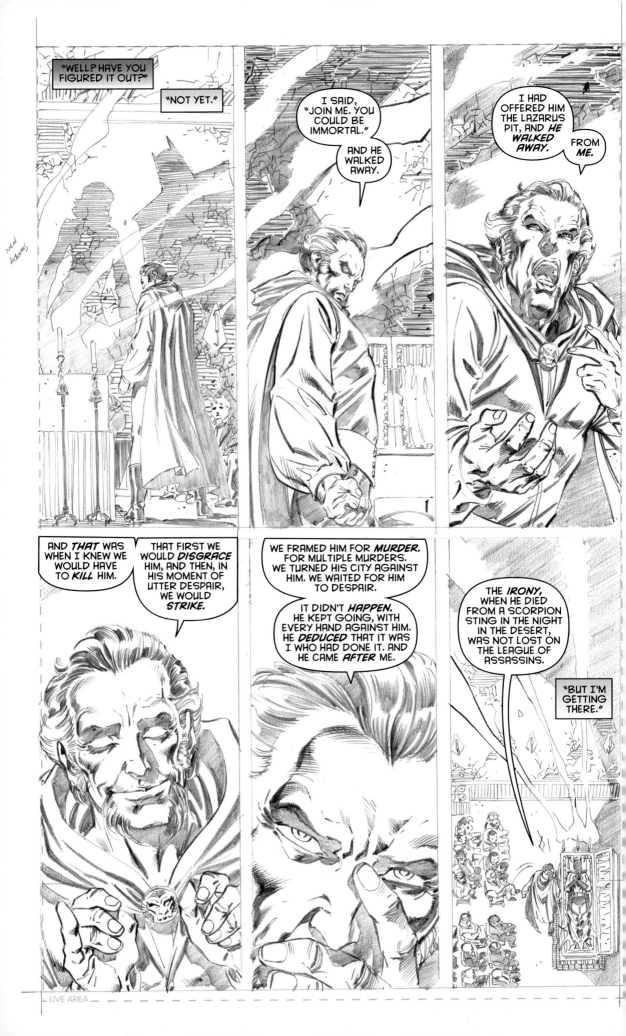

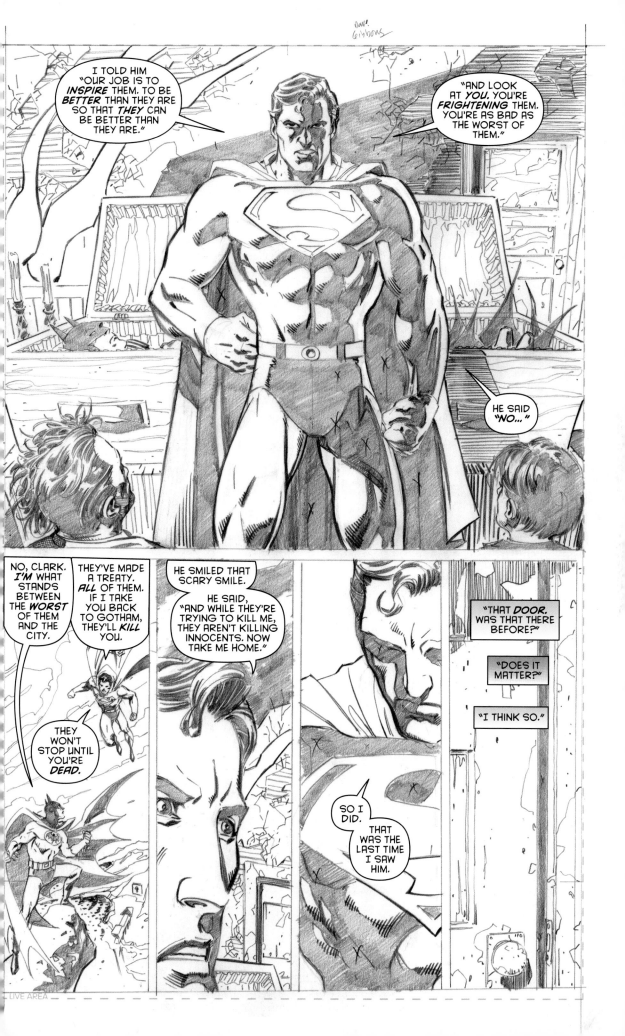

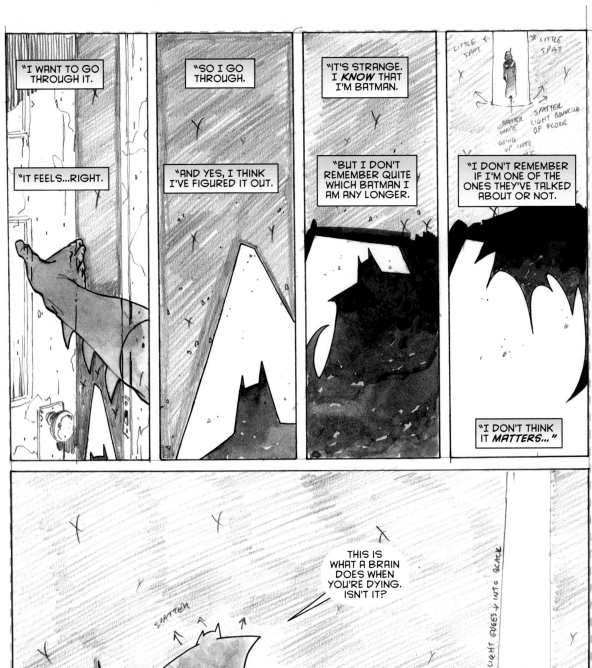
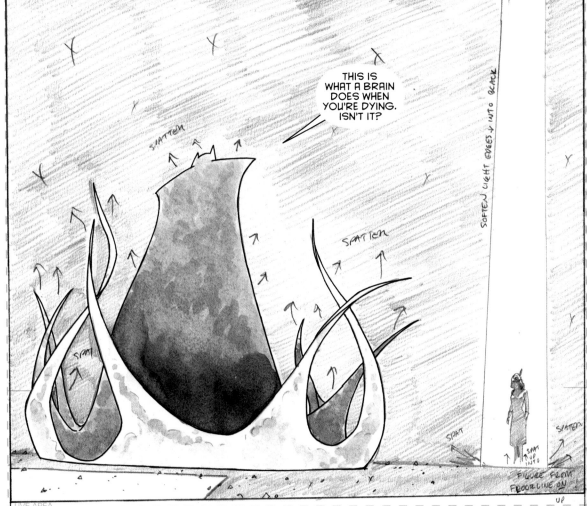

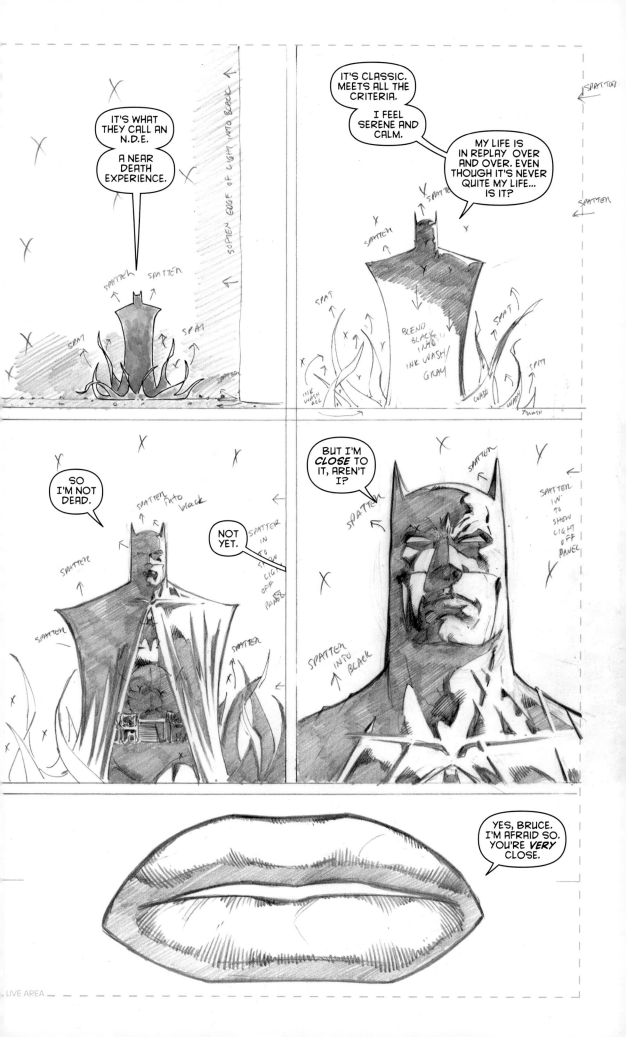

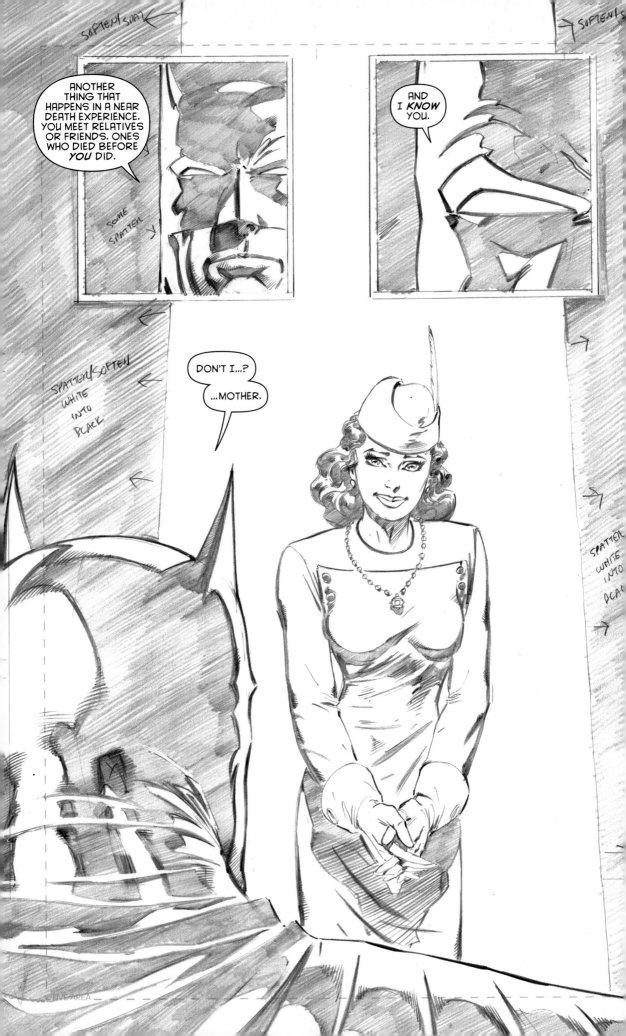

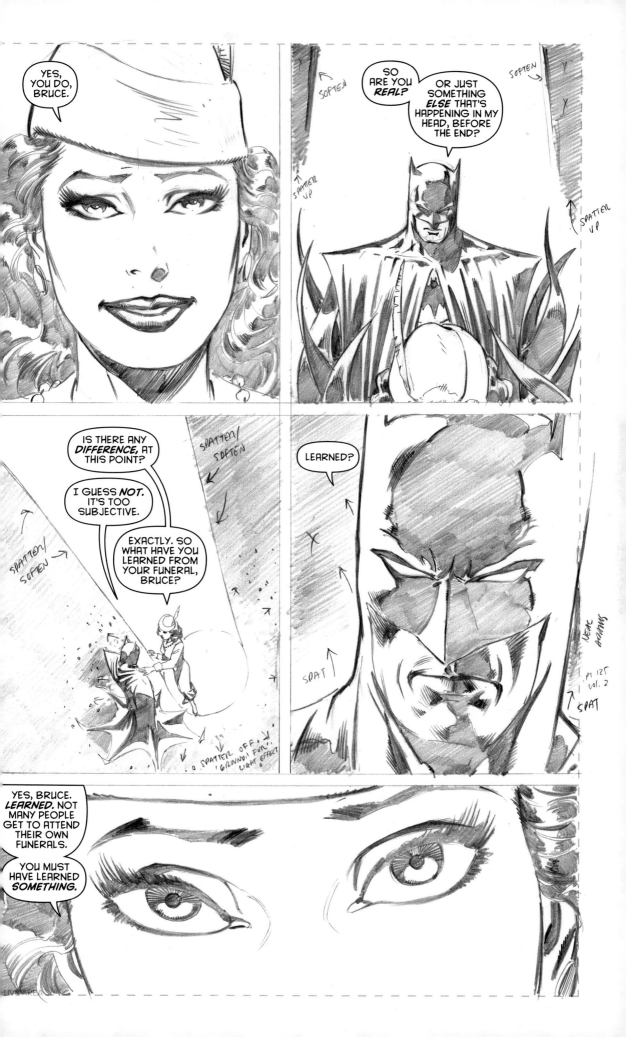

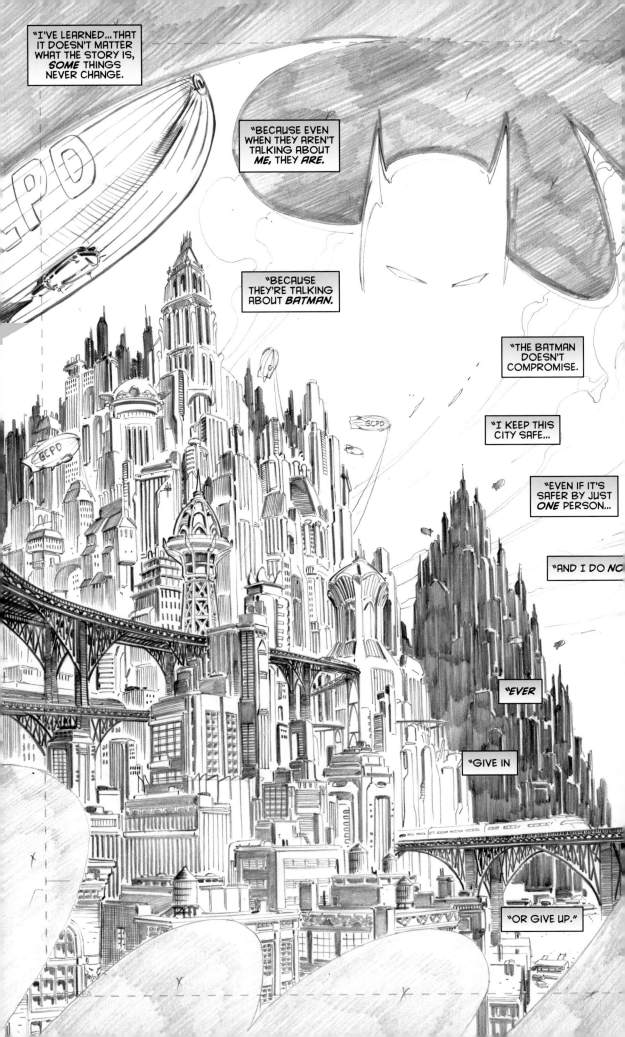

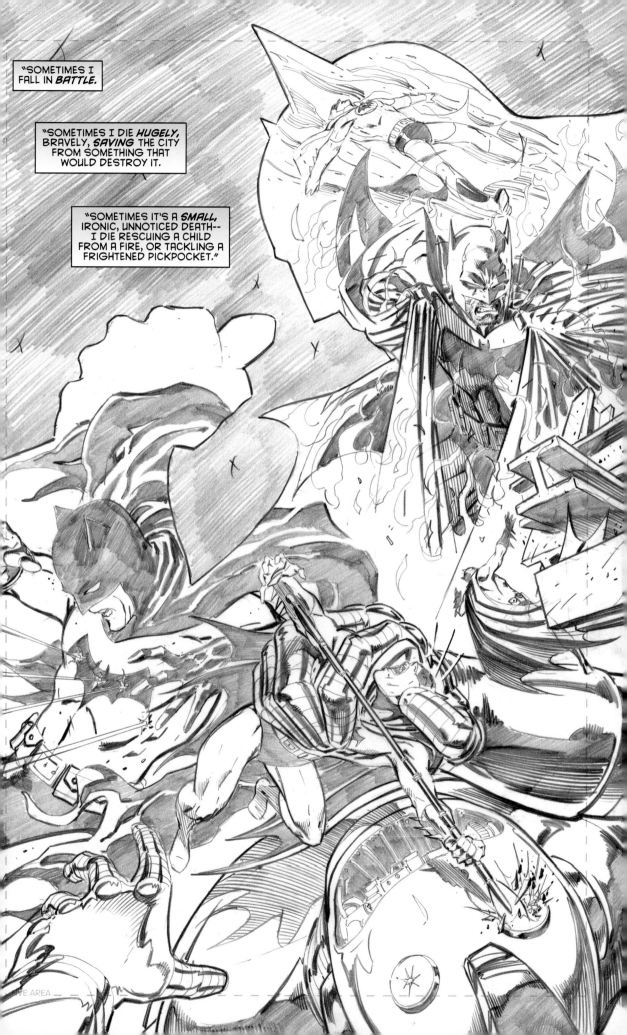

"SOMETIMES I FALL IN *BATTLE*.

"SOMETIMES I DIE *HUGELY*, BRAVELY, *SAVING* THE CITY FROM SOMETHING THAT WOULD DESTROY IT.

"SOMETIMES IT'S A *SMALL*, IRONIC, UNNOTICED DEATH-- I DIE RESCUING A CHILD FROM A FIRE, OR TACKLING A FRIGHTENED PICKPOCKET."

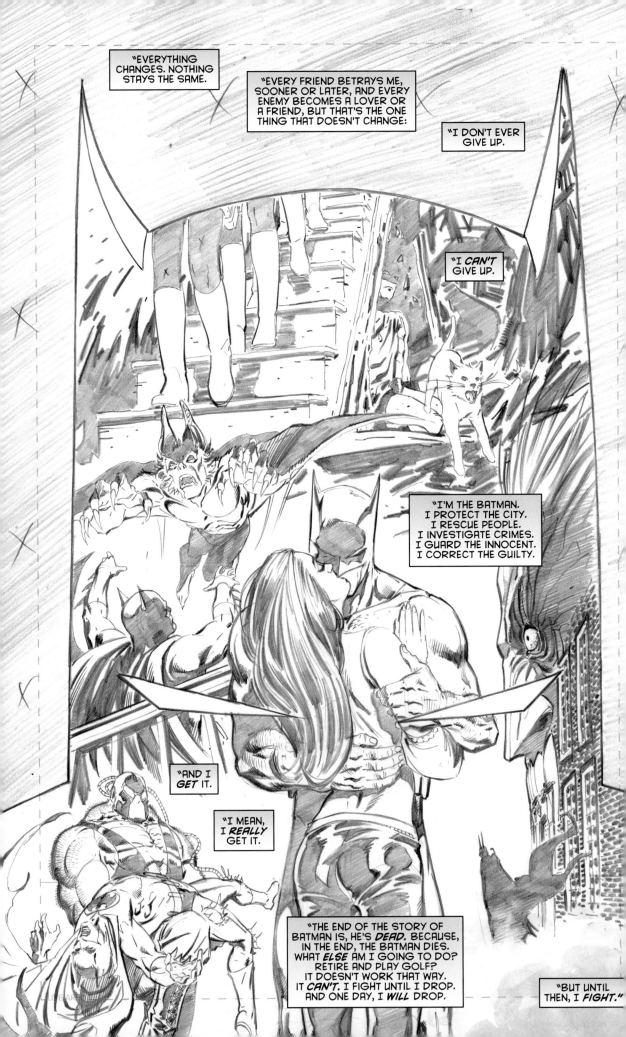

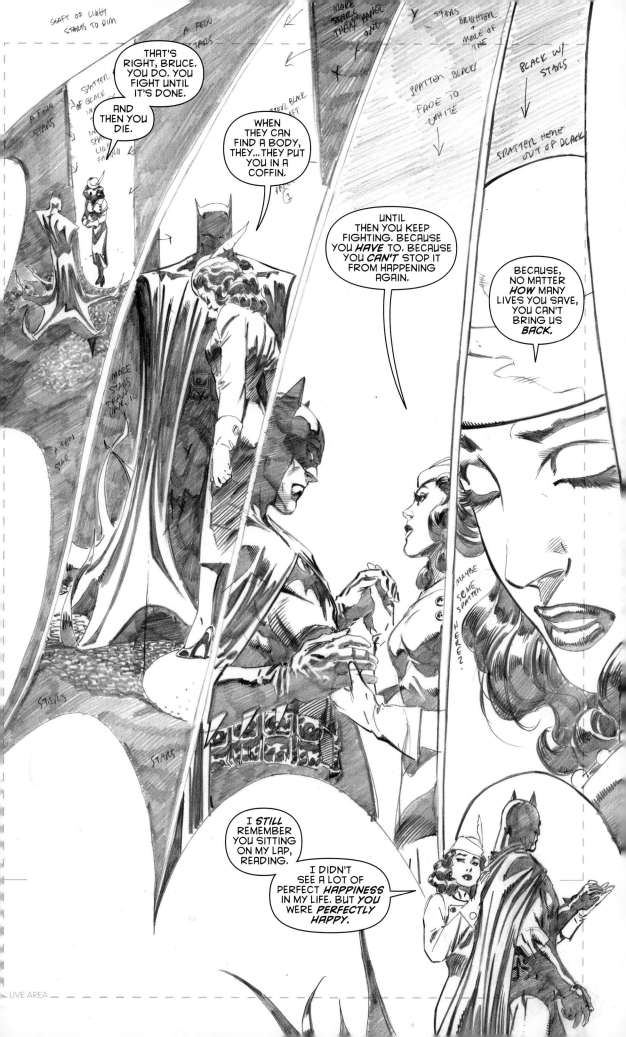

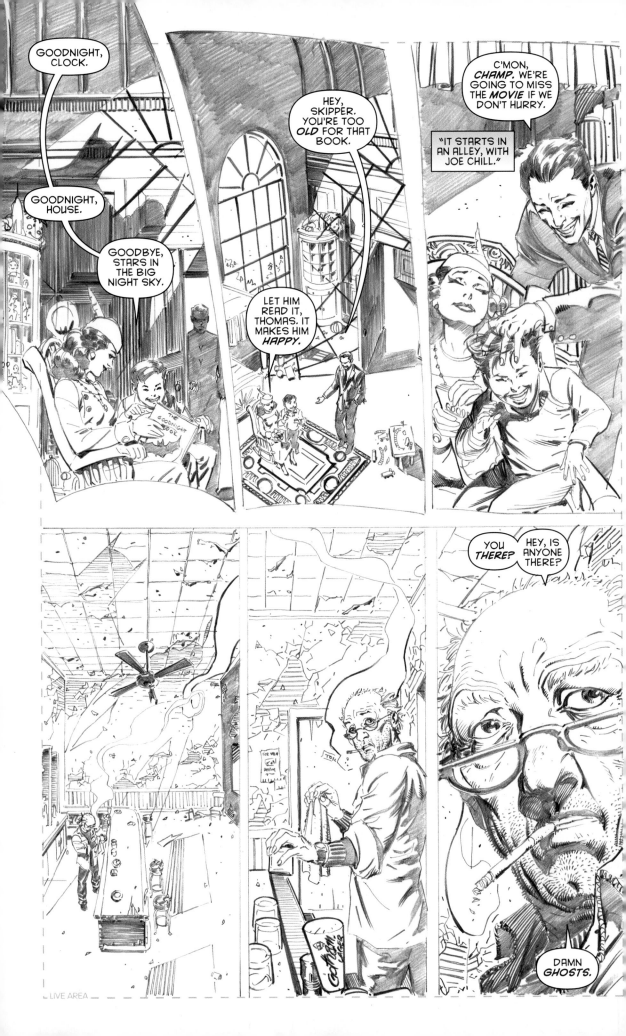

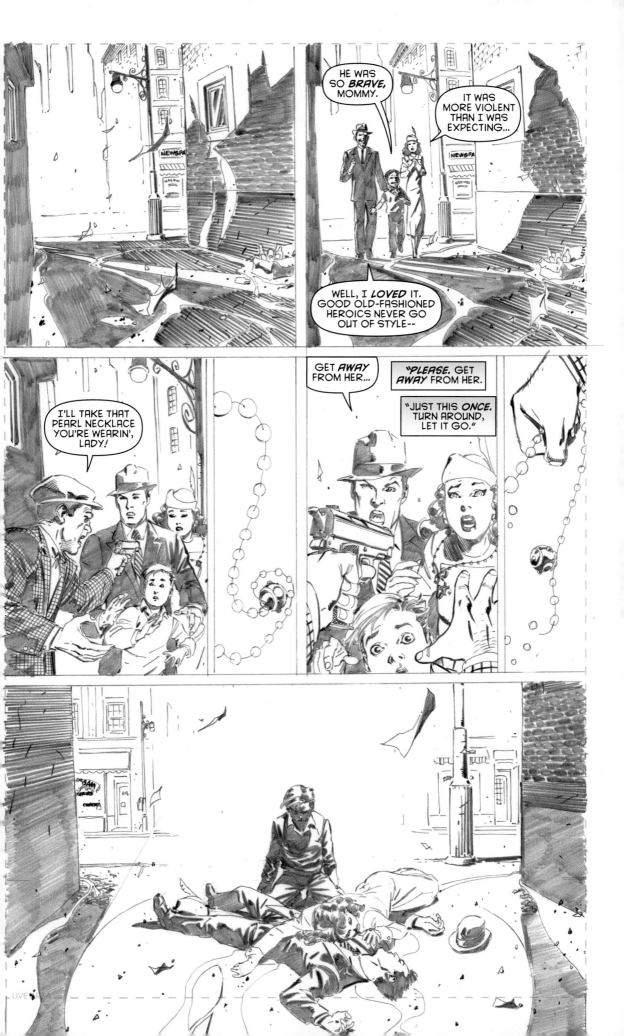

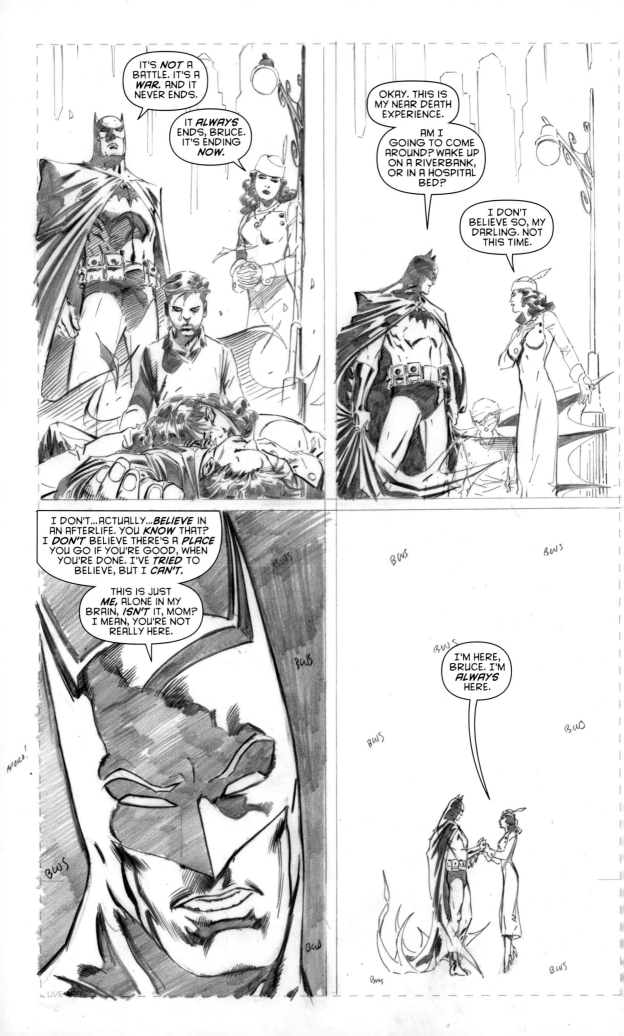

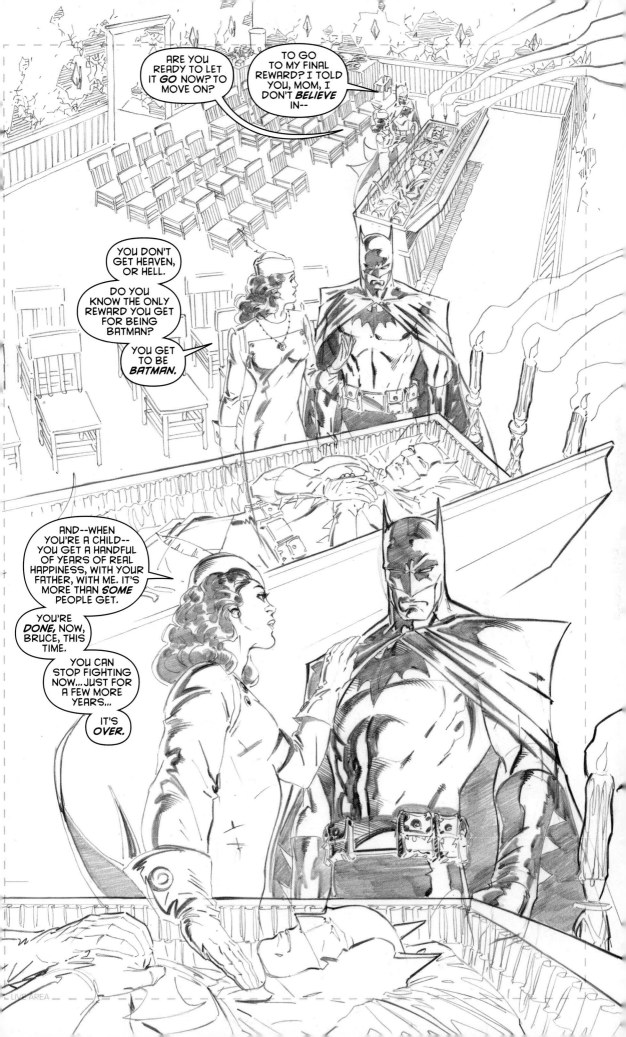

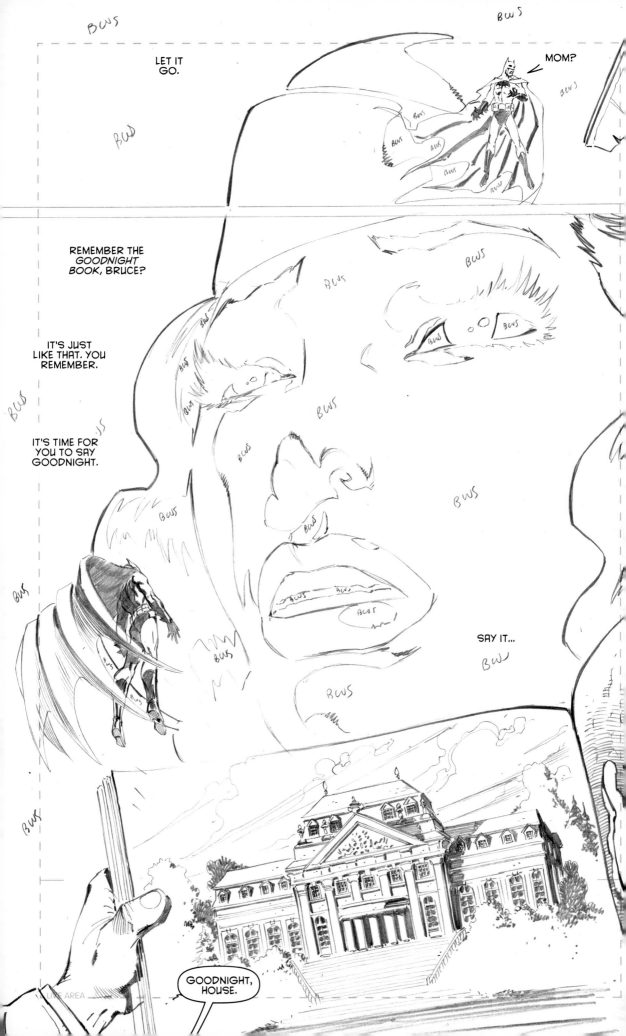

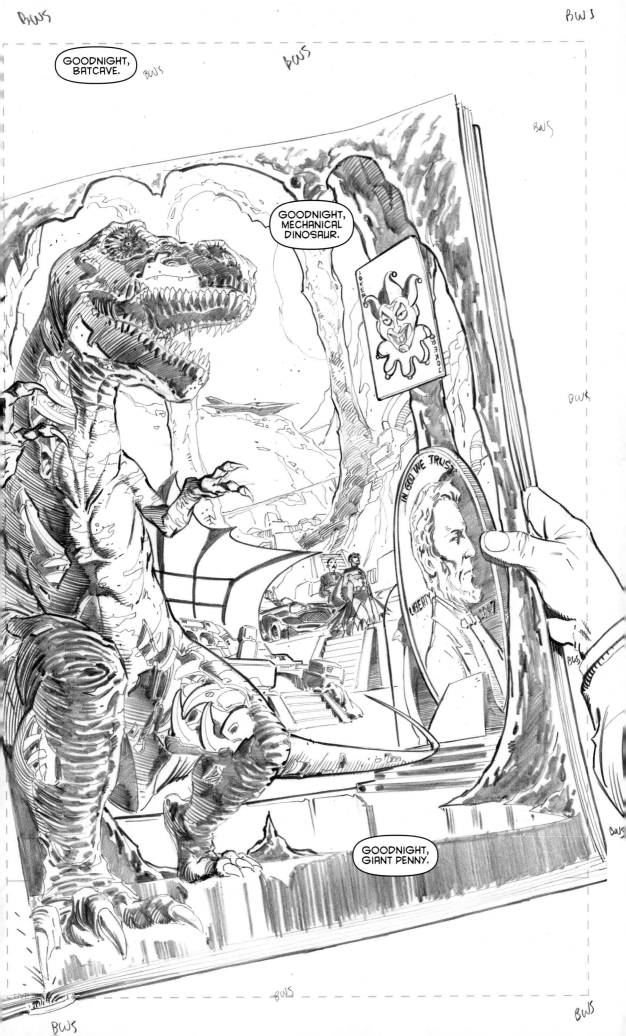

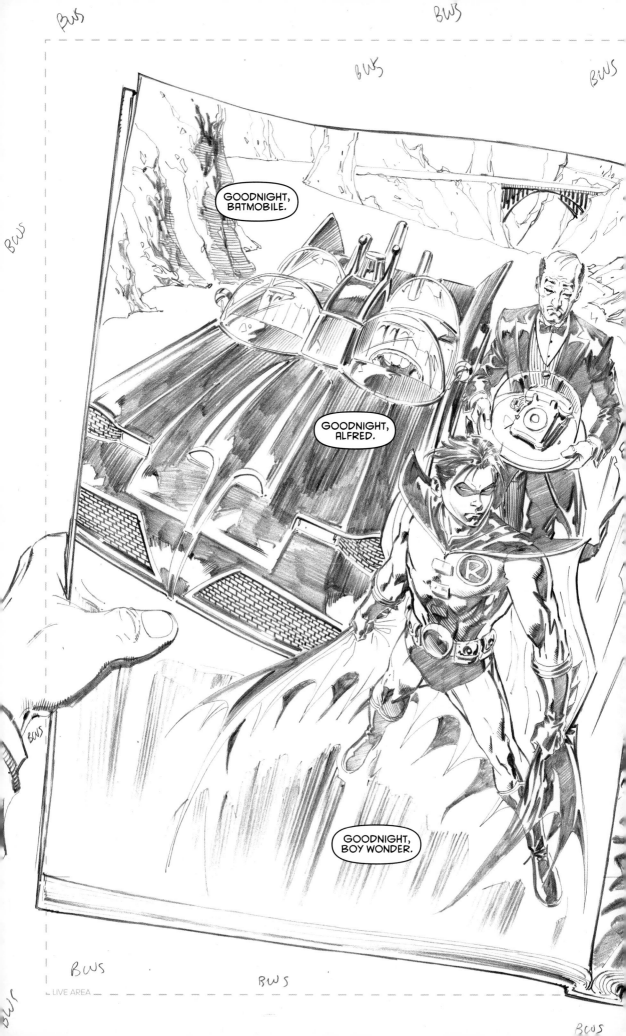

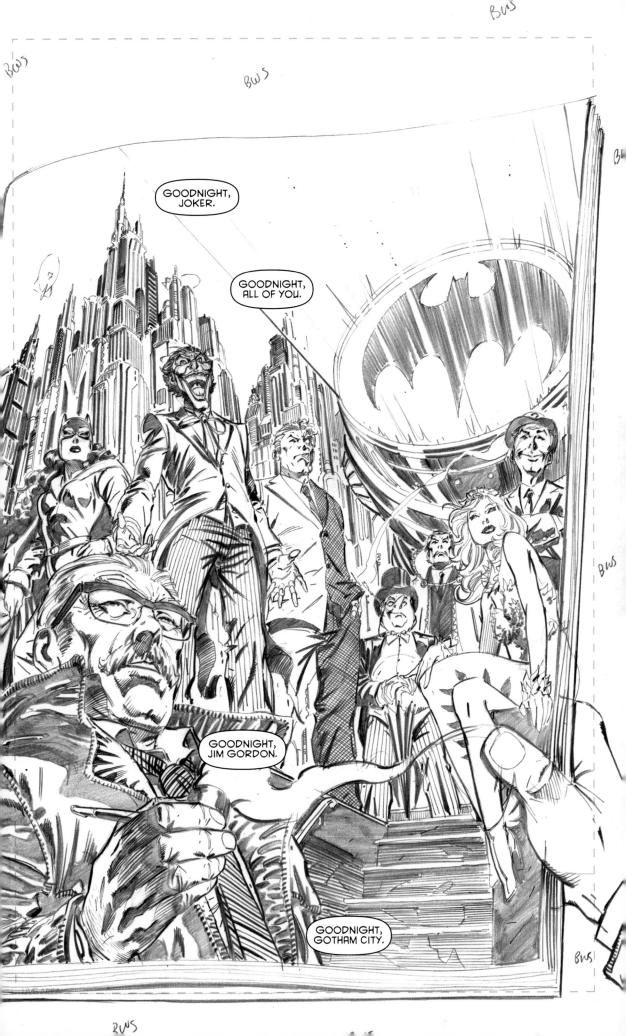

GOODNIGHT.

GOODBYE.

GOODNIGHT.

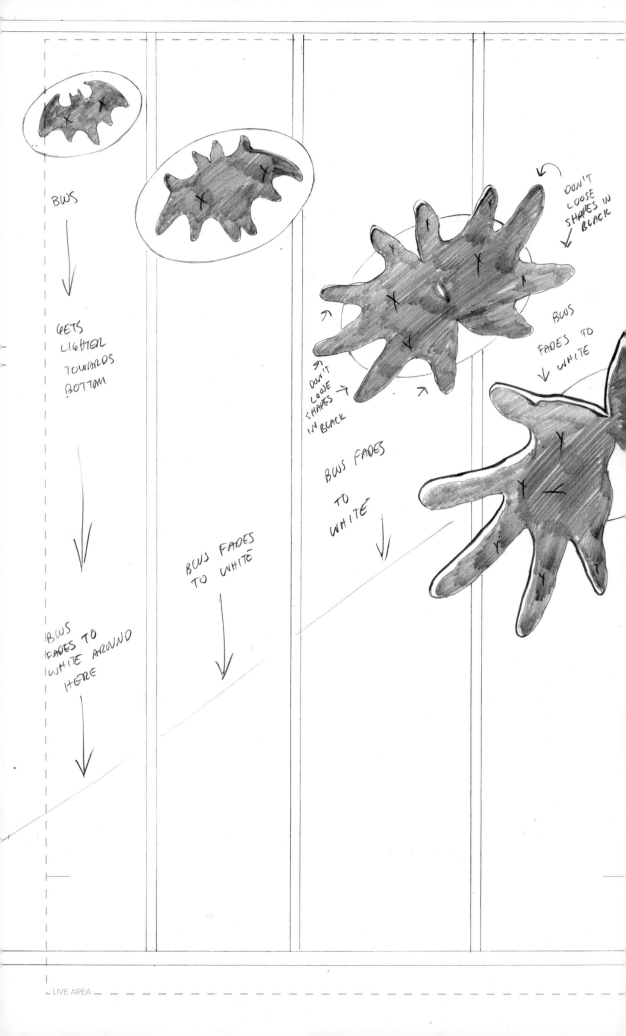

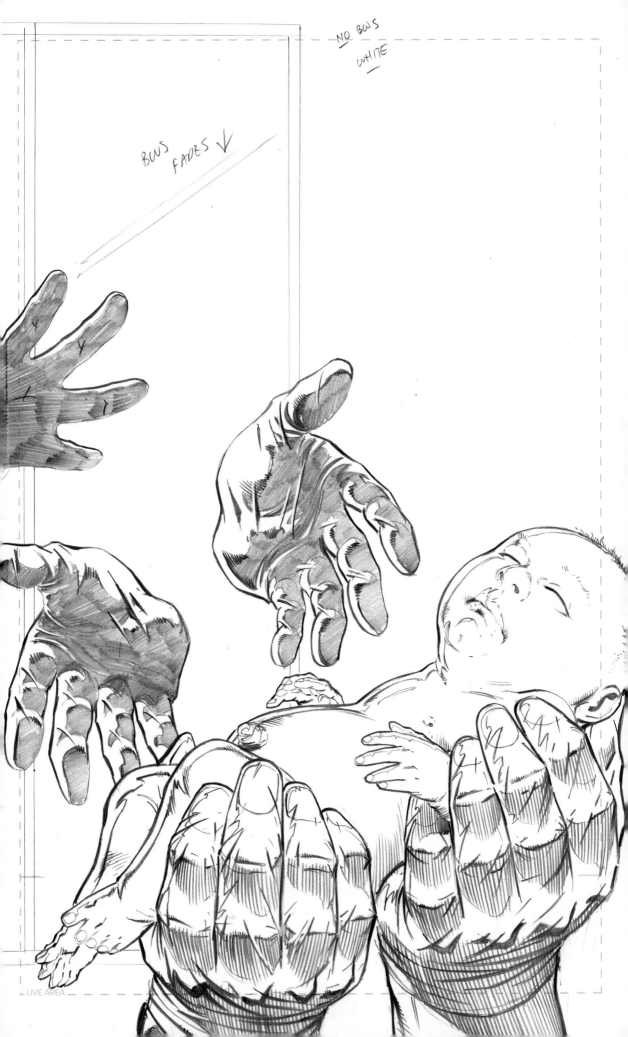

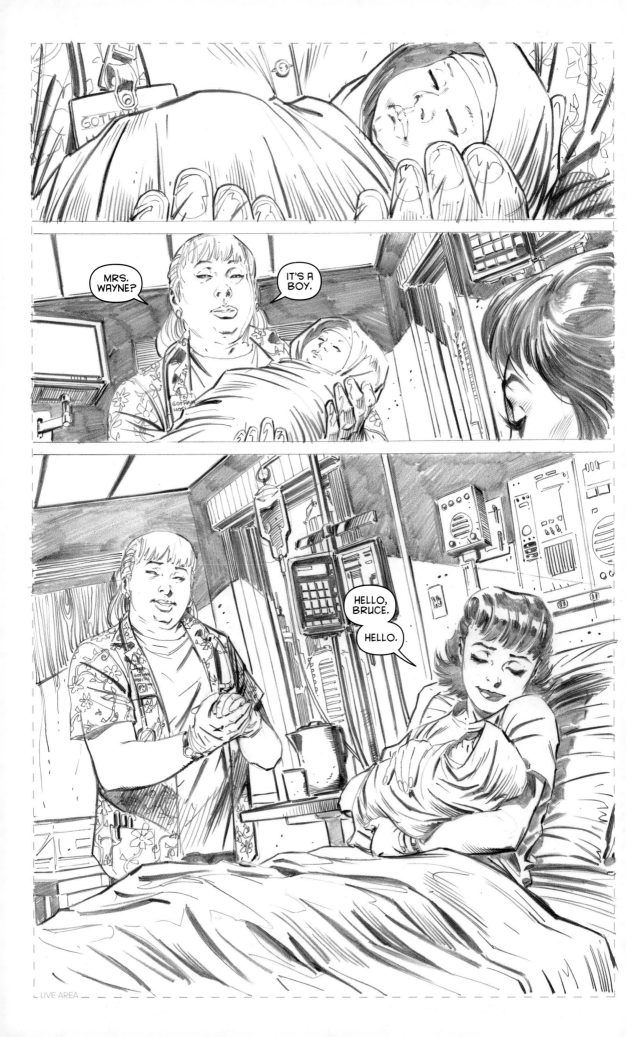

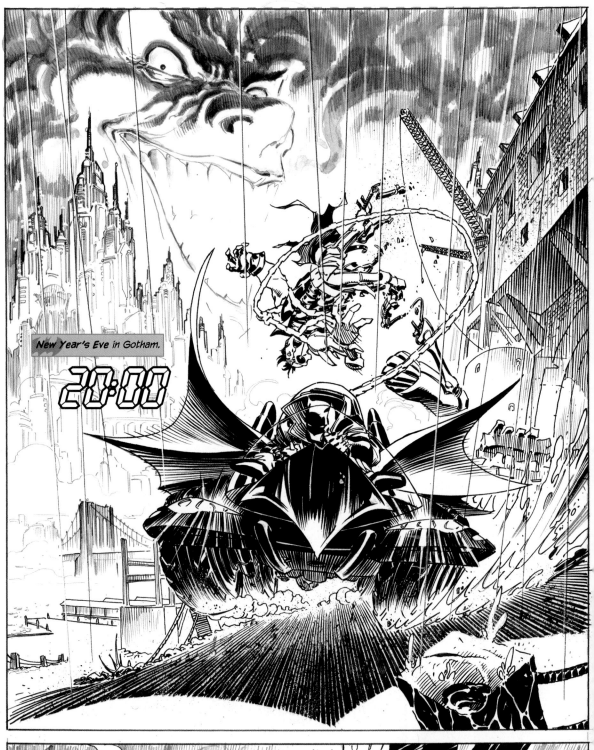

New Year's Eve in Gotham.

20:00

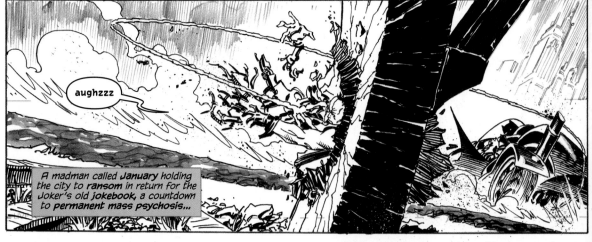

aughzzz

A madman called **January** holding the city to **ransom** in return for the Joker's old **jokebook**, a countdown to permanent mass psychosis...

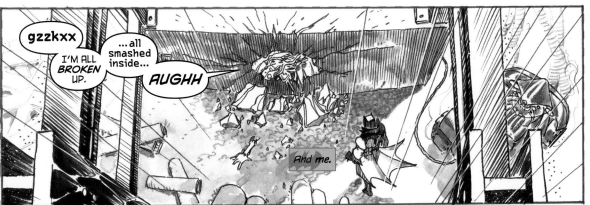

gzzkxx

I'M ALL *BROKEN* UP.

...all smashed inside...

AUGHH

And me.

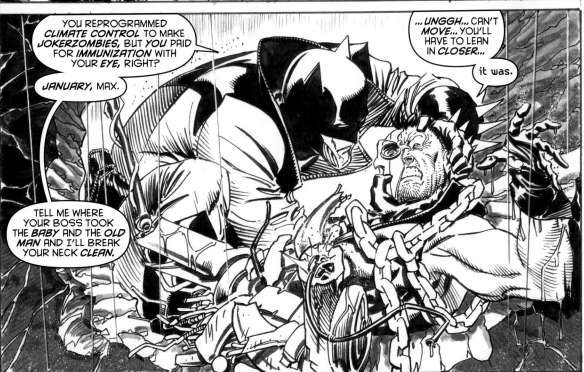

YOU REPROGRAMMED *CLIMATE CONTROL* TO MAKE *JOKERZOMBIES,* BUT *YOU* PAID FOR *IMMUNIZATION* WITH YOUR *EYE,* RIGHT?

JANUARY, MAX.

...*UNGGH...* CAN'T *MOVE...* YOU'LL HAVE TO LEAN IN *CLOSER...*

it was.

TELL ME WHERE YOUR BOSS TOOK THE *BABY* AND THE *OLD MAN* AND I'LL BREAK YOUR NECK *CLEAN.*

→PTTFF←

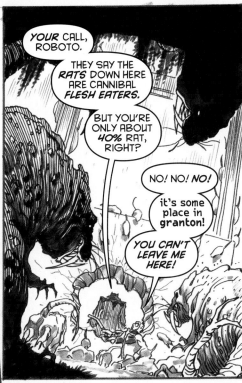

YOUR CALL, ROBOTO.

THEY SAY THE *RATS* DOWN HERE ARE CANNIBAL *FLESH EATERS.*

BUT YOU'RE ONLY ABOUT *40%* RAT, RIGHT?

NO! NO! NO!

it's some place in granton!

YOU CAN'T LEAVE ME HERE!

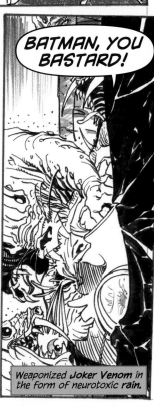

BATMAN, YOU BASTARD!

Weaponized *Joker Venom* in the form of neurotoxic *rain.*

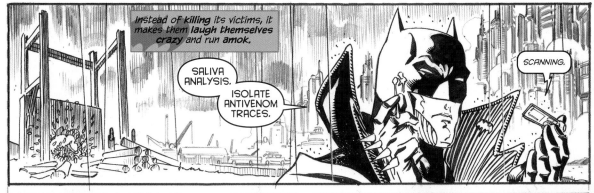

Instead of killing its victims, it makes them laugh themselves crazy and run amok.

SALIVA ANALYSIS.

ISOLATE ANTIVENOM TRACES.

SCANNING.

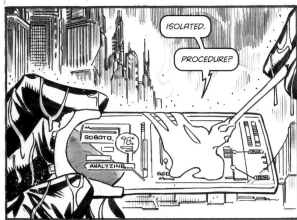

ISOLATED.

PROCEDURE?

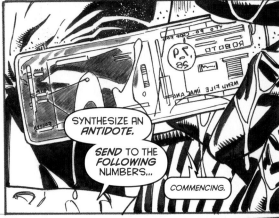

SYNTHESIZE AN *ANTIDOTE.*

SEND TO THE *FOLLOWING* NUMBERS...

COMMENCING.

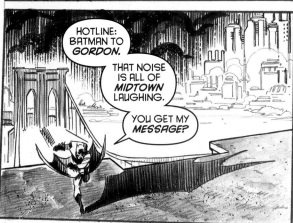

HOTLINE: BATMAN TO *GORDON.*

THAT NOISE IS ALL OF *MIDTOWN* LAUGHING.

YOU GET MY *MESSAGE?*

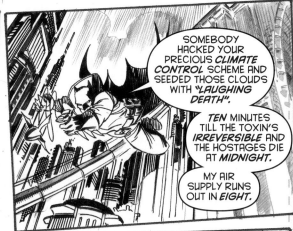

SOMEBODY HACKED YOUR PRECIOUS *CLIMATE CONTROL* SCHEME AND SEEDED THOSE CLOUDS WITH *"LAUGHING DEATH".*

TEN MINUTES TILL THE TOXIN'S *IRREVERSIBLE* AND THE HOSTAGES DIE AT *MIDNIGHT.*

MY AIR SUPPLY RUNS OUT IN *EIGHT.*

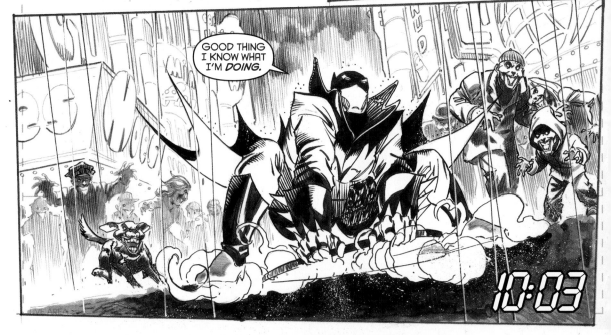

GOOD THING I KNOW WHAT I'M *DOING.*

10:03

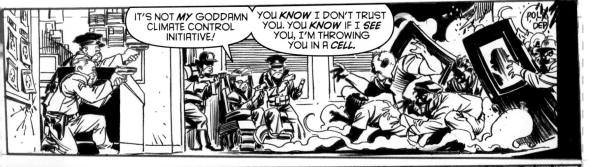

IT'S NOT *MY* GODDAMN CLIMATE CONTROL INITIATIVE!

YOU *KNOW* I DON'T TRUST YOU. YOU *KNOW* IF I *SEE* YOU, I'M THROWING YOU IN A *CELL.*

POL... DEP...

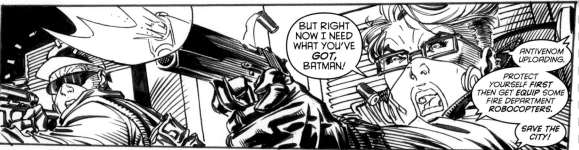

BUT RIGHT NOW I NEED WHAT YOU'VE *GOT,* BATMAN!

ANTIVENOM UPLOADING.

PROTECT YOURSELF *FIRST* THEN GET *EQUIP* SOME FIRE DEPARTMENT ROBOCOPTERS.

SAVE THE CITY!

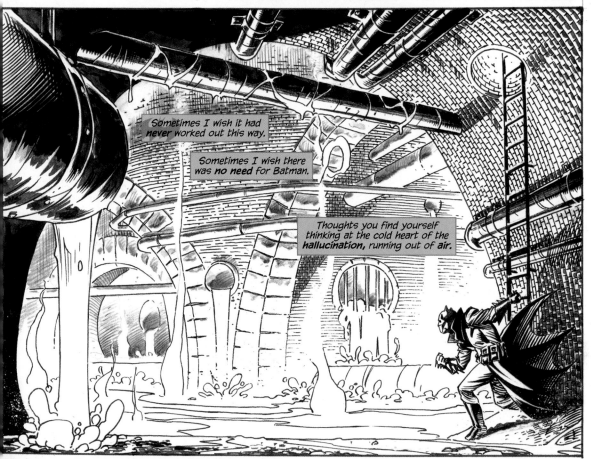

Sometimes I wish it had *never* worked out this way.

Sometimes I wish there was *no need* for Batman.

Thoughts you find yourself thinking at the cold heart of the *hallucination, running out of air.*

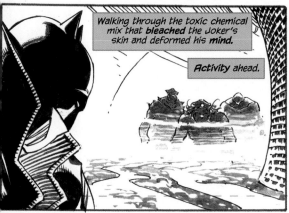

Walking through the toxic chemical mix that *bleached* the Joker's skin and deformed his *mind.*

Activity ahead.

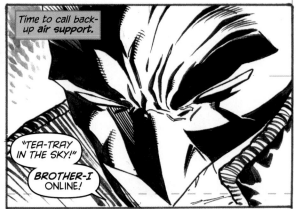

Time to call back-up *air support.*

"*TEA-TRAY* IN THE SKY!"

BROTHER-I ONLINE!

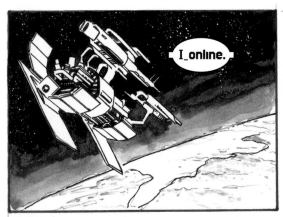

I_online.

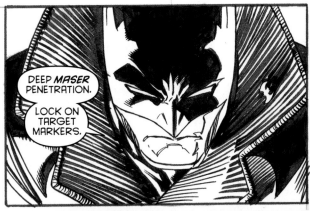

DEEP *MASER* PENETRATION.

LOCK ON TARGET MARKERS.

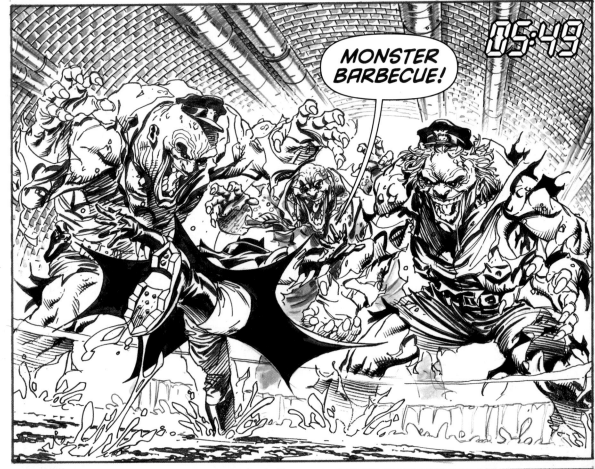

MONSTER BARBECUE!

05:49

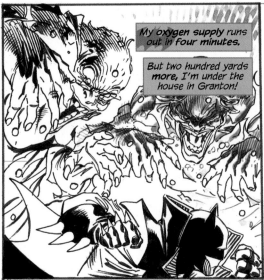

My oxygen supply runs out in four minutes.

But two hundred yards more, I'm under the house in Granton!

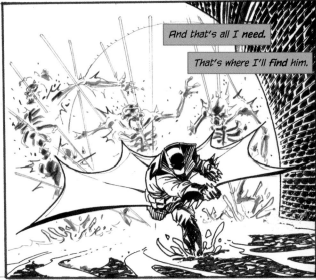

And that's all I need.

That's where I'll find him.

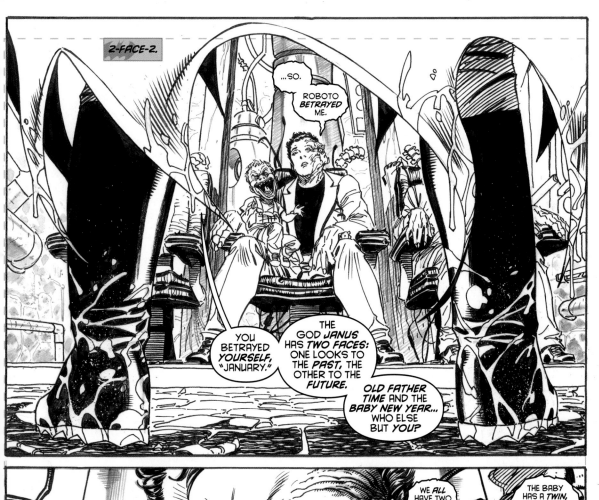

2-FACE-2.

...SO.

ROBOTO *BETRAYED* ME.

YOU BETRAYED *YOURSELF,* "JANUARY."

THE GOD *JANUS* HAS *TWO FACES:* ONE LOOKS TO THE *PAST,* THE OTHER TO THE *FUTURE.*

OLD FATHER *TIME* AND THE *BABY NEW YEAR...* WHO ELSE BUT *YOU?*

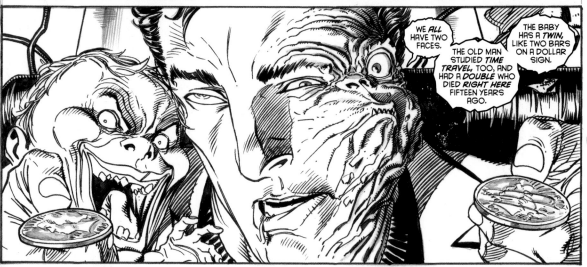

WE *ALL* HAVE TWO FACES. THE OLD MAN STUDIED *TIME TRAVEL,* TOO, AND HAD A *DOUBLE* WHO DIED *RIGHT HERE* FIFTEEN YEARS AGO.

THE BABY HAS A *TWIN,* LIKE TWO BARS ON A DOLLAR SIGN.

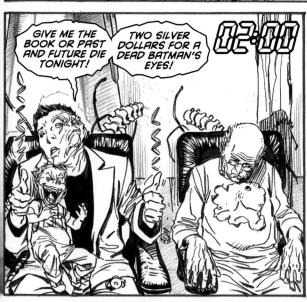

GIVE ME THE *BOOK* OR PAST AND FUTURE DIE TONIGHT!

TWO SILVER DOLLARS FOR A DEAD BATMAN'S EYES!

02:00

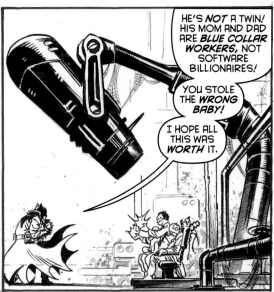

HE'S *NOT* A TWIN! HIS MOM AND DAD ARE *BLUE COLLAR WORKERS,* NOT SOFTWARE BILLIONAIRES!

YOU STOLE THE *WRONG BABY!*

I HOPE ALL THIS WAS *WORTH* IT.

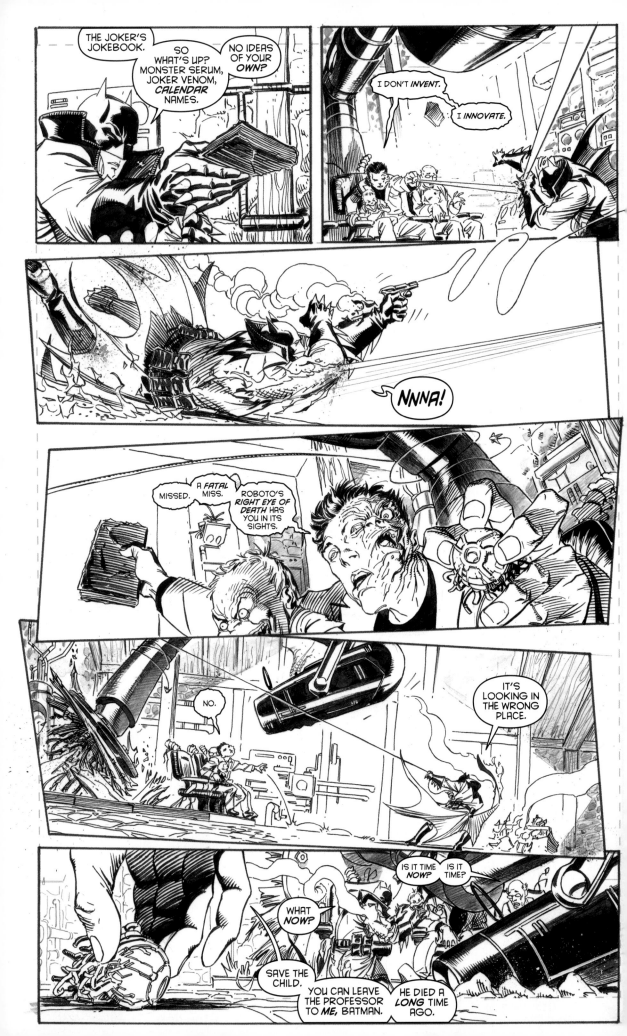

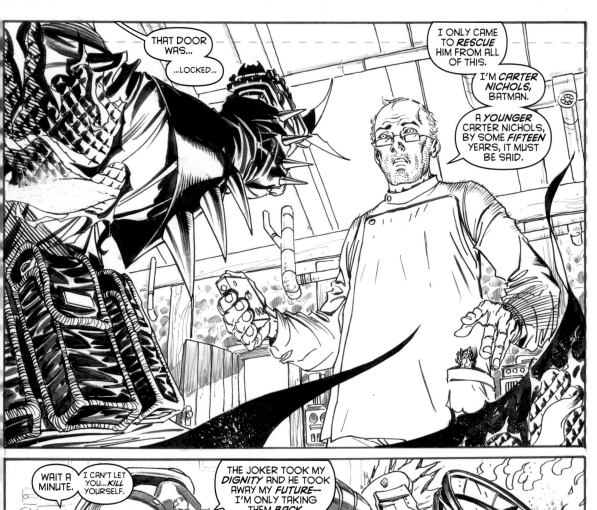

THAT DOOR WAS...

...LOCKED...

I ONLY CAME TO *RESCUE* HIM FROM ALL OF THIS.

I'M *CARTER NICHOLS*, BATMAN.

A *YOUNGER* CARTER NICHOLS, BY SOME *FIFTEEN* YEARS, IT MUST BE SAID.

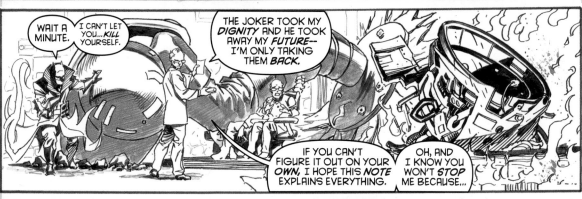

WAIT A MINUTE.

I CAN'T LET YOU...*KILL* YOURSELF.

THE JOKER TOOK MY *DIGNITY* AND HE TOOK AWAY MY *FUTURE*-- I'M ONLY TAKING THEM *BACK*.

IF YOU CAN'T FIGURE IT OUT ON YOUR *OWN*, I HOPE THIS *NOTE* EXPLAINS EVERYTHING.

OH, AND I KNOW YOU WON'T *STOP* ME BECAUSE...

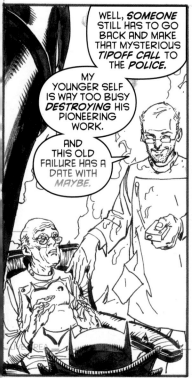

WELL, *SOMEONE* STILL HAS TO GO BACK AND MAKE THAT MYSTERIOUS *TIPOFF CALL* TO THE *POLICE*.

MY *YOUNGER* SELF IS WAY TOO BUSY *DESTROYING* HIS PIONEERING WORK.

AND THIS OLD *FAILURE* HAS A *DATE* WITH *MAYBE*.

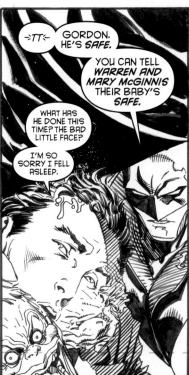

→*TT*←

GORDON. HE'S *SAFE*.

YOU CAN TELL *WARREN* AND *MARY* MCGINNIS THEIR BABY'S *SAFE*.

WHAT HAS HE DONE THIS TIME? THE BAD LITTLE FACE?

I'M SO SORRY I FELL ASLEEP.

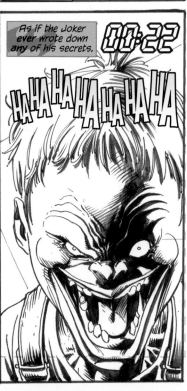

As if the Joker ever wrote down any of his secrets.

00:22

HA HA HA HA HA HA HA

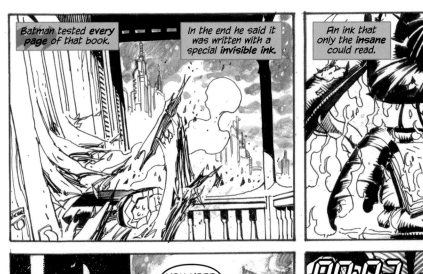

Batman tested *every* page of that book.

In the end he said it was written with a special *invisible* ink.

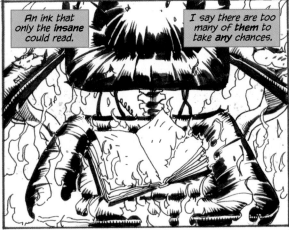

An ink that only the *insane* could read.

I say there are too many of *them* to take *any* chances.

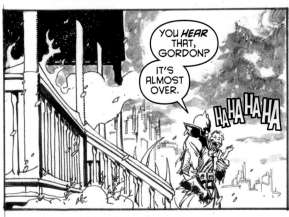

YOU *HEAR* THAT, GORDON?

IT'S ALMOST OVER.

HA HA HA HA

00:02 HA*

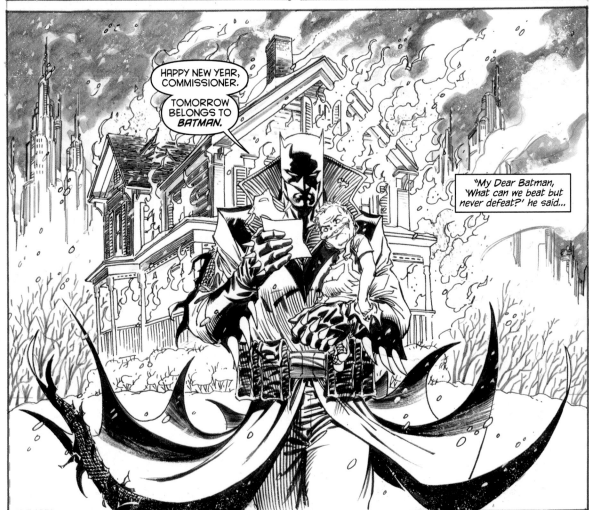

HAPPY NEW YEAR, COMMISSIONER.

TOMORROW BELONGS TO *BATMAN.*

"My Dear Batman, 'What can we beat but never defeat?' he said...

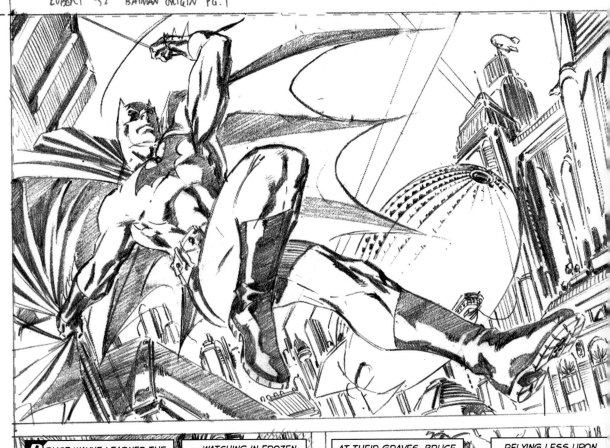

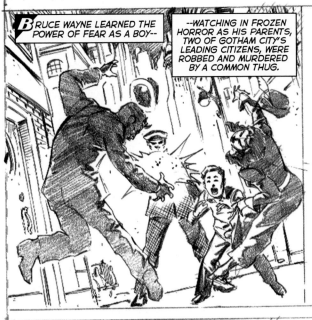

BRUCE WAYNE LEARNED THE POWER OF FEAR AS A BOY--

--WATCHING IN FROZEN HORROR AS HIS PARENTS, TWO OF GOTHAM CITY'S LEADING CITIZENS, WERE ROBBED AND MURDERED BY A COMMON THUG.

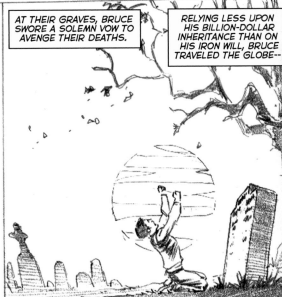

AT THEIR GRAVES, BRUCE SWORE A SOLEMN VOW TO AVENGE THEIR DEATHS.

RELYING LESS UPON HIS BILLION-DOLLAR INHERITANCE THAN ON HIS IRON WILL, BRUCE TRAVELED THE GLOBE--

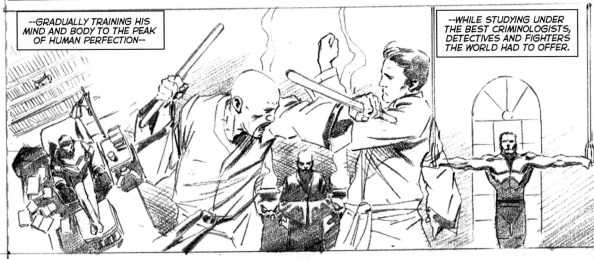

--GRADUALLY TRAINING HIS MIND AND BODY TO THE PEAK OF HUMAN PERFECTION--

--WHILE STUDYING UNDER THE BEST CRIMINOLOGISTS, DETECTIVES AND FIGHTERS THE WORLD HAD TO OFFER.

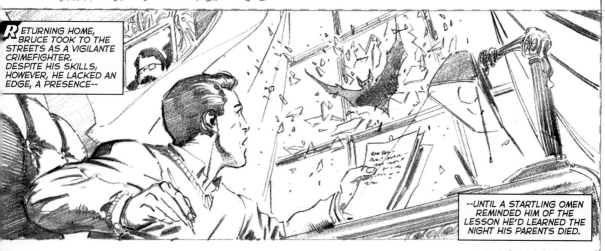

RETURNING HOME, BRUCE TOOK TO THE STREETS AS A VIGILANTE CRIMEFIGHTER. DESPITE HIS SKILLS, HOWEVER, HE LACKED AN EDGE, A PRESENCE--

--UNTIL A STARTLING OMEN REMINDED HIM OF THE LESSON HE'D LEARNED THE NIGHT HIS PARENTS DIED.

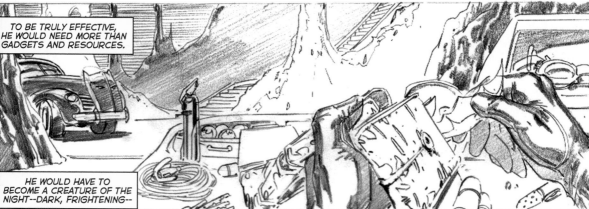

TO BE TRULY EFFECTIVE, HE WOULD NEED MORE THAN GADGETS AND RESOURCES.

HE WOULD HAVE TO BECOME A CREATURE OF THE NIGHT--DARK, FRIGHTENING--

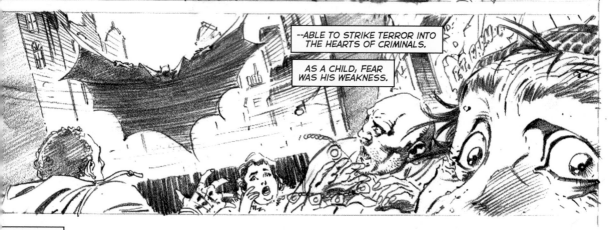

--ABLE TO STRIKE TERROR INTO THE HEARTS OF CRIMINALS.

AS A CHILD, FEAR WAS HIS WEAKNESS.

AS A MAN, IT BECAME HIS WEAPON.

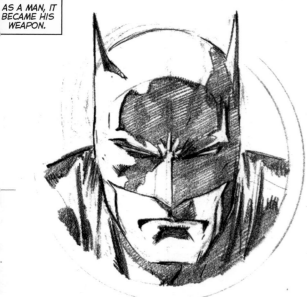

POWERS AND WEAPONS:

Besides being a master of fighting styles, the Batman is a legendary escape artist and the world's greatest detective. His utility belt is stocked with a wide array of tools and armaments, including batarangs, grapnels and zip-lines, gas and smoke capsules, and remote controls for his fleet of Batmobiles.

ESSENTIAL STORYLINES:

THE BATMAN CHRONICLES
BATMAN: YEAR ONE
THE DARK KNIGHT RETURNS
BATMAN: THE GREATEST STORIES EVER TOLD

ALLIANCES:

Justice League of America

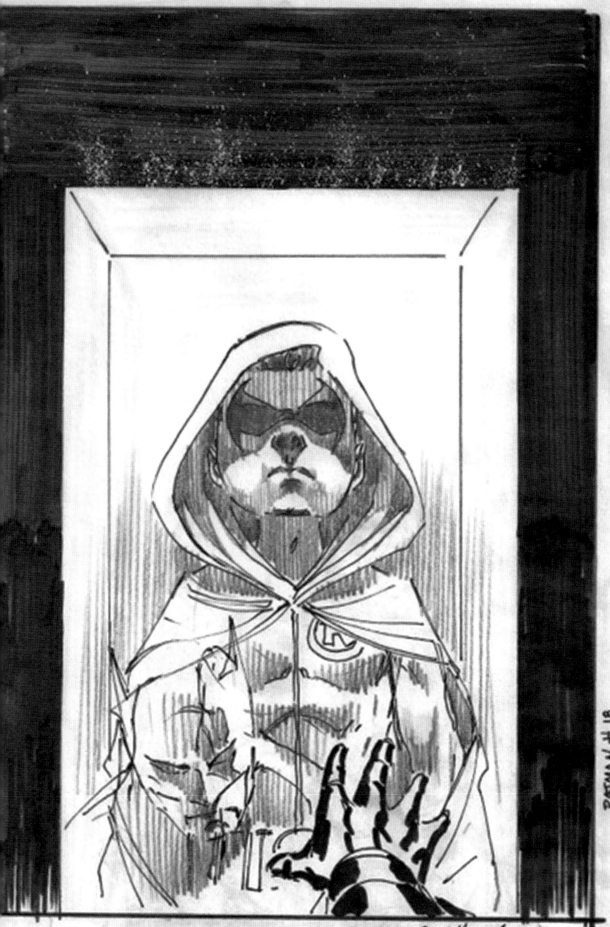

BATMAN # 18

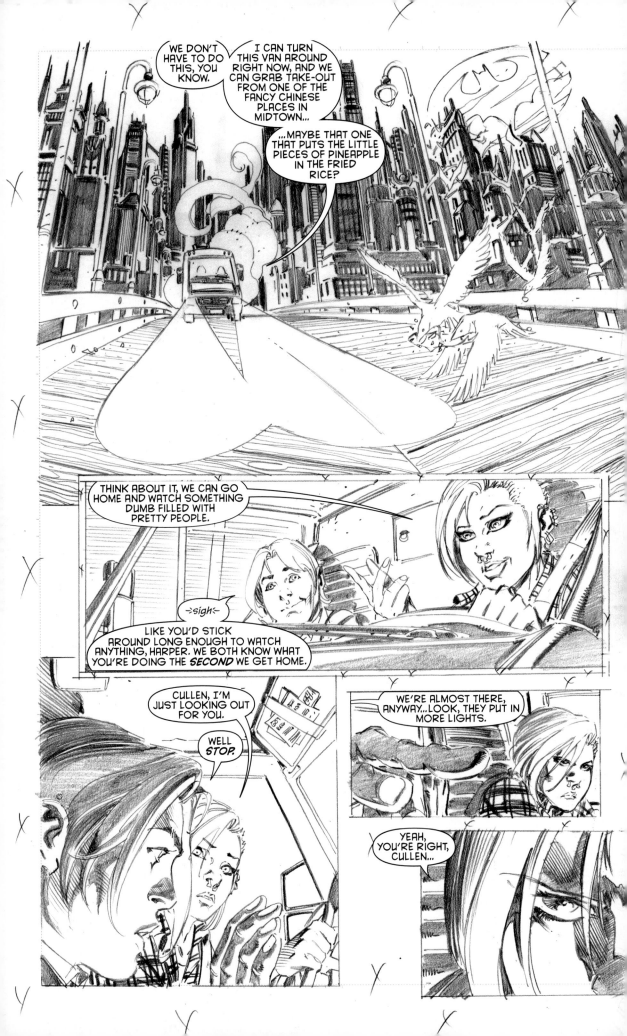

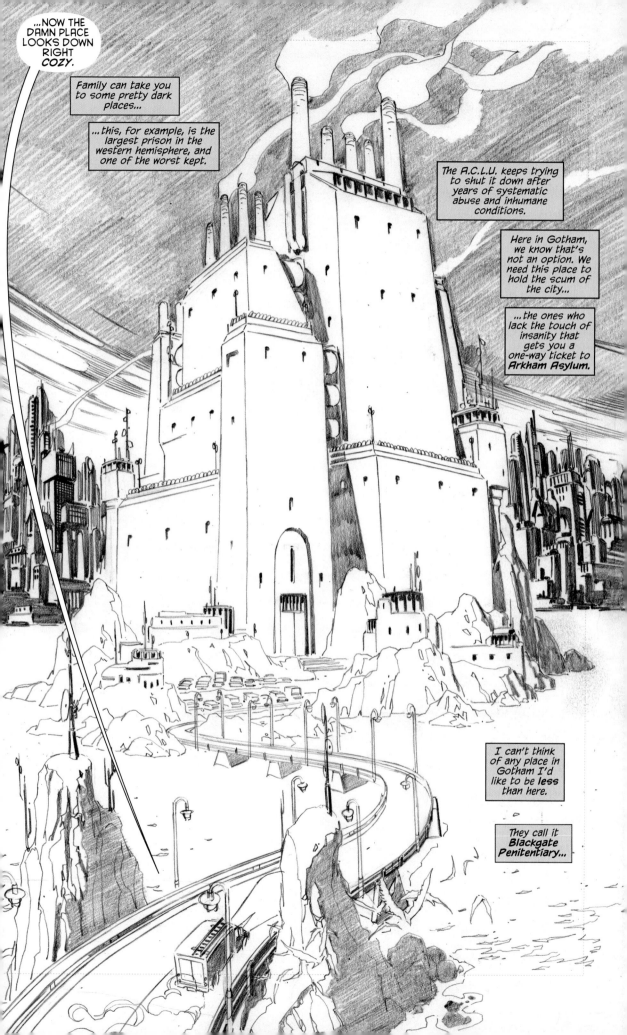

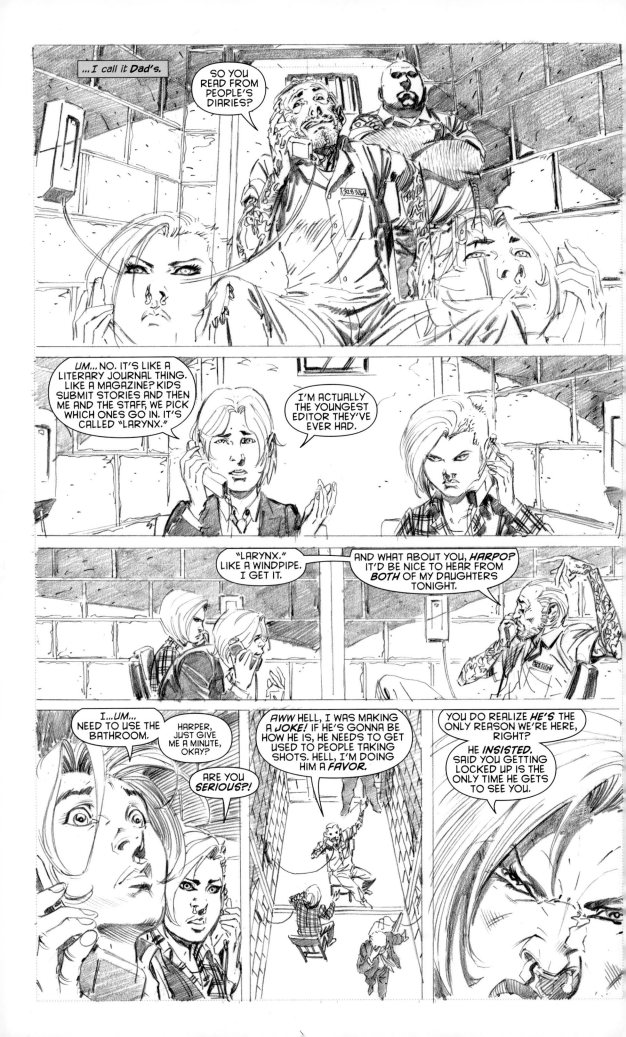

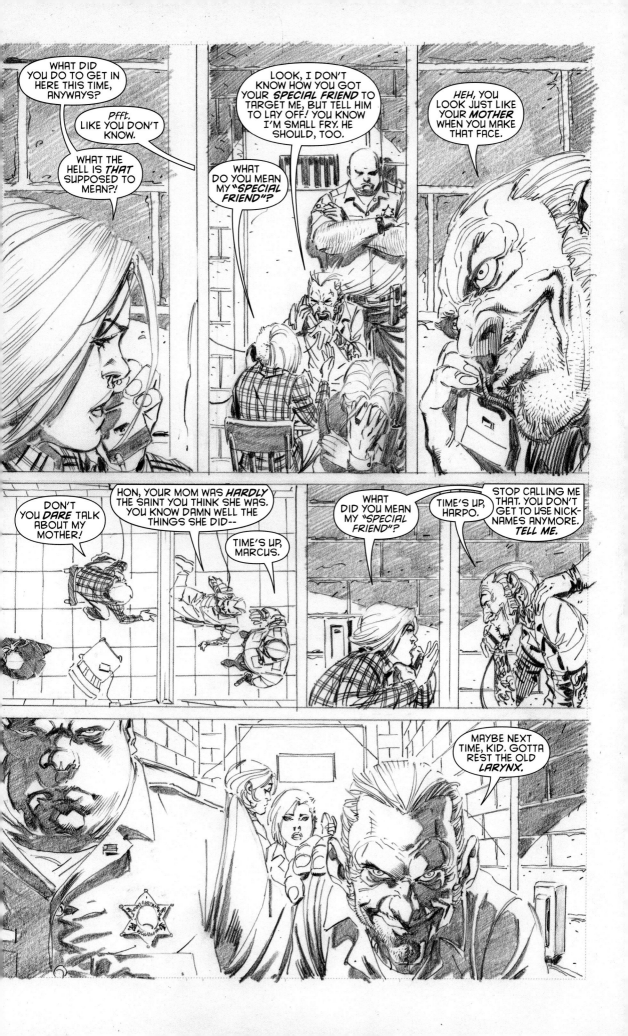

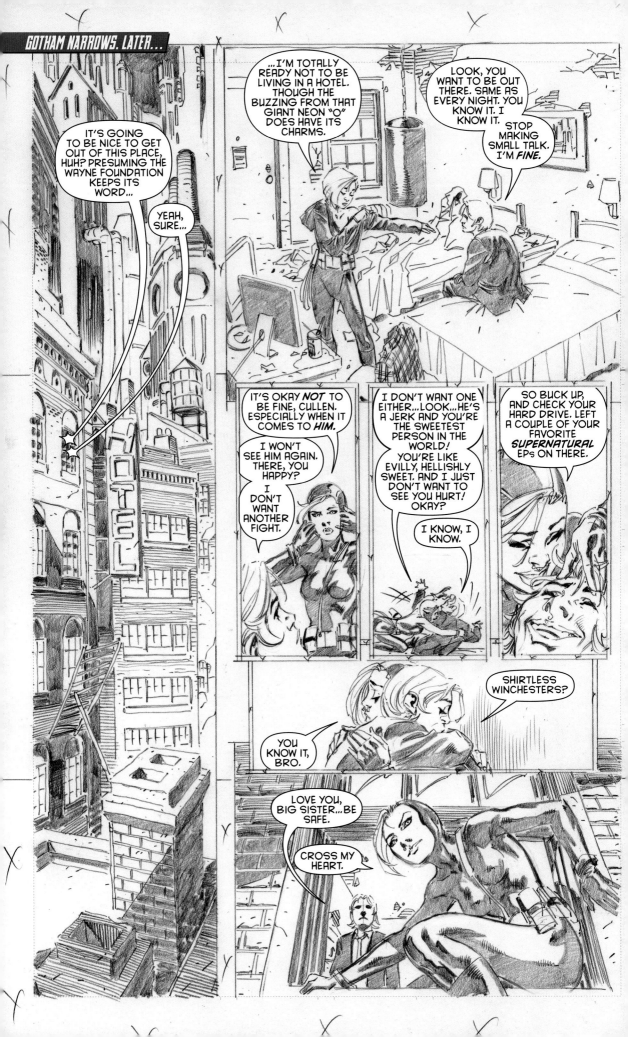

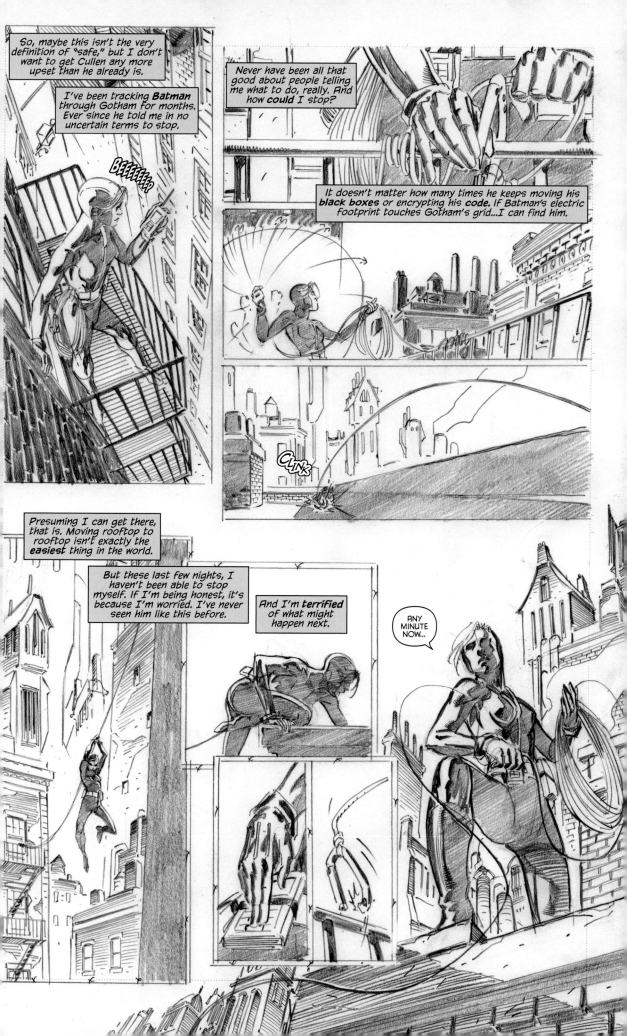

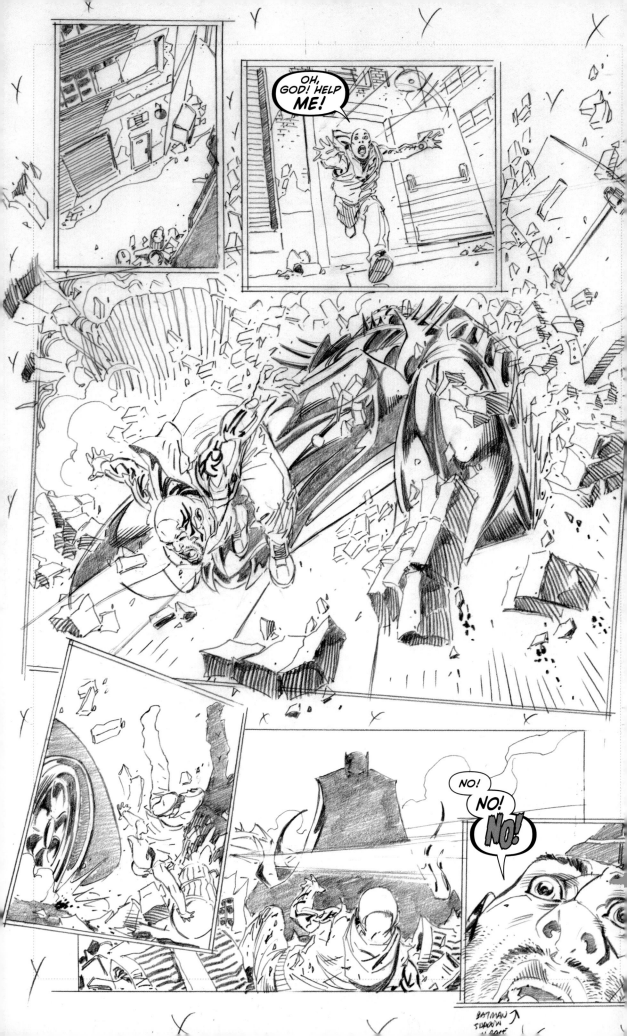

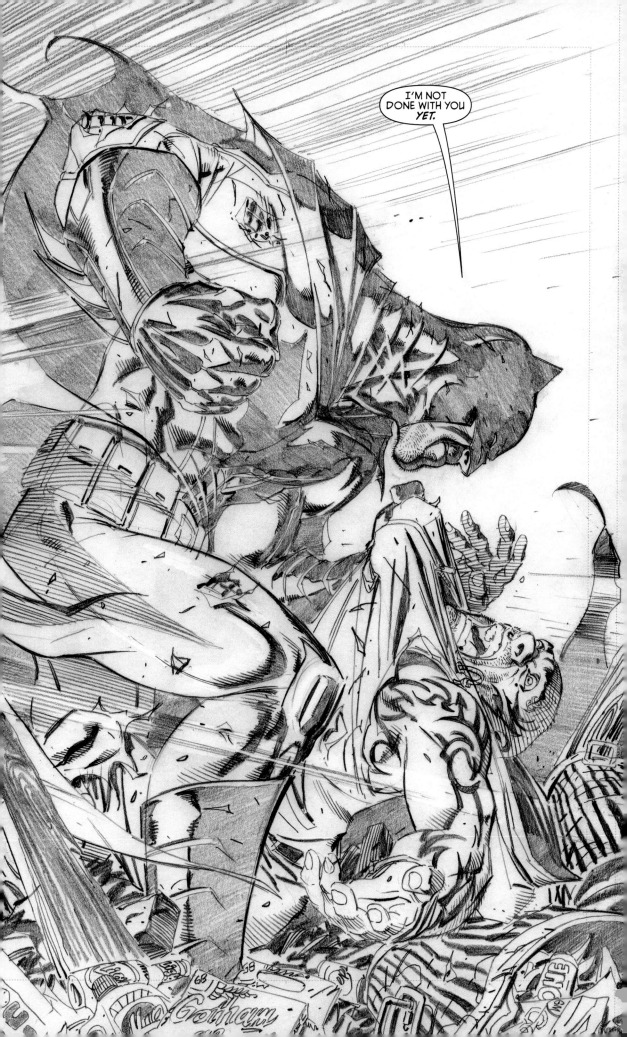

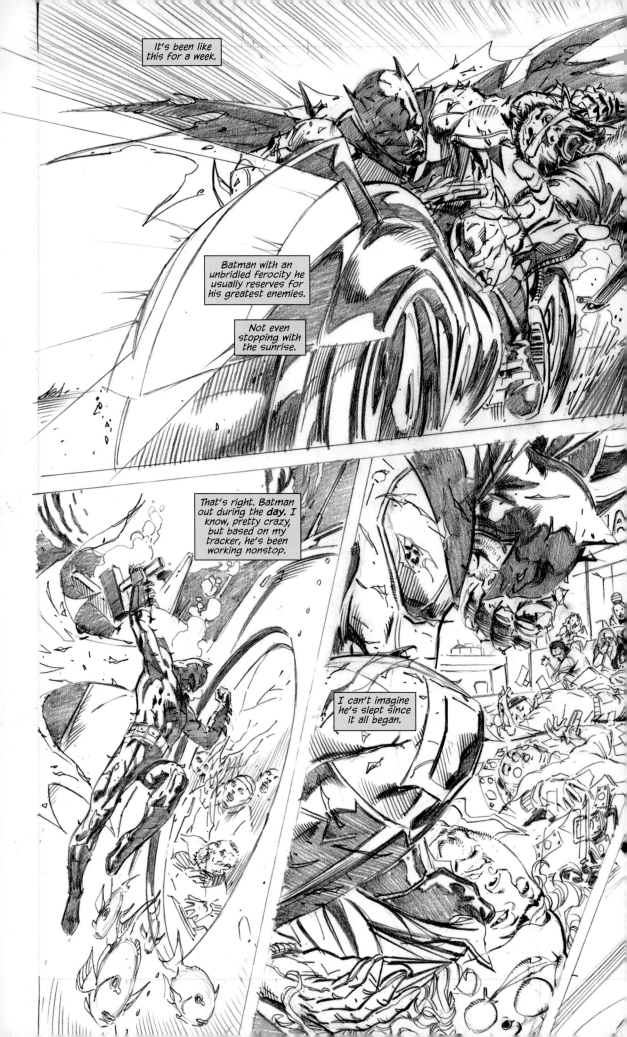

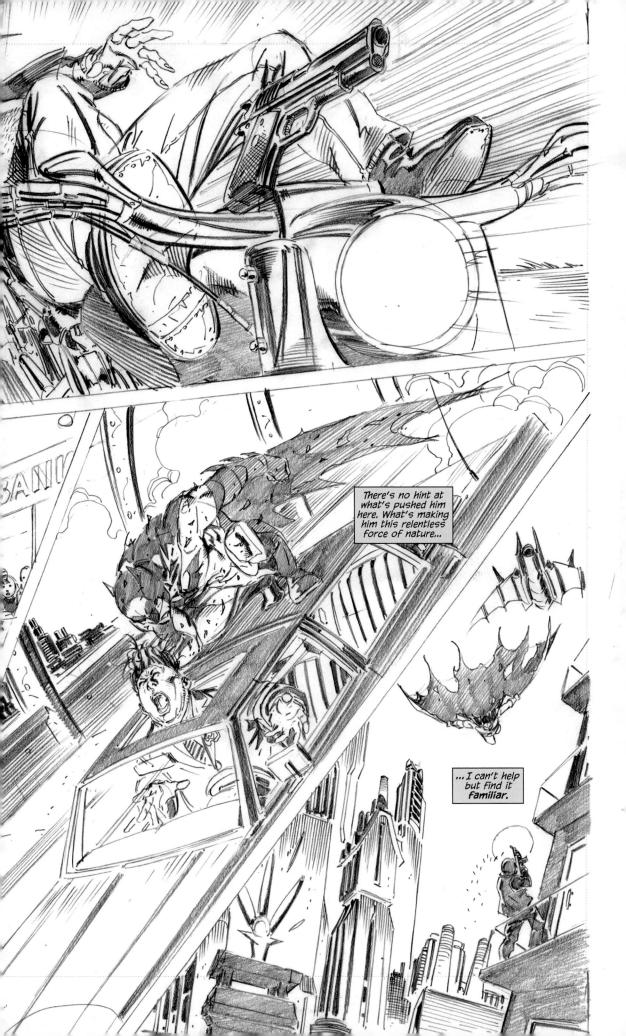

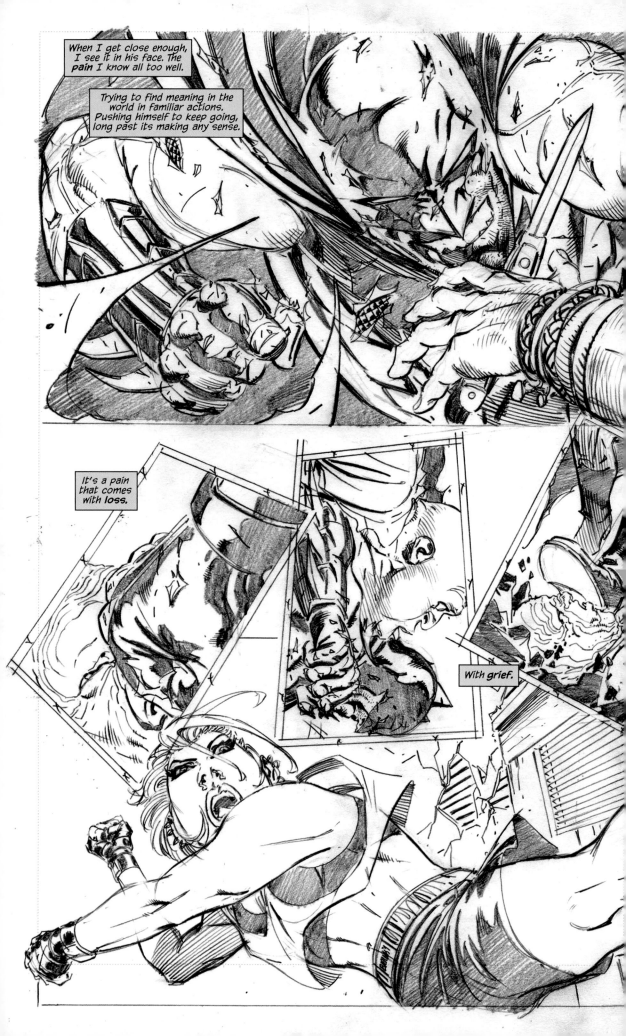

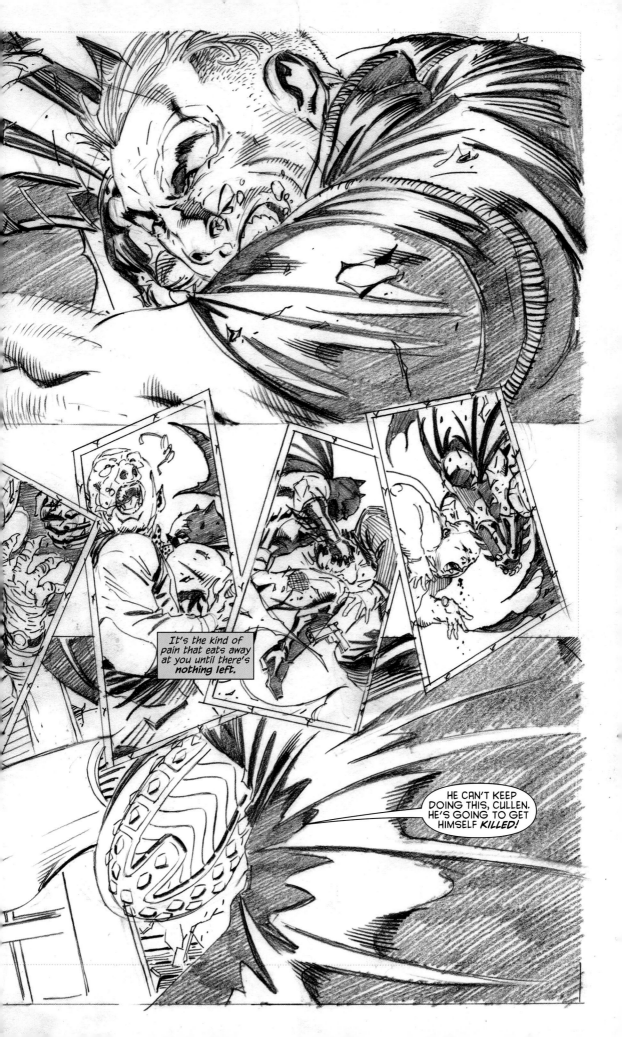

It's the kind of pain that eats away at you until there's *nothing left.*

HE CAN'T KEEP DOING THIS, CULLEN. HE'S GOING TO GET HIMSELF *KILLED!*

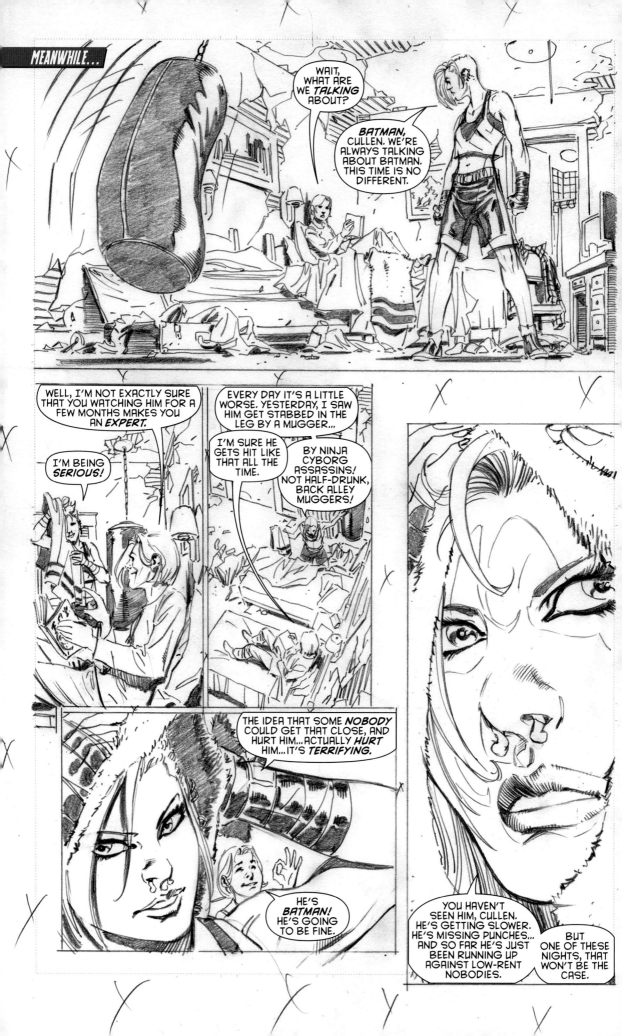

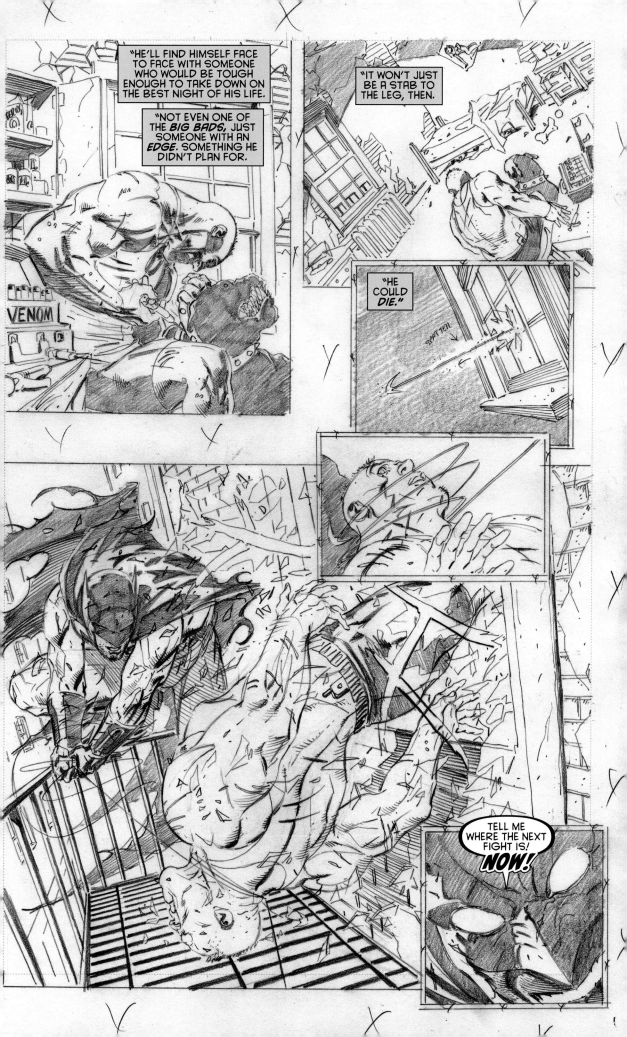

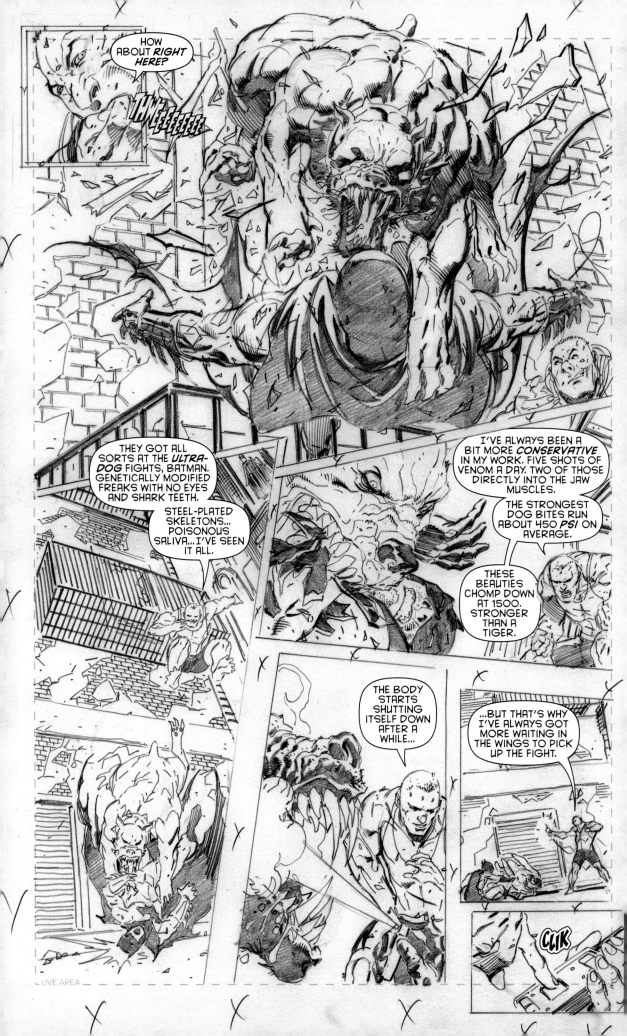

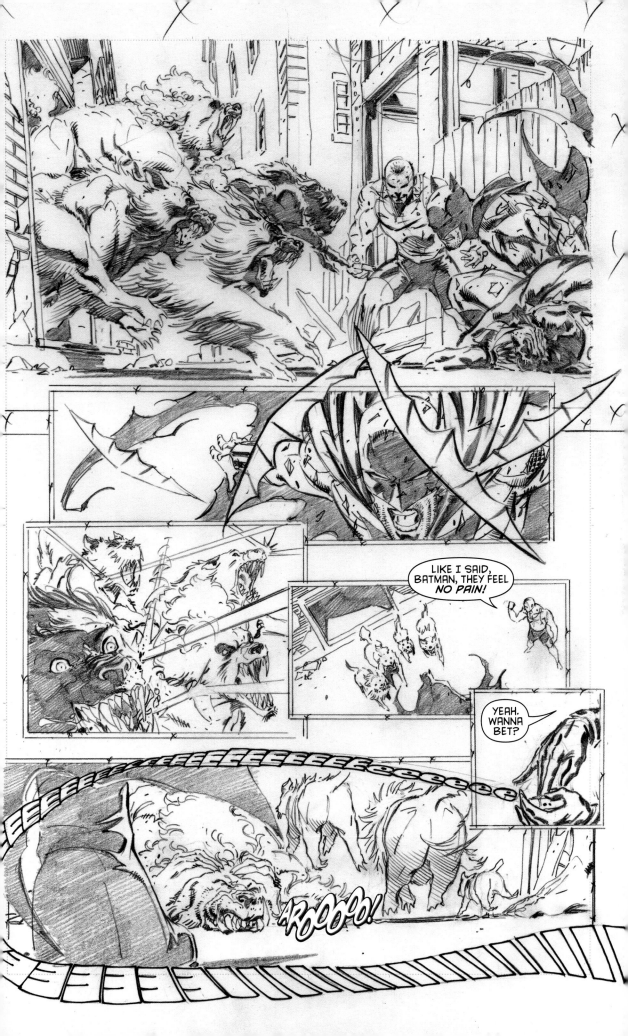

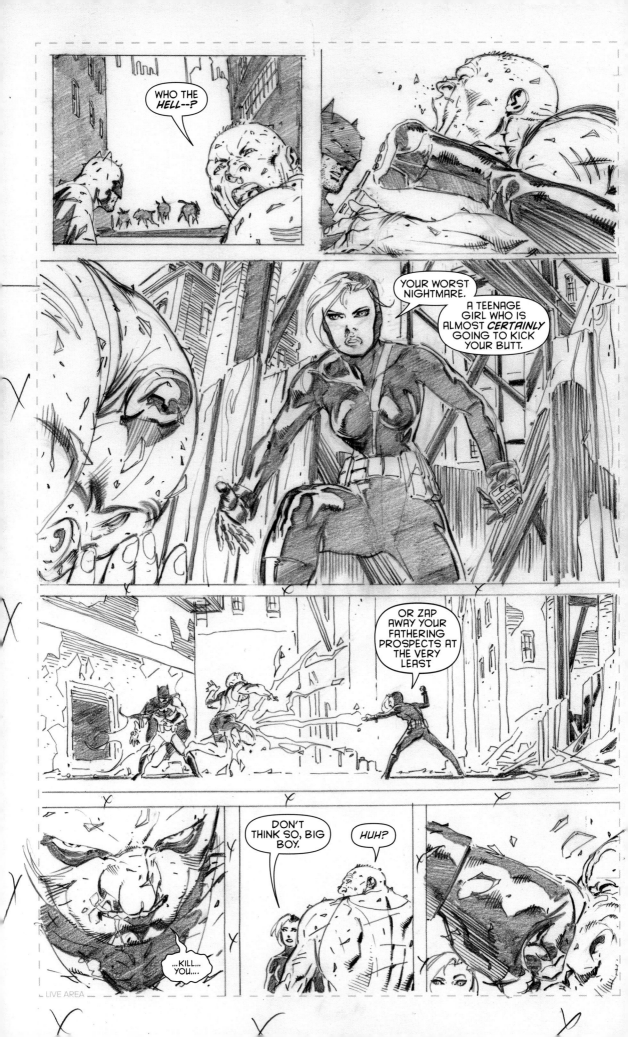

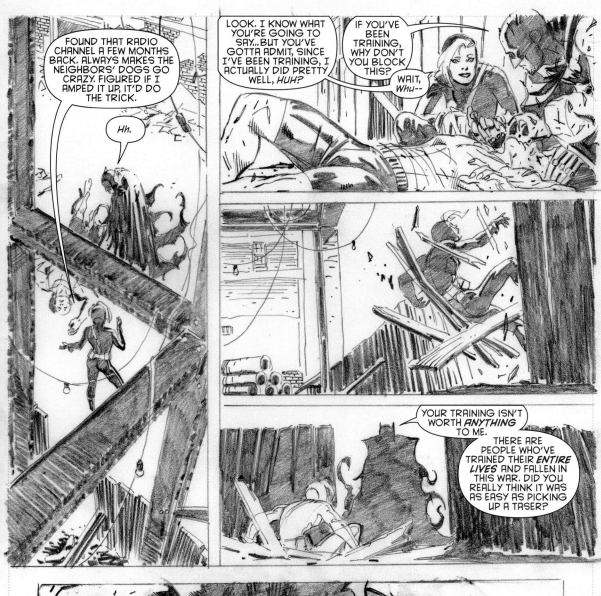

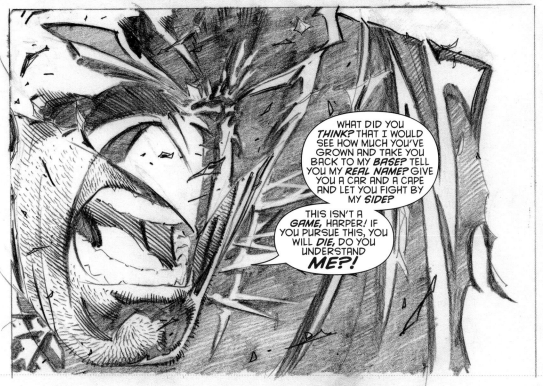

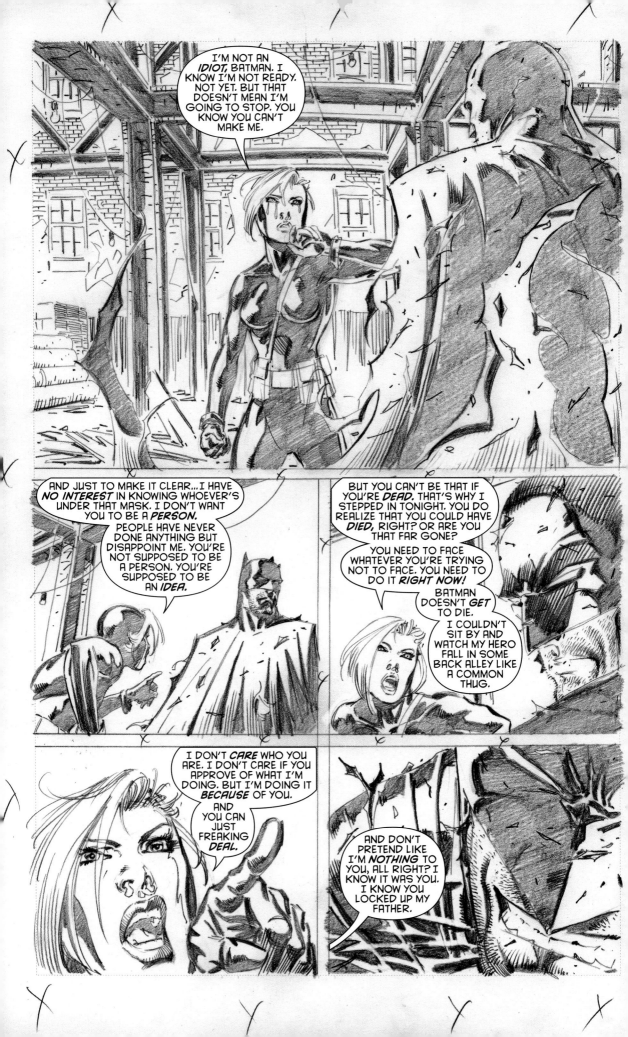

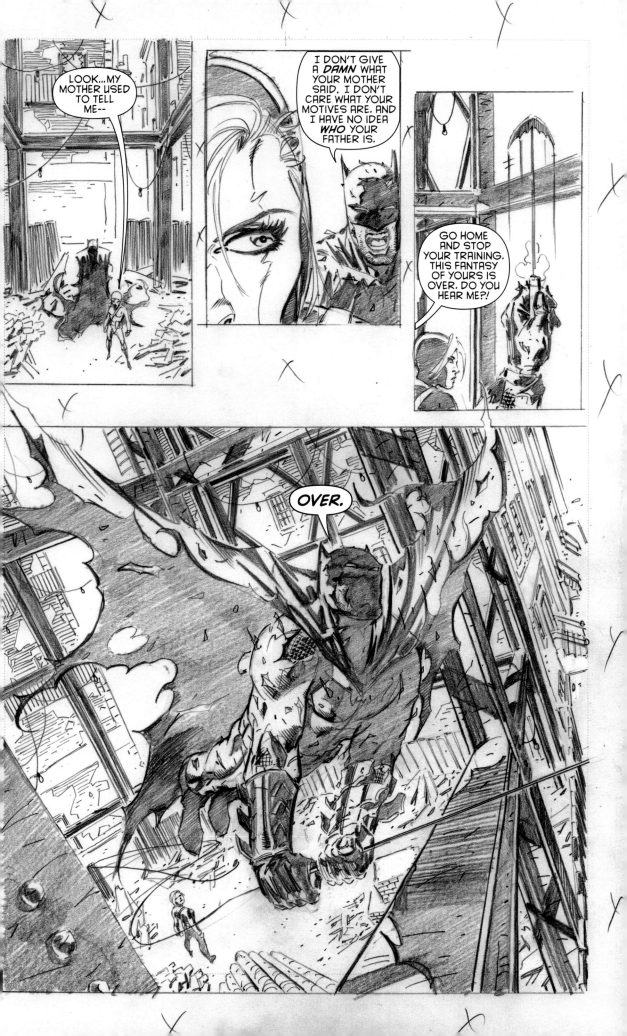

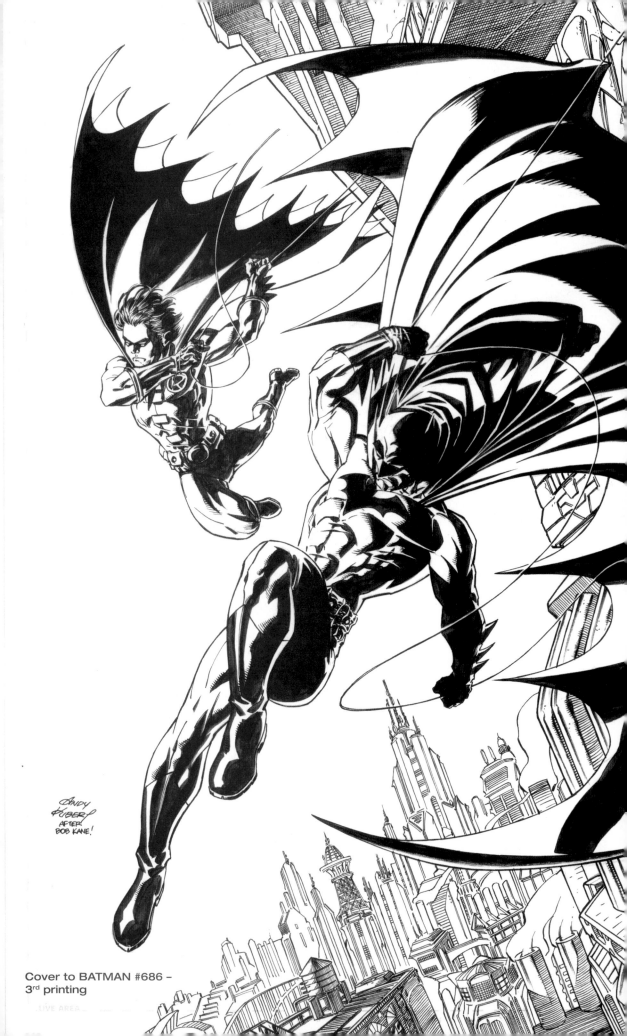

Cover to BATMAN #686 –
3rd printing

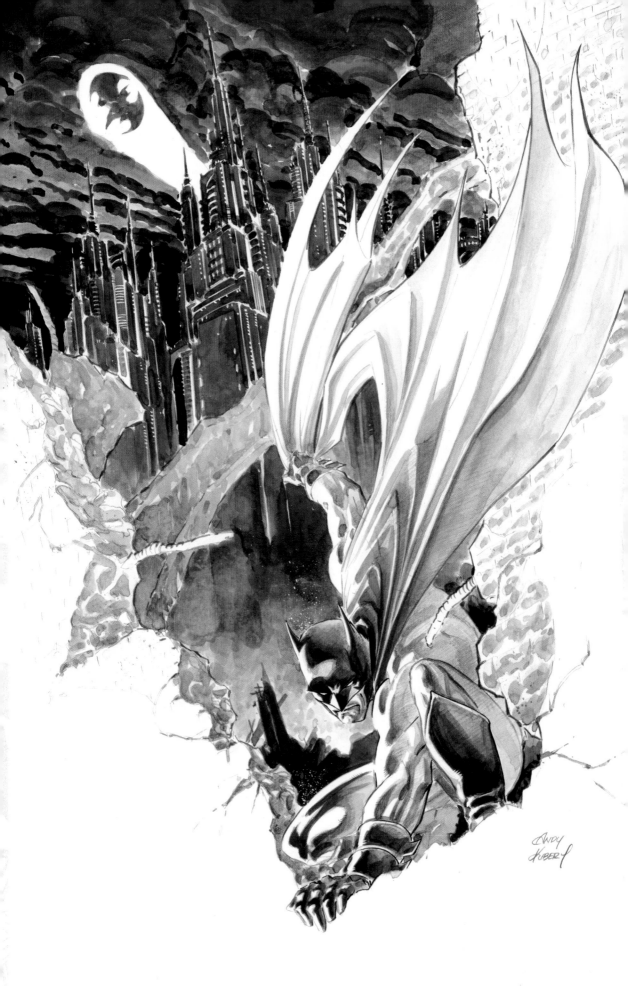

Cover to BATMAN #689

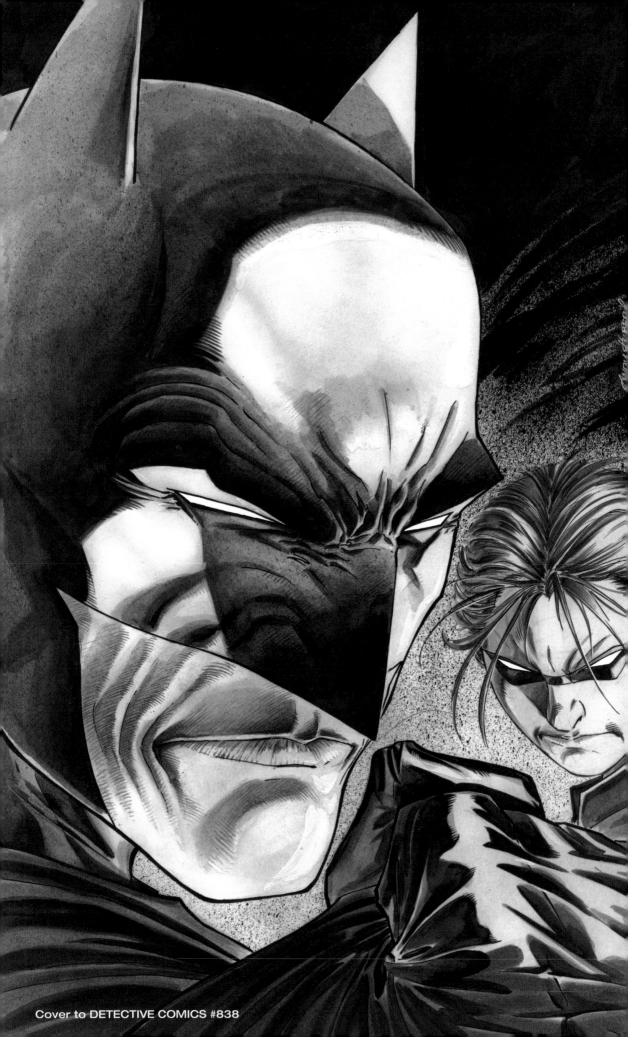

Cover to DETECTIVE COMICS #838

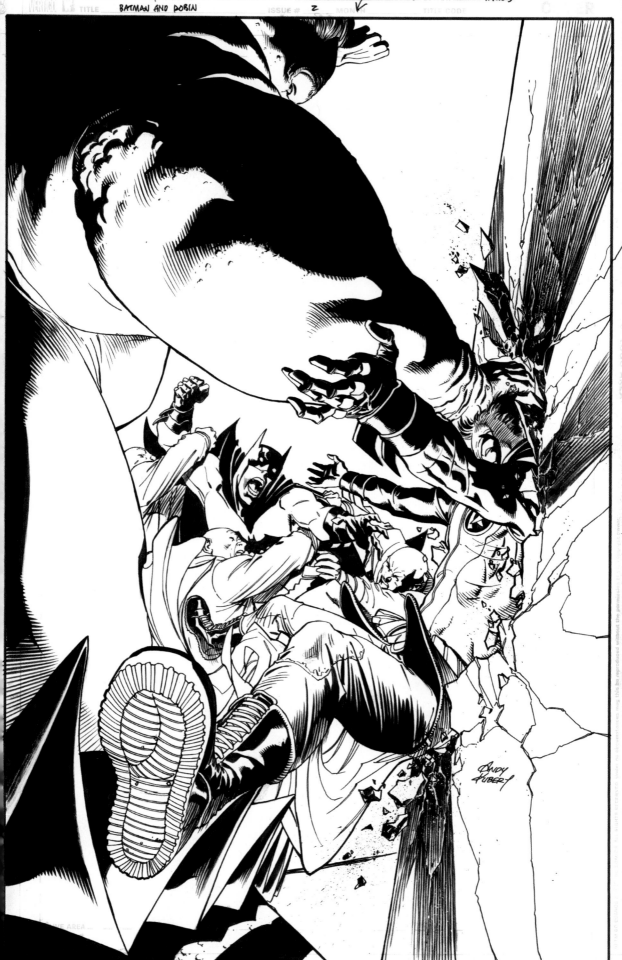

Cover to BATMAN AND ROBIN #2 - variant

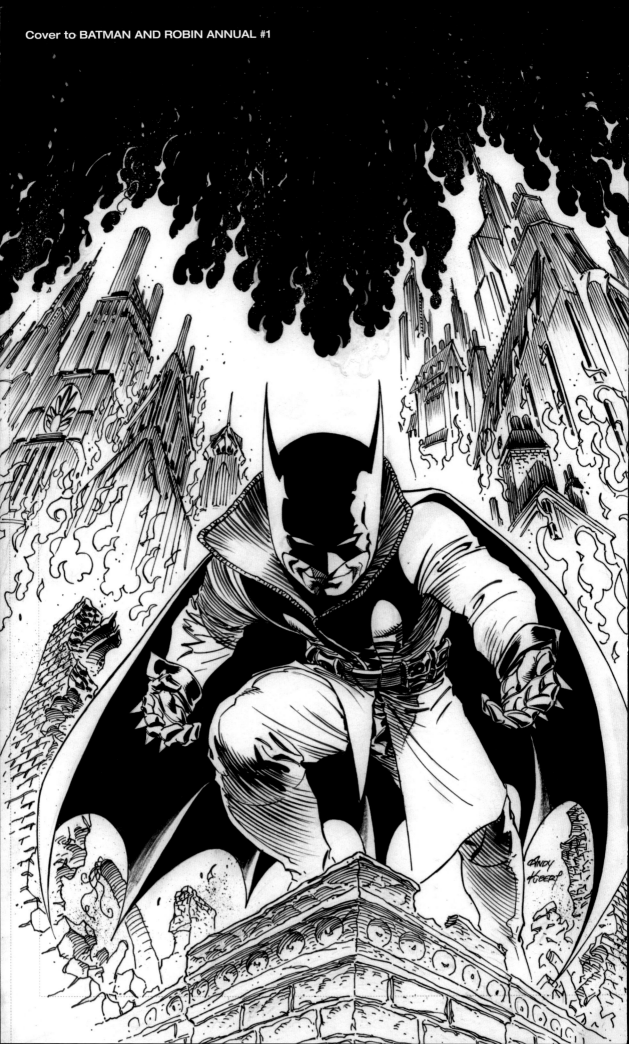

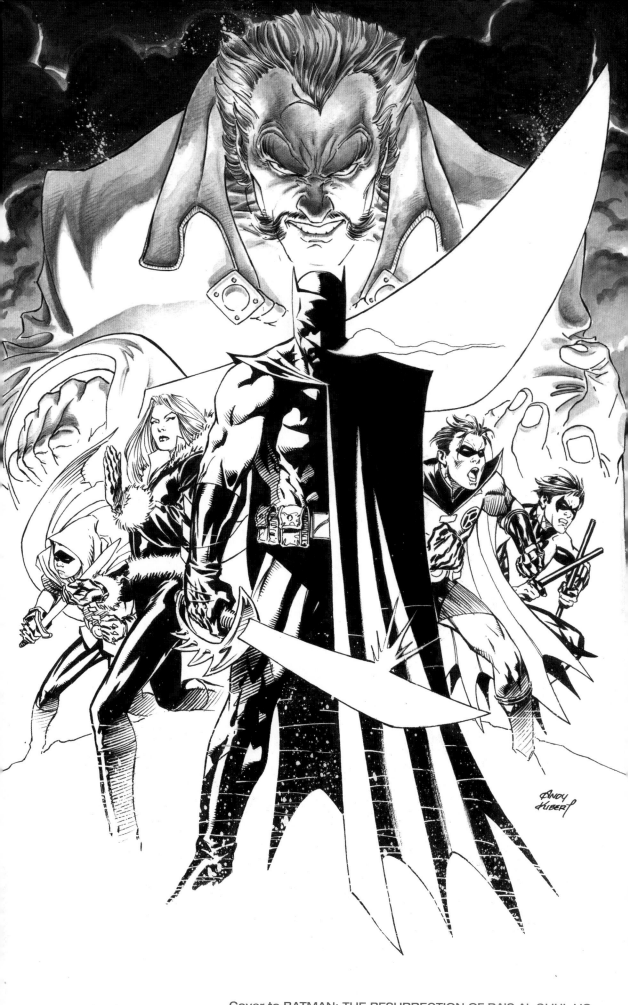

Cover to BATMAN: THE RESURRECTION OF RA'S AL GHUL HC

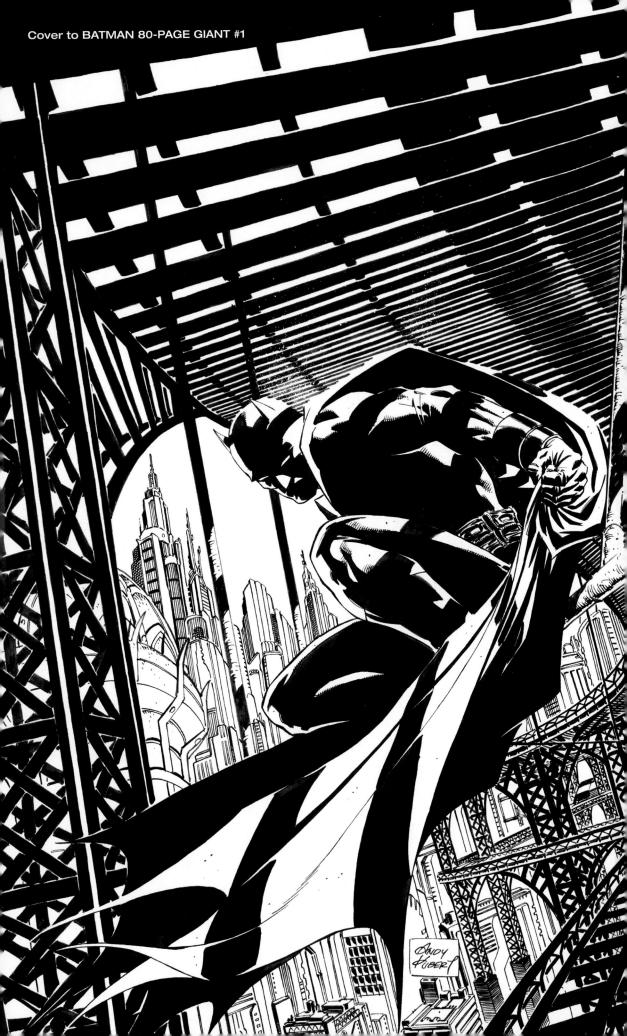

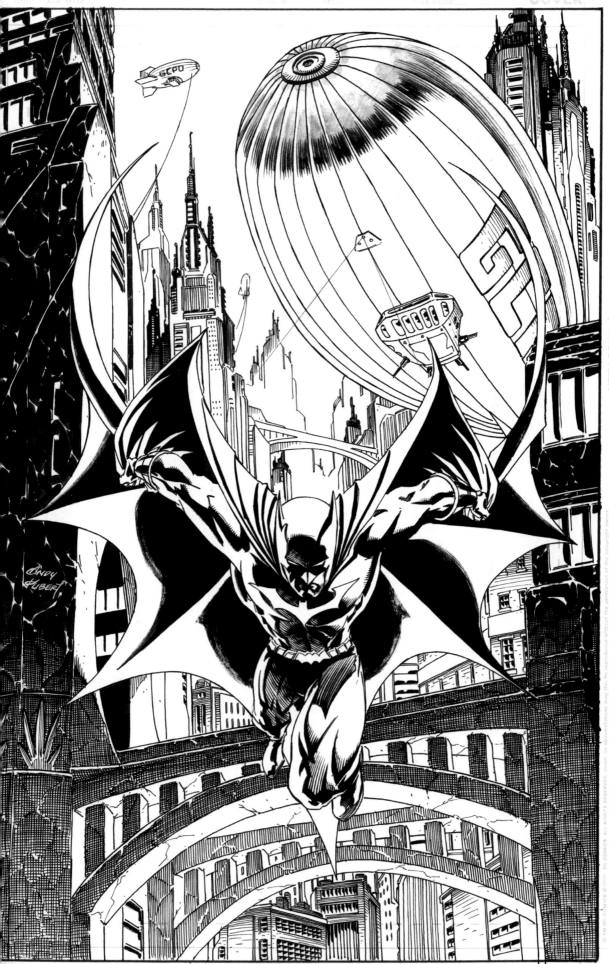

Cover to BATMAN CONFIDENTIAL #49

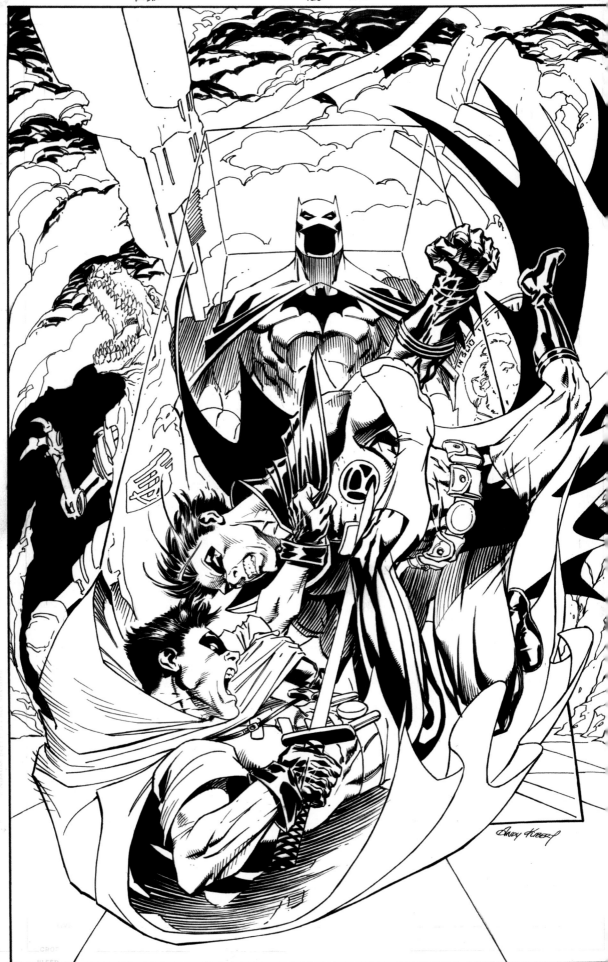

Cover to ROBIN #168

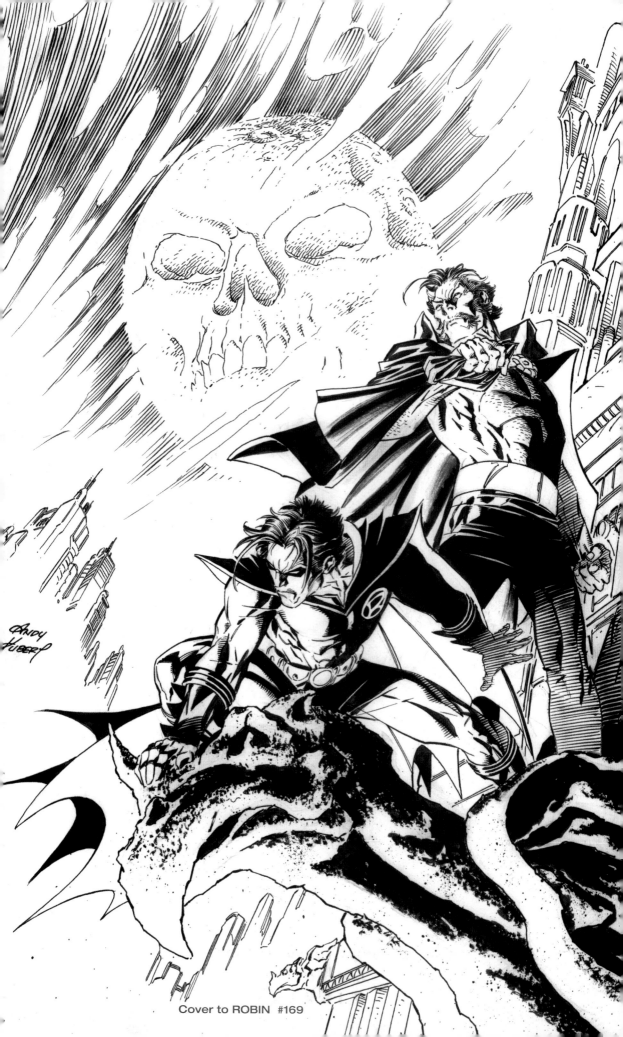

Cover to ROBIN #169

BIOGRAPHIES

ANDY KUBERT

Andy Kubert began his career at DC comics illustrating the first highly successful BATMAN VERSUS PREDATOR and ADAM STRANGE series. Andy went on to Marvel Comics' popular *X-Men* title, which was consistently a sales juggernaut and remained their top-selling comic during his six-year run. At Marvel he also illustrated such titles as *Ghost Rider, Captain America, Ultimate X-Men* and the *Marvel 1602* miniseries in which he collaborated with *New York Times* best-selling author Neil Gaiman and which earned a 2005 Quill Award for Best Graphic Novel.

Since returning to DC Comics, Andy has illustrated the best-selling BATMAN AND SON, FLASHPOINT and BATMAN: WHATEVER HAPPENED TO THE CAPED CRUSADER. His work has also appeared in other titles including ACTION COMICS and BEFORE WATCHMEN: NITE OWL. He is currently writing and illustrating the series DAMIAN: SON OF BATMAN and is an instructor at The Kubert School in Dover, New Jersey.

GRANT MORRISON

Grant Morrison has been working with DC Comics for more than twenty years, beginning with his legendary runs on the revolutionary titles ANIMAL MAN and DOOM PATROL. Since then he has written numerous best-sellers — including JLA, BATMAN and *New X-Men* — as well as the critically acclaimed creator-owned series THE INVISIBLES, SEAGUY, THE FILTH, WE3 and JOE THE BARBARIAN. Morrison has also expanded the borders of the DC Universe in the award-winning pages of SEVEN SOLDIERS, ALL-STAR SUPERMAN, FINAL CRISIS and BATMAN, INC., and reinvented the Man of Steel in the all-new ACTION COMICS.

In his secret identity, Morrison is a "counterculture" spokesperson, a musician, an award-winning playwright and a chaos magician. He is also the author of the *New York Times* best-seller *Supergods*, a groundbreaking psycho-historic mapping of the super hero as a cultural organism. He divides his time between his homes in Los Angeles and Scotland.

NEIL GAIMAN

Neil Gaiman lives mostly in America with two cats, two large white dogs and a number of awards from all over the world. He still does not understand how he came to be responsible for the feeding and domestic arrangements of these animals, nor, for that matter, what he is doing living in America. He has seven beehives and many bees. He has written novels and comics and movies and TV and poems and an opera and he keeps a Twitter feed, which is nothing like keeping bees at all. He is married to punk cabaret chanteuse Amanda Palmer and has played himself in animated televisual cartoons.

SCOTT SNYDER

Scott Snyder has written comics for both DC and Marvel, including the best-selling series BATMAN, SUPERMAN UNCHAINED, THE WAKE, AMERICAN VAMPIRE and SWAMP THING, and is the author of the story collection *Voodoo Heart* (The Dial Press). He teaches writing at Sarah Lawrence College and Columbia University. He lives on Long Island with his wife Jeanie, and his sons Jack and Emmett. He is a dedicated and un-ironic fan of Elvis Presley.

"Brilliantly executed."
—IGN

"Morrison and Quitely have the magic touch that makes any book they collaborate on stand out from the rest." —MTV's Splash Page

"Thrilling and invigorating....Gotham City that has never looked this good, felt this strange, or been this deadly." —COMIC BOOK RESOURCES

GRANT MORRISON

BATMAN & ROBIN VOL. 1: BATMAN REBORN with FRANK QUITELY & PHILIP TAN

VOL. 2: BATMAN VS. ROBIN

VOL. 3: BATMAN & ROBIN MUST DIE!

DARK KNIGHT VS. WHITE KNIGHT

grant **morrison**
frank **quitely** *philip* **tan**

BATMAN & ROBIN

"Morrison and Quitely have the magic touch."
— MTV'S SPLASH PAGE

BATMAN REBORN